Foundations of
Art and Design

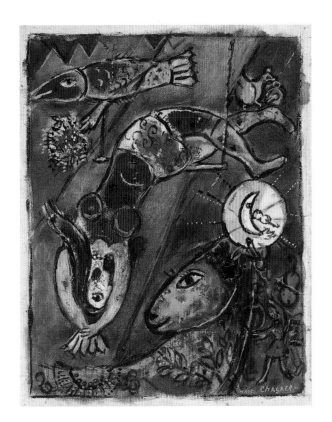

Foundations of Art and Design

Alan Pipes

Laurence King Publishing

Dedicated to my father Ronald Edward Pipes,
1924–2002

LAURENCE KING

Published in 2003 by Laurence King Publishing Ltd
71 Great Russell Street
London WC1B 3BP
United Kingdom
Tel: + 44 20 7430 8850
Fax: + 44 20 7430 8880
e-mail: enquiries@laurenceking.co.uk
www.laurenceking.co.uk

A catalogue record for this book is available
from the British Library.

ISBN 1 85669 375 9

Senior managing editor: Richard Mason
Design: Ian Hunt Design
Cover design: Frost Design
Picture researcher: Sue Bolsom
Typesetter: Marie Doherty
Printed in China

Halftitle: Marc Chagall, *The Blue Circus*, 1950. Oil on canvas, 13 x
10″ (33 x 25.4 cm). Tate, London.

Contents

Preface

"Reason informed by emotion... expressed in beauty... elevated by earnestness... lightened by humor... that is the ideal that should guide all artists."

CHARLES RENNIE MACKINTOSH

What is art? Art is what artists do, Dadaist Marcel Duchamp might have said. Art is what you can get away with, you may be tempted to think when looking at contemporary artworks. The word *art* derives from Sanskrit and means "making" or "creating something". We can only guess why our earliest ancestors started to make art, drawing and carving on cave walls. Egyptian wall paintings (**0.1**) and African art (**0.4**) have a ritual dimension, but still manage to delight our eyes. The ancient Greeks and Romans surrounded their lives with culture: poetry, theater, sculptures—and paintings (**0.3**), few of which survive. They were probably the first artists

0.1 Hunting scene, Tomb of Nebamun, Thebes, c. 1400 BCE. Fresco. British Museum, London.

Egyptian official Nebamun hunts marsh birds, accompanied by his wife and daughter. As the most important person, he is the largest figure—an example of hieratic scaling. The composition is non-realistic, but individually the animals have been carefully observed.

0.2 (opposite) Empress Theodora and attendants, San Vitale apse, Ravenna, c. 547 CE. Mosaic.

This mosaic reveals the power that Byzantine Emperor Justinian exercised over the church. The halo over Empress Theodora's head symbolizes her status akin to the Virgin Mary. The fountain indicates Theodora's Christian baptism. She is wearing Tyrrhian purple, the color of royalty.

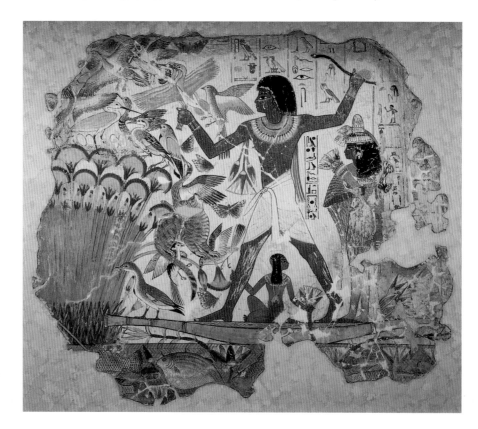

who painted purely for pleasure and for the joy their art gave others. Whatever the reasons for creating, art enriches our lives, stimulates our senses, or simply makes us think. Artists have come to be revered for their gift of profound insight into the human condition.

In Byzantine (**0.2**) and Renaissance times (**0.5**), being an artist was just a job: painters had workshops full of assistants, and artisans making paint and preparing panels and canvases. They generally produced religious artworks for wealthy patrons. It was only in the late nineteenth century that "art for art's sake" began to emerge, art being seen as an expression of the artist's emotions. Since then Hollywood has depicted such artists as Vincent van Gogh and Henri de Toulouse-Lautrec as glamorous yet tortured visionaries who suffered for their art, locked away in solitary garrets. Abstract art followed (**0.6**), and today almost anything goes.

What is design? Its roots are found in the Italian word *disegnare*, to create. In these days of designer jeans and kitchens, it is easy to think of design equating to stylish consumer goods or gadgets, made desirable by clever and knowing graphics (which draw ultimately on art for inspiration). We can forget that everything artificial—good or bad—has been designed by someone.

In its broadest sense, design is preparing for action: planning and organizing. We might have "designs" on someone, and plan how we can engineer a successful outcome. Architects design buildings, industrial designers design products, and artists design paintings and sculptures. This book looks at design in the easel-based arts, with references to the allied arts of photography and sculpture. By easel arts we mean drawing, painting, and printmaking, in the sense of making marks on paper

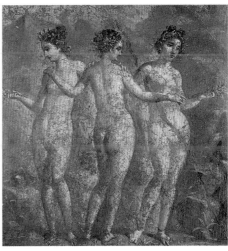

0.3 The Three Graces, House of Denatus Panthera, Pompeii, 1st century CE. Fresco. Museo Archeologico Nazionale, Naples.

The Three Graces, or Charities, were the attendants of Venus (Aphrodite in Greek): Aglaia (elegance), Euphrosyne (mirth), and Thalia (youth and beauty). (See **12.1**)

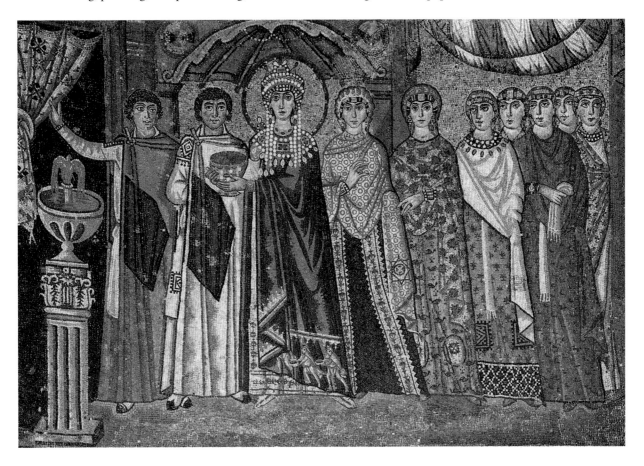

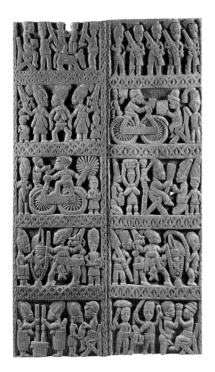

or canvas, or the screen-based arts: video, computer, and installation-based works. The computer has blurred the boundaries between the traditional creative disciplines, but they all share a need for planning and visual organization.

Design can also be considered as a form of problem-solving. But unlike math, in art there is never a single correct solution. This is why artists and designers are often called "creatives." Painters and sculptors often set their own tasks; designers and illustrators are given a brief with strictly defined parameters, and attempt a design based on those constraints. Even in abstract expressionism, where you might imagine that all the artist does is throw a pot of paint at the canvas and hope for the best, there are underlying processes at work. The artist's eye and hand in tandem are guided by a need to produce an outcome, and he or she is informed by the whole history of art up until that point. Chance and randomness do have a place, but serendipity is a better term: you need skill and experience to turn a happy accident to your advantage.

It is beyond the scope of this book to provide a comprehensive overview of art history, but there are plenty of other books and web resources—some of which are listed toward the end of this book, should you be inspired to explore further. Nor can this book be an art appreciation guide, although understanding how and why artworks were created, what the artists were trying to achieve, and who their influences were will pay dividends when planning your own works. Looking should be the main education of every artist.

0.4 (above) Areogun, Palace door panel from Osi-Ilorin, Yoruba (Nigeria), early 20th century. Wood, height 5′ 11″ (1.82 m). Fowler Museum of Cultural History, University of Los Angeles, CA.

The Yoruba inherit a long history of woodcarving. This is a recent example, as can be seen by the pipe-smoking cyclists and the policemen with rifles.

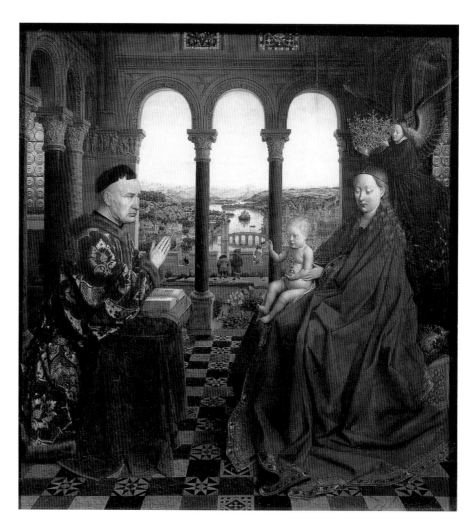

0.5 Jan Van Eyck, *The Virgin and the Chancellor Rolin*, c. 1420. Oil on wood, 26 × 24″ (66 × 62 cm). Louvre, Paris.

Van Eyck perfected the technique of oil painting and the depiction of deep space. Nicolas Rolin was prominent at the court of Philip the Good of Burgundy. Mary presents Rolin with the Infant Jesus. The lilies and roses symbolize her virtues; the two peacocks represent immortality and pride. (See **7.42**)

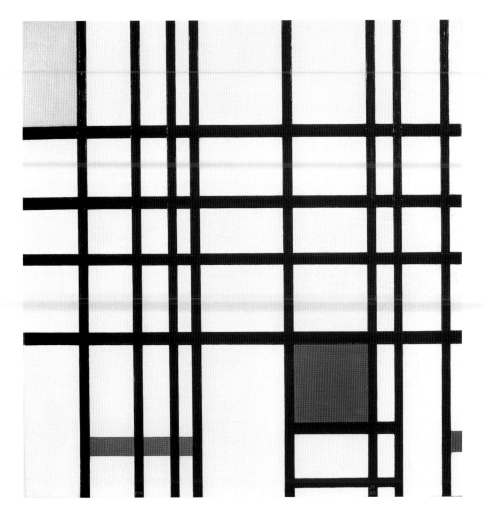

0.6 Piet Mondrian, *Composition with Yellow, Blue, and Red*, c. 1937–42. Oil on canvas, 28 ⅜ × 27 ¼″ (72.5 × 69 cm). Tate, London.

Mondrian left Paris in 1938, taking this abstract painting to work on in London and New York. He began with four horizontal and five vertical lines.

Design in the context of this book means, simply, composition. How do we place and arrange the various elements of design discussed in Part 1—of little use on their own—to create a unified and thoughtful piece of work that will interest the viewer? The way in which to go about this, using rules or principles, is outlined in Part 2. The many illustrations serve as examples, and as inspiration. Although the chapters are set out in a logical sequence, it is almost impossible to isolate a particular element—discussing line, for example—without mentioning its textural component. There will be some repetition and overlap, but perhaps the reader will recognize that all the elements and principles of design are equally important, and, once joined together in the right combination, they will result in a successful artwork. We describe them; how they are used is up to you.

Many people have contributed to the creation of this book. I should like to thank in particular Lee Greenfield for commissioning me to write it, my editor Richard Mason for his patience and eye for detail, my picture researcher Sue Bolsom for her tireless work and lateral thinking, and the designer Ian Hunt for assembling words and images into a harmonious composition. I should also like to thank friends and colleagues of the Brighton Illustrators Group, many of whom have contributed images, and the staff of Brighton University Library at St. Peter's House and of Brighton Public Library for their help in research.

Alan Pipes, July 2003

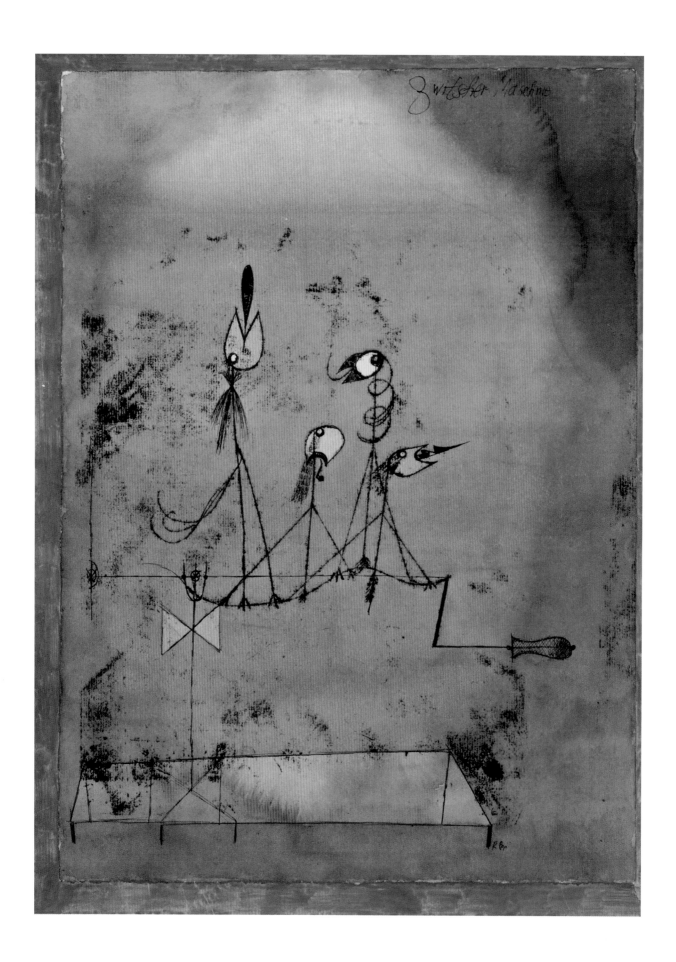

Part **1** | ELEMENTS

Line, shape, texture, space, motion, value, and color are the principal elements of art and design. In the following chapters, we introduce the elements one by one, starting with the first forays onto a blank canvas and ending with the most complex element of all—color. Although arranged in a logical sequence, the elements of art and design cannot be isolated; there will be some overlap and repetition. In Part 2 we will start to use them together.

Paul Klee, *Twittering Machine*, 1922. Watercolor and pen and ink on oil transfer drawing on paper, mounted on cardboard, 25 ¼ × 19″ (63.8 × 48.1 cm). Museum of Modern Art, New York. Purchase.

These creatures and hand crank, drawn with a wiry, nervous line, could be a music box to lure victims to the pit below. Klee copied the drawing onto tracing paper backed by a thin film of oil paint, then transferred the image to a new ground. The result was a rough, granular line, which he would work over with watercolor.

Prologue | Nothingness

"We turn clay to make a vessel, but it is on the space where there is nothing that the usefulness of the vessel depends."

LAO-TZU

White space. Nothingness. What American abstract expressionist Barnett Newman (1905–70) called "the void." An empty canvas, like the blank page to a poet, exists before the work begins. Some artists fear the white space so much that they cover it with neutral paint before they even attempt the first mark. To other artists, white space represents an almost-completed work. Russian artist Kasimir Malevich (1878–1935) reached what he considered to be the summit of abstract art in 1918 with his painting *White on White* (**0.8**)—a white square on a white ground.

As we shall see later, white does not always equate with emptiness. White is a pigment—a color—and it comes with a color's connotations and symbolic meanings. White means purity—bleached paper, primed canvas, a polar bear in the snow, or (at least in Western cultures) a wedding dress.

We can learn a lot about white space from Japanese art (**0.7**). In the late 19th century, *ukiyo-e* prints (pictures of the floating world) were a revelation to European artists, particularly Aubrey Beardsley (1872–1898), who turned the limitations of the recently invented photographic process block to his advantage, creating a new aesthetic—one that was asymmetric, free from clutter and backgrounds, with bold, flat areas of jet black, sinuous line, but mostly lots and lots of white space (**0.9**).

0.7 Toyokuni, *The Actor Fujikawa Tomokichi II as O-Kaji*, c. 1811. Woodblock print. Private Collection.

Ukiyo-e, "pictures of the floating world," depict the Kabuki actors and *geisha* (female entertainers) of urban Japan. Prints such as these fueled the craze for "Japonisme" in the 1870s–1880s.

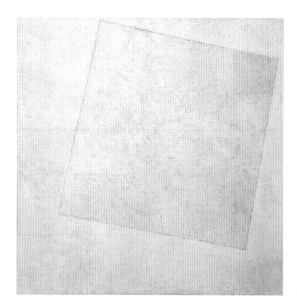

0.8 Kasimir Malevich, *Suprematist Composition: White on White*, 1918. Oil on canvas, 31 ¼ × 31 ¼" (79.3 × 79.3 cm). Museum of Modern Art, New York.

This abstract painting is deceptively simple, the tilted smaller square creating dynamic tension as it moves to the edges.

Japanese aesthetics are based on simplicity, irregularity, and perishability. Long before the minimalists, they saw beauty in uncomplicated arrangements of simple things—*kirei*, which means beautiful, and also simple and refined—and the concept lives on in cute *kawaii* stickers and mascots, in which faces are reduced to a few well-chosen dots and lines.

Our contemporary use of white space dates back to the Modernists of the 1920s who wanted to throw out what they considered Victorian vulgarity and over-ornamentation and start again from zero. Less is more, they said, and built plain white rectilinear functional boxes for living in. This seemed shocking at first, but the aesthetics of Modernism became absorbed into the mainstream, appropriated by consumerism as a marker for good taste.

White space has become a code for culture (**0.10**). To package perfume in a simple white box endows it with instant desirability. In graphic design, space is always at a premium. White space is an extravagance, representing areas of paper that you've chosen not to print on, even though it must still go through the press. You'll find little white space in a newspaper or mass-market publication, but in a glossy fashion magazine white space demonstrates that the publisher, advertisers—and you, the reader—have money to burn. Is it time for a change?

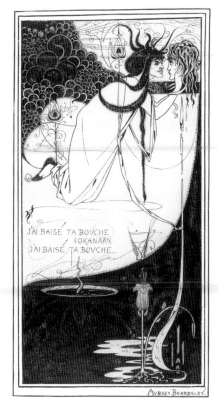

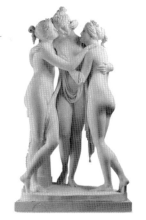

FREE GRACES

The Victoria and Albert Museum
is now free of charge for everyone

Information 020 7942 2000 www.vam.ac.uk
⊖ South Kensington

Victoria and Albert Museum: The National Museum of Art and Design
Entry to the Museum is free there may be a charge for some special exhibitions and events

0.9 (above) Aubrey Beardsley, Illustration from Oscar Wilde's *Salome*, 1894. Private Collection.

Beardsley was influenced by *ukiyo-e* prints (see **0.7**). He used their clean, graphic simplicity to turn the restrictions of the newly invented photographic process line block to his advantage, creating clean lines, areas of solid black, and tantalizing white space.

0.10 Johnson Banks, *Free Graces*, 2002. Poster. Victoria and Albert Museum, London.

This poster for the Victoria and Albert Museum advertises free admission. It shows the marble statue of Antonio Canova's *The Three Graces* (1814) surrounded by white space, symbolizing high culture.

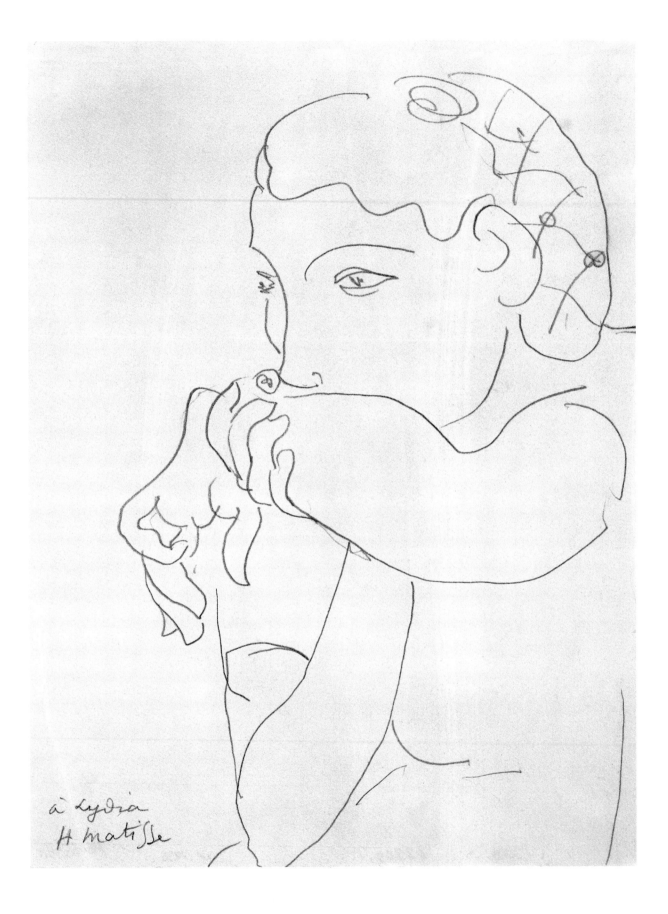

à Lydia
H Matisse

1 | Points and Lines

"The original movement, the agent, is a point that sets itself in motion. A line comes into being. It goes out for a walk, so to speak, aimlessly for the sake of the walk."

PAUL KLEE

Henri Matisse, *Portrait of a Woman*, 1939. Pencil on paper. Hermitage, St. Petersburg.

Matisse could capture a mood and a likeness with just a few deft pencil lines.

Introduction

Line is the most fundamental and versatile of all design elements. Lines are the first kind of marks children make (**1.1**), largely by virtue of the drawing implements they use—pencils, crayons, felt-tip pens, even brushes have pointed ends, no matter how blunt they may be. And with the natural movement of the hand, we use them to draw lines (**1.2**).

Our ancestors made some of the earliest pictorial images with lines, as typified by the cave paintings in France and Spain, where they used their fingers or pointed sticks to depict identifiable animals in charcoal and red ocher (**1.3**). Incised carvings of animals, in line, have been found carved into rocks the world over.

In mathematics, a line joins two or more points. It has length and direction, but no width—it is one-dimensional. In art and design, lines have to be seen and so have breadth, but this is not their most important characteristic. We can always recognize a line, whether it is as delicate and precise as those found in an etching or as broad as one of the Nazca lines—those enormous and mysterious drawings of birds (**1.4**) and insects in the Peruvian desert, some made from lines as wide as airport runways.

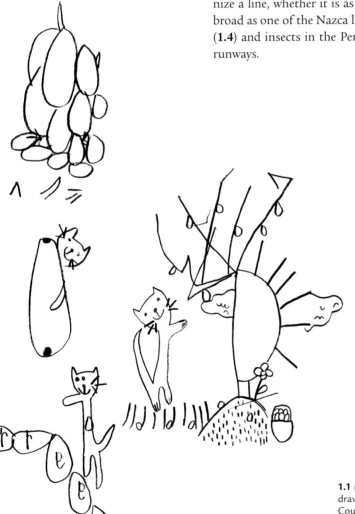

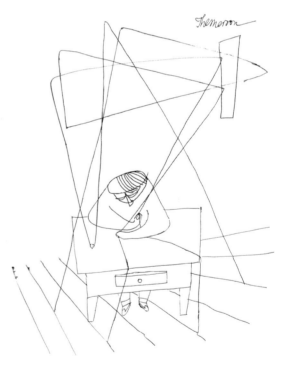

1.1 (left) Josie Carr, A child's drawing, 2002. Pencil on paper. Courtesy the artist.

Josie was aged 7 when she drew this. Children love to draw. We can learn a lot from their uninhibited use of line.

1.2 Franciszka Themerson, *Draughtsman's Studio: Drawing Board*, 1948. Ballpoint pen, 11 × 7 ¾" (28 × 20 cm). Themerson Archive, London.

Klee's advice to take a line for a walk (see p. 17) is clearly demonstrated in this joyful ballpoint sketch.

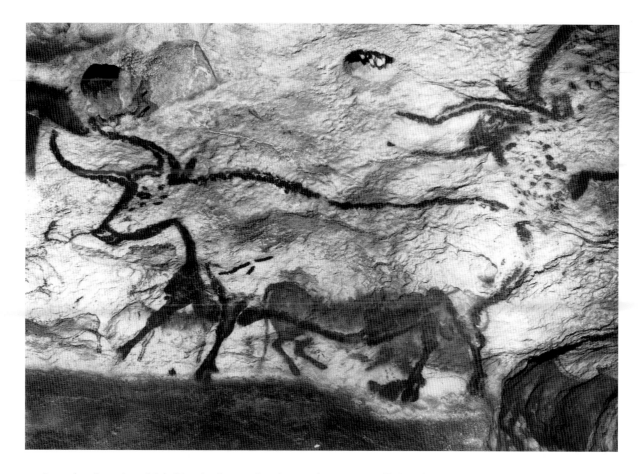

A work of art in which line is the predominant element is called a drawing, regardless of whether it was made with a pencil, pen, or brush. Paul Klee (1879–1940), the Swiss artist and teacher, described drawing as taking a point or a line for a walk. He was keen to draw spontaneously, without preconceptions, and often thought of the subject and title only after he was satisfied that the drawing had been completed.

But the analogy of a drawing being like a journey is a powerful one. All drawings start with a point, a mark on the paper, and, by the action of the hand in space, it becomes a line. We look back at what we have done, and, depending on what we see, the line may change direction. Eventually the "active" lines join and interconnect and become passive planes (more of which later) anchored onto the plane of the paper, and the process of creation continues. Thus lines are not only marks in two-dimensional space; they are also a visual record of movement over time. Says Klee: "Only the single dot, which has no life, no energy, lacks the dimension of time." In turn, the drawing is perceived by movement—of the viewer's eyes.

When we think of line drawings, we think first of outlines, such as the stark skeleton pictures in coloring-in books, the hard black lines around comic book characters, or the cold impersonal diagrams in instruction manuals. Although we can easily recognize what these drawings represent in the real world, they are largely abstract constructs—depicting the edges or boundaries between light and dark, for example, or between an object and its background.

As well as standing in for reality, line drawings can also be highly expressive in themselves, as we see in the works of Klee. Lines have other uses, too—they can be used to divide spaces in a composition or layout, and as decoration and embellishment.

1.3 Bull, Lascaux cave, France, c. 12,000 BCE. Pigment on limestone.

In 1940, four teenagers from the Dordogne region of France found the entrance to a cave that contained rock paintings from the late Palaeolithic period. Inside there are depictions of horses, bison, and deer full of motion.

1.4 Bird figure, Palpa river, Peru, first millennium BCE.

The lines were made by sweeping pebbles from the surface of the desert. They form outlines of huge monkeys, spiders, and birds, as well as spirals, rectangles, and trapezoidal figures of vast proportions.

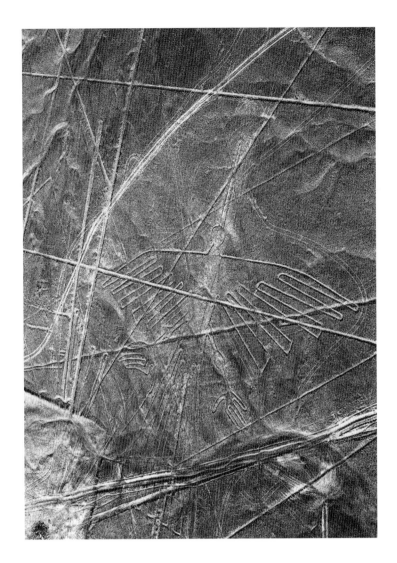

1.5 (right) Saul Steinberg, *Hen*, 1945. Pen and brush and India ink on paper, 14 ½ × 23 ⅛" (36.8 × 58.8 cm). Museum of Modern Art, New York.

Saul Steinberg declared that his illustrations "masqueraded as cartoons" and defined drawing as "a way of reasoning on paper." Here he plays with different line weights to create texture. (See p. 210)

A single straight line is one of the most abstract of elements, but it is capable of conveying all kinds of moods and emotions—anger, calm, fear, grace, excitement—when its attributes of size, shape, position, direction, and density are varied. Put lines together and you can construct planes and volumes with texture, value, and "color." You can create illusions, such as three-dimensionality and perspective, and conjure up all kinds of ideas (**1.5, 1.6**). Certain combinations of lines produce pictograms and letterforms, with all their layers of meaning.

In graphic design and print production line art refers to black or another single color, with no other shades or colors, that can be printed using a single plate—that is, one mixture of ink—and involving no intermediate process, such as screening. Think of the line drawings of Aubrey Beardsley, which are solid areas, dots, or lines of a single color with no gradation of tone.

There are ways of fooling the eye into perceiving shades of gray without having to mix up gray ink by stippling, cross-hatching, or converting the continuous tones of, say, a photograph or pencil drawing into an array of halftone dots that from a distance fade to shades of gray (see pages 36–37).

So far we have been talking about freehand lines made by pencil, pen, or brush. Straight lines can be made using a ruler and circles by using compasses. And, of course, the computer makes even these simple devices redundant. Curved lines are

another matter. Before computers were available to help them draw smooth, curved lines or ellipses, architects, boat designers, and draftspeople used French curves and various templates or splines in the form of long plywood strips or pieces of thick piano wire held taut by lead weights or "ducks."

The mathematics of drawing controllable curved lines was developed in the 1940s by French engineer Pierre Bézier (1910–99) to guide the paths of computer-controlled milling machines. Bézier curve tools, more accurately known as b-splines, are now familiar to anyone using drawing programs such as Adobe Illustrator or Macromedia Freehand (see **2.19**) or image-processing software such as Adobe Photoshop. More "natural" looking curves can be produced by using the mathematics of "fractals."

1.6 Evelina Frescura, *Woman with Garden*, 2002. Line drawing. Courtesy the artist.

Drawing freehand with a mouse in Adobe Illustrator, Frescura produced a series of drawings for the cable company ntl:home. This example promoted gardening programs. Graphic design was by the London agency Lambie Nairn.

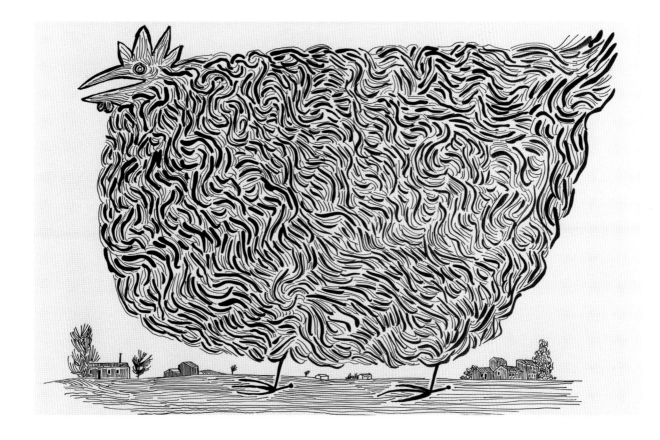

Points

Everything starts with a single point. In mathematics, a point has no dimensions, just a position in space. The Greek philosopher Euclid (*c.*325–270 BC) defined a point as "that which has no part." In art and design it may be difficult to make such a point, and instead we have the dot, dab, or blob. If it is to be seen, such a mark will always have a shape, called mass. Like the breadth of a line, the size of a point is not usually its most important attribute—it may be as tiny as a pin prick or as large as a planet, but it can still be described as a point.

Points aligned in the general direction of a line constitute a dotted line, and it is possible to make a picture by carefully arranging many points (**1.9**). This technique is called **stippling**, and a similar process is used in printmaking to simulate tonality. Engravers use special stippling tools mounted on roulettes or punches to reproduce the effect of a rough charcoal or pastel line.

When photography was invented, printers used ruled glass screens to convert areas of continuous tones of gray on photographs and illustrations into regular patterns of black dots of varying sizes that could be printed. The lens of the process camera produced dots that were always round. Today, this process is done digitally by scanners, computers, and laser imagesetters, and the dots can be elliptical, square, or any other shape, or equally sized dots can be randomly scattered to produce a more realistic effect. This is called **stochastic** screening.

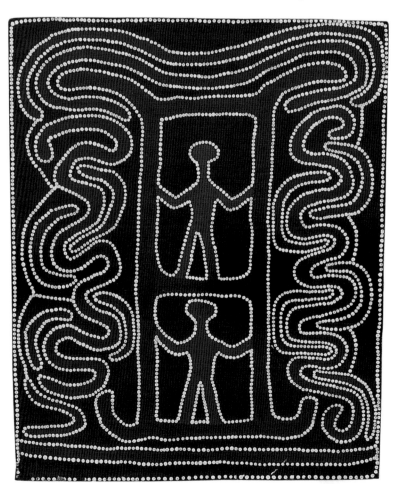

1.7 Jimmy Pike, *Ngan Payijarra (Two Men in a Cave)*, 1997. Acrylic on canvas, 35 ⅞ × 47 ⅝" (91 × 121 cm). Rebecca Hossack Gallery, London.

Dots are a traditional feature of Australian Koori (aboriginal) paintings called "dreamings." They are created by the painter moving around the support, which is placed flat on the ground.

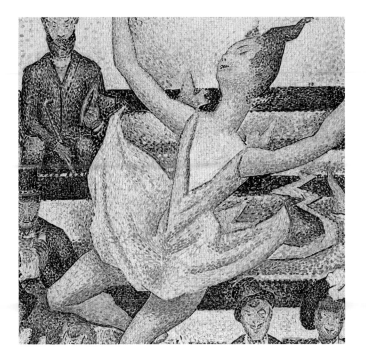

1.8 Georges Seurat, *Le Cirque* (detail), 1891. Oil on canvas, 73 × 60″ (185.5 × 152.5 cm). Musée d'Orsay, Paris. (See **7.25**)

The Pointillists were fascinated by scientific theories of color. They juxtaposed small dabs of pure primary color to mix secondary and tertiary colors visually and produce vibrant neutrals.

1.9 Alan Baker, *Babyface*, 1989. Ink on paper, 2 ⅜ × 2 ⅜″ (6 × 6 cm). Courtesy the artist.

Stippling, like cross-hatching, can simulate areas of value when viewed from a distance.

Many other arts and crafts use regular arrays of dots and dabs to create pictures and patterns—textile designs, tapestries, carpets, and cross-stitch embroidery use small, juxtaposed areas of color that, seen at a distance, merge into continuous tone. Mosaics are made using **tesserae** or small cubes of colored marble or glass in a limited range of colors arranged usually in **contours** rather than regular arrays, to give the appearance of a full tonal range of colors (see **0.2**).

Dots have traditionally been a feature in the art of Australian Koori (aboriginal) people, in body painting, bark painting, or, more recently, works in acrylic paint on paper or canvas called "dreamings" (**1.7**). Works are traditionally created by moving around the support, which is placed flat on the ground. This makes dotting—using a pointed stick or brush—an ideal technique.

Painters in the rest of the world have always used dabs of color, especially for highlights. The technique of quick-drying tempera painting relies on the close positioning of short dabs of color rather than on the blending of wet paint, which is possible with oils. The Pointillists were a group of French artists, including Georges Seurat (1859–91), who were fascinated by the latest theories of optical color. They used the close juxtaposition of small dabs of pure primary color to visually mix secondary and tertiary colors (**1.8**).

Later, artists such as Vincent Van Gogh (1853–90) would use the technique in a looser, chunkier way, with a more lively result, and recently, American photo-realist artist Chuck Close (b. 1940) has used optical mixing of composite dabs in his gigantic portraits (**1.10, 10.15**). Each "dab" is made up of a complex pattern of shapes and colors.

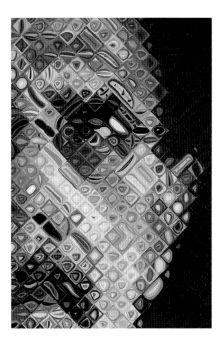

1.10 Chuck Close, *Self-Portrait*, (detail) 2000–01. Oil on canvas, 108 x 84″ (274.3 x 213.4 cm). Courtesy the artist. (See **10.15**)

Close uses a gridded "mosaic" of composite diamond-shaped dabs, each one containing abstract whorls of shapes.

Types of Line

Think of line, and we will first think of **outline**—the real or mostly imaginary lines that describe shapes and their edges or boundaries (**1.11**). Some of the earliest drawings were outlines or silhouettes with few interior details. As children, we are given coloring books full of outlines and encouraged to keep within the lines when coloring them in. Later, we encounter comic books with their strong outlines, sometimes filled with flat color. In art and design, we are familiar with stained-glass windows in churches, and the Pop-art paintings of Roy Lichtenstein (1923-97) (see **3.20**) and Julian Opie (b. 1958) (see **1.28**).

An outline is an abstract concept, most often describing the shape an object makes against its background—we can recognize the outline of a tree or flower, even though there are many different species of tree and every individual tree is different. We can do that from the outline alone, without the cues and clues of color, scale, or added texture (**1.12**).

A mathematical line has no width. In art and design, we may attempt to approach this perfection with an etching needle, or **silverpoint**, or even the precise line created by a computer driving a laser imagesetter, but most often the tools and implements we use impart mass and quality to a drawn line. You hear people talking about "economy of line," that Pablo Picasso (1881-1973) or Henri Matisse (1869-1954) could produce a picture of something with just a few deft strokes. It is spoken of as a virtue. Matisse and artists like him have set free the outline, breaking it up into a loose yet evocative impression (see p. 16). Cartoonists, too, attempt to convey an idea with the absolute minimum number of lines (**1.13**).

In addition to their function in drawings, lines can be used in composition to divide spaces and lead the viewer's eyes around the image. An **implied line** is created by arranging points or short lines in such a way that our brains join the dots, fill the gaps, and complete the picture (**1.14**).

A **psychic line** has no existence at all except as an imaginary ray of light joining, for example, a person's eyes to the object they are looking at, or the line that extends into space from the tip of a pointing arrow. Artists and designers use psychic lines to guide the viewer around a picture and direct their viewing experience.

In cartoons, lines are sometimes used to depict the invisible—the streak lines that show the speed of a moving airplane or car, for example, or the shaking of a cold or nervous person.

The word contour is often used as a synonym for outline. More accurately, it describes the lines within an outline that give an object its volume—the hoops around a barrel, for example, or the lines describing the sections of a beach ball. A contour line on a map is a line that joins equal heights, but a contour could also be the stripes around a lighthouse or the body segments of a caterpillar. Artists who use **cross-hatching** (see pages 36–37) to add value to an outline will often curve these shading lines around the contours of the object, to achieve a more realistic rendering.

1.12 (above) Ellsworth Kelly, *Five-Leaved Tropical Plant*, 1981. Pencil on paper, 18 × 24″ (46 × 61 cm). Private Collection.

Kelly captures the energy and fragile rhythm of organic matter.

1.13 (left) Alan Pipes, *Self-Portrait*, 2003. Pen and ink on paper, 4 ⅓ × 3 ¹⁵⁄₁₆″ (11 × 10 cm). Courtesy the author.

A cartoon aims to convey a message in the minimum number of lines. Here the author has drawn a self-portrait in pen and ink on paper.

1.14 (right) Alan Pipes (based on Gaetano Kanisza), *Triangle Illusion*, 2003. Macromedia FreeHand. Courtesy the author.

This optical illusion demonstrates implied lines. Do you see the white triangle? It's not really there; our brains fill in the gaps.

Line Direction

A line can have length and direction, and the orientation of the line can send different types of message to the brain of the viewer (**1.16**). Horizontal lines symbolize quiet and repose, possibly because we associate the state of being horizontal with being at rest or asleep. Vertical lines, like standing figures, denote potential for action. The English poet and artist William Blake (1757–1827) believed in more spiritual interpretations: static horizontal designs symbolized sorrow and the imperfect state of humans; verticals represented upward movement, suggesting happiness and the hope of attaining salvation (**1.15**).

Horizontal and vertical lines together form a grid, much used by graphic designers and artists such as Piet Mondrian (1872–1944) (see **0.6**) and Theo van Doesburg (1883–1931) (see **2.10**) of the Dutch De Stijl (The Style) movement. These artists were influenced by the religious beliefs of theosophy and sought to create universal harmony by reducing natural forms to simple elements of horizontal and vertical straight lines, and by replacing the natural gamut of color with the primaries—red, blue, and yellow—plus black and white. Mondrian and van Doesburg eventually fell out over the latter's insistence on using diagonals!

1.15 William Blake, *Pity*, c. 1795. Color print finished in ink and watercolor on paper, 16 ¾ × 21 ¼″ (42.5 × 53.9 cm). Tate, London.

This print illustrates lines from Shakespeare's *Macbeth*: "And Pity, like a naked, newborn babe/Striding the blast, or heaven's cherubim hors'd/Upon the sightless couriers of the air/Shall blow the horrid deed in every eye." For this poet-artist horizontal designs represented sorrow and the imperfect state of human beings.

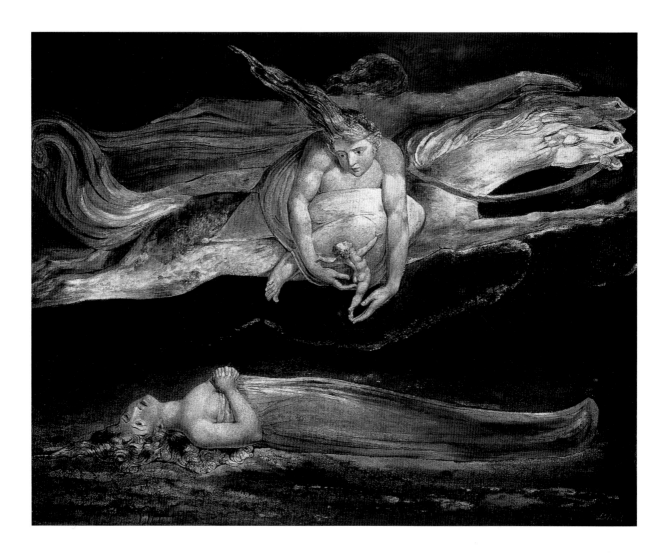

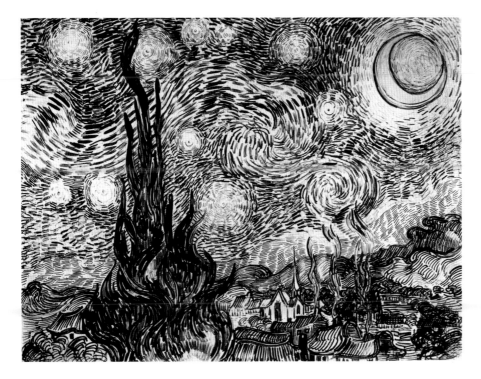

1.16 Vincent Van Gogh, *Cypresses*, 1889. Oil on canvas, 18 ½ × 24 ½″ (47 × 62.3 cm). Collection Kunsthalle, Bremen (lost during World War II).

Van Gogh's swirling lines are full of energy and dynamism, almost charting the force and movement of the wind.

1.17 Mel Bochner, *Vertigo*, 1982. Charcoal, conté crayon, and pastel on canvas, 9′ × 6′ 2″ (2.74 × 1.88 m). Albright-Knox Art Gallery, Buffalo, New York.

American conceptual artist Mel Bochner (b. 1940) moved away from depicting objects to conceptualizing art as a procedure. These diagonal zigzags ricochet dizzily around the edges of the canvas, creating agitation and anxiety in the viewer.

Diagonal lines are the most dynamic of all lines (**1.17–1.20**). People often lean forward when they are ready to spring into action, so we see the diagonal as signifying motion. Add to this the fact that most paintings are rectangular in shape or have rectangular frames, and you can see that any diagonals within or cutting through that rectangle will create tension.

De Stijl: Netherlands, 1917–1932

De Stijl is Dutch for "the style." Theo van Doesburg (1883–1931) and Piet Mondrian (1872–1944) started a journal named *De Stijl* in 1917. Mondrian published a manifesto entitled Neo-Plasticism in 1920. Other members included Gerrit Rietveld (1888–1965). Their work exerted tremendous influence on the Bauhaus and the International Style.

Horizontals and verticals provide stability—think of the steel frame beneath the skin of a building, or the solidity of a Greek temple. Join three points together and you have a triangle. A triangle is stable, that's why a milking stool has three legs, it won't tip over on rough terrain. Klee, however, saw triangles differently. His take on the triangle was a point entering into a relationship of tension with a line, between a base and its directional thrust—the thrust of diagonals, and "following the command of its Eros" discharging this tension. A triangle becomes an arrowhead, with all its intrinsic energy. "Form as movement, as action, is a good thing," he said, dismissing abstraction for its own sake. "Form as rest, as an end, is bad."

In graphic design, type set on a diagonal signifies dynamism, a style first expressed by Italian Futurists in their posters of the 1920s. This was taken up by the De Stijl movement, which had its own magazine of the same name in which type was liberated from its earlier rectilinear constraints. Wood or metal type was most easily set horizontally, but lithography was changing all that. Alumni of the influential German art school, the Bauhaus, and Russian Constructivists, such as Alexsander Rodchenko (1891–1956), influenced the designers that followed, and the dynamism of the diagonal line entered the commercial mainstream of graphic design. Nowadays, computers allow us to place and orientate type and lines any way we choose.

1.18 Franz Kline, *Mahoning*, 1956. Oil and paper collage on canvas, 80 × 100" (203.2 × 254 cm). Whitney Museum of American Art, New York.

The physicality of Kline's gestural line, made with a wide brush on newsprint, then cut and reassembled on canvas, provides a sense of power and movement. As the black begins to dominate, the white areas become shapes in their own right.

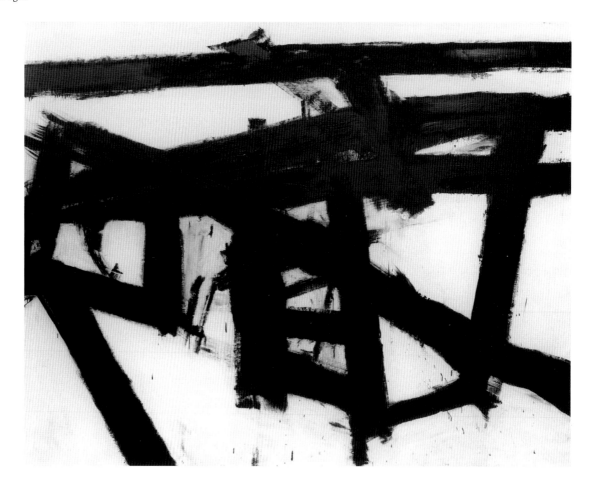

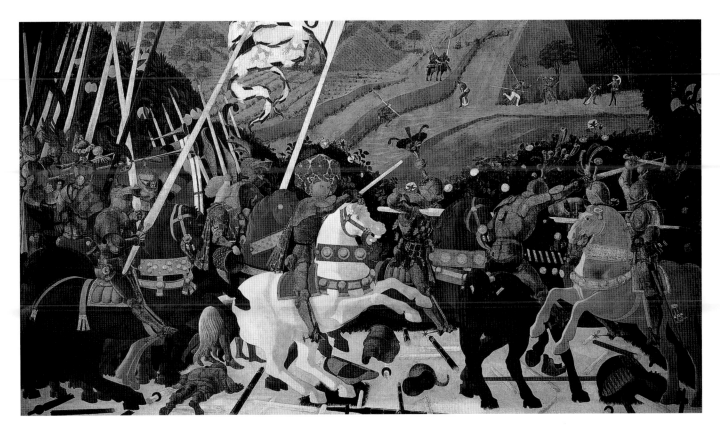

1.19 (above) Paolo Uccello, *The Battle of San Romano*, 1430s. Tempera on wood, 6′ × 10′ 6″ (1.82 × 3.2 m). National Gallery, London.

Uccello demonstrates one-point perspective in the foreshortened figure on the ground and the arrangement of broken lances. By progressing from near vertical on the left to below horizontal in the center, the lances supply movement and rhythm.

1.20 Umberto Boccioni, *States of Mind, Those Who Stay*, 1911. Charcoal and chalk on paper, 23 × 34″ (58.4 × 86.3 cm). Museum of Modern Art, New York. Gift of Vico Baer.

This painting depicts the stress over catching or missing a train, the fear of being parted from loved ones, and the excitement and uncertainty of travel. The people who saw the traveler off are trudging home to their monotonous lives through static vertical lines.

Line Quality

The quality of a line results from the interaction between the drawing instrument, the ground or support, and the hand of the artist (**1.21**). Line quality describes the appearance of a line rather than its direction, but like direction, line quality can also convey moods and emotion. Varying the quality of lines can also add interest to a drawing—compare a diagram from an instruction manual to a drawing by Matisse, for instance.

A line can be thick or thin, or vary between the two, like a piece of handwriting. It can be delicate and subtle (**1.23**), or bold and crude (**1.24**). It can be cold and impersonal (**1.22**), or free and expressive. The quality of line determines how a drawing will be interpreted.

1.21 (right) Alan Pipes, Line quality, 2003. Pen, pencil, and charcoal on paper, 4 ¹⁵⁄₁₆ × 2 ¹⁵⁄₁₆″ (10 × 5 cm). Courtesy the author.

Line quality is dependent on the medium and the texture. Here are a variety of marks made using pens, pencils, brushes, and charcoal on rough watercolor paper.

1.22 (below) Harold Cohen, Installation at Tate Gallery, London, 1983. Mural, prior to coloring.

Harold Cohen's computer program, AARON, has created original "freehand" drawings in museums worldwide. A mobile "turtle" carrying a pen draws the shapes, to which Cohen sometimes adds color.

A pencil line on smooth paper made using even pressure will look very different from a line on rough paper made using varied pressure and will give a different message to the viewer. Smooth paper encourages fluency and clarity, whereas rough paper breaks up the line, trapping graphite in the irregularities of the surface, and the line is less crisply defined. Varying the pressure produces a calligraphic, ribbon-like effect, which may be almost three-dimensional where the tonal variation is accentuated by the rough surface.

There are many types of drawing instrument. Pencils are available in many grades, from soft to hard, and there are also pens, markers, charcoal, pastels, brushes. There are also many kinds of support—paper, canvas, scratchboard, etching plate. You can appreciate that the quality of line is almost infinitely variable. With computer programs that aim to simulate "natural media," such as Corel's Painter coupled with a pressure-sensitive Wacom graphics tablet and stylus, it is possible to specify every feature of, say, a brush, almost down to the number of hairs it has and the clumpiness of the bristles and their degree of flexibility.

The variations in quality of a line can be compared to the pace, timing, emphasis, and inflection in a piece of music. By changing the quality of a line, you can help viewers make sense of a drawing or painting, showing them what's important and what's less important, as their eyes move over the surfaces of the drawn objects.

1.23 (left) F. Mathey, *Edgar Degas*, February 1882. Pencil, 18 × 12″ (48 × 31 cm).

This delicate pencil drawing of the Impressionist artist Degas has been rendered with very little shading or hatching.

1.24 (right) Jonny Hannah, *The Passing of Hank Williams*, 2003. Ink on paper. Courtesy the artist.

Jonny Hannah uses an expressive line, and he often incorporates ink as texture and raw, hand-lettered text.

Lines and Outlines—Describing Shapes

An outline is an abstract concept—a visualization of a scene's edges, or the boundaries between light and dark—but humans have the ability to read an outline as representing something that really exists.

Most painters begin with a drawing, a preparatory sketch, which is then transferred to the ground or support as a starting point for the application of paint. This first step is an outline drawing, describing the shapes to be rendered in color. Sometimes this outline will be obscured by subsequent marks; sometimes, as in the work of artists such as Georges Rouault (1871–1958)—who began his career as a stained-glass painter—Marc Chagall (1887–1985), and Fernand Léger (1881–1955), the line remains, and may even be accentuated with black paint.

In illustration, it seems a natural step to color in a line drawing done in pen and ink (**1.25**) with watercolor or gouache, first with flat color, then, perhaps, with more expressive marks. Kate Greenaway (1846–1901) used subtle washes of color over black line. Later illustrators such as Arthur Rackham (1867–1939) and Edmund Dulac (1882–1953) used richer, more varied colors, which still reproduced well despite the limited printing technology of the day. The method, still used today with computers, results in highly legible images that will print well on all grades of paper (**1.26**). If something went wrong and the colors didn't print, the black image would still make sense.

This method of producing illustration is still the most popular, not only for comic books and children's books, but also for mainstream editorial and advertising work. Even in the world of computer-generated artwork, where the means of drawing is the stylus and graphics tablet, the outline rules.

In fine art, the painters of the 1960s Pop-art movement, such as Roy Lichtenstein and Andy Warhol (1928–87), took comic-strip illustration as their inspiration and appropriated it to fill large-scale canvases, Lichtenstein also simulating the Ben Day mechanical tints once used to add tonality to newspaper graphics with his big, chunky dots. More recently, artists such as Julian Opie and Patrick Caulfield (b. 1936) have made thick black outlines a distinguishing feature of their work (**1.27, 1.28**).

1.25 Karen Donnelly, *Headmaster*, 2002. Ink on paper, 1 ⅛ × 1 ⅛" (3 × 3 cm). Courtesy the artist.

Illustrators of children's books often draw a simple outline. If necessary, they color them in using a flat wash of watercolor.

1.26 Graham Rounthwaite, Levi's SilverTab advertising campaign, nd.

Vector programs result in a crisp, even line and completely flat color. Some illustrators finish their drawings in Photoshop to add texture and a painterly touch.

The masters of the outline, however, were the Japanese printmakers Hokusai Katsushika (1760–1849) and Hiroshige Ando (1797–1858). Although the artists of China and Japan were virtuosos of spontaneous expressive brushwork, these artists managed to convey in the relatively even and regular lines of the woodblock relief prints known as *ukiyo-e* a haunting beauty that had a profound effect on Western art and design. The simplicity of the line, the absence of shadows and clutter, and the use of white space in composition influenced painters Edgar Degas (1834–1917) and Vincent van Gogh, graphic artists Aubrey Beardsley and Henri Toulouse-Lautrec (1864–1901), and architect Frank Lloyd Wright (1867–1959), among many others.

1.27 Patrick Caulfield, *After Lunch*, 1975. Acrylic on canvas, 8′ 2″ × 6′ 11″ (2.48 × 2.13 m). Tate, London.

Pop artist Caulfield mixes black-outlined imagery and fields of flat color with passages of photorealism, resulting in an uneasy and ambiguous composition. A photomural of the Château de Chillon hanging in a restaurant contrasts with its comic-strip surroundings.

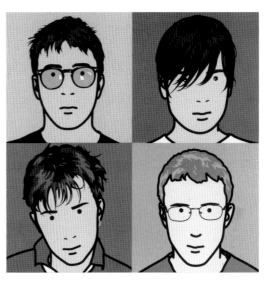

1.28 Julian Opie, Cover of *Blur* CD, 2000.

Opie traces photographs on his computer to produce his trademark reductive line. He either outputs to an inkjet printer, or to color separations for print, or to a vinyl-cutting machine that a sign writer uses to make vinyl signs.

Pop Art: England and America, 1950–1970s

Pop Art was a direct descendant of Dada. It mocked the consumerism of post-World War II society by appropriating images from popular culture and turning them into art. In celebrating everyday objects such as comic strips, soup cans, and soda pop bottles, the movement converted the commonplace into icons. American artists such as Jasper Johns (1930–), Roy Lichtenstein (1923–1997), and Claes Oldenburg (1929–) took familiar objects such as flags, clothespins and beer bottles as subjects for their paintings and sculptures, while English artists Richard Hamilton (1922–) and Peter Blake (1932–) used magazine imagery. Andy Warhol (1928–1987) brought Pop Art to the public's attention with his screen prints of Campbell's soup cans and film and pop stars such as Marilyn Monroe and Elvis Presley. By embracing industrial techniques, Pop artists set themselves apart from the painterly, introspective Abstract Expressionists.

Contours, Wireframes, and Freeform Gesture

A line is described as an **explicit line** when forms are clearly delineated. There may not always be a black line around them, but the forms have clear, distinct edges that stand out from the background. A painting with explicit lines would make sense if it was desaturated and reproduced in black and white, and could be traced in line with relative ease (**1.29**).

As well as outline drawings, there are also what are known as contour drawings and **gesture**, or expressive, drawings. Contours add interior detail to an outline that gives us clues about the volume of the object (**1.31**). As we have seen, a contour is a line that follows the form of a body or object, like the contour line in a landscape that follows a series of points of equal height. Contours can also describe real edges within an outline, such as the folds of drapery or facial features that do not form part of a silhouette.

1.29 Pietro da Cortona, *Allegory in Honor of Cardinal Antonio Barberini the Younger*, 16th century. Pen and brown ink, brown wash over black chalk, heightened with white gouache on brown paper, 20 ½ × 30" (52.07 × 76.2 cm). Metropolitan Museum of Art, New York. Rogers Fund, 1964.

This highly finished ink line drawing, with a monochromatic wash and highlights in opaque gouache, is a typical piece of baroque flattery to a patron.

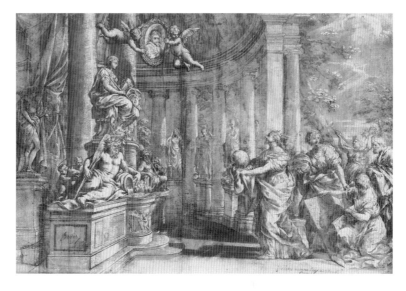

1.30 (left) Paolo Uccello, Perspective drawing of a chalice, 1430–40. Gabinetto dei Disegni e Stampe, Florence.

This Renaissance perspective study seems to anticipate computer wireframes. (See **6.22–6.24**)

1.31 (right) Henry Moore, *Sheep no. 43*, 1972. Black ballpoint and felt pen, 8 × 9 ¾" (20.3 × 24.8 cm). Courtesy of Mary Moore.

Moore uses contour lines—thin on top to increasingly thicker below—to suggest the sheep's bulky woollen form.

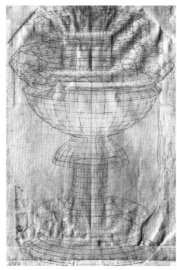

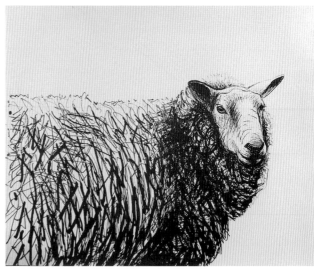

The ultimate contour drawing is a three-dimensional wireframe of the kind found in computer graphics (**1.30, 6.22**). These are produced either by using a modeling program or by laser scanning a solid object or body. The result is a mesh of points and planes in space that can accurately describe the solid form. Early wireframes could represent only simple geometric shapes, such as spheres, cylinders, and cubes, but advances in computer technology and programming mean that subtle freeform shapes, such as human bodies, can now be modeled convincingly. The wireframe was originally meant to be a framework on which to hang a "skin" of realistic texture, but it is sometimes used as a graphic device in its own right in technical and medical contexts.

A drawing can have precise contours, when we would recognize it as a realistic and highly finished drawing, or it may be made from more imprecise and hesitant marks, with no clear outline but with many lines that, once "averaged out" by the brain, will give an impression of a form in time and space (**1.32**). This kind of drawing is often seen in exploratory sketches, where the artist is trying out different ways of realizing the subject. This has become a style of its own, as in the drawings of Alberto Giacometti (1901–66) or Frank Auerbach (b. 1931). The marks may be imprecise, redrawn with hesitancy, but this dynamic kind of rendering tells us much about the creative process—we see the artist thinking aloud, analyzing the form in real time, in a quest to locate the forms in space.

A gesture drawing takes this one step further. The outline all but disappears, leaving marks that show the freshness and dynamics of a scene or pose and the action of drawing, rather than a planned and accurate arrangement of shapes. Lines are spontaneous and continuous, and they are drawn so quickly that the pencil or pen has no time to leave the surface of the paper but moves freely and nervously around the scene, following the eye of the artist.

1.32 Honoré Daumier, *Two Barristers*, 1830s. Pen and ink, 8 × 11″ (20.5 × 29.5 cm). Victoria & Albert Museum, London.

Gestures are dynamically and atmospherically captured in Daumier's quickly drawn line, which mimics our eye movement over the subject and establishes the figures in space.

Lines as Value—Cross-Hatching and Screening

First we looked at outlines; then we added the detail of contours and gesture lines. To give the impression of tonal variation in our drawings, to model them and to give them volume, we can shade them using pencil or wash. If we want the drawing to retain integrity as a pencil drawing or pen and ink drawing, or if it is needed for reproduction, we can also add lines as value.

Drawing several thin lines close together to create a patch of tone is called hatching. From a distance (not too far) these will merge together optically to give the impression of being gray. Depending on the pressure of the hand and the quality of line, you can produce areas that appear lighter or darker. These are called areas of value (see pages 124–141). More variation can be achieved by superimposing lines at right angles to the initial hatched lines, to form cross-hatching. Lines of hatching are more effective when they are sensitive to, and follow the contours of, the form being rendered.

Cross-hatching can be quite therapeutic, both to the artist and the viewer. Fans of comic-strip artist Robert Crumb (b. 1943) champion his cross-hatching (**1.33**). Some artists build up layer upon layer of cross-hatching until the surface is almost black, yet rich in texture (**1.34**).

1.33 Robert Crumb, *Beautiful Music*, from *Robert Crumb Draws the Blues*, Knockabout Comics, London, 1993. First published in *Weirdo* Magazine, San Francisco, CA, 1985. © Robert Crumb, 1985.

Crumb works almost exclusively in black line and is a master of painstakingly intricate cross-hatching.

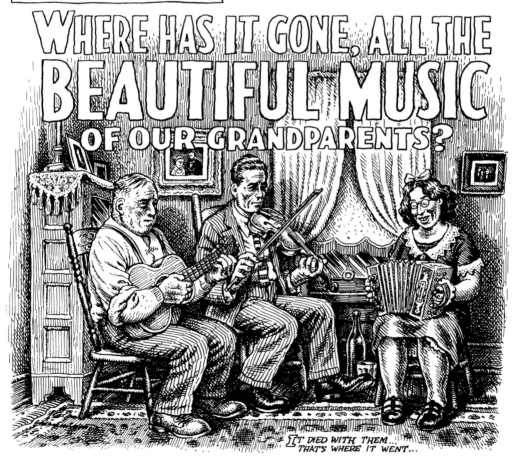

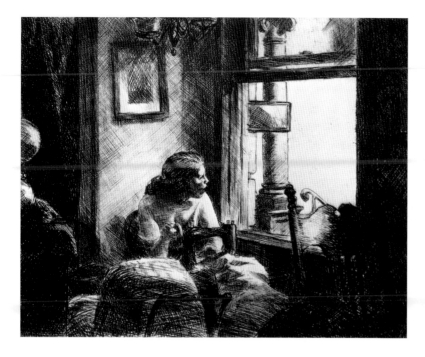

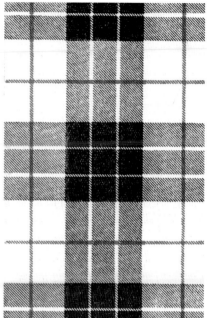

In woven textile and carpet design, where the blending of colors *in situ* is not an option, designers have developed patterns that make a virtue out of lines as value, juxtaposing threads of a limited palette to produce surprising new colors and geometric patterns (**1.35**).

In graphic design, there has always been the problem of rendering a continuous tone original—a photograph or painting—into something that can be printed using a single mix of ink and just one printing plate. In etching and engraving, the artist used very fine cross-hatching (**1.36**) or stippling. More subtle tonal variations could be achieved using **mezzotint**, a process in which the plate is pitted all over with tiny indentations that, if printed, would give a uniform dark area. The artist would then scrape and burnish this away to create areas of white. Lithography uses the action of greasy hard and soft crayons on the natural graininess of the stone or plate to produce lines that, when printed, have the texture of chalk or pastel.

To produce consistent, controllable tones, however, we had to wait for photography and the invention of the halftone screen, which converts a continuous tone into a regular pattern of different sized dots, which from a distance look like shades of gray. This process is now achieved digitally, using scanners, computers, and laser imagesetters or printers.

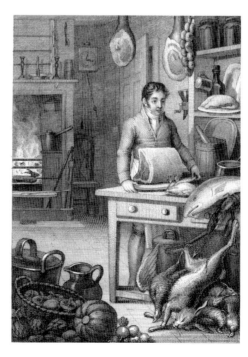

1.34 (left) Edward Hopper, *Night Shadows*, 1921. Etching, printed in black, 6 ¹⁵⁄₁₆ × 8 ³⁄₁₆″ (17.6 × 20.8 cm). Museum of Modern Art, New York.

In hard-ground etchings, the only way to introduce value is through cross-hatching.

1.35 (right) A MacLeod tartan, from *The Scottish Clans and their Tartans*, W. & A.K. Johnson, Edinburgh, 1928. Courtesy the author.

Tartan comprises thick and thin bands of straight lines, crossing at right angles. The MacLeod tartan has thick black and thin red hatchings on a yellow ground.

1.36 Frontispiece (and detail) of *The Complete Economical Cook* by Mary Holland, 1833. Steel-plate engraving, 29 ½ × 41 ⅛″ (75 × 105 mm). Courtesy the author.

This steel plate uses contour lines, cross hatching, and stippling to add shading and depth.

Imaginary Lines—Lost and Found Edges

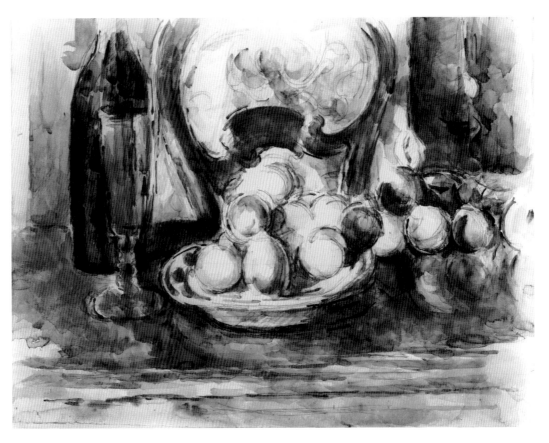

Sometimes, as in the drawings of Matisse, the lines that should form an outline don't join up. These are implied lines (see page 24) and the brain does a good job of joining them up and filling in the gaps (**1.37**).

In paintings that depend for their effect more on color and value than on line, there are no obvious explicit lines to be seen, only edges. Edges can be hard and sharp where a form is silhouetted against a light background, or an arm or a leg, say, is fully lit against a dark background. Alternatively, the edges may be soft and blurred, receding into the background. Where they come and go—sometimes there's a sharp contrast between the edge of an object and its background, and sometimes the edge is plunged into mysterious shadow—they are known as **lost-and-found edges**.

Compare a sphere or an apple by Paul Cézanne (1839-1906) (**1.38**) with a cube or building. The lines we draw to describe a cube represent its actual edges, but the circle that we draw for the sphere is like the horizon—it represents the disappearance from view of part of the form. A drawing or painting in which every edge is defined with equal clarity is likely to look stiff and cut out. We should let go of the idea that every object must be enclosed by a line and become aware of the differences between hard and soft edges. Soft edges help to connect adjacent objects. Making adjoining areas in an image similar in color and tone will help lose the edges and subtly knit those areas together.

Adjusting edge qualities gives you the opportunity to introduce an element of now-you-see-it, now-you-don't ambiguity to your work, and direct attention to selected areas. Other areas can be more simply suggested or even lost in shadow (**1.39**). A painting with hard, clear edges may logically seem more realistic, but those employing lost and found edges are closer to the way our brains, with their stored memory banks of expected shapes, perceive the real world. A computer would find it difficult to interpret the edges to make understandable shapes, but our brains can see through the ambiguities.

The Cubist artists Georges Braque (1882–1963) and Pablo Picasso shaded both the interior and exterior contours of forms, reducing them to flat or curvilinear planes. If two adjacent, parallel planes are graduated in opposite directions, from dark to light and light to dark, there will be an area where differences of value dissolve into lost and found edges. This is called the **bridge passage**, a fluid middle zone with double reversals and ambiguous open and closed areas (**1.40**).

Some would argue that there are no lines in nature—no straight lines, anyway—except in crystals, perhaps? Francisco de Goya (1746–1828) said: "Where do they find lines in nature? As for me, I can distinguish only luminous and dark bodies; planes that approach and recede; reliefs and concavities. My eye never perceives lines and details ... These minutiae do not distract my attention. And a brush cannot see more or better than I."

1.39 Georges de La Tour, *The Dice Players*, 1648–50. Oil on canvas, 36 × 51″ (92.5 × 130.5 cm). The Preston Hall Museum, Stockton-on-Tees, England.

In paintings with heavy chiaroscuro, edges are only seen where light falls or where edges are in silhouette against a lighter background.

Cubism: France, 1907–1914

The Cubist movement began in Paris around 1907 and was led by Pablo Picasso (1881–1973) and Georges Braque (1882–1963). It was named by a critic who talked of "bizarreries cubiques." Picasso and Braque broke from centuries of tradition by rejecting the single viewpoint and using instead an analytical system in which three-dimensional forms were fragmented into geometric planes and redefined from several different aspects simultaneously. The Cubists were influenced by African art and the later paintings of Cézanne, and in turn they pioneered collage.

1.40 Alan Pipes, Bridge passage, 2003. Graphite on paper, 2 ½ × 2 ½″ (7 × 7 cm), enhanced in Photoshop. Courtesy the author.

When a form and its ground are shaded in opposite directions, from dark to light and light to dark, there will be an area of similar value and the edge will dissolve. This is the bridge passage.

Exercises

1 Take a line for a walk: Using a pencil, sit in front of a still-life image or a real scene and draw what you see in outline, with constant line weight and without taking the pencil off the surface of the paper. Keep your drawing simple and don't worry about going over previously rendered lines.

2 Line weighting: Using a pencil or pen, make a line drawing (no hatching or shading) of a plant or part of a plant against a plain background. Use different line weights. Pay attention to the negative spaces around the subject. Draw a frame around the picture that incorporates sections of lines from the plant drawing.

3 Cross-hatching/Stippling: Make a drawing of a still life without outlines, describing the form *either* by cross-hatching *or* stippling. You are permitted to draw a faint outline in pencil first, but this must then be erased.

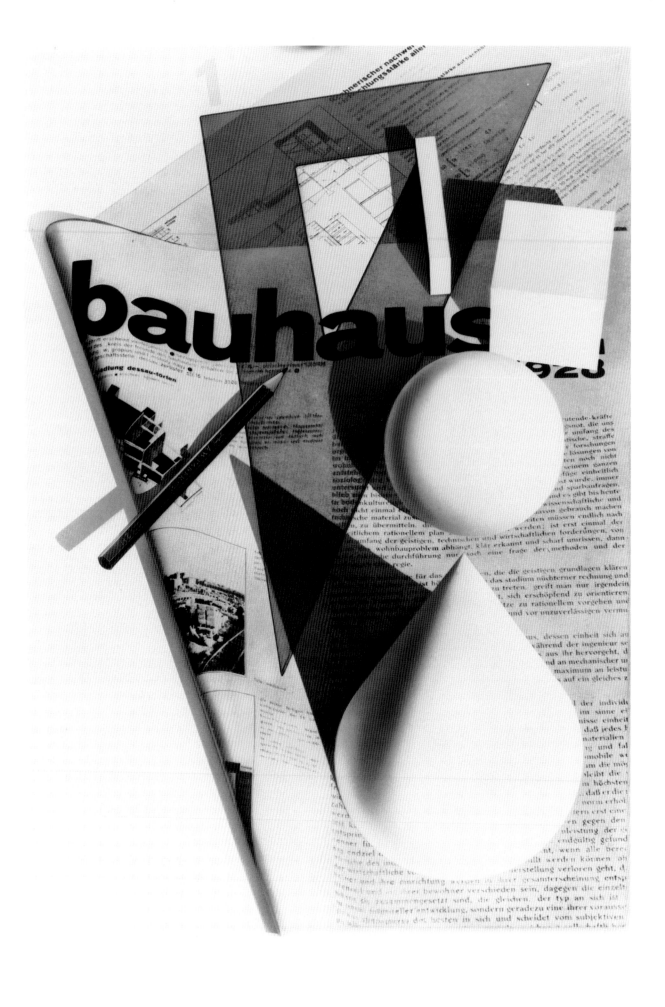

2 | Shape

"The first object of the painter is to make a flat plane appear as a body in relief and projecting from that plane."

LEONARDO DA VINCI

Herbert Bayer, Cover for the magazine *Bauhaus*, no. 1, 1928.

Bayer was head of the printing and advertising workshop at the Bauhaus. His photographic still life for the quarterly college magazine cover incorporates the designer's tools of the trade and the primitive geometric forms that became synonymous with Bauhaus designs.

Introduction

If we join some lines together we make a shape. Three straight lines joined together make a triangle; four lines make a quadrilateral or, if the lines are equal in length and meet at right angles, a square. Let the line wander and we might make all manner of shapes, some looking like real objects, others not. Some shapes are straight-edged and geometric (**2.1**); others are more rounded and freeform. And the lines that make up the outline of the shape do not necessarily have to join up for us to identify a shape, nor does a shape have to have hard edges—we see shapes even in clouds.

2.1 Vassily Kandinsky, *Swinging*, 1925. Oil on board, 27 ¾ × 19 ¾″ (70.5 × 50.2 cm). Tate, London.

The German title of this work, "Schaukeln," means rocking or swinging, and contrasts static geometric forms, such as triangles and grids, with curving arcs and floating circles that introduce movement. Line creates dynamic forces and rhythms.

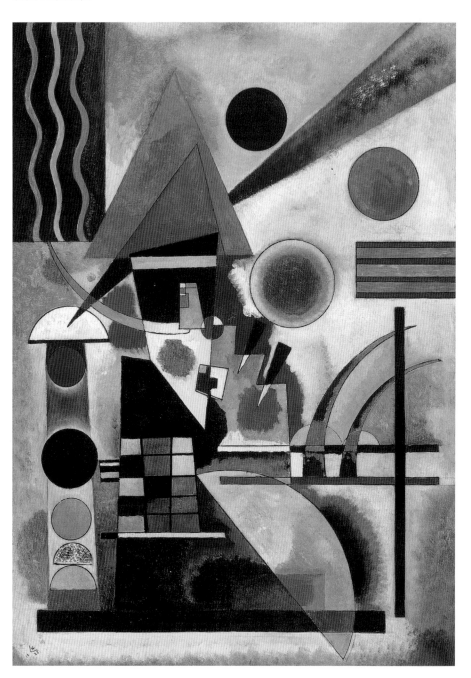

When we are drawing or painting, we are generally attempting to represent on the flat and two-dimensional surface of the paper or canvas something that exists in real life, something that is solid and three-dimensional. This representation of an object will, unless we are looking at it full on, probably be tilted or oriented away from us.

The position and orientation of a shape in this virtual space is called the **plane**. When the plane of a shape coincides with the surface of the paper or canvas, we call this the **picture plane** (**2.2**). It's like looking through the screen of a television—the three-dimensional scene we view appears to be inside the TV, far in the distance. If we stick cut-out, two-dimensional shapes onto the glass of the screen or if the TV presenter holds, say, a map right up to the camera, they are said to be on the picture plane.

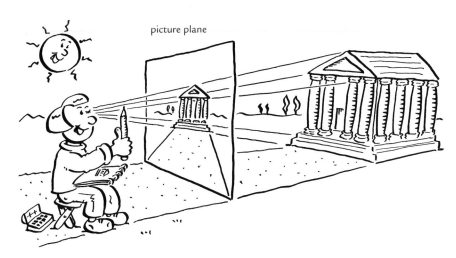

2.2 Alan Pipes, Picture plane diagram, 2003. Pen and ink on paper. Courtesy the author.

The picture plane is an imaginary "window" onto which the scene beyond is projected. (See **4.22**)

Planes can be better understood if we look at three-dimensional objects, such as a pyramid. If you can see that it's a pyramid, as opposed to a triangle, then all the faces of the pyramid will be on planes that are at different angles from the picture plane. A pyramid face in isolation—a triangle—may appear to be on the picture plane. It could, however, be a regular triangle that's been distorted somehow. There's no way of telling, just as an ellipse could be a circle that's tilted away from you or it could be an ellipse on the picture plane.

The rectangular shape that bounds and defines the picture plane is called the **frame**. This can be a physical frame, like the gilded wooden frames around old master paintings, it can be the edge of the sheet of paper, or it may be an arbitrary boundary.

A shape can also be implied by a few well placed lines. The human brain is good at inferring shapes from inadequate information—we seem to carry in our memories a catalog of shapes we have already encountered—sometimes we make wrong guesses, and this can be exploited in optical illusions (**2.3**). We can also discern shapes from areas of texture, color, or value. We can also make out the most vague of shapes. These we call **amorphous shapes**, which are so elusive that we would find it difficult to discern any edges at all (see **2.6**).

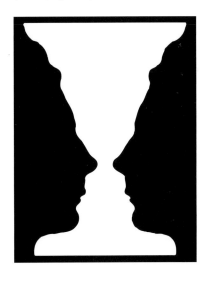

2.3 Alan Pipes, A version of the Rubin vase, 2003. Macromedia FreeHand. Courtesy the author.

Can you see a vase or two faces here? This is a classic optical illusion of figure/ground, positive/negative space.

We have already encountered the terms shape and form, but it will be useful to define them.

A **shape** is an enclosed area that is identifiably distinct from its background and other shapes. It can be bounded by an actual outline or by a difference in texture, color, or value surrounding a visually perceived edge, even when the edge is so blurred that the shape is amorphous. A silhouette is the most obvious and severe kind of shape, having little or no detail inside its outline. A shape has width and height but no perceived depth. It is two-dimensional, but can exist on a plane other than the picture plane.

The word **form** refers to the apparent solidity or three-dimensionality of a drawn or painted object. It is "apparent" because drawings, paintings, and photographs are often two-dimensional representations of three-dimensional real or imagined articles. Although a painting can be flat to the touch, the objects depicted in them are perceived to have the three dimensions of height, width, and depth. The most effective way of producing form is to make use of the way light falls on an object from the side, shaping it tonally and casting tell-tale shadows (see Chapter 6). Forms can be hard, with strong shadows, or soft, with very gradual tonal changes. Other visual cues are discussed in Part 2.

Mass is the apparent solidity of a form. The illusion of bulk and weight can be achieved by shading and lighting, or by overlapping and merging forms. Shapes can have mass—a big, black, blobby shape has more mass than a light, delicate, spindly construction. In sculpture and architecture, mass is the actual or apparent material substance and density of a form, although looks can sometimes be deceptive—a heavy-looking Greek column in a stage set could be made of cardboard or foam. A sculpture or two-dimensional shape of an elephant or a truck would have more mass than a wireframe kinetic sculpture moving gracefully in the breeze, even though the elephant might be hollow and weigh less than the mobile.

2.4 Barbara Hepworth, *Squares with Two Circles*, 1966. Bronze, 120 × 54 × 12″ (306.1 × 137.2 × 31.8 cm). Tate, London (on loan to Yorkshire Sculpture Park).

The sculptures of Barbara Hepworth made a positive feature of "negative" holes.

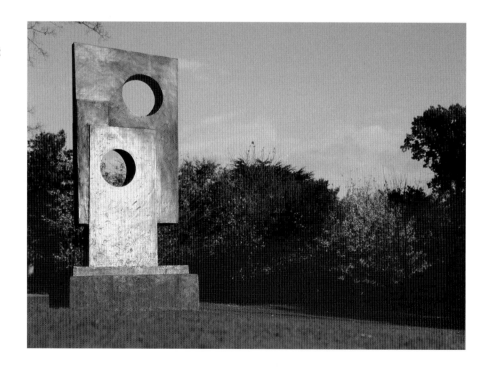

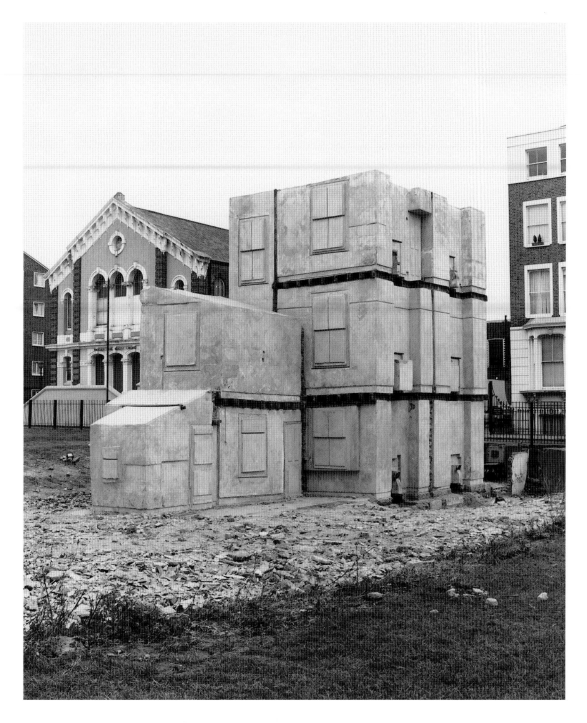

Volume is the illusion of enclosed space surrounded by, or implied by, a shape or form. It can also mean the space immediately adjacent to or around a painted form. In sculpture and architecture, it is the space occupied by the form and/or by the immediate surrounding space. An empty room has volume, but no mass; a brick has mass within its volume; an empty vase has volume within its mass. Mass can be thought of as positive space; volume as negative space. Mass is a mountain; volume is a valley. Mass is a Henry Moore (1898–1986) or Barbara Hepworth (1903–75) (**2.4**) sculpture: volume is one of the holes. British installation artist Rachel Whiteread (b. 1963) turns volume into mass by casting the spaces within buildings or under furniture into concrete or resin (**2.5**).

2.5 Rachel Whiteread, *House*, completed October 23, 1993, and destroyed January 1994. Poured concrete.

Whiteread investigates the "negative" spaces inside familiar objects, casting them in resin or concrete. Here she rendered in positive concrete the inside spaces of a condemned 19th-century house in East London.

More often than not, design entails arranging shapes in space. It is possible to produce paintings without line, color, or texture, but rarely, even in the most hazy atmospheric paintings of artists such as J.M.W. Turner (1775–1851) and Claude Monet (1840–1926), will shape be dispensed with altogether (**2.6**).

As important as the shapes themselves is the space between them. In most types of painting, we can talk about the **figure** or **field**, and the **ground**. The figure or field is the recognizable object we are depicting: it may be a human figure (hence the name), vase, or flower. The ground is the unoccupied or relatively unimportant space in the picture—think of the word background. Traditionally, the figure has been thought of as a positive shape, and the ground as a negative shape. Like large buildings, forms need space around them to be appreciated fully.

When an artist makes a mark, this is seen as a positive area, leaving the rest of the canvas (the ground) as negative space. The mark will also appear, as it is physically, in front of the ground. But ignore the negative shapes at your peril. A pleasing

2.6 Claude Monet, *Rouen Cathedral, West Portal and Tour d'Albane*, 1894. Oil on canvas, 14 × 9 ¾″ (35.5 × 24.5 cm). Musée d'Orsay, Paris.

Shapes are often bounded by an outline or edge, but edges can be so soft as to make the shape amorphous. Monet worked quickly to capture fleeting changes of light on a form, and the resulting variations (he did seventeen versions of this view) are subtle and dreamlike. (See **7.4** and **7.5**)

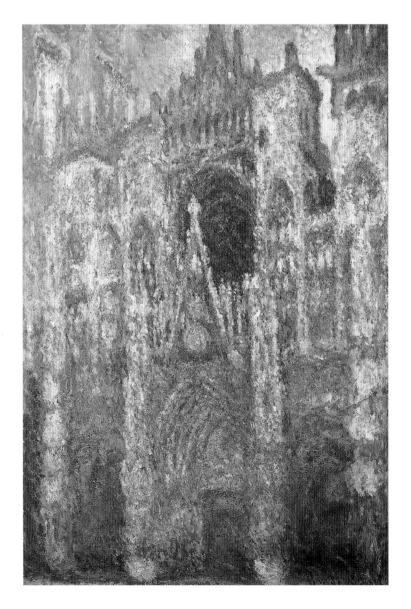

2.7 John Piper, *Abstract 1*, 1935. Oil on canvas over wood support, 36 × 42 ″ (91.4 × 106.7 cm). Tate, London.

This is a largely rectilinear painting. On the left is an illusion of deep space, as if through a window; toward the right planes overlap, suggesting a shallow recession. The canvas has been cut away in places to reveal the board behind, emphasizing the flatness of the painting's surface.

composition will almost always depend upon the negative shapes being given as much thought as the positive ones and becoming active components of the design.

Sometimes, especially in non-representational art and graphic design, it is not instantly obvious which shapes are positive and which are negative, or your attention may jump backward and forward between a supposedly positive black shape, which, through our experience with black pencil on white paper, we treat as the norm, to an equally informative white space (see **1.18**). This is termed **equivocal space**. It is the stuff of optical illusions, clever illustrations that make you smile, and the stock in trade of Dutch artist Maurits Cornelis Escher (1898–1972). Such ambiguities tease the brain's expectations and add another level of interest to the image (see **2.27**).

Shapes can come in . . . well, all shapes and sizes. They can be regular and **geometric**, based on simple mathematics and created with a straight edge and compasses, or they can be **curvilinear**, organic and freeform, with complex curves looking like those found in nature (**2.7**). They can be realistic and instantly recognizable, or abstract and non-representational. They can be not-quite-naturalistic—distorted in some way—or they can be polished up and **idealized**.

Geometric and Rectilinear Shapes

Geometric shapes, as the name suggests, are simple, mechanical shapes, which are defined by mathematical formulae and which can be produced using the implements found in geometry sets. We recognize them as triangles, rectangles, stars, circles, and ovals. They are some of the first shapes we learn to identify and explore as children in toys where we connect shaped pegs with their corresponding holes or in assembling gummed paper shapes into flowers and patterns.

These shapes, or planes, have their equivalent forms in three dimensions: in pyramids, cones, rectangular boxes, cylinders, spheres, and prisms (**2.8**). These are termed primitive shapes and forms. In theory, any complex form can be created by merging and/or subtracting the right selection of primitives. In computer graphics, complex shapes are developed using the Boolean operations of union, difference, and intersection (**2.9**). Union joins all selected shapes into a new, single shape. Difference, or subtraction, removes the overlapping portion of a second shape from the first. This operation, called "punch" in Macromedia FreeHand, is the equivalent of nibbling a part of a circle, say, from the edge of a square. Intersection leaves the overlapping part of the shape in common to both the original shapes.

Rectilinear shapes are types of geometric shape, produced using straight lines, usually parallel to the horizontal and vertical, like the doors and windows of a building (**2.10**). The best known exponent of rectilinear painting was Piet Mondrian, who produced simple grids of black lines enclosing rectilinear areas of white or primary color (see **0.6**). The Cubists Picasso, Braque, and Juan Gris (1887–1927) also made extensive use of rectilinear shapes, which seemed very modern then, echoing the forms of machinery.

Geometric shapes are also extensively used in cultures, such as Islam, that discourage representational art (**2.11**). The practice is not explicitly prohibited in the Qur'an, but it is thought that Islamic ornament has its source in a reluctance to imitate God's works. Muslim artists used mathematical sequences to produce patterns

2.8 Alan Pipes, Three-dimensional shapes and forms, 2003. Macromedia FreeHand. Courtesy the author.

Each primitive three-dimensional geometric shape has one or two corresponding solid forms: a triangle, for example, can be developed into a pyramid or cone; a circle can become a sphere or cylinder.

2.9 Alan Pipes, Boolean diagram, 2003. Macromedia FreeHand. Courtesy the author.

Two overlapping shapes can be combined by Boolean operations to create new shapes. Union adds both areas together; difference subtracts one from the other; and intersection retains the overlapping part.

2.10 Theo van Doesburg, *Composition IX, opus 18 (Card Players)*, 1917. Oil on canvas, 45 ⅝ × 41 ¾″ (116 × 106 cm). Gemeentemuseum, The Hague.

A founder of the De Stijl movement (see p. 26), Van Doesburg worked with geometric shapes and primary colors.

2.11 Mosaic detail from the Royal Palace, Marrakech, Morocco, nd.

Islamic art makes extensive use of geometry and pattern, deceptively simple designs often being based on arcane and complex numerology, as seen here.

that were later described by the Italian mathematician Leonardo Fibonacci (*c.*1170–*c.*1250). The **Fibonacci series** looks very simple, but it is capable of generating complex and beautiful patterns. You start with a number and add it to the previous number to produce the next in the series. Thus:

1, 1, 2, 3, 5, 8, 13, 21, 34, 55, 89 ... and so on.

A sequence of single numbers can be created using **cabalistic reduction**, in which you add together the first and second numbers of a double figure, repeating if necessary. For example: 89 = 8 + 9 = 17 = 1 + 7 = 8. The resulting series of numbers are used to define shapes and their placement in patterns.

Fibonacci series can be found everywhere in nature: in the seedhead of a sunflower, in pine cones, and the shells of the nautilus. If you divide each number by the one after it in the series, the result gets closer and closer to the value 0.618, the **golden section** (see pages 222–225). The French Modernist architect Le Corbusier (1887–1965) also used the Fibonacci series to give the proportions of his buildings a more human scale, but he took as his starting point an "ideal" 6 feet (183 cm), rather than the average 5 feet 9 inch (175 cm) tall Frenchman (see **2.34**).

Curvilinear and Biomorphic Shapes

2.12 Arshile Gorky, *Garden in Sochi*, 1941. Oil on canvas, 44 ¼″ × 62 ¼″ (112.4 × 158.1 cm). Museum of Modern Art, New York. Purchase Fund and gift of Mr and Mrs Wolfgang S. Schwabacher (by exchange).

"Sochi" is Armenian for poplar trees, which were planted to celebrate births.

If rectilinear shapes are hard and mechanical, curvilinear shapes, as the name suggests, are based on the organic shapes found in nature (**2.12**). Although there are straight lines and circles in nature, in the form of crystals and flowers, most natural objects seem to follow spontaneous freeform curves. These shapes are seen in the arabesque of Islamic art, a complicated, intertwined, flowing design of stylized floral and plant motifs originally based on vines, in the snake-like motifs of Celtic art, and in the art, design, and architecture of the late 19th century Art Nouveau style (**2.13**), which is based on sinuous roots and stems, seen typically in the posters of Alphonse Mucha (1860–1939) (**2.14**) and the buildings of Antonio Gaudí (1852–1926). Art Nouveau also inspired the psychedelic posters of the late 1960s (**2.15**).

Blobby shapes, more reminiscent of single-cell creatures, such as amoebas, are termed **biomorphic** (**2.16**). These shapes are key in the works of Surrealist painters such as Joan Miró (1893–1983) and Yves Tanguay (1900–55), who invented totally unreal shapes and forms, and Salvador Dali (1904–89), whose melting clocks and wilting forms have become synonymous with Surrealism (**2.17**). The sculptures of Henry Moore and Barbara Hepworth, with their soft, rounded shapes and negative-space holes, can also be called biomorphic (see **2.4**).

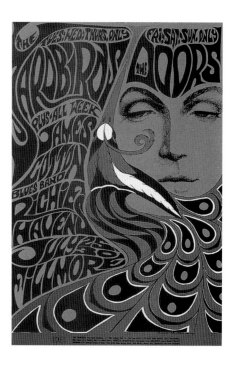

2.13 Hector Guimard, Castel Béranger entrance, Paris, 1894–9.

The gate to this apartment block in Paris is a beautiful example of sinuous, asymmetrical, Art Nouveau ironwork.

2.14 Alphonse Mucha, *Journée Sarah (La Plume)*, 1896. Color lithograph, 27 × 20″ (69 × 50.8 cm). Private Collection.

Mucha achieved fame when he designed a poster for Sarah Bernhardt, a great actress of her day. She and the public loved it. "Le style Mucha"—as Art Nouveau was first known—was born.

2.15 Bonnie Maclean, Rock concert poster for The Yardbirds, The Doors, and others at the Fillmore, San Francisco, July 25–30, 1967. Private Collection.

The psychedelic graphic art of the late 1960s drew heavily on organic Art Nouveau lines, shapes, and typography, and the use of vibrating complementary colors.

2.16 Edward Wadsworth, *Dux et Comes I*, 1932. Tempera on canvas, 20 × 24″ (50.8 × 61 cm). Tate, London.

"Dux et Comes" means leader and companion, used to describe choral roles in a fugue. The leader (soprano) sings in one key, the companion (alto) replies in another.

2.17 Salvador Dalí, *Autumn Cannibalism*, 1936. Oil on canvas, 25 ⅝ × 25 ⅝″ (65.1 × 65.1 cm). Tate, London.

Painted after the outbreak of the Spanish Civil War, these forms reveal a couple eating each other. The apple on the man's head refers to William Tell, the father forced to shoot at his son with a crossbow.

As mentioned earlier, curvilinear shapes can be drawn freehand or by using splines of plywood or piano wire bent into tension and held in place by lead weights (**2.18**). Sets of French curves were also used by draftsmen to produce flowing lines. Computer programs use controllable Bézier curves (**2.19**). Three-dimensional curvilinear forms are created in the computer using meshes of polygons, so complex that they can reproduce the subtle forms of the human face with all its means of expression.

2.18 Alan Pipes, Spline diagram, 2003. Macromedia FreeHand. Courtesy the author.

Before computers, architects and draftspeople used piano wire or thin ply held in position by lead "ducks" to draw long, freeform curves.

Art Nouveau: France, worldwide 1890–1914

Taking its name from La Maison de l'Art Nouveau in Paris, a shop promoting modern art, Art Nouveau was a decorative style based on sinuous lines, frequently depicting plant forms. Influenced by the Symbolists, as well as by Celtic and Japanese art, it flourished in England (Arts and Crafts movement) and the London shop, Liberty (Regent Street). In Germany the style was called Jungendstil. Exponents included Aubrey Beardsley (1872–1898) in England and Charles Rennie Mackintosh (1868–1928) in Scotland; the architect Victor Horta (1861–1947) in Belgium; the designer René Lalique (1860–1945) and architect Hector Guimard (1867–1942) in France; the painter Gustav Klimt (1862–1918) in Austria; the Czech artist Alphonse Mucha (1860–1939); the architect Antonio Gaudí (1852–1926) in Spain; the glassware designer Louis Comfort Tiffany (1848–1933) and the architect Louis Sullivan (1856–1924) in America.

2.19 Alan Pipes, Screengrab showing Bézier curves, 2003. Macromedia FreeHand. Courtesy the author.

Computer programs such as Macromedia FreeHand make extensive use of Bézier curves to create controllable freeform lines.

Abstract and Non-representational Shapes

2.20 (left) Pablo Picasso, *Ma Jolie (Woman with Guitar)*, 1911–12. Oil on canvas, 39 × 25″ (100 × 65.4 cm). Museum of Modern Art, New York. Lillie P. Bliss Bequest.

Cubism aimed to analyze forms into geometric structures of angular and fractured planes. In these first experiments with abstract art, color was subdued, so as not to be a distraction.

2.21 (right) Ijo peoples (Nigeria), Otobo mask, c. 1916. Wood, incrustation, pigment. Height 18 ½″ (47 cm). Indiana University Museum, Bloomington, IN. Raymond & Laura Wielgus Collection.

African sculptures such as this hippopotamus mask had a profound impact on European artists at the beginning of the twentieth century, particularly the Cubists Picasso and Braque.

Most people think that abstract means something made up by the artist, something straight out of the imagination that bears no relation to reality. In fact, to abstract something means to simplify an object down to its essential basics, removing all superfluous detail. All drawings and paintings are abstract to some degree—even photo-realistic paintings are simplifications of the real thing. In what is commonly regarded as an abstract painting, however, this simplification is exaggerated and made into a feature. Often the artist is striving to describe difficult ideas and emotions (**2.20**).

Abstract art is not new. The earliest cave paintings depicted animals reduced to their basic forms, most likely drawn from memory and often inspired by the shapes in the rocks they were drawn on. The African tribal masks that inspired and excited Picasso and kick-started Cubism seem strange and abstract to Western eyes (**2.21**).

Symbolic shapes are further removed from reality, often invented, but with their meanings deliberately assigned and agreed upon by the consensus of the community. Many symbolic representations are found in musical notation, signage, and technical diagrams. **Pictograms** are images in which highly stylized shapes represent people or objects (**2.22**). They can be seen in map symbols and in the earliest written languages, such as Egyptian hieroglyphs. A **logotype** (shortened to logo) is a symbol, often incorporating some lettering, used to identify an organization, corporation, or product (see **2.26**).

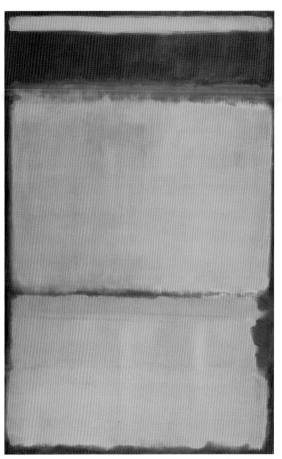

2.22 (left) Alan Pipes, *Keep off the Rocks*, 2003. Digital photograph. Courtesy the author.

Pictograms on warning signs are meant to convey meaning without words, crossing over linguistic and cultural barriers.

2.23 (below) Mark Rothko, *Number 10*, 1950. Oil on canvas, 7′ 6″ × 4′ 10″ (229.6 × 147 cm). Museum of Modern Art, New York. Gift of Philip Johnson.

Although Rothko's color-field paintings are non-objective, some people claim that they can see landscapes in their hazy, stacked shapes.

Shapes can be real or imaginary. If they are derived from observable things, they are called **objective** shapes. If the shapes are meant to look like objects found in the real world or nature, they may be called naturalistic, representational, or realistic. If the painting is intended to look as real as—or more real than—a photograph, they are called photo-realistic or hyper-real. If, on the other hand, the shapes have been contrived by the artist, they are termed non-objective, subjective, or **non-representational** (**2.23**). Surrealist artists generally aim to shock by arranging realistic, commonplace objects into unusual or disturbing settings.

Non-objective shapes have little to do with reality, but is it really possible to create truly non-objective shapes when our minds are always jumping to some conclusion or other and reading meaning into something that perhaps is not endowed with any?

Positive and Negative Shapes

We are so used to reading black text on white paper in books and on signs that we think of the black as the positive "figure" on the white negative "ground." But we are equally adept at reading white lettering on a dark ground. We seem to know intuitively what is important—the positive shapes—but we have also noted that an artist who considers the shapes of the negative areas of a composition will generally produce a more successful outcome than the artist who ignores it (**2.24**).

When we make a mark on a piece of paper or canvas, we start a composition. The mark will be generally smaller than the ground, and it will have physical presence on the benign ground, so we immediately endow it with the property of positivity. The position of the mark in relation to the frame has the effect of organizing the remaining white space into shapes of its own, especially if the mark is near to the edge of the frame or cropping beyond it. As the mark-making progresses and the area of black begins to exceed that of the white, change occurs, and the smaller white areas become positive (see **1.18**).

2.24 (above) John Geary and Sarah Moffatt, Excalibur logo, 2002. Adobe Illustrator. Courtesy Turner Duckworth.

This logo for Excalibur kitchen knives shows positive and negative space. It was a collaboration by illustrator John Geary and designer Sarah Moffatt, with creative direction by Bruce Duckworth and David Turner.

2.25 (below) Wen Cheng-ming, *Old Cypress and Rock*, 1550. Chinese handscroll, ink on paper, 10 × 19″ (26.1 × 48.9 cm). Nelson-Atkins Museum of Art, Kansas City, MO. Purchase Nelson Trust no. 46–48.

Chinese and Japanese artists took great care to consider the shapes of the empty white spaces between forms, resulting in much more satisfying compositions.

Japanese and Chinese artists have long manipulated the negative white space in their compositions to enrich our viewing experience (**2.25**), techniques that were picked up in Western art by Vincent van Gogh, Aubrey Beardsley, and artists ever since. The yin-yang symbol is a classic example of figure/ground or positive/negative ambiguity (**2.26**). In the sculptures of Henry Moore and Barbara Hepworth, negative holes are transformed into positive elements.

The human mind likes the positive shapes to be distinct from the negative ground and gets confused when shapes overlap or are cropped. Understanding is lost or uncertainty heightened, especially if there are many layers of positivity and negativity. This is called equivocal space—the ambiguity of "now you see it, now you see something else." Is the zebra a white horse with black stripes or a black horse with white stripes? This effect has long been exploited by graphic artists as an economical and entertaining way of getting a message across. Optical illusions making use of equivocal space excite and amuse us, and the Dutch artist Escher has made a career from distorting a chessboard pattern into **tessellations** of animals and strange exotic beasts (**2.27**).

The word tessellation comes from the Latin *tessera*, meaning a square tablet or, more commonly, a small square piece of stone or tile used for mosaics. To tessellate is to cover the plane with a pattern in such a way as to leave no region uncovered. Generally, tessellation requires just one or two shapes to make a repeating pattern. This is easy enough with a chess board or patchwork quilt, but more difficult to make both the positive and negative spaces complex yet meaningful.

In Cubism, the intention was the opposite. When Picasso produced a picture that was apparently ambiguous in terms of positive and negative space, instead of stimulating an instant response, he was inviting us to take our time to analyze the shapes and their relationship to one another.

2.26 Alison Sheard, Surrey County Council logo, 1997. Macromedia FreeHand. Courtesy Surrey County Council.

The Surrey County Council logo is a variation on the classic yin-yang symbol, but it uses positive and negative oak leaves. It was designed in 1974 and reworked in 1997 by Alison Sheard.

2.27 M.C. Escher, *Day and Night*, 1938. Woodcut. Private Collection.

Escher explores equivocal space by turning foreground into background before our very eyes, using a pattern of tessellations.

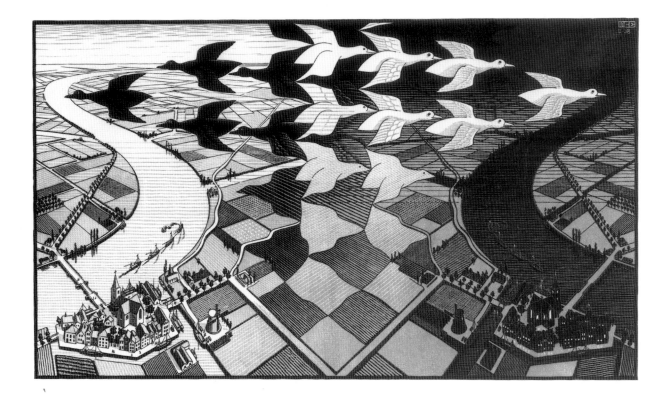

Distortion and Idealism

As well as simplifying reality, artists like to distort shapes (**2.28, 2.30**). Medieval artists used to make the more important figures in a composition bigger than the minor characters. Cartoonists and caricaturists emphasize some facial features over others to help us recognize their victim or for humorous effect.

If a subject is drawn or painted completely straight, as faithful to reality as is possible, we call the style **naturalistic** (see **7.35**). The 19th-century artists of the Pre-Raphaelite Brotherhood thought that art had lost its way since the studio paintings of Renaissance artists such as Raphael (1483–1520) and just about everyone else since, and they decided to go back to basics, painting directly from nature. William Holman Hunt (1827–1910) was so keen on authenticity that he traveled to the Holy Land to paint the backgrounds of his biblical epics.

Most lovers of "traditional" or chocolate-box art would call the art they like naturalistic or realistic, but most popular categories of art aim to depict something better than warts-and-all reality—a so-called idealized world.

2.28 Belle Mellor, *Whiskers*, 2003. Ink on paper, 4 × 5 ½″ (10 × 14 cm). Courtesy the artist.

Artists and illustrators enjoy the freedom to exaggerate and distort human features, in this case by shrinking the head and enlarging the hands and feet.

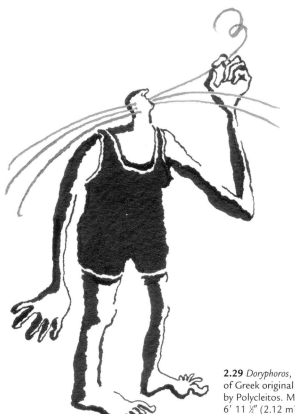

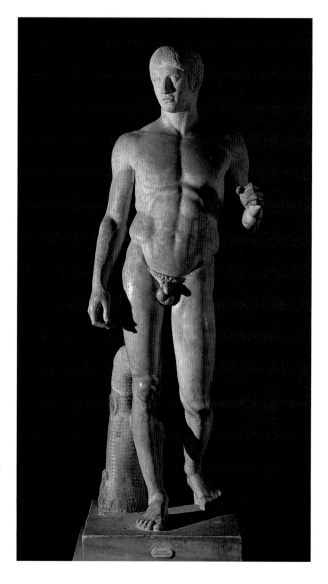

2.29 *Doryphoros*, Roman copy of Greek original (c. 440 BCE) by Polycleitos. Marble, height 6′ 11 ½″ (2.12 m). National Archeological Museum, Naples.

This spearbearer, striding slowly forward, head turned to the right, is said to have been modeled to illustrate the sculptor's theories of ideal bodily proportions. Polycleitos declared that "perfection arises from the minute calculation of many numbers."

2.30 Kit Ma, *Portrait of Wei*, 2000. Acrylic on canvas, 12 × 16″ (30.48 × 40.64 cm). Courtesy the artist.

Kit Ma's paintings introduce close-up fisheye distortions, more often seen in photography, into his representations of figures and backgrounds.

We may think of distortion as a 20th-century phenomenon, but it has been around since cave paintings with their abstracted—and idealized—animals with unrealistically long legs, emphasizing their ability to run swiftly. Greek and Roman sculptors (**2.29**) idealized their statues of leaders and other beautiful people by reducing the size of their heads and elongating their limbs. When the Greek painter Zeuxis (late 5th century BC) was asked to paint a picture of Helen of Troy, he found the most beautiful women he could and combined their best features into an image of ideal beauty.

The Renaissance: Italy, 14th to 16th century

Meaning "rebirth," the Renaissance featured a revival of interest in the artistic and scientific achievements of the Classical Greek and Roman worlds. The arts benefited from the patronage of wealthy families and popes. Artist and scientist Leonardo da Vinci (1452–1519) was the archetypal Renaissance figure. Others included Giotto (c. 1267–1337), Masaccio (c. 1401–1428), Piero della Francesca (c. 1420–1492), Michelangelo (1475–1564), and Titian (1485–1576). From Italy the Renaissance spread to northern Europe, the most notable figure there probably being the German artist Albrecht Dürer (1471–1528).

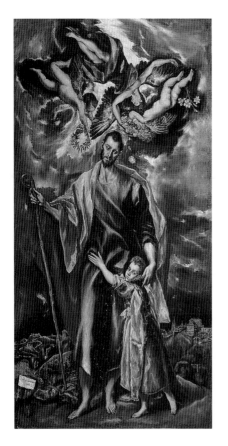

In the 5th century BC, the Greek sculptor Polycleitos wrote a treatise on mathematical proportions called "The Canon." He used the height of the head as a measuring module and arrived at an ideal body that was 7.5 heads high (**2.32**). A century later, other Greeks, such as Praxiteles, proposed an 8-head canon, while Leochares preferred an 8.5-head canon. Later, in the Renaissance, when classical idealism was revived, Michelangelo (1475–1564) used 7.5 for his *David*, but Leonardo da Vinci (1452–1519) thought 8 was better, and Botticelli (c. 1446–97) preferred 9 for his painting of St Sebastian. They were all outdone by El Greco (1541–1614) some years later who used a canon of 11 heads for his elongated figures—but he probably suffered from astigmatism (**2.31**). The actuality is more like 7.5 for the average man and 8 for someone with an athletic build. The Egyptians had their own canon (**2.33**) and in more recent times Le Corbusier introduced his system of measurement called The Modulor (**2.34**).

The Greeks believed in improving on nature, but their attempts at idealizing the human body left a mixed legacy. The artists of the Italian Renaissance devised a set of rigid rules called the Grand Manner, later broken by rebels such as Caravaggio (1573–1610) and Rembrandt van Rijn (1606–69). Idealized art has also been encouraged by governments and dictators in times of ideological conflict, notably in the "heroic" 20th-century art of New Deal America, Soviet Russia, and Nazi Germany. Idealism lives on in the glossy fashion magazines full of tall, thin supermodels with perfect air-brushed skin, and in Barbie dolls and Action Man figures.

2.31 El Greco, *St. Joseph and the Christ Child*, 1596–7. Oil on canvas, 42 ⅞ × 22″ (109 × 56 cm). Chapel of San José, Toledo.

El Greco used a canon of up to eleven heads for his elongated figures. He believed in guiding the mind upward to the divine transcendental cause.

2.32 Alan Pipes, Canon of proportions, 2003. Macromedia FreeHand. Courtesy the author.

Greek canons of proportion used the height of the head to measure an ideal body. Here an average man is shown 7.5 heads high, an "ideal" athletic man is 8 heads high, and a superhuman hero is 8.5 heads high.

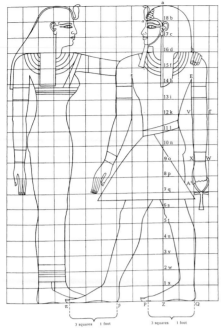

2.33 The Egyptian canon of proportions.

The Egyptian canon of proportions was based on the size of a fist. The distance from the hairline to the ground was 18 fists and the length of a foot was 3.5 fists. The persistence of such canons, plus the characteristic pose (see **0.1** and **4.39**), endured over a 2000-year period.

2.34 Le Corbusier, *The Modulor*, as in *Le Corbusier, The Modulor: A Harmonious Measure to the Human Scale, Universally Applicable to Architecture and Mechanics*, London 1954.

Le Corbusier's *Modulor* system of proportion is derived from a 1.83 (6 ft) person and based on the golden section and two superimposed Fibonacci series that he named the red and blue dimensions. These numbers governed the overall dimensions of a building and the smallest details.

2.35 Abogunde of Ede, A Shango shrine figure holding a dance staff, 19th century. Wood and beads, height 21 ½″ (54.6 cm). Collection, the late Ian Auld Halstead, England.

African sculptors had different ideas about physical beauty, for example, prizing the length of the neck. Figures were carved not as they appeared but according to essential components.

African sculptors, however, might enlarge the size of a head or the length of a neck in proportion to the rest of the body according to their ideas of what is beautiful (**2.35**). Cubist artists were once ridiculed for the "ugly" distortion of their figures. But over time, their way of seeing has been absorbed into our culture, and nowadays no one would be shocked by their work as our grandparents once were.

Exercises

1 Geometric shapes: Using a pencil or pen, draw a figure or still life using only circles, rectangles, and triangles. They can overlap. Color them in flat colors, or cut out the shapes from colored paper and glue them down. Trace the cut-out shapes and, on another sheet of paper, partially shade them in colored pencil or crayon to imitate a Cubist painting.
2 Pictograms: Pictograms are found on warning signs and should make sense without the need for words. Design a warning sign for a hazard that doesn't already have its own sign, for example, "Beware of lobsters" or "Danger—UFOs ahead."
3 Yin-yang: The English Surrey County Council logo (see **2.26**) is a variation of the Chinese black-and white yin-yang symbol, which can be constructed from a circle enclosing a stack of two smaller circles half the diameter of the larger circle. Design your own variation. The shapes of the black and white parts should be identical.

3 | Texture

"In collage you're doing it in stages so you're not actually doing it right there. You first of all draw it on the paper, then you cut it up, then you paste it down, then you change it, then you shove it about, then you may paint bits of it over, so actually you're not making the picture there and then, you're making it through a process, so it's not so spontaneous."

PAULA REGO

Vincent Van Gogh, *Sunflowers*, 1888. Oil on canvas, 36 ¼ × 28 ¾" (92.1 × 73 cm). National Gallery, London.

The dying sunflowers are built up with thick impasto, which evokes the texture of seed-heads. Van Gogh painted them to decorate Gauguin's room in the Yellow House, Arles, south of France, where they worked together. He wrote to his brother, Theo: "The whole thing will be a symphony in blue and yellow. I am working at it every morning from sunrise on, for the flowers fade so quickly."

Introduction

Food without texture can be bland and not very interesting. Texture adds interest and sensory pleasure to the experience of eating. Similarly, texture in art brings another of our five senses into the equation—that of touch. Even if we are forbidden by museum staff to approach the work of art, our eyes and memory join forces in invoking the sensation of touch, and we can imagine what the texture we see might feel like.

All drawings, paintings, and sculptures have texture, no matter how subtle it may be. Texture does not just mean rough, of course. There is a spectrum of texture, from the flat, glossy sheen of glass or porcelain, through heavily embossed watercolor paper and burlap canvas, to the coarse surfaces of sandpaper and weathered wood (**3.1**, **3.2**).

Actual physical texture—that which we can feel with our fingertips—is called **tactile texture**. It is a surface characteristic of the material or a result of how the material has been manipulated by the artist. If the artist is working in oil paint or acrylics, we may see little evidence of its deployment, being seduced into the subject matter by the strength of its story. The surface of the painting may be flat and featureless. Other artists prefer to apply the paint thickly, leaving ridges and furrows that catch the light and make shadows. Here we can see the hand of the artist at work—a visual record of the creative process. Vincent van Gogh, for example, applied his paint generously and vigorously (**3.3**). We know a human painted this. Other painters diligently remove all traces of human intervention, brushing and blending the paint until all textural traces have been smoothed out, and the painting has the surface of a photographic print. Artists' style can be defined by the texture they leave on their paintings.

When an artist applies paint thickly, the result is called **impasto**. Painters such as Jackson Pollock (1912–56) added wax and even sand to increase the bulk of the impasto into a whipped-cream consistency with true three-dimensionality. Adding real objects to a painted surface is called **collage**, from the French verb *coller*, to glue

3.1 Antonio Gaudí and others, Cathedral of Sagrada Familia, Barcelona, 1893–present.

Gaudí's cathedral has very few smooth surfaces, if any, every square inch being covered in intricate carvings. The eastern bell towers are adorned by polychrome mosaic facing. The cliff-like facades are geological in texture.

3.2 Le Corbusier, Church of Notre-Dame-du-Haut, Ronchamp, 1951.

Le Corbusier designed this hilltop chapel for pilgrims and chose sculptural forms, a combination of convex and concave "acoustical" shapes. The chapel's smooth, whitewashed plaster walls are topped by a naturally gray *béton brut* (shuttered concrete) cantilevered cowl roof.

3.3 Vincent Van Gogh, *L'Italienne*, c. 1887. Oil on canvas, 32 × 23 ⅝″ (81 × 60 cm). Musée d'Orsay, Paris.

Van Gogh's works are characterized by an expressive and emotive use of brilliant color applied thickly and energetically.

3.4 Chris Ofili, *No Woman No Cry*, 1998. Acrylic, oil, and mixed media on canvas, 7′ 9″ × 5′ 9″ (2.43 × 1.82 m). Tate, London.

Embedded in phosphorescent paint are the words "R.I.P. Stephen Lawrence"—a tribute to the family of the murdered London teenager. His face is collaged onto each of the crying woman's tears. Ofili's decorative patterning contrasts with the sombre subject matter. The title derives from a Bob Marley song.

or stick. Although collage had been used for many years in folk art and craft, it was the Cubist painters Picasso and Braque, and notably the German Dadaist Kurt Schwitters (1887–1948) who added the technique to the toolbox of artists. Early collages incorporated found pieces of paper, such as bus tickets and other fragments of printed ephemera, and today, collages can include pieces of printed material from magazines, each fragment having its own photographic texture, combined with the painted marks of the artist. Adding bulkier three-dimensional objects to the painted surface is called **assemblage**. Lengths of rope, textiles, even lumps of elephant dung—anything, in fact, that can be stuck to the painting—have been mixed with the painted surface to produce a truly three-dimensional artwork (**3.4**).

There are many other ways of introducing texture into a drawing or painting. Charcoal on rough paper produces texture in the line, as does paint laid onto a rough canvas with a dry brush. Wax crayon or soft pencil rubbed onto thin paper under which a coin has been placed produces a slightly embossed image of the coin's features. We may have done rubbings of historic memorial brasses or even of manhole covers. This is called **frottage**, from the French word *frotter*, to rub. The Surrealist painter and printmaker Max Ernst (1891–1976) introduced rubbings of woodgrain into his eerie, fossil-populated landscapes.

Textures that are created by the hand of the artist are called **visual textures**, or illusion textures. The old master painters were highly skilled in depicting the textures of lace, satin, and other textiles and draperies and the shininess of glass and pearls. If you were allowed to touch the surface, however, the actual physical surface of the painting would be almost as flat and smooth as a photograph (**3.5**). This is an illusion. Look closely at a painting by Jan Vermeer (1632–75) or Thomas Gainsborough (1727–88) and you will see flicks of paint, but step back and marvel as they transform into intricate patterns of lace. These painters did not slavishly copy real lace with a tiny brush—they made a lively impression of lace and still left traces of the hand that made them.

Taking the depiction of visual textures to an extreme results in a style called **trompe l'oeil**, from the French for "deceives the eye." Here the artist fools the observer into thinking that all or part of the painting is the real thing. Successful examples place objects right on the picture plane (see **3.25**) or look like collages, except the playing cards, photos, and newspaper cuttings attached to a noticeboard are not real objects at all, but painted. The technique is also seen on murals on many city walls. In sculpture, trompe l'oeil is used when an unlikely material is used to simulate a familiar one.

Interior designers use abstract textures to render surfaces so that they look like marble or woodgrain. These "faux" or fake surfaces are not slavishly copied from real marble and wood, but simplified and stylized to produce a pleasing result. Artists use abstracted textures to enrich or decorate areas of their paintings. There is no attempt to fool anyone, but from the context and pattern, we can recognize what the texture is meant to represent. If the rest of the painting is already abstracted—in a Picasso or Braque composition, for example—an **abstracted texture** will be appropriate.

Some textures in contemporary paintings look like nothing we see in nature. These are known as **invented textures** and are the result of the artist's imagination. A painting may look abstract to the casual viewer, but not to the artist, who may helpfully attach a descriptive title to the work. Some of the paintings by Howard Hodgkin (b. 1932) (see **4.48**) fall into this category.

As textures become more and more abstracted or invented, they become **patterns**. Pattern, although more often associated with printed and woven textiles, has less to do with tactile texture and more to do with decoration and it involves repetition and a degree of regularity and perhaps some symmetry. The essential difference between texture and pattern is that texture involves our sense of touch, but a pattern appeals to the eye. A texture may be a pattern; not all patterns have texture.

Sculptors make use of texture, too, creating smooth sensual forms in marble, or purposely leaving the mark of the chisel, or the rough manipulation of clay translated into bronze. Ceramicists like to combine shiny glazes with rougher areas of unadorned clay (**3.6**). Architects love to use contrasting finishes of glass, brick, stone, and metal, or will texture concrete to look like wood by employing rough shuttering in its formation.

3.5 Jean-Dominique Ingres, *Portrait of Madame Rivière*, 1805. Oil on canvas, 45 ¼ × 35 ⅜" (116 × 90 cm). Louvre, Paris.

Monsieur Rivière, a court official, had himself, his daughter, and his wife immortalized in three portraits by the young Ingres. Madame Rivière is dressed in white satin and a transparent white net which, together with the veil and sumptuous shawl, test the painter's powers to depict texture.

3.6 Margie Hughto, *Canyon*, 1991. Coloured clays, slips, glazes, and copper, 11 × 7″ (28 × 18 cm). Courtesy the artist.

Hughto uses slips (liquid clay) and glazes (fired, glass-like pigments) to decorate her ceramics with "natural" textures. Augmented by earth colors and copper oxidized to create verdigris, these all contribute to the sense of prehistory that a canyon conveys.

Tactile Texture

If you can feel the roughness you can see on the surface of the paper or canvas, it is tactile texture. There will always be some tactile texture in an artwork, by virtue of the roughness of the watercolor paper or granularity of the canvas ground, but in this context we mean the way the artist manipulates the paint, applying it thickly and not smoothing it flat. Some artists lay it on with a palette knife, straight from the tube. The result is an uneven, three-dimensional paint surface called impasto.

In prehistoric cave art, texture and technique were inextricably linked. Artists were inspired by protrusions on the walls of caves that reminded them of forms—buffalo, for example—and they used ocher and black pigments to add detail and color. Later, artists sought out smoother grounds, using tempera on wooden panels coated in smooth gesso (plaster of Paris), or frescos on wet plaster walls. The aim was to fool the viewer with an illusion of three-dimensionality. In the 19th century, artists became more interested in expressing their personalities in their paintings, through the marks and brushstrokes, and how they applied paint to the ground, seeing how far they could go before what they were depicting became unrecognizable.

When the Venetian painter Titian (c.1487–1576) sent the English queen Mary I a portrait of her husband-to-be Philip II of Spain, he included instructions to look at the picture in a dimmish light and from a goodish distance. Titian shocked his contemporaries with bold, loose brushwork, but when his work is viewed from a distance, the visual texture of rapid strokes or taches astonishingly turns into likenesses. Two centuries later, Thomas Gainsborough was also criticized for his free brushwork, but even his harshest critic, Joshua Reynolds (1723–92), conceded that "all those odd scratches and marks, by a kind of magic, at a certain distance, seem to drop into their proper places."

3.7 (left) Frank Auerbach, *Small Head of E.O.W*, 1957–8. Oil on board, 12 × 8 ½″ (30.5 × 21.6 cm). Tate, London.

The paint's thickness and texture result from hundreds of sittings governed by Auerbach's principle that "Nothing can be left out ... you have to bury the irrelevant in painting somehow."

3.8 (right) Frank Auerbach, *Small Head of E.O.W* (detail), 1957–8. Tate, London.

A detail of the tactile texture of the paint reveals a visual record of Auerbach's obsessive reworking of the image and his quest to find a visual equivalent for his "raw experience" of the sitter.

3.9 Louis Le Vau & J.H. Mansart, Hall of Mirrors, Palace of Versailles, near Paris, 1669–85.

In European palaces such as Versailles, walls almost disappear under ornate raised textures, stucco reliefs, colored marbles, mirrors and paintings.

Vincent van Gogh is the best-known impasto painter (see **3.3**). His combination of bright colors and the physicality of his brushwork, with swirling patterns of undiluted paint defining the contours of a face or the movement of a cornfield, convey more about the artist than the subject matter. You can see how he arrived at the finished work: which colors were applied first, which overlap, and which sit on layers painted earlier. The creative process in action is preserved in paint. Contemporary artist Frank Auerbach paints wet in wet with expressive impact (**3.7, 3.8**). Compare this with the surface of a painting by French artist Jean-Auguste-Dominique Ingres (1780–1867) (see **3.5**) who went to great pains to eliminate any trace of his hand, producing a porcelain-smooth surface.

Architects and sculptors work with real materials, each with its own intrinsic texture, although the tactile textures are more pronounced than the textures of paper and canvas. In 18th-century rococo interiors of European palaces such as Versailles, near Paris, walls almost disappear under ornate raised textures, combined with mirrors and paintings (**3.9**). This tradition carried on into the buildings of the Art Nouveau period, particularly in the sinuous structures of Spanish architect Antonio Gaudí, who encrusted his surfaces with organic textures and mosaics made from smashed plates.

Tactile texture has always been an essential element in non-Western art, such as textiles (see **3.27**), tribal masks, and other ritual objects, but the Swiss Surrealist Meret Oppenheim (1913–85) used unexpected textures to shock and confuse, lining the inside of an otherwise functional cup and saucer with fur, for example (**3.10**). Environmental artists make forms and patterns from natural objects such as leaves, icicles, and berries, even whole landscapes (see **10.3**).

3.10 Meret Oppenheim, *Object*, 1936. Fur-covered cup, saucer, and spoon. Museum of Modern Art, New York.

Oppenheim is best known for this fur-lined teacup, saucer, and spoon, one of the most recognizable and memorable Surrealist sculptures. The Surrealists made unlikely juxtapositions of otherwise familiar utilitarian objects and textures, rendering them decorative but useless. Here the sterile, shiny surface of a teacup has been replaced by something feral and unhygienic.

Collage

3.11 Pablo Picasso, *Bottle of Vieux Marc, Glass, Guitar, and Newspaper*, 1913. Collage and pen and ink on blue paper, 18 ⅜ × 24 ⅝″ (46.7 × 62.5 cm). Tate, London.

Whereas Picasso's earlier Cubist paintings deconstructed objects into their component parts and planes, works such as this one created a unified composition from abstracted fragments of those objects depicted.

3.12 Anonymous, *Delectable Mountains*, 1840–60. Quilt. Pieced cotton, 92 × 96″ (233.6 × 243.8 cm). Newark Museum Collection, NJ.

This design is named after John Bunyan's *The Pilgrim's Progress*: "They [The pilgrims] went then till they came to the Delectable Mountains...." The positive/negative shapes represent the mountains and sky.

Instead of going to the trouble of painting a bus ticket or piece of cloth, why not take the real thing and glue it to the surface of the picture? That's what Picasso, Braque, and Schwitters thought at the beginning of the 20th century, and they developed collage (**3.11**). If the attached scraps are paper-based, it is more correctly known as **papier collé**.

Collage has been found in folk art for many centuries—think of the way materials of different tactile textures are used and recycled—in appliqué and quiltmaking (**3.12**), or in mosaics made from pieces of patterned plates or tiles (**3.13**). New textures are created by juxtaposing found and discarded pieces of printed or plain colored textiles. Printed tin-plate from old drinks cans, bottletops, and other pieces of junk, which would otherwise be thrown away, are ingeniously re-used in developing countries across the world to make toys, jewelry, decorative objects, and sculptures. By placing "trash" in new contexts, artists are revealing unexpected relationships and qualities, magically endowing rubbish with new meaning, and transmuting commonplace materials into things of beauty.

In its simplest form, a collage can be assembled from shapes cut from pieces of colored paper and pasted to a ground. That's what Matisse did when his eyesight began to fail and he found painting difficult. He would paint sheets of paper or card in bright colors and cut out shapes from them with scissors. An assistant would place these shapes in various positions on the ground. When Matisse was happy with their positions, they would be glued in place. It sounds simple, but the results were some of his most striking and memorable work (**3.14**).

Collage is a good way to experiment with shapes before you commit to a final design. Like Matisse, you can cut out shapes from found or pre-painted sheets of paper and try different compositions and orientations before fixing them to the ground or transferring the design to a painting.

Pages from glossy magazines and other samples of ephemeral printed matter are a rich source of colors and textures, and you can quickly produce a complex design that transcends the cut-out shapes, turning mundane photographic images chosen for their qualities of color and texture rather than their subject matter into new textures. Be aware of copyright when you are using someone else's published photograph. Add painted textures to this composition and you have **mixed media**, a term used for any artwork that cannot be pinned down to the use of a single medium, such as oil paint, watercolor, or acrylic.

An immediate type of printmaking is a **collograph**, a type of relief printing in which the "block" is made from a collage of shapes cut from card, folded paper, corrugated cardboard, hardboard (masonite), or even chicken wire or bubble wrap. This surface is inked using a soft roller, which will reach into all the crevices, and the ink is transferred to paper under the pressure of a printing press or by burnishing.

Any found material can be used in collage proper. Picasso incorporated lengths of rope and cane from chairs to create textural interest. One of the trademarks of British artist Chris Ofili (b. 1968) is a piece or two of dried elephant dung attached to his paintings (see **3.4**). Inspired by and alluding to African art, Ofili attaches lumps directly to the canvas or to support the paintings when they are displayed in a gallery space. He also mixes resin, glitter, collaged images from magazines, and map pins into his multi-layered artworks.

3.13 Antonio Gaudí, Mosaic from Parc Guell, c. 1900.

Gaudí covered almost every undulating surface of the Parc Guell's upper structures with mosaics made from colorful smashed tiles and plates.

3.14 Henri Matisse, *The Snail*, 1953. Gouache on paper, cut and pasted on paper mounted on canvas, 9′ 3″ × 9′ 4″ (28.7 × 28.8 cm). Tate, London.

Inspired by a snail's shell, Matisse explained that "I first of all drew the snail from nature, holding it. I became aware of an unrolling. I found an image in my mind purified of the shell. Then I took the scissors."

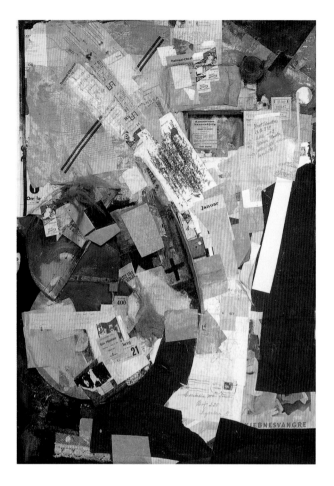

3.15 Kurt Schwitters, *Picture of Spatial Growths—Picture with Two Small Dogs*, 1920–39. Mixed media collage on board, 38 ⅛ × 27 ⅛" (97 × 69 cm). Tate, London.

Schwitters started this assemblage in Germany. When he fled the Nazis for Norway, he added theatre tickets, receipts, newspaper cuttings, scraps of lace, and a box with two china dogs. The different layers reflect the journey into exile.

Artists such as Picasso and Braque invented collage; the German Dadaist Kurt Schwitters made a career from it, which he called Merz (**3.15**). The word has no meaning, but comes from a fragment of paper used in a collage that once read *Commerz und Privatbank*. He used the abbreviation Merz to refer to a combination, for artistic purposes, of all conceivable materials, having equal rights with paint. Schwitters also created three Merz constructions, or Merzbau, which filled or partly filled whole rooms.

When collage escapes the bounds of the frame, or is truly three-dimensional, we call this assemblage, an assembly of material. A large assemblage, usually one that you can walk into or through, is called an **installation**, and if that installation has been created specifically for a particular location, making use of the local architectural space, it is a **site-specific installation**, and here we have moved into the realm of sculpture.

Environmental artists, such as Andy Goldsworthy, make collages and assemblages out of natural materials—leaves, twigs, thorns, and berries chosen for their range of colors and textures—often in remote locations and unlikely to be seen by anyone else. But he records their exquisite, fragile forms in photographs that can be observed at leisure in a gallery or book. Some environmental artists take care to return the scene to how it was, before they leave, so that no trace of their presence remains.

When elements of photography are assembled into new compositions so that they are still recognizable but their original meaning has been changed or subverted, we call the result **montage**. Another Dadaist, the German artist John Heartfield (1891–1968), who changed his name from Helmut Herzfelde to protest against World War I, annoyed the Nazis by designing magazine and book covers that used satirical **photo-montages** that parodied the propaganda of the time (**3.16**).

Several photographs of the same panoramic scene exhibiting subtle differences in color and focus can be combined to form a Cubist-style montage, as in the photographic works of David Hockney (b. 1937), a technique that has been tried, not always as successfully, by amateurs all over the world. Hockney, a true innovator, has also used the textural possibilities of paper pulp impregnated with pigment.

Dada: Germany and Paris, 1916–1922

The Dada movement began in Zürich after the Romanian poet Tristan Tzara inserted a penknife into the pages of a dictionary to find a random name: dada is French for hobby-horse. Dadaists were disillusioned by the carnage and futility exemplified by World War I, and aimed to shock people out of their complacency. Leading Dadaist Marcel Duchamp (1887–1968) invented "ready-mades" such as *Fountain* (1917), a simple urinal signed "R. Mutt." Other Dadaists included John Heartfield and Kurt Schwitters (1887–1948). Dada evolved into Surrealism.

ADOLF, DER ÜBERMENSCH: **Schluckt Gold und redet Blech**

3.16 John Heartfield, *Adolf the Superman—Swallows Gold and Spouts Junk*, 1932. Photomontage.

This photo-montage was used as an anti-Hitler poster during the 1932 elections. It drew attention to the financial backing Hitler received from wealthy industrialists who feared Germany might vote for a Communist government.

3.17 Gary Thompson, *The Grid*, 2001. Photoshop collage. Courtesy the artist.

This multilayered Photoshop collage was one of a series of pictures to illustrate peer-to-peer networking for an IT supplement in *The Economist* magazine.

Photographs are, of course, an almost essential element of collage, whether they are cut from magazines or specially taken, and today, with image-processing programs such as Adobe Photoshop, there is rarely a photograph published that hasn't been "improved" or manipulated in some way. This can be as innocent as color correction, removing a few blemishes from a model's face, or adding crocuses to a field by a windmill, but the procedure has more sinister implications in distorting reality. The Russian dictator Stalin used to have colleagues who were no longer in favor air-brushed out of historical photographs. It is easier to do that in Photoshop. Nevertheless, with their layering and compositing tools, computer programs such as Photoshop have become another medium enabling artists to investigate the endless potential of collage (**3.17**).

Visual Texture

3.18 Charles Sheeler, *Rolling Power*, 1939. Oil on canvas, 15 × 30″ (38.1 × 76.2 cm). Smith College Museum of Art, Northampton, MA.

This painting depicts the running gear of a steam locomotive, which in 1939 was at the forefront of industrial technology.

3.19 Sir Lawrence Alma-Tadema, *A Favourite Custom*, 1909. Oil on panel, 26 × 17 ¾″ (66 × 45.1 cm). Tate, London.

Victorian artists only depicted nudes in classical settings. Two women here take a cold bath at Pompeii. The eye is drawn up the picture to the open door and sunlight.

We can see that something has texture without having to touch it by the way it casts shadows, and by the gradation of tone that models the forms, especially under raking light. A smooth texture will be evenly lit, whereas a rough texture will exhibit sharp contrasts of light and dark, where tiny pits and crevices swallow the light.

A skilled painter can make us think that the textures in their paintings are real, when they are merely variations in the value and color of paint (**3.18**).

Apparent texture that is really flat paint on canvas is called visual texture. The ability to render the appearance of textures such as lace, satin, fur, and feathers—as well as human flesh—was highly valued in Dutch and Spanish paintings of the 17th century (see **3.24**). Still life and "genre" painters such as Willem Kalf (1622–93) and Vermeer painted small-scale, sharply detailed paintings designed for the living room walls of rich merchants. Kalf painted luxury objects they could aspire to—silver flagons, Chinese porcelain, and expensive fruits and flowers—but that often had an underlying moral message too, with a skull or burned-out candle to remind the viewer of their mortality while at the same time inviting them to enjoy life.

The skill of the artist in rendering visual texture reached its peak in the 19th century, in the work of artists such as Ingres, with his porcelain-skinned portraits of society ladies in silks and satins, adorned with pearls and jewels (see **3.5**). In Victorian England, the Pre-Raphaelites and Neo-classicists, such as Lawrence Alma-Tadema (1836–1912) (**3.19**), took realism to new heights, before Impressionism and Art Nouveau became fashionable in the early 20th century and realism became unfashionable. After this period, the painted surface became more tactile,

3.20 Roy Lichtenstein, *Big Painting, no. 6*, 1965. Oil on canvas, 7′ 8″ × 10′ 9″ (2.34 × 3.28 m). Whitney Museum, New York.

A cartoon-style image complete with tones rendered in Ben Day halftone dots suggests that everything is coded and learned through reproduction.

as in the paintings of van Gogh, and akin to pattern, as in the highly decorated surfaces of Gustav Klimt (1862–1918) (see **4.13**).

Pop artist Roy Lichtenstein depicted brushstrokes loaded with paint in a flat, stylized way, making jokes about the painting process (**3.20**). Realistic textures made a brief comeback in the late-1960s with Photo-realists, such as Richard Estes (b. 1936), but their hyper-real depictions of mundane landscapes were copies of photographs, rather than representations of reality (**3.21**). British artist Glenn Brown (b. 1966) meticulously recreates other people's smaller paintings on huge canvasses, rendering a freely painted Frank Auerbach picture in painstakingly tiny brushstrokes. On a gallery wall you would not mistake a Brown, with its perfect flat surface and glossy sheen, for a genuine Auerbach (see **3.7**), with its lumpy liquid paint, toil, and sweat, but side by side in a book, where most of us see art, they would be almost indistinguishable.

Although contemporary art is dominated by conceptual art, video, and photography, applying paint to canvas to make pictures still has passionate practitioners and supporters. Painters may strive to reproduce reality or be more interested in inventing textures. As abstract shapes are simplified shapes, so abstract textures are simplified natural textures. These can be stylized almost into pattern (see pages 76–77)—when there is no attempt to fool the viewer, and are used for their decorative effect. Invented textures neither simulate natural textures nor are they abstracted textures. They come from the imagination of the artist, and because they are non-objective in origin, they are mostly found in non-objective art.

3.21 Richard Estes, *Woolworth's*, 1974. Oil on canvas, 38 × 55″ (96.5 × 139.7 cm). San Antonio Museum of Art, San Antonio, TX.

The urban landscapes of Estes, often incorporating reflections in glass, are painted so meticulously that their shiny photo-realism transcends the banal subject.

Trompe L'oeil

No matter how realistically a painting is rendered, we intuitively know that it is ultimately an illusion. Sometimes, however, we are fooled and have to do a double-take: is that real or painted? An image that seems so real that we are momentarily taken in is called trompe l'oeil, from the French for "deceives the eye." (**3.23**) The phrase has come to mean a particular style of painting, and also a technique in interior design and in murals to delight the eye and cause us to smile (**3.22**).

Until relatively recently, the ability to paint and draw realistically was a highly prized attribute for an artist. There is a story that two Greek artists, Zeuxis and Parrhasios, held a contest to see who was the more skilful. Zeuxis painted some grapes so realistically that birds tried to peck at them. He thought he'd won, but when Parrhasios invited him to draw back the curtain concealing his entry to the competition, Zeuxis discovered that the curtain had been painted. He conceded victory because, although he'd fooled the birds, Parrhasios had fooled him. A similar story is told about Giotto. When he was a child apprentice in Cimabue's studio, he painted a fly on a portrait by his master, who tried several times to shoo it away.

Few Greek or Roman paintings survive, but the murals preserved at Pompeii suggest that trompe l'oeil was enjoyed in antiquity. We have already mentioned the Spanish and Dutch still lifes (**3.24**). Not only were these rendered as realistically as possible, but the artists would arrange fruit on shelves or hanging from strings

3.22 Fra Andrea Pozzo, *The Glorification of St. Ignatius*, Church of Sant'Ignazio, Rome, 1691–4. Ceiling fresco.

Pozzo gives us a breathtaking perspective of vertiginous architecture. Personifications of the four continents tower above the heathens yet to be converted to Catholicism.

3.23 Manuel Franquelo, *Untitled*, 1987. Acrylic and oil on wood, 32 ¼ × 32 ¼" (82 × 82 cm). Garel Jones Collection, London.

Franquelo uses the device of a shelf with cast shadows onto which he places everyday objects rendered in subdued colors, against a shallow ground.

3.24 Juan Sanchez Cotán, *Still Life with Game Fowl, Fruit, and Vegetables*, 1602. Oil on canvas, 26 ¾ × 35" (68 × 89 cm). Prado, Madrid.

Light falls upon a false frame (parallel to the picture plane), over which vegetables overlap. Other objects are suspended from the upper frame. Despite their naturalism, the isolation of each object, heightened by the shallow black background, gives them an artificial sculptural quality.

3.25 Ron Mueck, *Ghost*, 1998. Fiberglass, silicon, polyurethane foam, acrylic fiber, and fabric. Height c. 7 ½' (2.28 m). Tate, London.

Mueck makes hyper-realistic works in fiberglass and silicone. He first models his works in clay, rather than casting directly from his subjects. The distorted scale (7 ½ ft) and awkward posture of this young girl indicate her emotional state.

and have game hanging from hooks, often overlapping and casting shadows onto what you might think is a picture frame, giving the impression that the objects project out of the picture and into three-dimensional space. Later trompe l'oeil paintings purport to resemble collages, with every fragment of a bus ticket or folded letter painted meticulously, complete with subtle shadows and stained, torn, or creased edges. Playing cards and other pieces of printed ephemera are "attached" to the surface with thumbtacks, pins, or tape—all painted, of course.

One of today's clichés of graphic design, the drop shadow, is a well-worn device of trompe l'oeil and also fairground typography. The letters appear to hover in space, just above the surface of the paper.

Trompe l'oeil is seen in sculpture too, whenever the material or visual texture just doesn't look quite right: street performers and mime artistes who look like bronze or marble statues, life-sized statues placed on park benches, Madame Tussaud's waxwork exhibits, the frighteningly realistic shoppers of hyper-realist sculptor Duane Hanson and the eery out-of-scale figures of Ron Mueck (b. 1958) (**3.25**). Greek and Roman statues were once painted in realistic colors, but we are so used to seeing them in their cleaned state of lifeless marble or bronze, that to see a statue clothed and in healthy color can shock.

We also see trompe l'oeil in the false alcoves and niches, and overly grand doorways of baroque and rococo stately homes, and more often now on the sides of half-demolished buildings, where murals uplift depressed neighborhoods and give a sense of enchantment and enrichment.

Pattern

Most textures have a random, naturalistic quality. A **motif** is a recurring thematic element or repeated feature in design. It can be an object, a symbol, a shape, or a color. A texture may consist of repeating motifs, but you are more likely to notice the surface than the motifs. In a pattern, however, you will be more aware of the motifs and less interested in the surface. A sunflower is a motif, but a field of sunflowers is a texture, too random to detect a pattern. A square is a motif, a chessboard is a pattern, with very little texture. In a pattern, you see the group or organization first and the individual motifs second (**3.26**).

We associate pattern with printed and woven textiles and wallpaper, which have repeating patterns, some more complicated than others (**3.27**). Large areas of cloth can be patterned with a simple inked wood block, small enough to be handled. The repeats can be simple arrays, aligned along grid lines, or, more effectively, slightly offset from the previous row. As long as these offsets are consistent and not random, a pattern will evolve. More complex patterns follow the operations of **symmetry**.

3.26 (left) Rosemary Troeckel, *Untitled*, 1988. Machine-knitted wool, 78 ¾ × 126″ (200 × 320 cm). Courtesy Barbara Gladstone.

Troeckel designs patterns on computer, which are then manufactured by machine. She strips knitting from its female hobby connotations, and reduces the impact of provocative motifs by making them mere decorative elements in repetitive schemes.

3.27 (right) A Kente textile, Asante (Ghana), n.d. Fowler Museum of Cultural History, University of California, Los Angeles, CA.

In the early 19th century, the finest textiles, Kente, were made of silk recycled from European and Chinese garments. Long woven strips were stitched together to make large panels, worn like togas. The patterns of rectangles were filled with symbolic motifs.

Three common aspects of symmetry are **reflection**, **rotation**, and **translation**. When you look at an object's reflection in the mirror, does it change? Some objects do, but others don't. A circle or your face don't change (much), but your signature and your hand do. When you rotate the object, does it change? Take two copies of the object and rotate one of them to see if or when it is identical to the other. Draw the object on a sheet of transparent paper and place it on a lightbox or hold it up to a window. If you can lay one on top of the other and all the lines match, you know they are the "same." Translation means that if two copies of an object are superimposed (one on top of the other), you can glide or slide one of them—without rotating or reflecting—and it will land in a new place where the lines of the objects still match. Another form of symmetry is radial symmetry (**3.28**).

Making a pattern by placing simple geometric shapes next to each other is called **tiling**. A chessboard is a simple example of tiled squares. Modern mathematics has evolved ingenious "non-periodic" patterns for quilting paper towels, using rhombs (diamond shapes with opposite sides parallel), so that they can be embossed by simple machines but avoid unsightly bumps and bunching when they are made into rolls. This kind of pattern cannot be translated by gliding.

Although we often associate patterns with textiles, pattern in art rarely invokes our sense of touch. Whereas all textures make some sort of pattern, not every pattern has texture. Pattern in painting is often seen as decoration or ornament, such as in the repetitive silkscreens of Andy Warhol, or the spot paintings of Damien Hirst (b. 1965), a small example of which, on board *Beagle 2*, will be the first piece of human art to land on Mars (**3.29**). Because the spot painting is done with various iron oxides and known minerals, scientists will be able to use it to calibrate the craft's spectrometers before they begin to analyze Martian materials.

Exercises

1 Physical texture: Add different materials to your paint to make it thicker and more like the consistency of whipped cream. You can add starch to tempera, or sand or expanded polystyrene beads to acrylics, in order to bulk the paint up. Then apply the paint to the ground as thickly as possible, leaving brush marks and peaks. Don't try this with oil paint; it will take ages to dry.

2 Torn-paper mosaics: Make a self-portrait using small torn pieces of paper from a magazine. Use pieces of skin color for your face, but do not use any recognizable features, such as eyes or lips; these must be created using changes in value. Use similarly sized pieces of paper throughout, even for the flat color of the background. Create a background that looks flat from a distance but varied in texture close up.

3 Quilts: Make a five-by-four grid of squares, both a thumbnail and a full-size version. On the thumbnail, create a quilt pattern using different values or colors. Cut out pieces of paper from a magazine, choosing them for their color and texture to approximate the look of printed textiles. Using the thumbnail as a guide, paste the paper pieces onto the full-size grid. Try this with more complex patterns. For inspiration, consult http://ttsw.com/MainQuiltingPage.html, or do a WWW search for "quilting blocks."

3.28 (left) Fred Tomaselli, *Bug Blast*, 1998. Photographs, collage, pills, leaves, insects, acrylic, and resin on paper, 5 × 5′ (1.52 × 1.52 m). Private Collection.

Tomaselli deals with the perceptual slippage between reality and artifice. This radial mandala looks painted but is an assemblage of pills, hemp leaves, cut-out butterflies, and real bugs in resin.

3.29 (right) Damien Hirst, *Spots in Space*, 2002. Pigments on aluminum, 3 ⅛ × 3 ⅛″ (8 × 8 cm). Photo: Mike Levers.

Hirst's painting for Mars lander *Beagle 2* will calibrate cameras and spectrometers that will analyse rock samples to detect evidence of life on Mars. It will be the first human painting on another planet.

4 | Space—Creating the Illusion of Depth

"Oh! che dolce cosa è questa prospettiva!"
("Oh! what a sweet thing perspective is!")

PAOLO UCCELLO

Illustration from *eBoy*, Laurence King Publishing, 2002, p. 140.

eBoy is the shared identity of Steffen Sauerteig, Svend Smital, and Kai Vermehr working in two studios in Berlin, and Peter Stemmler making vector graphics in New York. Their pixel-based cityscapes, all isometric projections, are created exclusively in Photoshop (see **4.40**).

Introduction

4.1 (left) Pierre Adolphe Valette, *Albert Square, Manchester*, 1910. Oil on jute, 59 × 44″ (152 × 114 cm). Manchester Art Gallery, Manchester.

Valette taught at the Manchester School of Art. He painted atmospheric scenes of Manchester, including this one facing the town hall.

4.2 (right) Alan Pipes, Perspective optical illusion, 2003. Macromedia FreeHand drawing. Courtesy the author.

Which policeman is the tallest? They are all the same height. We are fooled by the background "perspective" lines into thinking the right-hand policeman is the tallest.

When we think of space, we conjure up thoughts of space travel and outer space, deep space, wide open spaces, and expansive vistas. Have you ever seen a situations vacant advertisement for a space salesman and imagined someone selling plots of land on Mars? The job title has a more mundane explanation: it involves selling advertising space in newspapers. Empty space is anathema to newspaper designers, although white space can be an element of design in its own right, just as empty space around a building or sculpture can allow us to better appreciate its beauty, which is why many modern art galleries paint their walls white and give the works on show plenty of space in which to be seen.

All representational drawing and painting is about depicting three-dimensional space on the flat picture plane of a two-dimensional canvas or sheet of paper (**4.1**). Even abstract and non-representational art can evoke a feeling of depth and space within the mind of the viewer, no matter how shallow that space may seem. As children, we learn how to judge depth and distance by interpreting subtle cues, and these same responses can be used by the artist to simulate space. We are sometimes fooled, however, and optical illusions that subvert these learned rules can confuse and amuse us (**4.2**).

The first depth cue we learn is relative size. We know we can hold an apple in our hands but that the moon is big and far away. We can predict fairly accurately how far someone is from us, because we consult a model of an average-sized person in our brains and compare what we see with it. We learn that as objects move further away, they seem to diminish in size. In abstract pictures with similar shapes or motifs, we like to think of smaller variants being further into the picture, away from the picture plane, but this phenomenon is not so marked when the shapes or motifs are more varied.

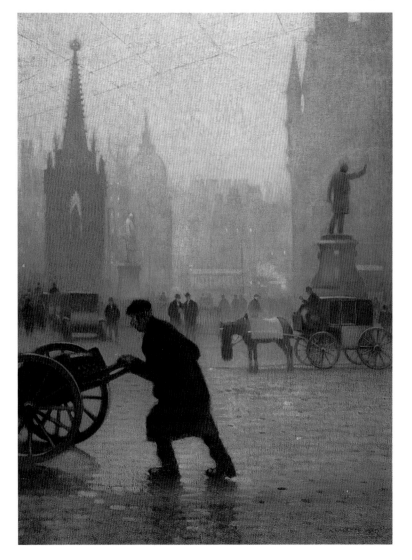

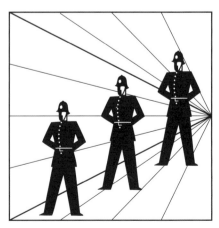

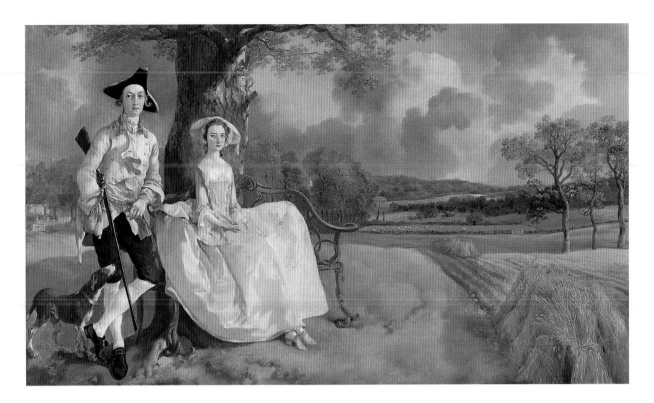

In early art and some non-Western cultures, size has also been used to denote status or importance (**4.4, 4.19**). The subject of the painting—a saint or king, for example—would be larger than the less important people. This is called **hieratic scaling** (see Chapter 10). In most kinds of art, however, if something is bigger than a smaller version of something similar, we assume that the larger object is nearer the picture plane.

If we imagine the picture plane to be a window into a three-dimensional landscape, we can divide the space we see through the window into three distinct areas, like the flats and backdrop of a stage set. In the distance is the **background**: the sky, mountains, and distant hills. Nearer to us is the middle ground or **mid-ground** of trees, bushes, and buildings. Closest of all is the **foreground**, which is often the space that our subject inhabits (**4.3**). There are no exact numerical values for the distance at which the mid-ground turns into background—these are just convenient bands of distance. Some artists exaggerate the feeling of depth by placing the subject of the painting so close to us that we cannot see the whole of it because it is cropped by the picture frame, but our mind's eye model of the subject helpfully "fills in" the missing bits. Cropping the subject also creates a dynamic shape within the picture plane, adding movement and interest to the composition.

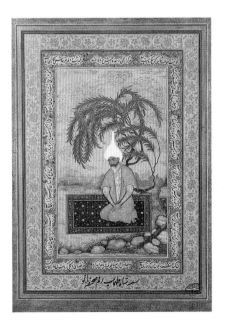

4.3 Thomas Gainsborough, *Mr and Mrs Andrews*, c. 1749. Oil on canvas, 27 ½ × 47″ (69.8 × 119.4 cm). National Gallery, London.

This double portrait evokes the status and estate of a wealthy Suffolk squire, holdings that cover a garden and farmland. His wife sits on a rococo-style bench. An unfinished space on her lap was perhaps intended for a child.

4.4 Sahifa Banu, *Portrait of Shah Tahmasp*, early 17th century. Pigment on paper, 6 × 3 ¾″ (15 × 9.5 cm). Victoria & Albert Museum, London.

Although the rocks and tree are shaded in this Indian album miniature, there is no attempt to put the rug in perspective; it could be a magic carpet hovering above the ground.

Another method for showing relative position is through **overlapping** (**4.5**). Shapes of similar size can immediately be put into order of depth by the way parts of one shape are hidden by another, which we assume must be closer to us. Imagine some playing cards scattered on a tabletop, some overlapping others. We make the assumption that they are all the same shape and size, so we can safely conclude that the ones we can see in their entirety are the ones on top of the pile. This shallow-space example may seem obvious and self-evident, but artists make use of overlapping in larger, three-dimensional scenes to establish the depth order of objects of similar size, when relative size may not be significantly different. In an ambiguous scene, overlapping will also overrule relative size. For example, if the smaller of two spheres overlaps the bigger one, we must assume it must be nearer to us. Overlapping combined with relative size give us a clearer impression of spatial depth in compositions.

Overlapping objects do not need to be opaque to be effective in conveying depth. Translucent objects, such as bottles or glasses, can also indicate spatial position, especially when the shape or color of objects seen through them are distorted or modified. In 20th-century art, from the Cubists onward, **transparency** has also been used to confuse and add information to a picture. If two objects are overlapping and transparent it is not always apparent which is closer to us. This intentional ambiguity is called equivocal space. It has the effect of stopping us in our tracks and slowing down our exploration of the picture, while we try to work out the positive and negative shapes (see also pages 54–55). This is also a device for reminding us that just because part of an object—even a whole object—may be hidden from this viewpoint, it is still there, it exists, and it has a presence. With transparency, a complex pattern can be created from just a few simple overlapping shapes, and a much more interesting composition will result.

The vertical position of an object on the picture plane can also be an indicator of depth. Again, our experience suggests that the higher the object on the picture plane, the further away it is. Sky and mountains are always at the top of a

4.5 Jacques-Louis David, *The Oath of the Horatii*, 1784–5. Oil on canvas, 14 × 11′ (4.27 × 3.35 m). Louvre, Paris.

The Horatii brothers vow to their father to sacrifice themselves for their country. Stoicism and patriotism are conveyed with economy, taut muscles contrasting with the collapsed, grieving poses of their mother and sisters.

4.6 (opposite, below left) Chris Corr, Cover of Vikram Seth's *A Suitable Boy*, 2002. Gouache on paper, 12 × 12″ (30.48 × 30.48 cm). Courtesy the artist.

Corr's almost decorative space is flattened further by employing a vibrant red, a color that normally moves forward, in the background. He also uses vertical placement—all the figures, apart from the subject and the party on the green, being of similar shape with little overlapping.

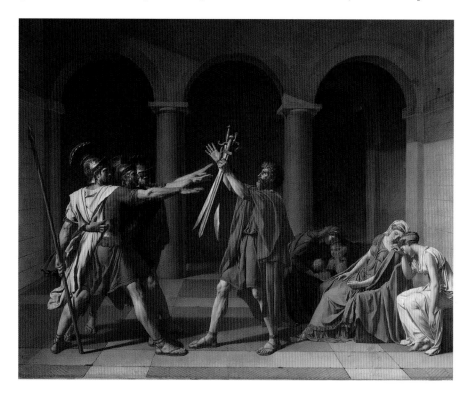

4.7 Peter Paul Rubens, *Autumn Landscape with A View of Het Steen in the Early Morning*, c. 1636. Oil on wood, 47 ¾ × 90 ¼″ (132 × 229 cm). National Gallery, London.

This painting shows an autumnal scene with sharp wintry light and atmospheric perspective along the horizon. The rising sun lights up the front of the house and the cart.

4.8 (below) Ahmad Kashmiri, *Razmnama* (battle between Babhruvahana and snakes), from *Mahabharata*, Mughal School, India, 1598. Illuminated MS. British Library, London.

The hero's arrows turn into storks, peacocks, and ants—the snakes' enemies—and he obtains the jewel to save Arjuna's life. Their vertical location suggests depth, enhanced by overlapping horsemen.

conventional landscape, with a mid-ground of trees and buildings somewhere near the middle of the vertical axis, and nearer figures, particularly if we have a high viewpoint, are down below us at the bottom of the picture plane. The closest point to us, out of the picture plane, is the ground we are standing on (**4.7**).

This convention of **vertical location** was used in paintings from Asia and the Middle East and in medieval European illuminated manuscripts (**4.8**). There was little or no use of relative size to indicate distance. The device is also found in more recent naive and outsider art and by some contemporary artists (**4.6**). It is a convention we can understand, despite our usual insistence on more sophisticated means of depicting depth.

The furthest place on earth we can see on a clear day is the line of the horizon, the edge of the visible world, as the earth curves away from our view. This is the level of our eyes—if we were higher, we would see further. Anything above the horizon is higher than eye level. In a conventional landscape, the horizon will be roughly halfway up the picture plane, unless the artist wishes to devote more area to the clouds or ground or is composing the picture according to mathematical rules and placing the horizon on the line of golden proportion (see Chapter 10). The closest point to us is the ground at our feet; the furthest are the heavenly bodies in the sky. Between them is the horizon. Since the invention of flying machines and skyscrapers, however, there is another way of looking at the world—the bird's eye view. We may still see the horizon, but the ground is now some distance below our feet, and other objects may be nearer. Similarly, if we are surrounded by tall buildings, a worm's eye view gives us another unconventional look at our surroundings.

A further depth cue exploits the phenomenon that distant objects, such as mountain ranges seen through the haze of atmosphere, appear to have less detail and contrast than nearer objects, take on a lighter value (see Chapter 6), and shift their color toward the blue end of the spectrum (see Chapter 7). This is called atmospheric or **aerial perspective** (see pages 100–101).

Real perspective, or **linear perspective**, is a formal method for drawing and painting the way in which distant objects appear to be smaller than similar objects that are nearer to us (**4.9**). Perspective isn't so noticeable in natural settings, but where humans have built straight roads and rectilinear buildings on grids of land, we can more easily observe that lines we know to be parallel, such as the steel rails on a long stretch of railroad track, seem to converge to a point on the horizon: the **vanishing point**. It is likely that the rules of perspective were understood by

4.9 Gerrit Berkheyde, *The Market Place and the Grote Kerk at Haarlem*, 1674. Oil on canvas, 20 ⅜ × 26 ⅜″ (51.8 × 67 cm). National Gallery, London.

This view in two-point perspective shows Haarlem's market place. The town hall's Doric portico is on the right. Across the square is the 15th-century Grote Kerk (St Bavo church) and the "Vleeshal" (meat market) is to the right.

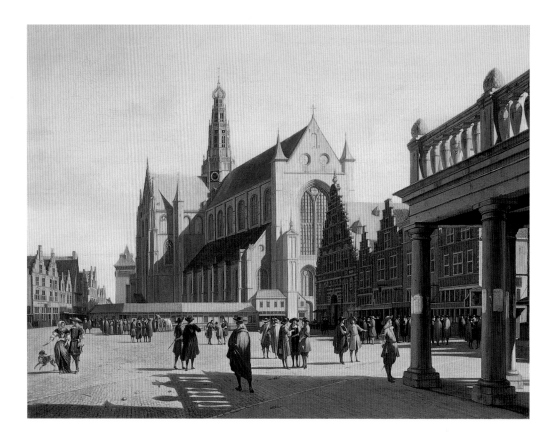

the ancient Greeks and Romans, but it became a science during the Renaissance, with artists and architects, such as Piero della Francesca (*c.*1410–92), Leonardo da Vinci, and Masaccio writing treatises and devising elaborate set-pieces to show off their skills in constructing scientifically accurate views of the built environment (**4.10**).

Along with perspective came the idea of **foreshortening**, the effect that something seen lying away from us will appear to be shorter than if it were viewed full on—a circle, for example, would be foreshortened to an ellipse (see **4.37**). Perspective is an essential tool to the architect, interior designer, and product designer, and nowadays computer programs can accurately render perspective views. To the artist, perfect perspective has become less important and is used or ignored as necessary. There are many other ways of depicting the three-dimensionality of forms, originally developed to be of more use to stone masons and cabinet-makers, such as isometric and oblique **projections**, examples of which can also be found in oriental art (**4.11**). Rules, however, once learned and absorbed, can be broken and adapted to produce works that may at first confuse us, then amaze, but ultimately provide lasting pleasure.

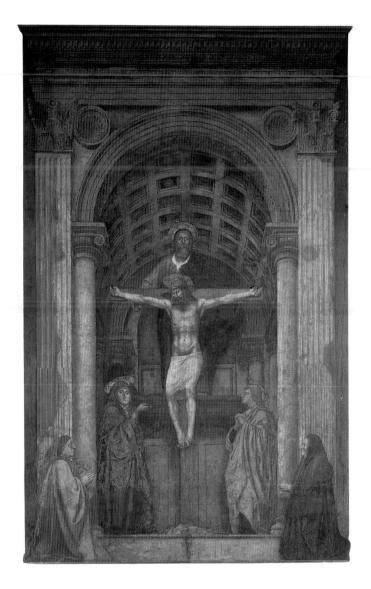

4.10 (right) Masaccio, *Holy Trinity*, 1425. Fresco, 21′ 9″ × 9′ 4″ (6.67 × 3.17 m). S. Maria Novella, Florence.

Masaccio depicts a chapel's vault in one-point perspective with the vanishing point and eye level at the cross's base. In earlier paintings, the figures would have been smaller than Christ, but here in perspective they are larger.

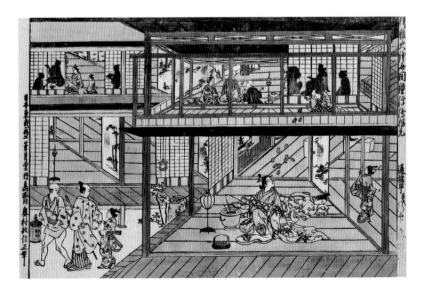

4.11 Okumura Masanobu, *Interior of a Brothel*, c. 1740. Woodblock print, *urushi-e*, 12 ⅓ × 17 ½″ (31.3 × 44.5 cm). Geyger Collection, Germany.

Chinese and Japanese parallel perspective has no explicit vanishing points; every scene in a scroll painting had to work individually and a vanishing point lying outside the portion of the narrative being viewed would create a disoriented view. Chinese and Japanese painters solved this problem by drawing receding lines in parallel, placing the horizon infinitely high above the painting.

Space—Shallow and Deep

A painting with all its interest on the picture plane and that makes no attempt to depict depth is called flat or **decorative space**. In much abstract and non-representational art, all activity is on the surface, and perhaps the only "depth" we are aware of is in the effect of certain colors appearing to come forward and others to recede (**4.13**). It is surprisingly difficult to produce a truly decorative space because our brains are so highly trained in interpreting size cues. Imagine a pattern consisting of similar motifs differing only in size—an assembly of different sized squares or circles, for example—and we will instinctively assume that the larger ones are nearer to us and the smaller ones are further away.

Real three-dimensional artworks, such as sculptures, jewelry, and ceramics—anything made using molding or modeling—are termed the plastic arts, and **plastic**

4.12 Caravaggio, *Conversion of St. Paul*, c. 1601. Oil on canvas, 7′ 6 ½″ × 5′ 8 ¾″ (2.3 × 1.75 m). S. Maria del Popolo, Rome.

On the way to Damascus, Saul the Pharisee (later Paul the Apostle) fell to the ground when he heard Christ's voice, and temporarily lost his sight. The foreshortened Saul lies stunned on the ground, dazzled by light that streams down the horse's mane. The space is cramped and claustrophobic.

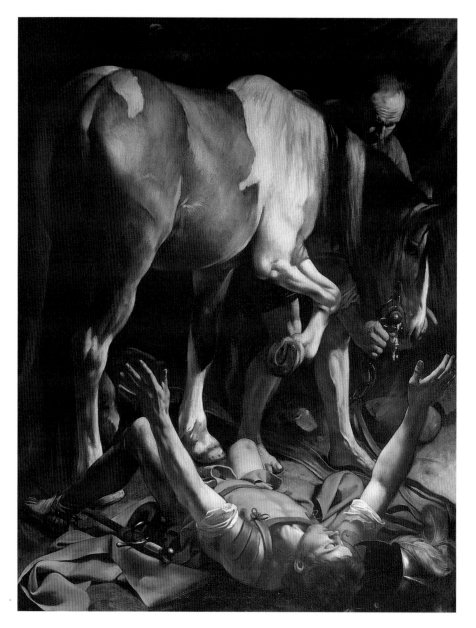

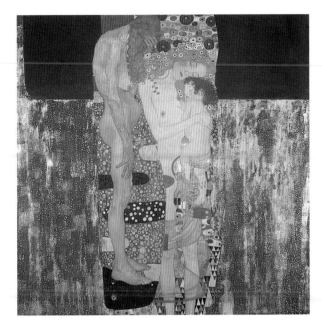

4.13 (left) Gustav Klimt, *The Three Ages of Woman*, 1905. Oil on canvas, 70 × 78″ (178 × 198 cm). Galleria Nazionale d'Arte Moderna, Rome.

Klimt combined naturalistic elements, such as shaded faces and hands, with areas of decorative pattern. The inhabited space is as shallow as the thickness of the canvas.

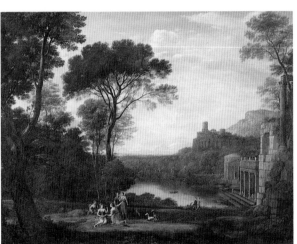

space is three-dimensional space or the illusion of space. Painters place their subjects somewhere in plastic space, usually in the foreground.

In infinite or **deep space**, the picture plane is really just a window or opening through which we look into the distance (**4.14**). We are not talking about outer space, but landscapes of distant mountains and rolling hills. Infinite space was popular from the Renaissance until the late 19th century (**4.15**), but in the 20th century artists began to prefer to explore limited or **shallow space**.

Artists such as Caravaggio and the Dutch genre painters created poorly lit, claustrophobic interiors (**4.12**), cloaked in shadows and with mysterious opaque windows, but these are more akin to stage sets, with the most distant point from the viewer being the backdrop or the back wall of the interior. Post-Impressionist painters, such as Matisse and Paul Gaugin (1848–1903), used similar confined shallow spaces for their compositions, and the Cubist abstracts are shallower still, almost pressing up against the picture plane. As art became more self-referential and the point was to show the painting process, the shallow space became decorative space. In trompe l'oeil, objects can appear to burst through the picture plane, to protrude in front of the picture's frame.

4.14 (middle left) Claude (Lorraine), *Landscape with Nymph Egeria Mourning over Numa*, 1669. Oil on canvas, 61 × 78 ¾″ (155 × 199 cm). National Museum of Capodimonte, Naples.

Claude was a master at depicting deep space in his rich, idealized landscapes. Here the goddess Diana's nymphs comfort Egeria on the death of her husband Numa.

4.15 (above) Albert Bierstadt, *View of Niagara Falls from the American Side*. Private Collection.

In 1858 Bierstadt made his first trip to the American West. He travelled extensively, establishing his fame and reputation as the premier painter of epic romantic landscapes.

Size Cues

4.16 William Hogarth, Frontispiece to *Dr Brook Taylor's Method of Perspective*, 1768. Engraving. Private Collection.

Hogarth breaks every rule in attempting to depict depth in this "Satire on False Perspective." The original caption read "Whoever makes a Design without the knowledge of perspective will be liable to such Absurdities as are shewn in this Frontispiece."

We view the real world using stereoscopic vision—our two eyes, spaced apart as they are, see slightly differing views of three-dimensional objects, which our brains combine to make the object look solid and fixed at a certain location in space. We also have another type of seeing, called kinesthetic vision, in which the eye darts around looking at forms, trying to match them to any memories we may have of similar objects. Close-up objects stimulate more eye movement than distant ones, and this adds to our experience of depth.

On the two-dimensional surfaces of drawings, paintings, and prints we have only kinesthetic vision to help us decipher distance: stereo vision can detect the surface texture of a painting only. So we need other cues to help us judge apparent depth and distance.

Apart from our stereo and kinesthetic vision, we use various cues to help us judge depth and distance. The first one is size. If we see two similar objects in a picture—one large and one small—we can assume that either one is large and the other is small and they are a similar distance away, or that they are of similar size but one is further away than the other (**4.16, 4.17**). It's all a matter of context—a human figure and an automobile, for example, allow us to reach conclusions about their size and position.

Size also has another connotation in some cultures and contexts. In their compositions, children drawing their mothers, artists from the Middle East, and the manuscript illuminators of medieval Europe sometimes show important characters larger in scale than the subsidiary figures (**4.19**). This hieratic scaling, while not being true to nature, is nevertheless a convention that is understood by most of us, and it survives in cartoons and symbolic charts.

If there is any remaining doubt in judging the relative positions of similar objects, then overlapping will settle the matter (**4.18**). Two similar objects of different size in a picture could just be different sized objects, but if one of them overlaps

4.17 Pieter Brueghel the Elder, *Hunters in the Snow*, 1565. Oil and tempera on panel, 3′ 10″ × 5′ 4″ (1.16 × 1.6 m). Kunsthistorisches Museum, Vienna.

The vastness of the landscape is accentuated by the larger figures on the left, leading us into the picture. We know that the figures on the ice are distant, being smaller in scale. These size cues are echoed in the trees.

4.18 Edgar Degas, *Place de la Concorde*, 1876. Oil on canvas, 30 ⅞ × 46 ¼" (78.4 × 117.5 cm). Formerly collection Gerstenberg/Scharf, Berlin. Hermitage, St. Petersburg.

Degas was influenced by instantaneous photography—the snapshot—as seen by the cutting-off of the figures and the seemingly random composition. The elements, however, are cleverly balanced.

4.19 (below) Duccio, *Maestà*, 1308–11. Tempera and gold leaf on panel, 7 × 13' (2.13 × 3.96 m). Museo dell'Opera del Duomo, Siena.

This altarpiece detail illustrates hieratic scaling. The Virgin Mary towers above the hierarchically ranked angels and saints. Mary was the patron saint of Siena.

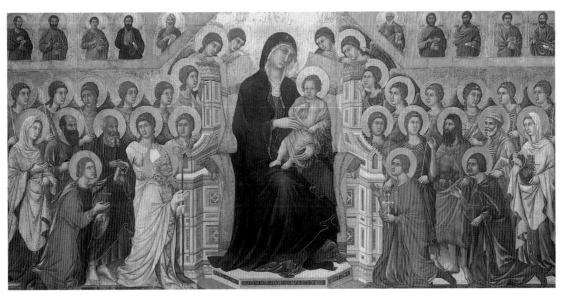

part of the other, hiding a portion of it, then we assume it is in front of the other object, regardless of its relative size. It could be an elaborate optical illusion involving the physical cutting away of part of an object, but in a painting there is no way of testing that possibility.

An overlapping object usually obscures our view of what is behind it, but if we are able to see through the overlapping form, it must be transparent or, if there is only a vague shape showing through, translucent. We can see clearly though materials, such as glass and some plastics; Cubist artists also enjoyed giving opaque objects the attributes of transparency to create more ambiguous compositions. And if there is **interpenetration**, where objects or planes seem to slice though one another, it is easier to locate the position and depth of these constructions in space.

Another way of pinpointing an object's location in space is by establishing a **ground plane**. If the feet of a figure, for example, are not seen to be firmly rooted to the ground plane—the floor—the figure might appear to be floating in the air. In some early works and in cartoons, the ground plane might be a simple horizontal line, like the floors in the cross-section of a house, but as the depiction of space became more sophisticated, the ground plane more realistically began to conform to the rules of perspective.

Linear Perspective

When we are faced by seemingly overwhelming worries, we are often advised to "put things into perspective." The idea behind the platitude is that, once put in their proper place relative to everything else going on in the world, our concerns may not seem to be so important in the overall scheme of things. Perspective, or rather linear perspective, to distinguish it from aerial perspective, is a mathematical method for placing objects into a scene according to their size and relative to an eye level or horizon. Its basic tenet is that parallel lines appear to converge with distance, ending up at a single spot called the vanishing point.

If there is one vanishing point, it is known as one-point perspective (**4.20**). Three-point perspective is the most convincing, although many artists find that even when they use a perspective scheme to plan a composition, they will bend the rules when it comes to the finished artwork. Somehow, strict adherence to the rules of perspective can result in a picture that just doesn't look real.

During the Renaissance of the 15th century, artists were obsessed by mathematics, but it was the ancient Greeks who laid the foundations of Western geometry, and the methods of Euclid were taught almost exclusively until the end of the 19th century. Greek astronomers, notably Apollonius of Perga (c.262–c.190 BC), understood the notion of projections in their flattened maps of the semi-spherical heavens. Given that many Greek writings were lost over the centuries, it is almost unbelievable to imagine that they missed completely the theory of perspective, especially when the stereographic projection is considered to be a special form of generalized perspective.

Both the artist Paolo Uccello (c.1396–1475) and the architect Filippo Brunelleschi (1377–1446) are credited with inventing the principles of perspective from around 1420 onward. This is not to say that the third dimension did not exist at all in drawings, for various kinds of non-converging oblique projections can be seen in drawings from all cultures from the earliest times.

Perspective is a way of introducing systematic distortions into drawings to symbolize reality. Objects appear to diminish and converge as their distance from the viewer increases. Lines drawn between the object and the observer will intersect the picture plane (which is assumed to be held vertically in front of the viewer, normal to the line of sight) at various points (**4.22**). A perspective drawing is made by plotting these points and connecting them together. The horizon is assumed to be infinitely distant, so that parallel lines meet at vanishing points (**4.21**). It should always be remembered that perspective is only a simulation of reality because in real life there will be many, changing vanishing points as the viewer's head moves and (two) eyes wander around the scene.

It is difficult to believe that perspective had to be invented. The technique has become so embedded in the consciousness of artists these days that nearly all "perspectives" are now drawn freehand, by eye, rather than being constructed according to conventional methods.

4.20 Carlo Crivelli, *The Annunciation, with St. Emidius*, c. 1480. Egg and oil on wood, 81 ½ × 57 ¾" (207 × 146.7 cm). National Gallery, London.

In this study of one-point perspective, Saint Emidius, Ascoli's patron saint, is carrying a model of the town, which is dominated by towers. News that the pope had granted Ascoli self-government had reached the town on the feast of the Annunciation.

4.21 (above) Donatello, *Feast of Herod*, mid 1420s. Bronze, 23 ⅝ × 23 ⅝" (60 × 60 cm). Siena Baptistery, Siena.

This bronze was the first relief to be sculpted according to the rules of perspective. The successive planes create the impression that further airy spaces extend beyond the foreground, making the relief look deeper than it is.

4.22 Albrecht Dürer, An artist drawing a nude through a grid, c. 1500. Engraving.

The artist is transferring onto gridded paper what he sees from a fixed point through a gridded screen at the picture plane so as to position his model in perfect perspective (see **2.2**).

Perspective drawing has obsessed artists and architects since Filippo Brunelleschi, a Florentine goldsmith turned architect, who discovered that geometrical mathematics could be used to establish the laws of visual perception in perspective. His theories were used from 1420 by Piero della Francesca (**4.23**), working from plan and elevation with the added effect of a vanishing point. The painter Paolo Uccello is also credited with establishing the first principles of perspective. Both Alberti and Dürer published treatises on perspective c.1540, and these were followed by a spate of learned works on the subject.

Perspective aids (the descendants of the camera obscura) began to appear in the 18th century (**4.24**), notably James Watt's perspective apparatus, Cornelius Varley's graphic telescope, Peter Nicholson's perspective delineator (an instrument for drawing lines to inaccessible vanishing points), and William Hyde Wollaston's camera lucida.

The camera lucida (*camera* is Latin for room, *lucida* is Latin for bright, full of light), was designed in 1807. It was a reflecting prism that enabled artists to draw outlines in correct perspective. Consisting of an extendible telescopic tube, with 45 degree prism and sighting lens, it quickly became popular. No darkroom was needed: the paper was laid flat on the drawing board, and the artist would look through the lens containing the prism, so that they could see both the paper and a faint image of the subject to be drawn. Similar prism-based models are still available today.

The earliest mention of a camera obscura (*obscura* is Latin for dark) was by the Chinese philosopher Mo-Ti (Mo-tzu) in the 5th century BC. He saw an inverted image formed by light rays passing through a pinhole into a darkened room. The Greek philosopher Aristotle (384–322 BC) observed the crescent shape of a partially

4.23 Piero della Francesca, *The Flagellation of Christ*, c. 1460. Oil and tempera on panel, 23 ⅛ × 32 ¼″ (58.4 × 81.5 cm). Galleria Nazionale delle Marche, Urbino.

The perspective in this enigmatic painting has been studied in many physical and computer models, particularly the tile pattern. The characters to the right are a mystery, perhaps the patrons or celebrities of the day. The proportion of the picture is root 2.

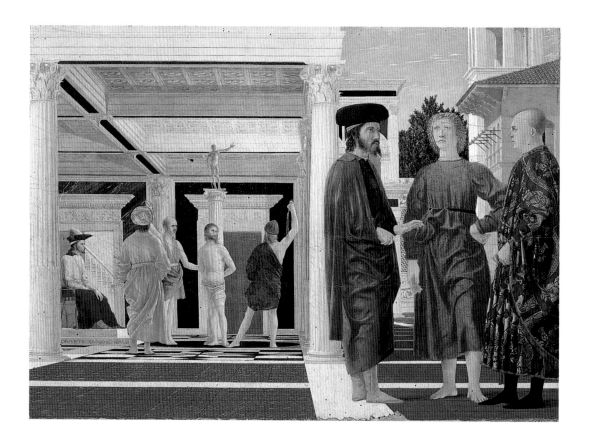

eclipsed sun projected on the ground through the holes in a sieve, and the gaps between leaves of a plane tree. In 1490 Leonardo da Vinci gave a clear description of the camera obscura in his notebooks. Image quality was improved in the 16th century by adding a convex lens in the aperture and a mirror to reflect the image down onto a viewing surface.

The name was coined by the German astronomer Johannes Kepler in the early 17th century, and in the 17th and 18th centuries many artists, including Vermeer and Canaletto (1697–1768), used them. By the beginning of the 19th century the camera obscura evolved into the photographic camera.

Most three-dimensional computer modeling programs contain interactive perspective functions which will maintain parallel vertical lines. The underlying theories of perspective are complex, and second-hand shops are full of books ancient and modern outlining systems and methods for setting up perspectives, usually from **orthographic projections** (see pages 102–103) (**4.25**).

The art of constructing a credible perspective is in choosing the viewpoint, and hence the position of the horizon and the vanishing points. A well-chosen viewpoint will give an impression of size and scale, will show off the object to the best advantage, and will bring to the fore its most important features.

Drawn by C. Varley for G. Dollond, with the Camera Lucida.

4.24 Cornelius Varley, *Artist Sketching with a Wollaston Camera Lucida*, 1830. Engraving. Gernsheim Collection, Humanities Research Center, University of Texas at Austin, TX.

The camera lucida enabled artists to draw outlines in perspective. The paper was laid flat. The artist looked through the lens containing a prism to see the paper and an image of his subject.

4.25 Gordon Murray, Formula One racing car. Drawings.

An orthographic drawing, or "blueprint," generally comprises a plan, a side elevation, and a front elevation. Here we have just two views, with notes.

One-Point Perspective

Chinese artists developed a form of perspective called *dengjiao toushi*, which means "equal-angle see-through." It was used in ancient Chinese scrolls, which could be 30 feet (10 meters) long, and were viewed by unrolling them from right to left. Rather than having a "subject," the scroll is based on a scenario depicting, say, life along a river: we see people boarding a boat on a river, then the boat crosses a lake, navigates rapids on a river, and arrives at its destination at the shore, in a continuous and seamless visual image. Unlike linear perspective, this form of axonometry has no vanishing point and hence does not assume a fixed position by the viewer. Art historians speak of a "moving" or "shifting" perspective in Chinese paintings.

Western artists were not nearly so adaptable, and during the Renaissance, mathematics ruled. The first and simplest form of perspective is **one-point perspective**, which is ideal for drawing railway lines or long, straight roads with telegraph poles along either side (**4.26**). The height of the pole can be deduced by the proportion of it between the horizon and the ground, which corresponds to the height of the viewer's eyes above sea level. One-point perspective—that is, with one vanishing point toward which all lines except those normal to the viewer's sight line will recede and converge—is only appropriate to interiors or vistas. We are viewing a building front on, parallel to the picture plane, and the doors and windows are parallel to the ground and vertical and not distorted by convergence (**4.27**). If we can see a side wall, if the building is off to one side, or if it is an interior view, for example, the horizontal lines will converge toward the vanishing point. The imaginary lines that join the horizontal lines of a building to the vanishing point are called sight lines, guide lines, or **orthogonals**—that is, receding parallel lines at right angles to the field of vision (**4.28**).

A vertical axis through the vanishing point is called the **viewer's location point**. One-point perspective assumes that the viewer is at a fixed point and is looking with

4.26 Alan Pipes, One-point perspective, 2003. Macromedia FreeHand drawing. Courtesy the author.

In one-point perspective, all lines not parallel to the picture plane converge toward a vanishing point, generally on the horizon.

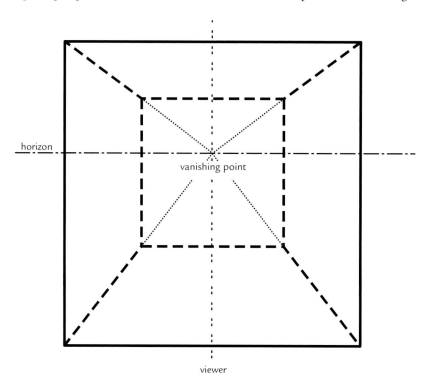

horizon

vanishing point

viewer

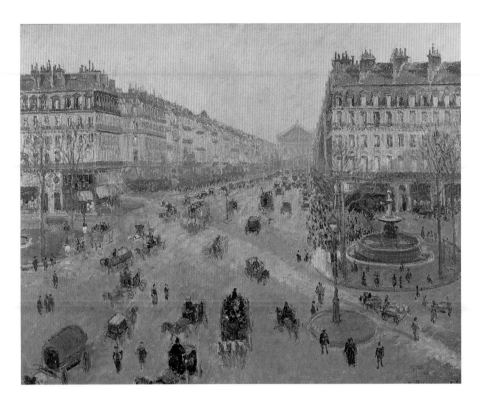

4.27 Camille Pissarro, *Avenue de L'Opéra, Sunshine, Winter Morning*, 1898. Oil on canvas, 28 ¾ × 36 ⅛" (73 × 91.8 cm). Musée des Beaux-Arts, Reims.

In this one-point perspective view, traffic leads us into the Avenue, which converges to a point in the distance.

one eye through the "window" of the canvas to the three-dimensional world beyond, and artists such as Dürer used devices and grids as aids to creating perspectives from a fixed point (see **4.22**).

The vanishing point should be in the center of the horizon, but unless a symmetrical composition is required, it is often placed slightly to the left or right. If it is too far from the center, you ought to be using two-point perspective.

4.28 Raymond Hood, *A Busy Manhattan Corner: Aerial View Visionary Plan*, 1929. Watercolor. New York Historical Society.

This unusual bird's-eye view uses one-point perspective, but the vanishing point is in the very center of the picture. There is no horizon.

Two-Point Perspective

Two-point perspective has two vanishing points, which are placed on the horizon at the left and right of the object, as far apart as possible and usually off the picture plane, or canvas (**4.29**). The closer the vanishing points are, the more distorted and exaggerated the perspective will be (**4.30**). If we are viewing the leading edge of a building, both walls will converge toward vanishing points. Verticals, however, will remain parallel. The visual field of our eyes is around 60 degrees, although we have some awareness for a further 30 degrees, and within these limits, two-point perspective works well (**4.31**).

In 1956 Jay Doblin devised a simplified method tuned to the needs of artists and designers. It uses a cube as a basic perspective unit to measure height, depth, and width concurrently. If you can construct a cube in perspective, it can be multiplied and subdivided to build up a framework for describing any shape of object you choose.

Briefly, Doblin's system imagines the viewer standing on an infinite floor, covered in perfectly square tiles. If the line of sight is 45 degrees to the sides of the tiles, along a diagonal, it will meet the horizon at the **diagonal vanishing point** (dvp). Lines projecting from the sides of the tiles will meet the horizon at the left and right vanishing points, which will be equidistant from the dvp. The side-to-side diagonal will be horizontal and parallel to the horizon. It will experience no convergence and so will provide a constant unit of measurement. Using this grid, a cube of any rotation can be constructed, which, as long as it is positioned between the center and around halfway to the vanishing points and its nearest angle is greater than 90 degrees, will look suitably undistorted.

The cube can be subdivided by first intersecting the diagonals to find the mid-point. The center of a circle within a true square will be at the intersection of the diagonals and will be tangent at the midpoints of the sides of the square. A circle in perspective is in fact an ellipse, although it appears to be asymmetrical—the half nearer the viewer is obviously less foreshortened and looks fatter. This is not an

4.29 Alan Pipes, Two-point perspective, 2003. Macromedia FreeHand drawing. Courtesy the author.

In two-point perspective, all vertical lines are parallel, but all other lines converge toward two vanishing points, usually on the horizon.

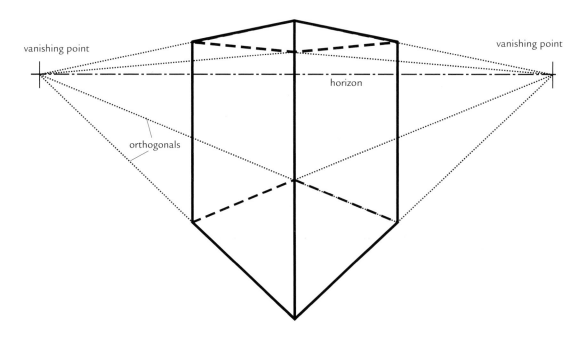

vanishing point

vanishing point

horizon

orthogonals

4.30 Ed Ruscha, *Trademark no. 5*, 1962. Oil, tempera, ink, and pencil on paper, 7 × 13″ (18 × 33 cm). Tate, London.

In this reworking of the movie logo done with two-point perspective, the right-hand vanishing point is visible, but the left one is way off the edge of the paper.

anomaly. What has happened is that the major axis of the ellipse (the widest distance across the ellipse) is tilted from the vertical. Concentric circles in perspective, as you would find when drawing an automobile wheel for example, would have displaced major axes. The minor axis (the shortest distance across the ellipse), however, will coincide with a line drawn perpendicular to the perspective circle—that is, the axle of the wheel. From the cube and the circle/ellipse, it is possible to construct other primitive shapes—cylinders, cones, and spheres (the sphere is unique in perspective because in outline it remains a circle).

This 45-degree oblique view is useful for drawing objects with two interesting sides, but it could look dull and monotonous if the sides were of similar dimensions. A similar arrangement using a 30- and 60-degree orientation (and with one vanishing point twice as far from the dvp than the other) would result in a more pleasing asymmetrical composition.

4.31 Gerit Berckheyde, S. Bavo exterior, Haarlem, Holland, 1666. Oil on panel, 23 × 33″ (58 × 83.8 cm). Private Collection, on loan to the National Gallery of Art, Washington, DC.

This baroque architectural study is a perfect example of two-point perspective, complete with cast shadows and full of detail.

Three-Point Perspective

Two-point perspective is a special case of **three-point perspective** in which the vertical lines are parallel to the picture plane. A better representation would have the vertical lines of a small object (situated below eye level) converging toward some third vanishing point directly below the object (and the sides of a large object, such as an office block, would similarly converge upward to some vanishing point in the sky) (**4.32**). The **vertical vanishing point** will be somewhere along the line of the viewer's location point (**4.33**).

Three-point perspective assumes three horizons, forming the sides of an acute triangle—that is, a triangle in which all three angles are less than 90 degrees. Simplifications to the construction can be contrived when the cube is symmetrical, with the front and rear corners coinciding with the line of sight, or, for a less monotonous composition, with the faces inclined 45 degrees to one horizon, and 30 and 60 degrees to the others.

Architectural photographers go to great lengths to eliminate the "distortion" of three-point perspective by avoiding wide-angle lenses and by taking the photograph from a viewpoint that is as near halfway up the building as possible, usually from a building nearby. If this is not an option, they correct converging verticals by

4.32 (left) Charles Sheeler, *Delmonico Building*, 1926. Lithograph, 9 ¾ × 6 ¾″ (24.7 × 17.4 cm). Private Collection.

Drawings that illustrate three-point perspective are rare. Architectural illustrators and photographers prefer idealized two-point perspective.

4.33 (right) Alan Pipes, Three-point perspective, 2003. Macromedia FreeHand drawing. Courtesy the author.

In three-point perspective, vertical lines converge to a third vanishing point—upward in a worm's-eye view and downward in a bird's-eye view.

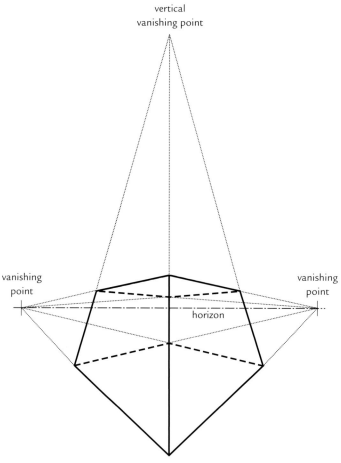

adjusting the front and backs of their large-format bellows cameras, twisting the plane of the film, and raising the lens. Today, perspectives can be modified and ameliorated using the tools in Photoshop.

Older books on perspective insist that three-point perspective is unnecessary because the drawing is subject to the same laws of optics as the object. If a tall object is drawn with parallel verticals and viewed from the same point as the original object, the lines on the drawing representing the verticals on the object should converge in the same manner and by the same degree. Remember, however, that perspective is not necessarily the whole truth—it is a convention with many assumptions and not an explicit means of representing the way a person perceives the real world (**4.34**).

In some ancient Chinese prints we see a sort of reverse perspective, in which the orthogonals converge not to a vanishing point but toward the eye of the viewer, so that the nearest plane of a building is narrower than the back and we are able to see more of the sides than we should.

In all three forms of perspective the assumption is that we are standing still and peering through one eye from a fixed point. This is not true in real life, nor is it true when we look at a painting. This poses problems for painters of panoramic views or for those who, like Chinese artists, work on long scrolls that are meant to be unrolled and viewed like a comic strip. Nor are all roads flat, of course, and there are sloping roofs with skylights and open doors to contend with. In **multi-point perspective** each plane or group of parallel planes will have its own set of vanishing points and horizons. If all this becomes too complicated, artists take the intuitive approach, trusting their powers of observation to create a convincing and aesthetically pleasing "perspective" view.

4.34 Giovanni di Paolo, *Birth of St. John the Baptist*, c. 1460. Tempera on wood, 12 × 14 ⅜" (30.5 × 36.5 cm). National Gallery, London.

Saint Elizabeth, the mother of John the Baptist, lies in a bed of very dubious reverse perspective—the near edge of the foot of the bed being shorter than the edge further away. The composition is chaotic, although not without charm.

Amplified and Aerial Perspective

We have become atuned to the distortions that photography introduces into images. In photography, perspective is altered according to the focal length of the lens being used. A telephoto lens with a long focal length will compress and flatten our view of a scene. A portrait taken using a moderate telephoto lens will generally flatter the sitter by, for example, foreshortening and squashing a prominent nose. A wide-angle lens, on the other hand, has greater depth of field, and most of the picture will be in focus, but the perspective will be extended. The most extreme version of this is the fish-eye lens, in which close-up objects seem nearer and far-off objects seem even further away (see **2.30**). Alfred Hitchcock's much-imitated shot in the film *Vertigo* used a combination of zooming in while moving the camera back along a dolly track, resulting in a dramatic change in perspective.

Artists make use of these photographic phenomena to distort perspective and introduce drama into their compositions (**4.35, 4.36**). In painting and drawing, this is called **amplified perspective**—the foreground objects seem to hover in front of the picture plane, drawing us in and directing our gaze into the story (**4.37**).

4.35 (below) Alexander Rodchenko, *At the Telephone*, 1928. Gelatin-silver print, 15 ½ × 11 ⅞″ (39.6 × 30.2 cm). Museum of Modern Art, New York. Mr and Mrs John Spencer Fund.

This bird's-eye view with severe foreshortening and a distortion of perspective was quite shocking in the 1920s.

4.36 (above) Giorgio de Chirico, *The Mystery and Melancholy of a Street*, 1914. Oil on canvas, 33 ½ × 27 ¼″ (85 × 69 cm). Resor Collection, New Canaan, CT.

The dreamlike urban landscapes of de Chirico have their own view of perspective. Either this street is very long, or the perspective has been manipulated to add to the mystery.

4.37 (above) Andrea Mantegna, *Lamentation over Dead Christ*, 1480. Tempera on canvas, 26 × 31 ⅞″ (66 × 81 cm). Brera Gallery, Milan.

In this illusionistic perspective Christ seems to follow the viewer around the room. The simple, window-like framing of a confined space defines it as the cell of a morgue with its corpse, swollen by the exaggerated foreshortening.

4.38 (right) Caspar David Friedrich, *The Wanderer above the Mists*, c. 1817–18. Oil on canvas, 29 × 37″ (74.8 × 94.8 cm). Kunsthalle, Hamburg.

A philosopher ponders the meaning of the precipitous view, a scene enhanced by aerial perspective. We, the viewers, are either on a higher rock, or airborne.

Atmospheric or aerial perspective is caused when white light is selectively scattered by molecules and tiny particles of water, ice, and dust in the atmosphere. The shorter blue wavelengths are generally scattered downward toward the earth. This makes the sky and distant mountains appear blue when the sun is high in the sky and the opposite at sunset, when all the blue is scattered away from our eyes, leaving the reds and oranges. Artists use aerial perspective not only by painting distant hills in soft blues and purples, but also by emphasizing foreground objects in sharp bright colors and high contrast, while leaving backgrounds vaguer, misty, and in less saturated neutral colors.

Aerial perspective relies on the optical effect of dark, contrasty forms appearing to come forward in a composition, toward the viewer, while softer backgrounds recede into the mist of a high-key distance. To emphasize this atmospheric effect, artists sometimes use the device of a **repoussoir**—a prominent dark or contrasty form in the foreground, such as a tree or lonely figure silhouetted against the landscape (**4.38**).

Metric Projections

Some paintings and drawings allow us to see planes that we could not possibly see in reality, unless we could get inside the picture and walk around. Linear perspective hides side walls that recede behind an elevation that we see full on, but in some pictures we may see, say, a front elevation of a building and the side wall, even though in most buildings they are supposed to be at right angles to one another. How is this possible? The artist is allowing for the fact that we don't simply stand and admire the view from one vantage point.

This device is termed multi-point or **multiple perspective**, although it is not really perspective at all. Oblique views of all kinds—those showing some sort of three-dimensionality—can be found from the beginnings of art. A typical ancient Egyptian wall painting or relief combines a side view of the head, a front view of the torso, and a side view of the legs. Add to this the front view of an eye (**4.39**), and we end up with what we regard as a very contorted pose. The Egyptian artist was simply choosing the most recognizable aspects of the different parts of the body and combining them into one composite image. This **fractional representation** was revived in the nineteenth century by artists such as Cézanne in still lifes of groups of objects seen from many different viewpoints, and by Picasso, whose synthetic composites combine elements of plan, elevation, and sections into one satisfying, unified whole. Picasso's French Cubist colleague Georges Braque is quoted as saying: "Perspective is a ghastly mistake which it has taken four centuries to redress."

4.39 The brother of Ramose and his wife, c. 1370 BCE. Limestone relief in the tomb of the Vizier Ramose, near Thebes.

The gem-like cutting of the wig curls contrasts with the uncarved swelling of the orbs of the eyes, highlighted in black paint.

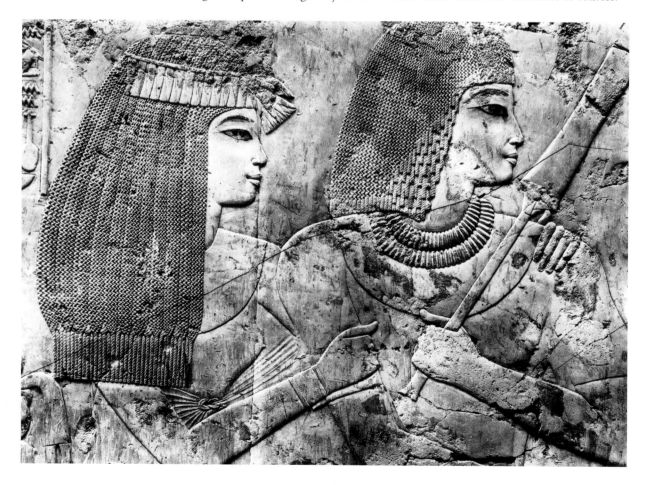

Of the many ways of representing a three-dimensional object on paper, the **orthographic projection** of a plan (top view), elevations (side views), and (cut away) sections, is the most abstract and the most commonplace. It is used by architects, engineers, and product designers (see **4.25**). More organic shapes are almost impossible to communicate orthographically.

The method of orthographic projection, perfected by William Binns in 1857 and based on Dürer's method of 1525, is notoriously ambiguous. Hundreds of conventions have grown up to try to make sense of it, describing what should be seen, and what is hidden but must be indicated say by a dotted line, and it needs expertise to read and interpret them. Unfortunately, the orthographic projection is entrenched in design and engineering culture, where it is known as the blueprint.

Metric projections—isometric, axonometric, and so on—are simple pictorial methods of drawing objects to give an impression of three-dimensionality (**4.40, 4.41**). They were used successfully by the De Stijl group in the 1920s and have come back into vogue recently in the work of among others, the Memphis designers. They have an important advantage over perspectives in that length, breadth, and height dimensions are retained in measurable form on metric projections.

A planometric or **axonometric projection** contains a true plan and is the simplest to set up (see **4.43**). As a means of representation it is most often associated with interior design and architecture. Drawings are usually made with the aid of a 45-degree set square, although as long as the plan remains true, the angle at which it is tilted to the horizontal can be varied to produce the best effect. Circles on plan remain true circles in an axonometric projection; circles in elevation become ellipses.

4.40 Illustration from *eBoy*, Laurence King Publishing, 2002, p. 241.

This pixel-based eCity module was created pixel by pixel in Photoshop. The images are all isometric projections.

4.41 David Hockney, *Self-Portrait with Blue Guitar*, 1977. Oil on canvas, 5′ × 6′ (1.5 × 1.8 cm). Courtesy David Hockney.

Hockney has used an oblique projection for the table and rugs, the receding edges of which are drawn parallel instead of converging. This gives the composition a fresh, oriental appearance.

The **isometric projection** (**4.42**) was developed by Sir William Farish in 1820 as a form and derivative of orthographic projection. Isometry means "equal measures," because the same scale is used for height, width, and depth. It results in a less extreme and "unrealistic" drawing than the axonometric projection. Elevations are constructed using a 30-degree set square and as a result the "plan" is distorted. Circles appear as ellipses in both plan and elevational views. Verticals have true depth; measurements along the isometric axes can be taken off the drawing using an isometric scale (measurements along the isometric axes are 0.816 true size). The popular acceptance of isometrics came in the 1920s, when Modernist architects from the German Bauhaus and Dutch De Stijl movements embraced it.

4.42 George Hardie, *The Same Difference*, 2001. Lithographic print. Courtesy the artist.

Spot the similarities. All the objects are drawn to an isometric grid. Created with technical pen and color separations, this print was commissioned by the London design group Pentagram as a Christmas present to its staff.

Two "pictorial" systems that became popular in the mid-20th century are the more generalized **trimetric** and **dimetric** projections, which are based on isometrics. Trimetric projections need scales or templates for each axis. Dimetric projections are a special case in which the scales of two of the axes are the same, and "idealized" angles—of 7 degrees and 42 degrees to the horizontal—are used for the x and y axes. These have a modern application in computer games (**4.44**).

Oblique projections are used if the front elevation of the object is of particular importance—in furniture design, for example—and the side and top views of the object are tacked onto the edges of the front face. To make the side and top faces join, they are distorted, and the line representing the common edge runs at an oblique angle across the picture surface. The lines representing the top and side faces are usually parallel, although they can converge, giving an inverted perspective effect. Oblique projections are the precursors of perspective and, despite being logically impossible, are found on Greek vases dating from the 4th century BC and were used in Chinese paintings until the 18th century.

The oblique lines emerging from the elevation can be any length. In a **cavalier** projection they are true lengths; in a **cabinet** projection they are half the true length (**4.43**).

The oblique angle is usually 45 degrees. The horizontal oblique projection, in which only the front and side of the object are visible, and the vertical oblique projection, in which only the front and top of the object are visible, are special cases where this angle is 0 degrees and 90 degrees, respectively. In oblique projection, upright cylindrical objects always look distorted.

Any shadow projected onto a flat plane is an oblique projection. Incorporating shadows in a drawing, as was common practice in the 19th century to add realism—it is called sciagraphy in architecture—is effectively superimposing an oblique projection onto an orthographic projection.

4.44 Electronic Arts, *SimCity 4, City Water*, 2003. Screenshot. Courtesy Electronic Arts.

Many 3D computer games use isometric projections, because true perspective is too complex to compute. SimCity 4, however, uses a trimetric projection.

4.43 Alan Pipes, Metric projections, 2003. Macromedia FreeHand drawing. Courtesy the author.

Here we see a parade of projections, from axonometric on the left, with its true plan, through isometric, to the more convincing dimetric. The two oblique projections on the right are cavalier and cabinet.

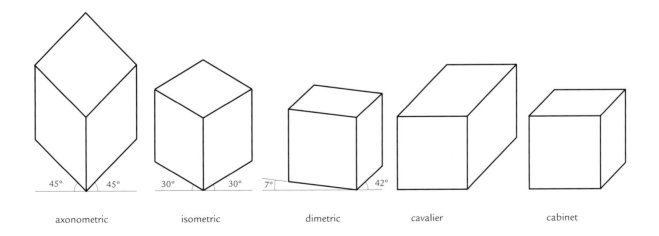

axonometric isometric dimetric cavalier cabinet

Open and Closed Compositions

4.45 William Bailey, *Monte Migiana Still Life*, 1980. Oil on canvas, 54 ⅜ × 60 ⅜" (137.9 × 237 cm). Pennsylvania Academy of Fine Arts, Pennsylvania, PA.

Bailey's arrays of pots, jugs, eggs, and bowls are straightforward closed forms. Nothing spills out, thrusts forward, nor wants to be touched or possessed.

An artist can present us with the subject and scene in its entirety or offer us a tantalizing glimpse of an incomplete scene, which may be cropped by the picture frame, with portions of the subject going out of view and which our imagination must complete. Although almost any view will be only a partial one, if the majority of the interesting subject matter is in full view, we call this a **closed composition**. Think of a Dutch still life or a full-length standing portrait. Some elements of the picture—the table in the still life or the drapery behind the figure—will continue outside the picture plane, but what interests us is all there to see (**4.45**).

An **open composition** leaves much more to the imagination, cropping in close to, say, the figure to make intriguing shapes where the partial form interacts with the picture frame (**4.46**). Composition (as we shall see later) then relies more on the balance of forms and elements. In trompe l'oeil paintings objects often break out of the enclosure of the frame, and objects can overlap and cast shadows on false painted "frames." In sculpture we are sometimes shown both the inside and outside of objects (**4.47**). Closed compositions are often formal static compositions that look as if they are going nowhere. Open compositions, on the other hand, often capture transient moments that might change at any time.

The open composition arrived with photography. Before photography, artists contained all the action within the frame, even though, in real life, we rarely see the whole picture. Think of the film director making a rectangle with his hands to try to imagine how a scene might look on film. In the past artists used similar devices to frame their compositions. A photograph cannot include everything of interest within its four edges, but this can be turned to advantage.

4.46 Edgar Degas, *Woman with Chrysanthemums (Mme Hertel)*, 1865. Oil on canvas, 29 × 36" (73.6 × 91.4 cm). Metropolitan Museum of Art, New York. Bequest of Mrs H.O Havemeyer, 1929.

Mme Hertel is leaning into the picture as though Degas is taking a group photograph. Her communication with something going on beyond the frame makes the composition an open one.

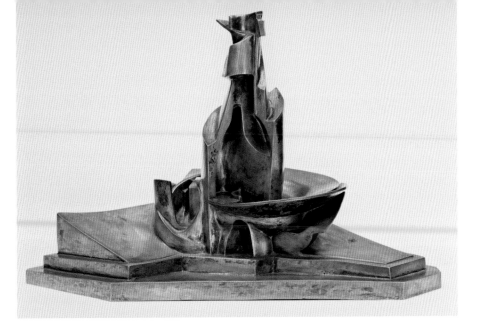

4.47 Umberto Boccioni, *Development of a Bottle in Space*, 1912. Silvered bronze (cast 1931), 15″ (38.1 cm). Museum of Modern Art, New York. Aristide Maillol Fund.

The Futurist Boccioni takes the inside and outside of a cut-away bottle and turns it into a spiraling Constructivist monument cast in bronze.

Edgar Degas admired *ukiyo-e* Japanese prints and the fortuitous accidental compositions of "instantaneous" photography, with its unexpected cutting off of forms, which created an implied space, external to the painting—"in the wings," as it were—juxtapositions of differences in scale, and distorted (if realistic) perspective. They seemed shocking and radical at the time, though they are familiar to modern eyes. There has always been a stigma associated with painters using photography—it seems like cheating— but Degas certainly owned a camera and enthusiastically embraced the spontaneity of the snapshot in his ground-breaking compositions (see **4.18**).

For some reason, artists have long preferred the physical frame that encloses a picture to be rectangular and parallel to the horizontal and vertical, like a window in the wall of a building. After trying painting on the walls of caves and then on pointy Gothic architectural panels, artists settled on the rectangle, although you can still find some examples of oval, circular, diamond shaped, or surreal, freeform frames. In Victorian times, artists made or had made frames to complement their paintings, often containing inscriptions or poems. In contemporary art, the frame is either dispensed with completely or made to become an integral part of the painting, as in the painted frames of Howard Hodgkin (**4.48**).

4.48 Howard Hodgkin, *Dinner at Smith Square*, 1975–9. Oil on board and wood, 37 ¼ × 49 ¼″ (94.6 × 125.1 cm). Tate, London.

Hodgkin uses color and pattern to create a visual equivalent of his memories. This painting was based on evenings dining with friends in Smith Square, London: "Two old friends talking across their table below a small painting by Bonnard." His paintings often continue over the conventional frame.

Spatial Confusion

Once we are aware of the cues and conventions of conveying the illusion of depth and space in a painting or drawing, we can start to subvert them and confound the expectations of the viewer (**4.49**). The brain can be jolted out of a complacent interpretation of the picture before it by conflicting cues or visual dilemmas, ranging from the uneasy perspectives with strange slopes and impossibly long buildings of Giorgio de Chirico (1888–1974) (see **4.36**) to the contorted, claustrophobic perspectives of Giovanni Piranesi (c.1720–78), in whose etchings of seemingly immense and impenetrable imaginary prisons diminutive figures appear doomed to climb endless staircases, and vaults, arches and stairs recede indefinitely (**4.50**). The visual conundrums of the Surrealists, particularly René Magritte (1898–1967) (see **10.17**), lull us into a false sense of security with the deadpan realism of everyday objects that are not quite the size we expect them to be. Then there are scenes that defy any logic, but always appear at first glance to be perfectly possible. Escher takes us to impossible places with buildings that appear to obey the laws of perspective but, on closer inspection, reveal they could not physically exist—at least not in the form we assume them to have (**4.51**).

Even in the solid world of architecture, size cues and perspective effects can be used to fool us (**4.52**). Buildings can be made to look grander and more imposing by systematically altering the sizes, shapes, and spacings of columns and other elements—tapering columns so that they appear taller, for example.

In stage and movie sets with limited space, **forced perspective** provides the illusion of distance by using properties that are physically smaller than their real equivalents, so that when they are positioned in the background of a set they give the impression that they are located some distance away.

We use the term **intuitive space** if the conventions of perspective are manipulated for pictorial effect, with little attempt to mimic reality. Elements such as line, shape, texture, value, and color have spatial properties that must be recognized and controlled. Objects with thicker outlines seem closer to the viewer than those made from thinner lines. Diagonal lines appear to move from the picture plane into space. A modulated line, changing from thick and dark to thin and light, can remind us of a line in perspective and invoke the same response.

4.49 (above) Robert Colescott, *Grandma and the Frenchman (Identity Crisis)*, 1990. Acrylic on canvas, 7' ×6' (2.13 × 1.83 cm). James Dorment Collection, Rumson, NJ.

The central figure's face is a Cubist fragmentation—black to white and black again. All around are Grandma's different views of herself. Smaller figures overlapping larger ones results in spatial confusion.

4.50 (below) Giovanni Battista Piranesi, *The Prisons*, 55 × 41" (139.7 × 104.1 cm). Private Collection.

Piranesi's most famous prints are from his etched prison series, *Carceri d'Innenzione*. These influenced designers in search of inspiration for dungeons and torture chambers.

Shapes and planes, too, although two-dimensional, can create the illusion of floating in three-dimensional space by reminding us of the distortions caused by convergence and perspective—of a circle to an ellipse, or a square to a trapezoid. Value, as we shall see in Chapter 6, also brings with it the baggage of depth: any shading of an object implies solidity, and the placement of the light source has a huge impact on the illusion of depth. If it shines from over the shoulder of the viewer, foreground objects will appear bright and near, while background objects will be darker and recede into the gloom. Neutral grays will move backward relative to bright, contrasting colors, and some bright reds and oranges will appear to float in front of the picture plane. And in this static three-dimensional space, we begin to perceive the fourth dimension—motion.

4.51 (above) Maurits Cornelius Escher, *Waterfall*, 1961. Lithograph. Private Collection.

Escher's convincing yet impossible building subverts the rules of perspective. A woman putting out the washing is unconcerned that water seems to be flowing uphill.

4.52 (left) Zaha Hadid, Berlin IBA housing project, 1994. Drawing. Courtesy the architect.

Hadid's deconstructivist architecture appears too complex to build. She stretches the boundaries of architecture, extending existing landscapes in pursuit of a visionary aesthetic that encompasses all fields of design.

Exercises

1 Deep-space photo-montage: Choose various color photographs from magazines. For the foreground look for large (close) contrasting objects with bright, warm colors in sharp focus. For the background look for a picture of hills or mountains in blurry, bluish colors. The middle ground could be buildings, trees with smaller figures, or an interior of a room with the background seen through a window. Cut out the layers and stack them to create a convincing illusion before gluing them down. Make the horizon line consistent.

2 Perspective: Choose a small table that can be moved easily. Draw a still life of various boxes and cylindrical objects—cans and pans, for example. Sit close to the table facing a corner; no table edge should be parallel to your drawing paper. When you've finished the drawing, take some tracing paper and continue the converging lines of the boxes to any vanishing points, which may be beyond the edges of the paper. Is your drawing in perspective?

3 Isometric village: Find or draw an isometric grid (vertical lines plus other lines at 30° and 150°). Now draw roads with plenty of space between them, then buildings and other geographical features. Flat roofs are easiest. Draw in pencil first, because some buildings will overlap the roads. Use the grid for the basic shapes, but details can be added freehand. The result should look like a scene from the computer game SimCity (although SimCity is trimetric) or eBoy (see **4.40**).

5 | Time and Motion

"How wrong are those simpletons, of whom the world is full, who look more at... color than at the figures which show spirit and movement."

MICHELANGELO

Cornelia Parker, *Cold Dark Matter: An Exploded View*, 1991. Mixed media, 13 × 16 × 16′ (4 × 5 × 5 m). Installation. Tate, London.

Parker has frozen an explosion in time. Inspired by Marcel Proust's *A la recherche du temps perdu*, she assembled a time capsule from a garden shed filled with memorabilia, then blew the capsule up in a field. Here a moment of time has been reassembled around a single light bulb.

Introduction

Before movies, television, and computers, artists could rarely create real movement or represent the passing of time. With photography came exotic-sounding devices for making motion—kaleidoscopes, flickbooks, thaumatropes, and zoetropes— which use the persistence of vision to create the illusion of movement. These are, however, little more than children's toys, rendered obsolete by the advent of the movies. Sculptors have had it easier, harnessing air currents to move weather vanes, wind harps, and kites and, more recently, kinetic sculptures and mobiles (**5.1**), or using water, clockwork, or hand-cranking to power automatons into motion.

With the easel arts, however, we are talking about apparent motion. The word "apparent" has been used a lot in this book because the artist is attempting to create an illusion of reality in just two dimensions, in this case conveying the illusion of four dimensions on the flat, two-dimensional canvas or sheet of paper—three dimensions of form and space plus the dimension of time (**5.2**).

Many early works of art were intended to tell stories. Murals in churches helped illiterate people to understand the teachings of the Bible; Chinese scrolls, wall paintings, and sculptural friezes recounted tales of the Buddha. These are the forerunners of the comic strip, and we are now literate in the conventions of storytelling by means of linked images, where the same characters are shown doing different things at different times.

The simplest way to represent time in a painting or photograph is to freeze it into a single moment, "the decisive moment," as French photographer Henri Cartier-Bresson (b. 1908) described it (**5.4**). The art of the successful photographer is in choosing the right moment to shoot. So with the painter or illustrator, who must choose a "snapshot" in the course of a story to make the point that will best encapsulate the message. Of course, painters have the advantage that they can choose to incorporate many different moments into one image.

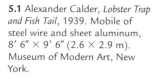

5.1 Alexander Calder, *Lobster Trap and Fish Tail*, 1939. Mobile of steel wire and sheet aluminum, 8′ 6″ × 9′ 6″ (2.6 × 2.9 m). Museum of Modern Art, New York.

Real movement in works of art is rare, but Calder's kinetic sculptures—or mobiles—are meant to be seen in motion, changing gracefully with wafts of air.

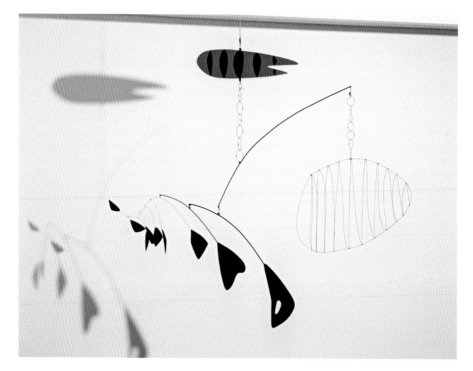

Painters also need the observational skills to stop time and capture a moment of action—swirling water, a breaking wave, the motion of a swing or spinning wheel, a charging or rearing horse, or a leaping lion (**5.3**). This is not always as easy as it sounds. The 19th-century photographer Eadweard Muybridge (1830–1904) set up a series of cameras and trip wires to settle a bet about whether a galloping horse ever has all its feet off the ground, something that couldn't be seen by even the keenest observer. The 12-shot sequence he took in 1878 proved for once and all that the "flying gallop," popular with painters from Egyptian times, was a myth (see **5.17**).

Early photographers were hindered by slow film and long exposure times. Sitters for portraits even had their heads restrained to prevent them from moving and blurring the picture. As materials and equipment improved, split-second freeze-frames, using stroboscopic lighting, became possible (**5.5**). Synonymous with high-speed photography is Harold "Doc" Edgerton (1903–90), whose subjects included apples and light bulbs being shot with bullets, and coronets formed from splashing milk drops—events hitherto invisible to the eye.

Freeze-frame is even more impressive in the movies, where not only can a moment be frozen, but we can pan around the action to see it "in the round" almost as if it were a hologram. In films such as *The Matrix*, a bank of high-speed cameras arranged in an arc around the action lets us see *anime*-style martial arts frozen in time or in extreme slow motion. Known as virtual camera movement, this technique was the creation of cinematographer Dayton Taylor.

5.2 Alexander von Wagner, *The Chariot Race*, 1890. Oil on canvas, 54 × 136″ (138.3 × 347 cm). Manchester Art Gallery, Manchester.

Wagner anticipated widescreen film epics in his vast reconstructions of historical events. The painting appears to show us 180-degree vision, a distortion of what we actually see.

5.3 Leonardo da Vinci, Studies of water bypassing or going through obstacles and falling into a pool. Pen and ink drawing. Royal Collection, © 2003 Her Majesty Queen Elizabeth II. RL 12660v

Leonardo made many studies from nature, including moving water (see **11.24**).

Telling a story using a narrative sequence of pictures is familiar to us from comic strips and instruction manuals. Showing a progression of events in a single image is less familiar but was understood by ancient Greeks and Romans, who used it in vase decorations and on columns depicting military triumphs, by the monks who illuminated medieval manuscripts, and by artists until the Renaissance. It seems odd to modern eyes to see the same character—usually identifiable by distinctive clothing or facial features—appearing more than once in the same painting, although we can accept this on long tableaux like the Bayeux Tapestry (see **5.11**), where we are not expected to take in the whole image in one glance.

Artists have often told stories through a series of illustrations or prints. In the 18th century there was a vogue for satirical engravings, from artists such as William Hogarth (1697–1764) and Thomas Rowlandson (1757–1827), that were the forerunners of the newspaper strips and cartoons popular during the 19th and 20th centuries. Later cartoon books were mainly aimed at children, although underground comics for adults, drawn by artists such as Robert Crumb (see **1.33**), emerged during the 1960s and evolved into the graphic novels of today. In a strange deconstruction of the narrative process, single frames from comic strips became appropriated by Pop artists such as Roy Lichtenstein, who blew up a single image on a huge canvas, making popular culture into high art.

Motion can be implied by the shape and orientation of forms, when it then becomes **anticipated motion**. Experience has given us mental pictures of how people and objects in motion should behave. When we see sprinters, muscles tensed on the starting blocks, we can anticipate them springing into action and running down the track. Cues such as an unstable body position, with its potential for movement, stimulate what we call **kinetic empathy**,

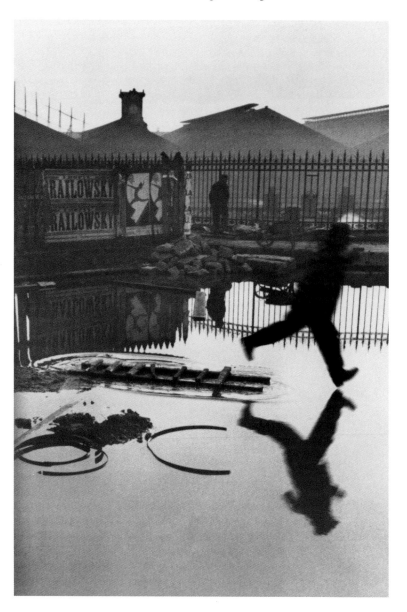

5.4 Henri Cartier-Bresson, *Behind the Gare St. Lazare*, 1932. Gelatin-silver print.

Cartier-Bresson coined the phrase "the decisive moment" encapsulated here in this candid snapshot in which he catches a man in mid-air—complete with motion blur—jumping over a Parisian puddle.

5.5 Stephen Dalton, *European Tree Frog*, 1990. Fujichrome 50 transparency film.

Dalton specializes in high-speed photography of wild life. This frog was captured at a shutter speed of 1/25,000 of a second at an aperture of f11.

where we re-create in our minds an inevitable course of action. We also have memories of what can move and what cannot, so the contrast between static, immovable buildings and dynamic figures can evoke a sense of imminent movement. Some objects that move, such as trains and automobiles, can, by their streamlined forms, induce thoughts of speed even before they set off.

An artist can show the anticipated progress of a figure or object by using indistinct shapes and blurred edges. The multiple planes of a Cubist painting, for example, can allow us to look all around a form, even if it exists in only two dimensions, and the way the eye is led around a composition is another kind of movement—rhythm, which is explored in Chapter 12.

In the early 20th century artists became fascinated by speed and machinery. One technique they used was to show a single moving figure with many superimposed positions. Marcel Duchamp's *Nude Descending a Staircase* (see **5.15**) was directly influenced by the photographs of Étienne-Jules Marey (1830–1904) (see **5.18**), who, like Muybridge before him, had taken sequences of photographs. The Futurists also produced many examples of multiple-exposure painting. Cartoonists cue movement by adding speed trails and shiver lines around the edges of their figures (**5.6**).

5.6 Paul Cemmick, *Run Rabbit Run*, 2002. Photoshop drawing. Courtesy the artist.

Cartoonists often indicate movement by adding speed lines, as seen here in this rabbit from the Funday Times (a supplement to the *Sunday Times*) strip *Dagsy Dog*.

There are some images that stimulate the optical illusion of movement. These range from the experiments of Duchamp (see **7.3**) with their vibrating complementary colors, to the Op-art paintings of Bridget Riley (b. 1931) (see p. 242) and Victor Vasarely (1908–97) (see **9.30**), which exploit visual quirks of perception to produce works that seem to move before our eyes.

Anticipated Motion

5.7 Sir Henry Raeburn, *The Reverend Robert Walker Skating on Duddingston Loch*, 1784. Oil on canvas, 30 × 25″ (76.2 × 63.5 cm). National Gallery of Scotland, Edinburgh.

The silvery background of snow and sky shows the minister in silhouette, entirely alone, despite the scratch marks on the ice. This dynamic pose is the epitome of manly vigor, and it is hard to envisage an activity other than skating in which a minister could look more ludicrous.

From earliest times, artists have struggled with the problem of transferring the movement they see in the real world to the flat plane of the canvas or the static petrified marble or bronze of a sculpture. As in the stories of Pygmalion and Pinocchio, they strive to bring their creations to life, but until recently the best they could do was preserve a frozen moment of time in a single snapshot. But our eyes and brains want to see movement.

We read text from left to right, right to left, or up and down depending on the language, but a painting can be "read" in many directions, in straight or sweeping lines. As we have seen, line direction has an influence on how we interpret a composition—verticals and horizontals seem static but balanced, whereas diagonals, especially when they are contrasted against a rectilinear frame, are dynamic and unstable. We associate diagonals with a body that is poised, ready to spring into motion (see **5.5, 5.7, 5.8, 5.10**). Diagonals introduce tension into a design. As we shall see in Chapter 12, it is important in certain types of painting to take the viewer's eyes on a guided tour around the picture or sculpture in a smooth, flowing, rhythmical journey.

In a seated portrait, such as the *Mona Lisa* (see **6.16**), the subject is so dominant that little eye movement is required to appreciate it: to the eyes, down to the enigmatic smile, and perhaps into the landscape beyond. It is a calm, static composition. In busier, more populated paintings, the artist must provide a starting point and route map for the exploration.

Before the Renaissance, paintings were generally static, but artists such as Titian in his altarpiece *Assumption of the Virgin* (1518) (**5.9**), changed everything by introducing anticipated motion. You can almost see the Virgin Mary ascending into heaven. Her eyes and arms point up toward the golden light, while her draperies are blown earthward by the upward motion, which is emphasized by the arrowhead triangle made by the lines of the gesturing apostles. In *Bacchus and Ariadne* (1521–3) (see **7.1**), the god of wine is leaping from his chariot—frozen in mid-air—as Ariadne turns toward him and the party-goers dance into the picture from the right. Paintings of the Renaissance, and of the baroque period that followed—particularly the paintings of Peter Paul Rubens (1577–1640)—are full of energy.

5.8 Bull-leaping fresco, from Knossos, c. 1500 BCE. Fresco, height 32″ (81.3 cm). Iraklion Museum, Crete.

This fresco from a wall of the Palace at Knossos shows a bull in a pose reminiscent of the flying gallop seen in depictions of horses. The red figure is probably male, the white figures female—a color convention in Minoan painting.

5.9 (left) Titian, *Assumption of the Virgin*, 1516–18. Oil on panel, 22′ 6″ × 11′ 10″ (6.9 × 3.6 m). S. Maria Gloriosa dei Frari, Venice.

The Virgin is shown ascending to heaven, her draperies blowing in the wind, pushed upward by the dynamics of the red triangle formed by the gesticulating apostles below (see **9.27**).

We recognize impending or potential movement in a figure because of kinetic empathy (**5.10**). Our memories tell us how we expect to see a person who is still and at rest, whether it is a vertical guardsman with both feet firmly on the ground or a horizontal reclining nude almost sleeping. Similarly, a person in motion is unstable—their feet hardly touching the ground, arms flailing, body diagonal. If they were a statue they would fall over. We react physically to the imminent action, muscles involuntarily tensing in concert with the dancers, soldiers, and revelers. These illusions of motion can be further emphasized by contrast with objects we know to be immobile, such as buildings, rocks, and even statues. But some inanimate objects—automobiles, locomotives, and airplanes—are meant to move and at speed. They are often streamlined, partly for fuel efficiency—but mainly for aesthetic reasons. We now associate streamlining with speed, and streamlined machines can make us think they are moving before they actually are.

5.10 Théodore Géricault, *Charging Chasseur*, 1812. Oil on canvas, 11′ 5″ × 8′ 9″ (3.49 × 2.66 m). Louvre, Paris.

The horse's outstretched hindleg leads us into the action. The rider's eye direction and the line of arm and sword, continuing into the horse's other hindleg, lead us around the image suggesting the excitement and confusion of battle.

Repeated Figures

When we are dealing with events that happen over longer time periods, as in a narrative, we need other strategies to indicate the passage of time. It is not enough to show imminent action; we have to show the consequences of the action—what happens next (**5.11**).

Paintings and prints have often been used for educational purposes, aimed at the general population, most of whom could not read. Much early art was created to be seen in churches. Murals and paintings in Christian churches illustrated stories from the Bible to inspire or frighten peasants into being law-abiding citizens. In the East, wall paintings and sculptural reliefs depicted the life of the Buddha or stories of Krishna. These traditions were carried forward into the illuminated manuscripts and books of medieval Europe, and the scrolls and miniatures of the Asian cultures. Miniatures were not always tiny; the name derives from the Latin *minium*, for the red lead used to emphasize initial letters on manuscripts.

These narrative paintings often included several versions of the same character, seen at different times, doing different things—a convention that is a little confusing to modern eyes. In Masaccio's *Tribute Money*, for example, a fresco painted in Florence *c*.1427, three different moments from a story in St Matthew's Gospel are shown with three different Peters and two versions of the tax man in the same scene. In the center Jesus tells Peter that the money the tax man is demanding will be found in the mouth of a fish; on the left, we see Peter catching the fish in Lake Genezaret and extracting the coin; and on the right, Peter hands over the tribute money to the tax collector in front of his house (**5.12**).

5.11 *Here King Edward Addresses His Faithful Ones*, from the Bayeux Tapestry, c. 1073–83. Bayeux Tapestry Museum, by special permission of the city of Bayeux.

The Bayeux Tapestry is like a comic strip without frames, and characters appear more than once in the same section. Here in an upstairs room the king is surrounded by a cleric, his wife, and Harold, to whom he extends his hand. Below, his body is shown shrouded for burial.

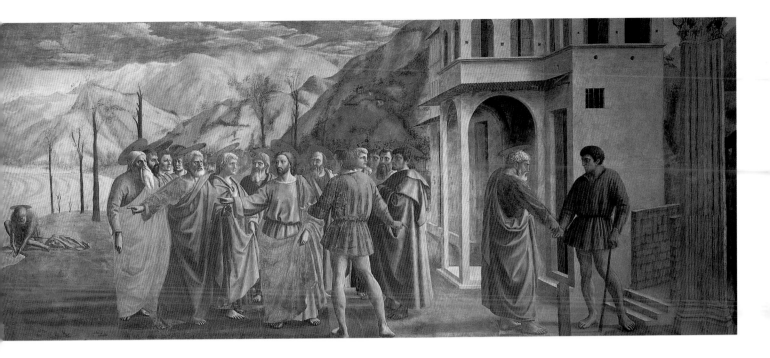

Comic strips can be traced back to medieval manuscripts, where different events take place with the same cast of characters but within distinct boxes or sub-pictures. We can follow the adventures of our hero, frame by frame, over the timescale of the story. The strip cartoon we are familiar with derives from the satirical prints of the late 18th century, notably those of Thomas Rowlandson, who is credited with inventing the modern frame format, speech and thinks bubbles, and the first cartoon hero, Dr Syntax.

Another pioneer of narrative illustration was Gustave Doré (1832–83) who, in his epic *L'Histoire de la Sainte Russie*, introduced speed lines to simulate movement, juxtaposed long shots and close-ups, and used frames with silhouette action for visual variety. These innovations were taken up in newspaper and magazine strips.

Great artists of the golden age of comics in the 1920s include Winsor McCay (1867–1934) with "Little Nemo in Slumberland" and George Herriman (1880–1944) with Krazy Kat (**5.13**). Comics sank into the popular culture until the 1960s, when they were rediscovered as an artform by Pop artists such as Roy Lichtenstein and re-emerged as underground adult comics from the pen of Robert Crumb and others. Now the comic book is undergoing a renaissance with the stylish Chris Ware's Acme Novelty Library and graphic novels by Daniel Clowes.

5.12 Masaccio, *Tribute Money*, mid 1420s. Fresco, Cappella Brancacci, S. Maria del Carmine, Florence.

Here are three Peters, and two versions of the tax man. In the center Jesus tells Peter that the money he owes will be found in a fish's mouth; on the left, Peter extracts a coin from a fish; on the right, Peter gives money to the tax collector.

5.13 George Herriman, *Krazy Kat* (detail), 1928. Ink on paper, 7 ¾ × 6 ¼" (20 × 16 cm). Courtesy Fantagraphics Books, Seattle.

Krazy Kat is one of the greatest of all comic strips. It is a love story: Krazy Kat adored Ignatz Mouse; Ignatz Mouse just tolerated Krazy Kat. Note the panels' symmetry and the continuance of the lines.

Multiple Images

In gesture drawings, where the outline is indistinct and consists of a messy web of lines, we can almost see the figure breathing. As the artist explores and analyzes the location of the form in space, they also endow the figure with life. Standing figures do not stand still, they fidget and constantly readjust to their surroundings. This is recognized in the **multiple image**, yet another means of suggesting movement, in which a single figure or object is seen in many different positions superimposed in a single image, either showing two extremes of a movement and the intermediate steps between or in a continuous rolling motion (**5.14**).

The best known example of this layered-time technique is Marcel Duchamp's 1912 painting *Nude Descending a Staircase, No. 2*, a painting that is by no means naturalistic (**5.15**). An artist's wooden mannekin is manipulated to appear in a stop-frame animation. It combines the Cubists' fracturing of form—but instead of "one moment, many views" Duchamp created "one view, many moments"—with the Italian Futurists' depiction of movement. The Futurists Umberto Boccioni (1882–1916) and Giacomo Balla (1871–1958) (**5.16**) produced many examples of multiple-exposure painting. The painting portrays a single shape, repeated six times, each permutation shifted down and to the right. We see sweeping shins, blurred into wedge shapes, with curved speed lines or lines of force representing the swinging of the legs, along with the dotted lines more often associated with what-goes-where construction instructions.

Duchamp was inspired by the photographs of Eadweard Muybridge, Étienne-Jules Marey, and Thomas Eakins (1844–1916). Muybridge—his real name was Edward Muggeridge, but he preferred a fake Anglo-Saxon version—had been enlisted in 1872 by Leland Stanford, the governor of California, to settle a wager regarding the position of a horse's legs when galloping and trotting (**5.17**). Using the fastest shutter available, Muybridge could provide only the faintest image. Five years later, employing a battery of cameras with mechanically tripped shutters, he showed clearly the stages of the horse's movement: at top speed, a trotting horse has all four hooves off the ground simultaneously, and in a different configuration from that of a galloping horse. Muybridge went on to study of the motion of other animals and humans, and his most important work, *Animal Locomotion*, containing over 100,000 photographs, was published in 1887 in 11 volumes.

5.14 Snowboarder Björn Mortensen performing a cab 540 degrees, from *Onboard* 5/72003. Photo by Scalp/DPPI. Morphed by "Intergalactic" Tony Cormack.

This "morph" is a composite image of a snowboarding trick. A fast, motorized camera captures the individual shots, which are combined in Photoshop.

5.15 Marcel Duchamp, *Nude Descending a Staircase, no. 2*, 1912. Oil on canvas, 4′ 10″ × 2′ 11″ (1.47 × .89 m). Philadelphia Museum of Art. Louise & Walter Arenberg Collection.

Here is a single shape repeated six times in motion with shins blurred like wedges, and curved lines suggesting swinging legs.

Futurism: Italy, 1909–1916

Futurism was an Italian movement founded in 1909 by the poet Filippo Tommaso Marinetti (1876–1944), the painters Giacomo Balla (1871–1958) and Umberto Boccioni (1882–1916), and other artists inspired by Cubism and the motion photography of Étienne-Jules Marey. The core themes of Futurist thought and art were machines and speed. The Futurists rejected the static and irrelevant art of the past and celebrated change, originality, and innovation in culture and society, claiming that "a roaring motor car, hurtling like a machine gun, is more beautiful than the Winged Victory of Samothrace" (an ancient Greek statue in the Louvre, Paris). The course of Futurism came to an end with Boccioni's untimely death in 1916.

5.16 Giacomo Balla, *Dynamism of a Dog on a Leash (Leash on Motion)*, 1912. Oil on canvas, 2′ 11 ¾″ × 3′ 7″ (91.4 × 109.2 cm). Albright Knox Gallery, Buffalo, New York. George F. Goodyear Bequest.

By multiplying the numbers of ears, legs, tails, leashes, and shoes, Balla creates the illusion of a dachshund and owner out for a brisk walk. The impression of speed is emphasized by diagonal lines.

The American painter Thomas Eakins was also interested in motion. He helped arrange for Muybridge to work at the University of Pennsylvania, Philadelphia, where he conducted his own experiments in photographing the phases of movement superimposed on a single plate, a method that Marey adopted.

The French physiologist Étienne-Jules Marey is famous for his **chronophotographs**—multiple exposures on glass plates and strips of film (**5.18**). Muybridge visited Marey in 1880 with his pictures of horses but said he had had no success photographing birds in flight. Marey invented a "photographic gun" with a rifle-like sight and a clock-mechanism that made 12 exposures at 1/72nd of a second. He also made many studies of humans in motion wearing black suits with white strips running the length of an arm or leg. The subjects moved in front of black panels, and their movements were recorded by a single camera, on a single plate. Marey's photographs and diagrams inspired artists such as sculptor Naum Gabo (1890–1977), the Futurists, and, of course, Duchamp. A similar technique is used today by video-game designers to translate the natural movements of human actors into virtual computer graphic characters.

5.17 (below left) Eadweard Muybridge, Gravures from horse photo sequences of trot and gallop. From *La Nature*, December 1878.

Muybridge employed a battery of cameras with mechanically tripped shutters to show that a trotting horse has all four hooves off the ground simultaneously.

5.18 (right) E.J. Marey, *A Sword Thrust*, c. 1895. Photograph.

Marey's photographs influenced the Futurists. They show each phase of movement in its correct spatial position, relative to the others in the sequence, on the same plate.

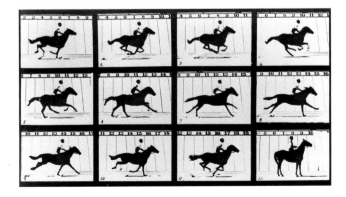

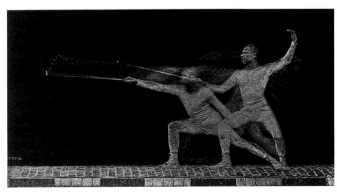

Motion Blur

5.19 Umberto Boccioni, *Unique Forms of Continuity in Space*, 1913. Bronze (cast 1931), 43 × 34 × 15″ (109.2 × 86.3 × 38.1 cm). Museum of Modern Art, New York. Lillie P. Bliss Bequest.

This sculpture is deformed by speed, like a person in a wind tunnel, trousers flapping. Boccioni exaggerated the body's shape aerodynamically to embody a mechanized "superman" as envisaged by the philosopher Nietzsche.

Although we will have seen the spokes of a rapidly moving wheel or the propeller of a pre-jet airplane disappear into blur—a phenomenon exploited by spinning tops—we know about motion blur mostly through photography. In early photography, with its necessarily long exposure times, urban scenes often included ghostly figures, captured by the camera as they walked through the field of view, too quickly to be caught by the shutter.

When we take a photograph, the shutter opens, and the image begins to form on the film. While the shutter is open, however, the object is moving, and this causes the image on the film to be blurred in the direction of motion. This is known as **motion blur**, and a frame with motion blur carries more information than a frame without.

Motion blur is seen to some extent in almost every movie, TV program, and computer game and animation, although it goes largely unnoticed, except perhaps in the streaky starfields in science-fiction movies. We notice its absence, however, for its presence gives an air of realism. Computer animations that do not contain rendered motion blur look jerky and unrealistic, as do movies shot using modern high-speed cameras.

Speeding machines and athletes produce blur, and if the photographer pans the camera to match the speed of the passing car or runner, the background will be blurred into streaks. Blur has thus entered our visual language as another cue for movement (**5.19**).

Before the age of machinery, painters such as J.M.W. Turner saw blur in extreme weather. His later work was already impressionistic and indistinct, even in the brightest weather conditions, but in his depictions of rain and snow storms, the swirling blur of the air is very evident, particularly in *Rain, Steam, and Speed—The Great Western Railway* (painted sometime before 1844) and *Snowstorm—Steam Boat off a Harbour's Mouth* (exhibited 1842) (**5.20**), in which we feel disoriented and off-balance, drawn into a whirlpool of sky, sea, and cloud toward a struggling steamboat, its mast bent by the elements. Turner claimed that he had been lashed to a boat's

5.20 J.M.W. Turner, *Snowstorm—Steam Boat off a Harbour's Mouth*, 1842. Oil on canvas, 35 × 48″ (91.4 × 121.9 cm). Tate, London.

Turner draws us into the center of a whirlpool of sky, sea, and cloud to find a steamboat, its mast bent by the wind. The almost abstract treatment of the paint led one critic to describe it as "soapsuds and whitewash."

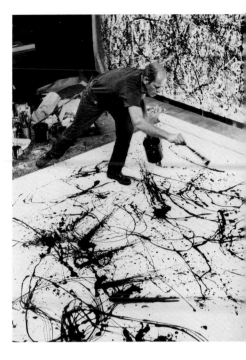

Abstract Expressionism: America, 1940s–1960s

Emerging in the 1940s in New York City, Abstract Expressionism was exemplified by the action paintings of Jackson Pollock (1912–1956) and the color-field paintings of Mark Rothko (1903–1970) and Barnett Newman (1905–1970). The movement was marked by its freedom of individual expression and massive canvases, conveying powerful emotions through the very gestures of painting. The term originally described the work of Kandinsky but was then adopted to define the American movement. Its practitioners disliked being pigeonholed and preferred the more general term "New York School." The influence of the movement was such that New York began to replace Paris as the center for contemporary art.

mast while he painted it. The violent and almost abstract treatment of the paint upset the critics of the time, one of whom described it as "soapsuds and whitewash."

Another physical demonstration of movement in art is in action painting—a style of abstract painting that uses the dribbling, splashing, throwing, pouring, dripping, or smearing of paint on a canvas, often laid flat on the floor. The action of painting is the artwork, the canvas merely a record of the event. Action painting is mostly associated with Jackson Pollock and the abstract expressionists—but not all abstract expressionists were action painters (**5.21**).

Pollock relied not only on his arm and hand, but also on the leverage of his entire body to determine where the paint would go, producing by his movements entwined webs of paint. French artist Yves Klein (1928–62) is perhaps best known for his blue monochrome paintings in IKB (International Klein Blue), but in 1958–60 he made *Anthropometries* by directing nude models to roll in blue and gold paint then press themselves against the canvas and smear it about, leaving imprints of their bodies. Once the canvas was vertical, the figures seem to fly like angels through a celestial space, as if on an altarpiece.

5.21 Jackson Pollock at work in his Long Island studio, 1950. Photo © Hans Namuth, New York, 1983.

Pollock relied on the leverage of his entire body to determine where the paint would fall—dribbling, splashing, throwing, pouring, dripping, or smearing paint onto a canvas.

Exercises

1 A gesture strip: Draw boxes for a comic strip comprising three frames. Get a friend to pose for you, preferably standing. Try to express in a gesture drawing the space that your friend is occupying. Ask him/her to change pose and do another drawing in the second frame. Change pose again for frame three. Try to incorporate as many cartoon devices as possible to show movement.

2 Motion blur: Collect some advertisements showing cars in motion for reference. Draw one car speeding along a desert road. Blur the wheels and background. Draw another version but this time have the background in focus and the car blurring in the direction of motion. Add speed lines to heighten the effect.

3 A thaumatrope: Cut some disks out of heavy paper or index card. Make two small holes near the edge of each disk, opposite one another. Loop and attach string through both holes. Each disk should then have two loose sets of string, unattached to one another. Draw a lightning bolt on one side of the first disk and an upside-down scene with mostly sky on the opposite side. Twirl your thaumatropes, then pull the strings tight. As the thaumatrope unwinds, the images will combine, showing lightning in the sky. Try black paper and brightly colored chalk drawings to create a different effect.

6 | Value

"Color is an inborn gift, but appreciation of value is merely training of the eye, which everyone ought to be able to acquire."

JOHN SINGER SARGENT

Johannes Vermeer, *Girl with a Turban*, c. 1660. Oil on canvas, 18 ⅓ × 15 ¾" (46.5 × 40 cm). Mauritshuis, The Hague.

Vermeer brings this portrait to life with just a few highlights—on the eyes and lips, and on the pearl earring. Eleven of Vermeer's painted women wear pearls, which in the seventeenth-century were an important status symbol and were linked with virginity.

Introduction

Value, also known as brightness, is a measure of the relative lightness or darkness of a color. There is a spectrum of lights and darks, from the purest white to the deepest black, and all the grays in between. Value is one of the main attributes of color: if we add black to a color, we get a **shade**; if we add white to a color we get a **tint**. For the time being, however, we will restrict ourselves to the so-called **achromatic** grays, which are made from mixing black and white together with no other color.

In the absence of a light source, there is complete darkness and we see nothing. We need light, from the sun, or a candle, or light bulb, to experience the world through sight (**6.1**). The eye contains two types of sensor: rods, which are sensitive to dim light but not color, and cones, which are sensitive to bright light and color. Both rods and cones respond to differences in value, but only cones can detect **hue**—what distinguishes one color from another. Rods, which are more numerous and more sensitive than cones, come into their own at night, and night vision relies more on **contrast** than on color.

Contrast is important in identifying shapes—many drawings and paintings can be identified if reproduced in black and white from the shapes of the objects. The "shape" the dark and light areas make is called the **value pattern**.

The achromatic grays can be arranged in a chart or value scale, ranging from black to white (**6.2**). The more steps there are, the more difficult it becomes to distinguish between neighboring grays. The eye can discern around 40 distinct tints,

6.1 Joseph Wright of Derby, *An Iron Forge*, 1772. Oil on canvas, 47 ¾ × 52" (121.3 × 132 cm). Tate, London.

The dramatic light effects from the single source create an almost religious atmosphere, and by showing the various family generations together Wright alludes to the theme of the "ages of man."

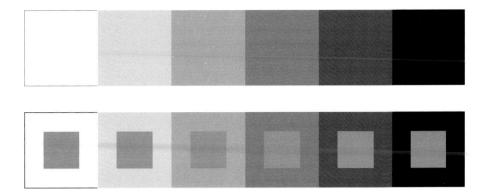

6.2 (left) Alan Pipes, Chromatic scale, 2003. Macromedia FreeHand drawing. Courtesy the author.

This scale shows values from white (the paper) to black, with tints of 20%, 40%, 60%, and 80% in between. Note the fluting effect caused by the contrast where the tints change.

6.3 (right) Alan Pipes, Chromatic scale with constant gray, 2003. Macromedia FreeHand drawing. Courtesy the author.

This scale is the same as in **6.2**, with the addition of a square of 50% tint. The square against the light background looks darker than the square against the darker background. This is called simultaneous contrast.

and when there are more than this we see a continuous **graduated** tint. Computer graphics programs use 256 tints of gray, which is more than enough to cover the whole grayscale spectrum. In such a chart there will be little contrast between neighbors, and we need contrast to allow us to distinguish between the tints, but the perception of a tint of grayscale (and color) also relates to the tint next to the one we are looking at (**6.3, 6.4**).

The relationship between adjacent areas of light and dark is called **value contrast**. In our chart, neighboring grays have low-value contrast. Remove some of the chips and the contrast increases. The highest contrast of all is black on white—like the text on this page.

Artists employ light and dark for many reasons: to depict the time of day; to enhance the three-dimensionality of a scene; to direct the viewer's attention to the important areas of the picture; to create emphasis or add meaning to a subject; or to establish a mood (**6.5**). Despite the invention of color photography, some photographers and film makers still prefer, in some circumstances, to work in "evocative" monochrome.

If we look again at the value chart, the tints at the center, midway between black and white, are called **mid-tones**. The darker tints, those between black and the mid-tones, are **low-key values**; the light tints between the mid-tones and white are called **high-key values**. If the value pattern of a picture is predominantly composed of high-key values with few dark shadows, we say this high-key work is understated, calm, and tranquil. On the other hand, a dark low-key work can be solemn or mysterious. Contrasty paintings appear dramatic and edgy. The key that is chosen will determine the mood.

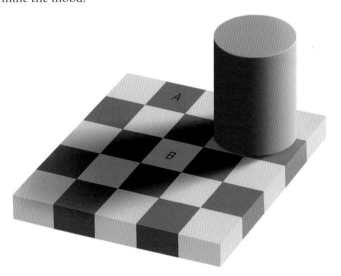

6.4 Edward H. Adelson, Checker-shadow illusion, 1995. Photoshop illustration. Courtesy the artist.

Amazingly, the squares marked A and B have the same value of gray. Here the light check in the shadows is surrounded by darker checks, and although it is physically dark it is lighter than its neighbors. The dark checks outside the shadow are surrounded by lighter checks, so they look darker by comparison. Shadows often have soft edges and the visual system ignores these gradual changes.

When light falls on an object, its three-dimensional form will affect and alter the distribution of light and shade. A smooth, rounded object will disperse the light gradually and subtly (see **6.17**), whereas light shining on an object with angular surfaces will result in distinct areas of contrasting light and shade. These are called **local values**.

Unless an object is in a photographer's studio or on a stage set, it cannot receive light from all directions at once. The side closest to the light source will receive the most light and will have the highest value (**6.6**). It will also prevent light from reaching anything else behind the object and create shadows. A **core shadow** is the dark part of an object, away from, and not directly illuminated by, the light source—it is attached to the object or encompasses a space. A **cast shadow** is projected from an illuminated form onto other objects or the background. If they are not considered in the composition, cast shadows can break up shapes and forms in harsh, unwanted ways. Light travels in straight lines and, although the progress of light rays through and around a composition, and the way shadows are cast, can be worked out scientifically in a similar way to perspective (see pages 138–141), artists often manipulate the positions of their shadows to enhance the organization of their compositions.

Remember, too, that light does not stop dead when it hits a surface, but bounces around the scene, diminishing in strength as it goes. Even the side of an object hidden from the light source will receive some degree of illumination from light reflected and retransmitted from other objects nearby.

A **highlight** is the highest value on a modeled form or a bright distinct dot or area on the surface of a shiny form that accentuates its glossiness. Vermeer created

6.5 Henry Fuseli, *Lady Macbeth Seizing the Daggers*, 1812. Oil on canvas, 40 × 50″ (101.6 × 127 cm). Tate, London.

Lady Macbeth is shown seizing the bloodied daggers from her husband who has just murdered King Duncan (Act 2, scene 2). The dramatic content is intensified by the contrast in value.

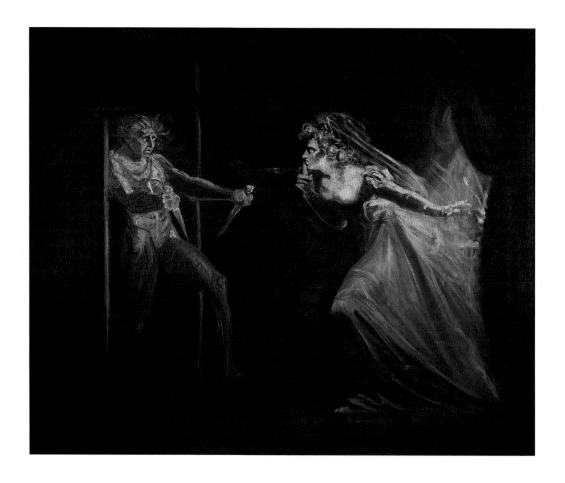

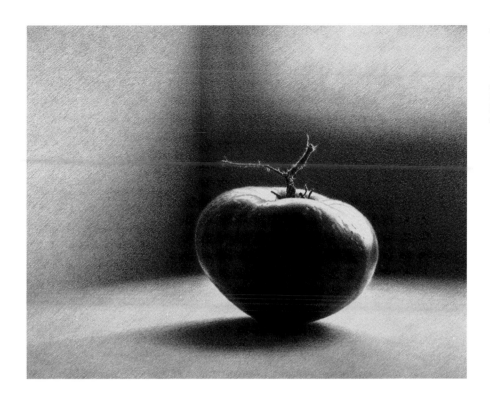

6.6 Martha Alf, *Tomato no. 1*, 1977. Pencil on bond paper, 12 × 18″ (30.5 × 45.7 cm). Newspace, Los Angeles, CA.

Alf's delicately drawn, theatrically lit tomato explores the way a point light source interacts with and enhances its organic form.

6.7 Johannes Vermeer, *Girl with a Turban* (detail), c. 1660. Oil on canvas, 18 ⅛ × 15 ¾″ (46.5 × 40 cm). Mauritshuis, The Hague.

It is likely that this was a drop earring in glass, altered and enlarged by Vermeer as he painted it (see the whole painting on p. 124).

highlights floating above the pearls or other shiny objects they are supposed to be attached to (**6.7**), and a cartoonist will often add a dot of white to accentuate a bright red nose or balloon, as shorthand for "shiny." Strictly, the source of light in a typical Vermeer painting is daylight through a window, so the highlight should be square to reflect the shape of the window, and the fact that the highlights are generally round supports the suggestion that he used some kind of lens or optical device to help in the composition of his work. Cartoonists often add a "window" highlight to a balloon or bottle, even if that object is out of doors or illuminated by a light bulb.

Creating a distinct area of high or low value in a painting or drawing and surrounding it by a contrasting key will attract the eye to that part of the picture, creating emphasis or a focal point (**6.8, 6.9**). This is especially effective when a figure or symbol is imbued with meaning, and it is seen in many early nativity scenes, where the baby Jesus, dressed in white, seems to be radiating light and illuminating the figures around him.

Light and dark can also be used to create a feeling of distance or space. So-called aerial or atmospheric perspective (see Chapter 5) relies on the optical effect of dark contrast forms appearing to come forward in a composition, toward the viewer, while softer backgrounds recede into the mist of a high-key distance. To emphasize this atmospheric effect, artists sometimes use the device of a repoussoir, a prominent dark or contrasty form in the foreground, such as a tree or lonely figure silhouetted against the landscape.

Light and dark ranges from the overpowering brightness of the sun to the dark of the deepest mine or cave. Black and dark objects appear that way because they absorb the light that falls upon them. The darkest black we can see is a nickel-phosphorus alloy called NPL Super Black, which is used to coat the insides of telescopes and other optical instruments and which absorbs 99.7 percent of visible light. In contrast, the blackest paints absorb only 97.5 percent of visible light. The artist has only pigments to work with, so the range from the most reflective white to the most absorbing black is inevitably compressed into what we call the **dynamic range** of values. Photographers often have to choose the important parts of their pictures when they are setting the exposure on their cameras: if they decide to best capture

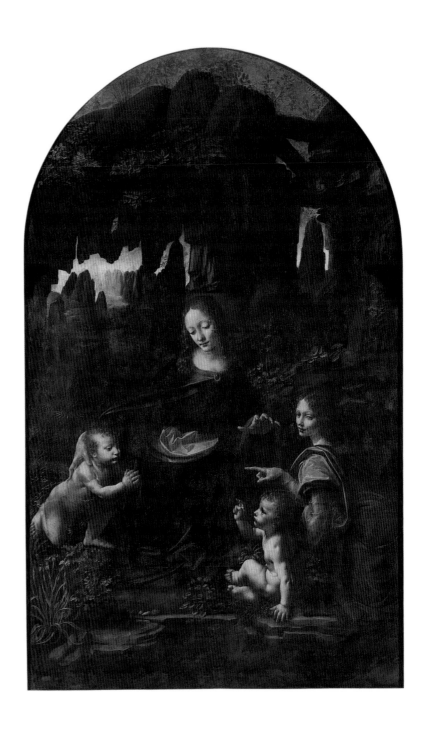

6.8 Leonardo da Vinci, *Madonna of the Rocks*, 1483–1508. Oil on panel, 6′ 6 ½″ × 4′ (2 × 1.22 m). Louvre, Paris.

Leonardo was a master of light and shade. The title seems not to refer to the mystery of the Immaculate Conception, but depicts the type of subject he might have painted in his native Florence where legends concerning the young John the Baptist were popular.

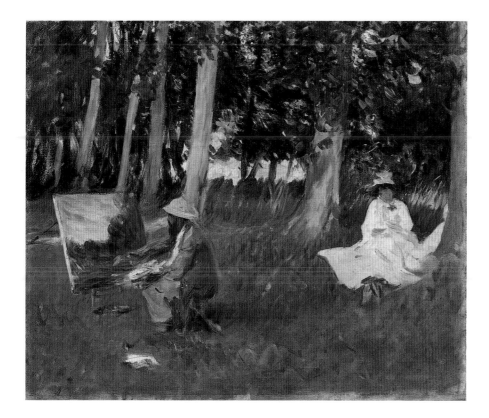

6.9 John Singer Sargent,
*Claude Monet Painting by the Edge
of a Wood*, 1885. Oil on canvas,
21 ¼ × 25 ½" (54 × 64.8 cm).
Tate, London.

Sargent and Monet painted
together at Giverny near Paris.
Sargent admired the way in which
the French Impressionist worked
outdoors, and he revealed Monet's
working methods in sketches such
as this one. Monet and his canvas
are balanced by his patient wife, a
patch of light value to the right.

the light areas of the scene, the dark areas will be **underexposed**, uniformly black, and lacking in detail in the shadows. If they adjust their cameras to capture a darker object against a light background, then the light areas will be **overexposed**, bleached out, and similarly lacking in any detail. Imagine trying to take a photograph of a figure in the snow—unless you use flash to "fill in" and expose the figure, the subject will end up as a silhouette against white.

Unlike photographers, painters can choose a dynamic range to fit the available pigments, technique, or subject matter, and often our brains will compensate to produce a plausible result. As we shall see, the Italian artist Giotto di Bondone (*c.*1267–1337) rarely used black for shadows, but the purest pigment, with no added white (see **6.15**). The image may look flatter than reality, but all the tonal relationships will be depicted.

Art does not have to follow the laws of optics, of course, and should an artist choose to restrict the tonal range, value can be used decoratively, as in a flat cartoon illustration or medieval illuminated manuscript, where clarity of image is more important than verisimilitude. Much contemporary art is completely free of illusionary lighting—from the shallow space of the Cubists, with forms deconstructed into individually lit and shaded planes, to the dynamic, two-dimensional value patterns of abstract and non-representational art. In recent years artists have worked with light itself, whether it be the extraordinary manipulation of the colors of daylight on pigmented surfaces in the installations of James Turrell (b. 1943), the use of neon tubes by Bruce Nauman (b. 1941), or the large-scale photographs of Catherine Yass (b. 1963), whose method of combining two identical transparencies, one on positive film, and the other on positive film presented as a negative, on lightboxes, heightens the colors and turns any light areas into an array of glowing blues.

Patterns of Value

Screw up your eyes and squint at a painting: you will gain an insight into its value pattern. The value pattern is the picture condensed to its bare essentials, no detail, no color, no subject matter, just shapes of light and dark—pure composition. Artists often plan the value pattern of their paintings by making small-scale thumbnail sketches or tone drawings to experiment with different compositions before they embark on the finished artwork (**6.10, 6.11**). These monochromatic drawings in line and wash can quickly establish rhythms and ambiguous shapes, before positions are established, detail is added, and the underlying structure is all but hidden. There is more on composition in Part 2.

6.10 (above) Nicolas Poussin, *Study for the Rape of the Sabine Women*, c. 1633. Pen, bistre, and wash, 6 × 18″ (16.4 × 21.9 cm). Devonshire Collection, Chatsworth.

Artists often plan the value patterns and rhythms of their compositions in preparatory thumbnail sketches before committing to a final design.

6.11 (right) Théodore Géricault, Study for *The Raft of the "Medusa,"* c. 1819. Pen and sepia wash, 8 × 11 ⁹⁄₁₀″ (20.2 × 28.7 cm). Musée des Beaux-Arts, Rouen.

Géricault was moved by the real-life drama of 149 shipwrecked sailors from the frigate *Medusa*, abandoned for 12 days on a raft off the African coast. This was the first time a contemporary news item was the subject for a large-scale painting; this is the preparatory study.

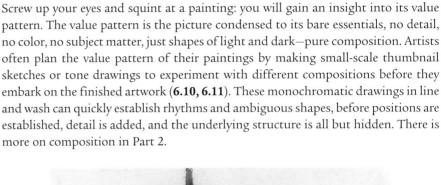

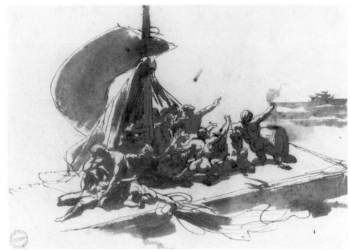

6.12 Francisco de Goya, *The Third of May, 1808*, 1814. Oil on canvas, 8′ 6″ × 11′ 4″ (2.6 × 3.45 m). Prado, Madrid.

The eye is drawn to the bright white shirt, about to be stained blood red by Napoleon's troops. It is possible that Goya witnessed the massacre, perhaps with a telescope.

Value patterns also establish the mood of a painting. The two main components of value are contrast and tonal range, and the legibility of a form largely depends on how much contrast there is between it and its background or surroundings. Black and white are at the opposite ends of the grayscale spectrum and together have the highest contrast. A black shape against a white background or a white shape on black will be highly visible and noticeable (**6.12**). With less contrast comes reduced visibility, and the skilful use of this effect allows the artist or designer to control emphasis and direct the way in which viewers explore the image.

6.13 Rembrandt van Rijn, *Self-Portrait at the Age of Thirty-Four*, 1640. Oil on canvas, 41 ⅛ × 31 ½" (102 × 80 cm). National Gallery, London.

This low-key painting shows Rembrandt, a master of chiaroscuro, at the height of his career. He adopts a self-assured pose and is wearing the fashionable clothes of his time.

The tonal range selected for the picture allows the artist to set the ambience and mood of the image. As we have seen, a tonal range consisting of black to mid-tones is called low key, and can create an air of mystery, seriousness, or doom (**6.13**). A high-key tonal range, consisting of mid-tones to white, emits a sense of lightness and positivity to the atmosphere of the picture (**6.14**). Color adds another dimension, however, and some high-key pictures, such as those by the British artist Gwen John (1876–1939), can seem desperately sad.

Adding small areas of black to a predominantly high-key picture can make the blacks appear even blacker and rescue the overall image from looking flat. Similarly, an area of white in a low-key picture, such as a moon or a highlight, will be given added emphasis. The way light and dark areas are arranged in a picture can direct attention to the focal point of a composition, the starting point for an exploration of the picture.

6.14 Alexandre Cabanel, *Birth of Venus*, 1863. Oil on canvas, 4' 4" × 7' 6" (1.3 × 2.29 m). Musée d'Orsay, Paris.

Cabanel was an academic painter contemporary with the Impressionists, whom he opposed. This titillating subject, influenced by Ingres, is painted with a high-key palette of colors.

Chiaroscuro—Light and Shade

The technical term for the organization of light and shade is **chiaroscuro**, from the Italian *chiaro* (clear or light), and *oscuro* (obscure or dark). The French term is *clair-obscur*. Although the term generally covers all representations of illuminated three-dimensional objects rendered onto flat grounds, the word has come to be applied especially to the more dramatic theatrical compositions achieved by contrast and light, particularly those by the artists Caravaggio (see **6.18**) and Rembrandt (see **6.19**).

Chiaroscuro was developed much earlier during the Renaissance. Giotto is credited as the founder of the Western tradition in art. He broke free from the kind of stylization and painting technique seen in Greek and Russian icons of saints, and developed a technique that would allow him to paint draperies realistically in his frescos (**6.15**). An artist painting into wet plaster must work quickly, and Giotto devised a scheme for working on a wall in sections, equivalent to what he could comfortably complete in a day and called *a giornate*, replacing the *a pontata* system of plastering the whole wall in one go.

6.15 Giotto, *The Kiss of Judas*, c. 1305. Fresco. Scrovegni Chapel, Padua.

When painting frescos, artists have to work quickly before the plaster dries. Giotto used a three-pot method for shading draperies, using pure pigment instead of black for the shadows.

Giotto prepared three pots of paint: one with pure pigment plus a little water for the shadows and dark areas; pure color plus some white for the mid-tones; and a pot with even more white for the lightest tones. He did not mix in any black. Some artists discipline themselves to shade with just five basic values: the white of the paper or panel; light gray, the color of reflected light seen around the edge of an object as light reflects from surrounding surfaces; mid-gray, the local tone that represents the actual color of the object without the effects of either direct light or shadow; dark gray, representing the core shadow, the shadowed side of an object as it recedes from the light; and near-black for the cast shadows. This shadow is darkest where objects meet surfaces and lightens as it moves away from the object (**6.17**).

Giotto also used a monochromatic version of chiaroscuro called **grisaille**, a trompe l'oeil painting done in shades of gray or a neutral color that imitates the appearance of low-relief sculptures. Although he modeled the faces and drapery of his figures, they were still defined by outlines and bold shapes. It wasn't until the work of the Venetian painters Giorgione (c.1477–1510) and Titian that tonality became the dominant form-creating device in art.

With quick-drying fresco and egg tempera there is little scope for blending tones to achieve smooth transitions from one to another. Most artists working in tempera use a technique of painstakingly cross-hatching with tiny brushes. With the widespread introduction of slower drying oil paint by Jan van Eyck (c.1390–1441) (see **7.43**) and others in the mid-15th century, artists could work on blends to produce more subtle forms of shading.

Leonardo da Vinci brought a new subtlety to shading with a technique known as **sfumato** (from the Italian word for smoke). It describes a transition of tone from light to dark that is so gradual that the eye cannot detect any distinct tones or boundaries between values (**6.16**). Leonardo wrote that light and shade should always merge without lines or borders, in the manner of smoke, and the art historian Giorgio Vasari regarded this innovation of mellowing outlines that were once all too obvious in earlier paintings as one of the marks of a "modern" painting. Sadly, the effects of age, and his need to experiment—not always successfully—with new techniques and materials, do not do Leonardo's surviving works any justice.

6.16 Leonardo da Vinci, *Mona Lisa*, c. 1503. Oil on panel, 38 ½ × 21″ (97.8 × 53.3 cm). Louvre, Paris.

The famous enigmatic smile was created by Leonardo's use of the subtle method of shading called *sfumato* (from the Italian for "smoke").

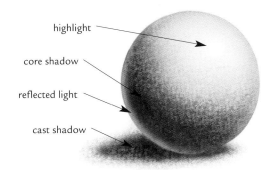

highlight

core shadow

reflected light

cast shadow

6.17 Alan Pipes, Shadows, 2003. Graphite on paper, finished in Photoshop, 2 ¾ × 2 ⅜″ (7 × 6 cm). Courtesy the author.

Light falling on a form creates shadows. The part of the form away from the light is the core shadow, and the part of the background where the light cannot reach is the cast shadow. Light reflects off other surfaces to illuminate areas in shadow. Highlights appear where light is strongest.

The name we associate with light and shade is Caravaggio, an extremely colorful character, some might say a rogue, who developed his own dark flavor of chiaroscuro called **tenebrism** (from the Italian word *tenebroso*, meaning obscure), a style of painting characterized by a little bright light and lots of almost black shade (**6.18**). The difference between Caravaggio's paintings and Leonardo's is that the principle behind chiaroscuro is to leave the light parts as they are, so that they can be seen clearly, and to darken the "obscure" parts—the areas the artist deems less important—so that they do not distract the viewer. Tenebrism takes the process to an extreme by brightening and intensifying the colors of the light parts of the composition.

We are used to intensity of value, being exposed to cinema, television, and billboard art, but 17th-century viewers must have found it shocking. Caravaggio also perfected the technique of placing a bright light source just behind the plane of the picture frame and often hidden by a dark central figure, with the faces of other people in the picture brightly illuminated by this light source. His dramatic paintings take place in confined, shallow spaces, the chiaroscuro allowing him to banish daylight and paint indoor scenes of the underworld. His enthusiastic followers were called the Caravaggisti, and spread his fame around Europe. Georges de La Tour (1593–1652) (see **1.39**) and Joseph Wright of Derby (1734–97) (see **6.1**) carried on the tradition and took "candle-light" painting to new dramatic heights.

The master of the "dark manner" of painting, as the style was also known, was Rembrandt (**6.19**). His paintings are characterized by luxuriant brushwork, rich

6.18 Caravaggio, *Judith slaying Holofernes*, 1598–9. Oil on canvas, 56 ¾ × 76 ¾" (142.2 × 193 cm). Galleria Nazionale d'Arte Antica, Palazzo Barberini, Rome.

Caravaggio developed a style of chiaroscuro called tenebrism—a little bright light and lots of almost black shade. During the siege of a Jewish city, the widow Judith saves her people by assassinating the Assyrian general, Holofernes, with his own sword.

color, and a mastery of chiaroscuro. That his paintings can look dull and brown is a result of the poor varnish that was used. His famous painting known as *The Night Watch* was wrongly named until it was cleaned in the 1940s. A more appropriate title would be *The Militia Company of Captain Frans Banning Cocq*, and it is a group portrait of a company of civil guards awaiting the command to fall in line. The canvas is now brilliant with color, movement, and light. In the foreground are two men—Cocq in black and his lieutenant in bright yellow, the shadow of one color toning down the lightness of the other. The focal point of the painting, however, is a little girl dressed in yellow and illuminated by a hidden light source.

The mistaken idea that great masterpieces should be brooding and dark (**6.20**) or muddy brown like the uncleaned Rembrandts had a bad influence on painting, until Ingres returned to the smooth, undramatic *sfumato* of Leonardo with his Neo-classical modelling of forms (**6.21**) and the Pre-Raphaelite Brotherhood returned in the 19th century to painting from nature and using pure unadulterated pigments on white grounds.

6.21 Jean-Auguste-Dominique Ingres, *The Turkish Bath*, 1862. Oil on canvas, 42 ½″ (108 cm) diameter. Louvre, Paris.

The smoothly shaded contours of bodies and a repeated use of the same model add to the sensuality of this accumulation of flesh.

Digital Shading and Lighting

Leonardo was the archetypical "Renaissance man," an inventor and scientist as well as an artist. He believed observation to be the basis of all art and made scientific studies of how light creates shadows as it falls onto objects. He also believed that his paintings and drawings should relay scientific truth and natural observation without bias or alteration. Today we can use computers to plot the paths of light rays as they bounce around virtual environments.

Attempts at computer graphics shading started with Gourand shading in 1971 to provide smooth core shadows. **Specular reflection** with highlights, which was introduced by Phong Bui-Tuong in 1975, was based on the empirical observation that shiny surfaces reflect light unequally in different directions (**6.22, 6.23**). Only in a perfect mirror are the angles of incidence and reflection equal. However, an illuminated object does not look real unless cast shadows are present, and programs have been developed that determine which surfaces can be "seen" by sources of light, both ambient and local (**6.24**).

None of these techniques takes account of the light-transmitting properties of a surface, with the result that images can look limp and lacking sparkle. It is the subtle colors found in shadows and reflections that help bring a picture to life. In 1980 Turner Whitted applied the laws of physics to a light ray's journey round a scene. He established that every time a ray encounters a surface, it divides into three parts:

6.22 Raysan Al-Kubaisi, Uccello chalice, 2003. 3DStudio Max modeling program and wireframe, 1600 × 1200 pixels. Courtesy the artist.

Uccello's Renaissance perspective study of a chalice (see **1.30**) was used as the starting point for this computer wireframe.

6.23 Raysan Al-Kubaisi, Uccello chalice, 2003. 3DStudio Max modeling program, 1600 × 1200 pixels. Courtesy the artist.

This is an intermediate form of rendering in which individual facets are given a color and value dependent on an average amount of light falling on them.

6.24 Raysan Al-Kubaisi, Uccello chalice, 2003. 3DStudio Max modeling program, 1600 × 1200 pixels. Courtesy the artist.

Here the computer model has been smoothed, with surface reflections added and shadows cast to enhance the realism.

into diffusely reflected light; into specularly reflected light; and into transmitted or refracted light. Each ray leaving a surface is the sum of varying contributions from these three sources.

Luckily, most of these rays shoot off to oblivion, but to make the computation manageable, the process is done in reverse—rays are traced back from the viewpoint (from the pixels of the display's screen), bounced around the scene, and eventually arrive back at the light source. The process is known as **ray tracing**. Ray-traced images, which once took hours or days to render on supercomputers, can now be created on a personal computer. Ray tracing does have shortcomings, however—although it is good for producing hyper-real images of shiny objects lit by point light sources and with sharp shadows, it is not so good with diffuse shadows. Ray tracing won't show the glow from obscured local lights, nor color "blushes" from one object to another. And each rendered image depends on the current position of the observer. Shift the viewpoint and the whole composition has to be recalculated again.

There are two types of lighting and shadow-casting programs: direct illumination and global illumination. Ray tracing is an example of the former. **Radiosity** is a global approach that calculates the light-energy equilibrium of all the surfaces in an environment, independent of the observer's position at the time (**6.25, 6.26, 6.27, 6.28**). While each object in a ray-traced scene must be illuminated by some light source for it to be visible, with radiosity an object may be lit simply by its immediate surroundings. Anything that is visible is either emitting or reflecting light and is, therefore, a source of that light. Radiosity is not at all good at highlights, however, and research is currently under way to combine specular reflection with radiosity.

No matter how powerful computers get and no matter how good the software is at rendering a scene accurately and convincingly, there will always be the need to have an artist or designer at the controls, designing, positioning, and sculpting the forms and directing the light source that falls onto them. Without the artist's creativity, vision, and drive, all we will be doing is recreating on screen what we can already see all around us.

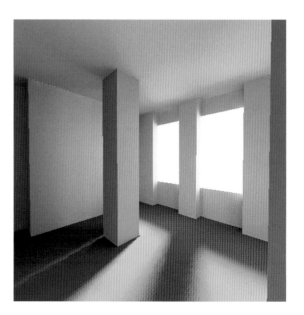

6.25 (above) Hugo Elias, Directly illuminated room, 2000. 3DStudio Max models, 480 × 480 pixels. Courtesy the artist.

The sun is the only light source. When first rendered, the entire room was black, except for a few floor patches. Increasing ambient light made the room grey, except for the red floor and light patches. Adding a point light source in the middle brought out detail.

6.26 (right) Hugo Elias, Globally illuminated room, 2000. 3DStudio Max models, 480 × 480 pixels. Courtesy the artist.

The scene has been rendered with a radiosity program. The sun is the sole light source. Although the low-resolution image is pixellated, the room is visibly lit, even surfaces facing away from the sun. Shadows are softer. Walls glow pink with the reflected floor color.

6.27 (left) Hugo Elias, Directly illuminated room, 2000. 3DStudio Max models, 480 × 480 pixels. Courtesy the artist.

This is another view of the same scene lit directly.

6.28 (right) Hugo Elias, Globally illuminated room, 2000. 3DStudio Max models, 480 × 480 pixels. Courtesy the artist.

This is another view of the scene lit using radiosity.

Exercises

1 Chromatic scale: Draw six squares in a line, abutting each other. Add increasing amounts of black paint to clear water to paint each successive square. The aim is to create a series of tints with equally spaced values (see **6.2**). Test each new tint on the edge of a separate piece of paper and hold this against the scale.

2 Negative and positive values: Using only black and white pastels on gray paper, draw a still life using the white pastel for areas where the light strikes the objects and creates positive edges. Define only the darkest areas with the black pastel and leave all other tones as the gray of the paper.

3 Pixellated portrait: Find a photograph of a face in a magazine and enlarge it on a photocopier so that it fills the frame. Draw a grid of squares over the photocopy, and draw a similar grid on a plain sheet, which could be scaled up. Look at each square of the photograph in turn and try to average-out the value in that square. Paint that gray tone in the corresponding empty grid. When finished, the "pixellated" portrait should come together when viewed from afar.

7 | Color

"The purest and most thoughtful minds are those which love color the most."

JOHN RUSKIN *THE STONES OF VENICE*

Emil Nolde, *Mountain and Sky*, 1938–45. Watercolor on paper, 8 ⅝ × 6″ (22 × 15.3 cm). Private Collection.

In Nolde's watercolors, color seems sensually heightened, subdued, and more transcendental than in his better-known oil paintings. The painter writes in his memoirs about the energy of color: "In the cool zone of our Nordic lands ... where we have long, glowing morning and evening skies, there are many more colors than are found under the pale, burning equator sun. We, the Nordic people, love warmth and color."

Introduction

Until now we have restricted ourselves to black and white and the grays between, although everything discussed about line, shape, texture, space, and movement applies equally to color. Of course, black, white, and gray are colors, too, and only a pedant would argue otherwise.

We know that black and white are colors—alongside blue, red, yellow, and green—because we can buy them in tubes or pots from the art shop or in cans of household paint from the hardware store. We are surrounded every day by brightly colored plastic goods and printed material, and we take it for granted that we can select any color of the rainbow from an art supplier, choose clothing dyed to any color that's available, and re-create any color that we might see in nature on our computer screens.

In the past, it was not possible for artists to reproduce the colors that they could see all around them: the blue of the sky, the green of grass, the yellow of flowers, and the red of sunsets and fire. Prehistoric artists had a palette limited to the browns they could find in rocks—the earth colors—plus white from chalk and black from

7.1 Titian, *Bacchus and Ariadne*, 1523. Oil on canvas, 68 × 75″ (175.2 × 190.5 cm). National Gallery, London.

This sumptuous painting is a catalog of exotic pigments: Ariadne (on the left) has draperies of ultramarine—made from semi-precious lapis lazuli—and a sash of vermilion; the sea is azurite; and the leaping Bacchus has robes of vermilion lake.

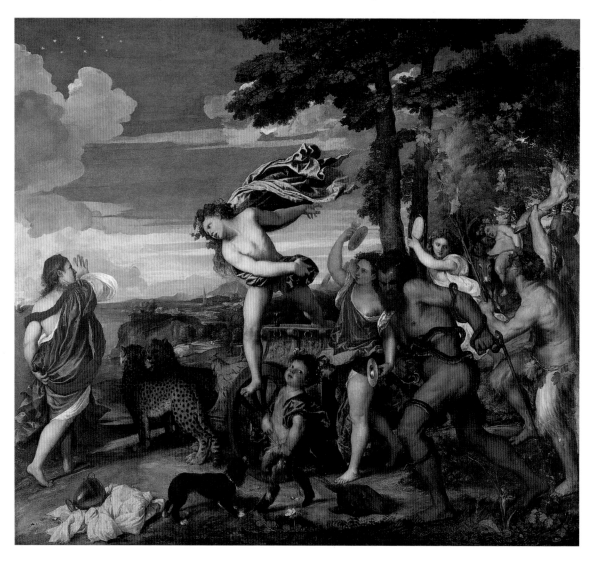

7.2 Franz Marc, *Red and Blue Horses*, 1912. Oil on canvas, 26 × 41″ (66 × 104 cm). Galerie im Leubach haus, Munich.

Marc, Klee, and Kandinsky formed Der Blaue Reiter (The Blue Rider) group, a more poetic and colorful form of Expressionism. Marc considered animals to be more beautiful and spiritual than humans. Using non-naturalistic colors, he painted them as he believed they felt their own existence.

burned wood or bones. They had no way to turn the liquid colors they found around them—the red of blood or the purple of berries—into paints that would permanently exhibit the colors that were seen when fresh.

Over the years, artists discovered new sources of color: rare colored rocks, such as blue lapis lazuli, a semi-precious stone; richer browns from rocks; and red from the dried and crushed cochineal beetle. It wasn't until the mid-20th century that we could assemble a wide range of colors that would behave consistently and not fade, and that wouldn't poison us (**7.2, 7.3**).

The discovery of new colors during the 16th century led to a change in painting style, from shape-based compositions to designs where color became more important than outlines. This revolution took place in Venice, where artists such as Titian (**7.1**) and Giorgione painted pictures of intense and vibrant color but did not spend too much time producing preparatory drawings.

In his *Lives of the Artists*, written in 1550, Vasari posed the question of what was more important, drawing (*disegno*) or color (*colore*). Michelangelo was the master of drawing at the time (although he wasn't too bad with color either, as evidenced by the restored Sistine Chapel), whereas Titian's habit of composing as he went along on the canvas was the essence of *colore*.

Venice was an international trading port, and also a center for textiles and glass. As well as all this local expertise, there were also the rich patrons who could afford the expensive pigments, such as ultramarine (the name means "from overseas," and the best came from Afghanistan) made from lapis lazuli, red vermilion (from the Latin for "small worm"—it could come from cochineal and from a rock called cinnabar), orange realgar, and yellow orpiment (both made from toxic arsenic compounds).

The obvious materials were not always the best choice, however. Real gold leaf was used to decorate religious paintings, but was useless for depicting gold objects. Yellow pigment and the skill to render highlights, shadows, and reflections resulted in more convincing paintings.

7.3 Marcel Duchamp, *Fluttering Hearts (Stockholm)*, 1961. Print, paper, and ink, 12 ⅞ × 20 ⅛″ (2.5 × 51.1 cm). Courtesy Virginia Green & Associates.

Although red and blue are not direct complementary colors, they are close enough to vibrate optically when placed together.

It was during the Renaissance that scientific enquiry into color began, but it was not for two centuries that Isaac Newton (1643–1727) not only demonstrated that white light could be split into its component rainbow colors by passing it through a prism, but also that, if they were sent through another prism, they would recombine to form white light.

Newton first used the word **spectrum** for the array of colors produced by a glass prism in 1666. He recognized that the colors that make up white light are refracted or bent by different amounts, and he also understood that colors are merely a range of wavelengths. He arranged the colors of the spectrum into a circle or **color wheel**, with **complementary colors** opposite one another (see **7.17**). In light, the three **primary colors** are red, green, and blue. In pigments, the three primary colors are red, yellow, and blue. Mix any two of these, and you have the **secondary colors** of orange, green, and purple. Complementary colors—red and green, yellow and purple, blue and orange—would cancel each other out if mixed: to black if pigments, or to white if light. We now know that the brain accepts four colors—red, yellow, green, and blue—as primaries, and this is reflected in the composition of modern color wheels.

In the 15th century, Leon Battista Alberti (1404–72) and Leonardo da Vinci had observed that certain colors work well with each other. "There is a certain friendship of colors so that one joined with another gives dignity and grace," wrote Alberti in his *Della Pittura* (*On Painting*) of 1435-6. Newton's theories were revived in the 19th century in a mass of books and treatises. The work of the French chemist Michel-Eugène Chevreul (1786–1889), for example, directly influenced the ways in which Eugène Delacroix (1798–1863), the Impressionists, and the Pointillists used colors in shadows to complement nearby objects in full light—a blue-purple shadow to an orange-yellow haystack, for example (**7.4, 7.5**). This mimics the physiological

7.4 Claude Monet, *Haystacks, Late Summer, at Giverny*, 1891. Oil on canvas, 23 ⅞ × 39 ½" (60.5 × 100.5 cm). Musée d'Orsay, Paris.

Monet painted many subjects over and over, at different times of day and under different lighting and weather conditions (see **2.6** and **12.5**). Here he paints haystacks in a field, weaving complementary colors into the shadow areas.

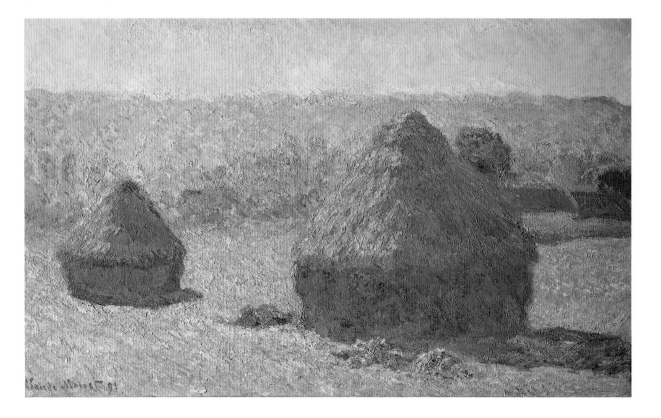

behavior of the eye. If you stare at a patch of bright color for a while, then look at a blank piece of paper or wall, you will see its complementary color as an **afterimage**.

A small but significant milestone in the history of color was the invention in 1841 by John G. Rand (1801–73), an American portrait painter working in London, of the collapsible lead tube to contain paint. Preparing pigments was a laborious task, and artists like Titian employed assistants to grind up the minerals and make the paint every day. Leftovers could sometimes be stored for a short time in animal bladders. Later, professional artists' color merchants set themselves up to supply ready-made paint. Manufactured paints became more consistent, and packaged in portable tubes to enable artists to work outdoors.

Aniline dyes, derived from coal tar and petroleum, led to the introduction in the early 20th century of inexpensive synthetic colors, many of which we use today. Artists are no longer restricted to painting with pigments on paper or canvas, but like the medieval stained-glass masters (**7.6**), can paint with light—in neon, video installations, and on computer screens.

7.5 (left) Claude Monet, *Two Haystacks*, 1891. Oil on canvas. J.H.Whittemore Collection, Naugatuck, NJ.

This is another version of **7.4**. The subject is the same but the treatment and color scheme are different.

7.6 (above) *The Crucifixion*, Poitiers Cathedral, c.1165–70. Stained-glass window, 31′ 4″ × 11′ 6″ (9.5 × 3.5 m).

This axial window was a gift to France from Eleanor of Aquitaine and the English King Henry II, who are illustrated in the window. The predominant colors are blue, red, yellow, and green.

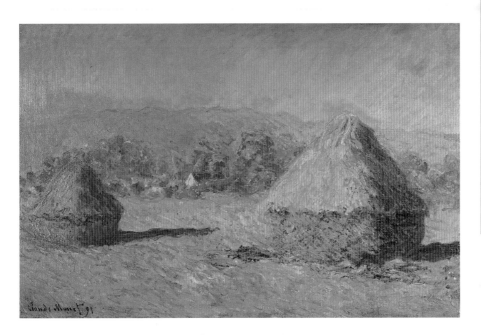

Impressionism: France, 1867–1886

The first Impressionists included Claude Monet (1840–1926), whose painting *Impression: Sunrise* (1872) gave the group its name. "Impressionism" was at first a term of abuse, but was later accepted by members of the group. Monet, Alfred Sisley (1839–1899), and Pierre-Auguste Renoir (1841–1919) were later joined by Camille Pissarro (1830–1903), Paul Cézanne (1839–1906), Edgar Degas (1834–1917), and Edouard Manet (1832–1883). The Impressionists embraced scientific research into color physics, applying paint in small touches of pure color, and painting contemporary scenes outdoors to catch fleeting impressions of color and light. Rejected by the academicians of the Parisian Salons, they organized a series of their own exhibitions (which they called the Salon des Refusés) up until 1886. Monet continued painting in this style until he died.

What Is Color?

A color is a particular wavelength of light, and it arrives at our eyes by taking one of three main routes. It is transmitted directly from an energy source, such as the sun, a candle flame, or a lightbulb. It is reflected from a "colored" object, when some of the wavelengths of transmitted light hitting the object will have been absorbed and what we see are the wavelengths that survive. Or it has been refracted, scattered, or diffracted, like the blue of the sky or the iridescent colors of a peacock feather or butterfly wing.

Visible light is a small part of the full electromagnetic spectrum, which ranges from the shortest wavelengths of cosmic rays, through gamma rays, x-rays, the ultraviolet, the visible, the infrared, microwaves, to radio waves at the longest wavelengths. Our eyes can detect visible light from violet, with a wavelength of around 400 nanometers, to red, at about 700 nanometers. As Newton discovered, we perceive this range of light wavelengths as a smoothly varying rainbow of colors—the visual spectrum.

Transmitted color is light direct from an energy source, or shining through colored filters in the theater or displayed on a computer screen through the use of a cathode-ray tube, which works by moving a stream of electrons back and forth behind the screen to illuminate red, green, and blue phosphor dots on the inside of the glass tube. The **primary colors** of light are red, green, and, blue (RGB), and other colors are made by combining different intensities of these three colors (**7.7**).

Pigment colors are created because the materials in pigments and dyes absorb different wavelengths of light, and reflect or re-transmit others. We say that color is a property of light, not the material itself, but the molecular structure of an object influences how some wavelengths of light are absorbed and others re-transmitted. Green grass absorbs (subtracts) all the colors except green, so that's how we see it. The color produced depends on the characteristics of that particular pigment,

7.7 (left) Alan Pipes, Additive colors, 2003. Macromedia FreeHand drawing. Courtesy the author.

The additive primary colors are red, green, and blue, and are based on light. Added together they make white.

7.8 (right) Alan Pipes, Subtractive colors, 2003. Macromedia FreeHand drawing. Courtesy the author.

The subtractive primary colors are red, yellow, and blue, and are based on pigments. Added together they make black.

which is why there are so many colors available in art stores: it is usually impossible to achieve the same vibrant orange or green from a pigment of that color by mixing the primary colors of pigments—red, yellow, and blue—together (**7.8**).

Objects also change color with the lighting conditions, time of day, or the color of the artificial light falling upon them. The proximity of other colors also affects our perception of colors (**7.9**), but the **constancy effect**—because we *know* grass to be green, we see it as green, even in twilight when it will really appear blue-gray—will override what we actually see.

Light color is inherently **additive**; pigment color is inherently **subtractive**. A color display starts out black and light is added to the screen to create color. The more red, green, and blue added, the brighter and lighter the screen becomes. At 100 percent intensity of red, green, and blue, the screen will be white.

When we use pigments, we mix different amounts of paint to create color. However, the more pigment we add, the darker the color becomes. The absence of any pigment is white—white paint reflects all the wavelengths of light—and the more pigments are added, the more wavelengths of light are absorbed or subtracted. Therefore, 100 percent pigment (theoretically) gives black.

The color temperature of light is a physical attribute equivalent to the temperature you would have to heat a "black body" and is measured on the Kelvin (K) scale. Sunrise and sunset are about 3200K, a red-orange color. Light temperature rises as the sky becomes progressively bluer. During mid-morning and mid-afternoon, color temperature is about 5500K, perceived as neutral. On a hazy day, with no direct sunlight, color temperature can rise as high as 7500K. To see colors as they really are, they need to be viewed away from the influence of other colors. Therefore, in graphic design and printing, computer monitors and color proofs are viewed in booths painted neutral gray and illuminated by a 5000K light source.

7.9 Alan Pipes, Proximity of colors, 2003. Macromedia FreeHand drawing. Courtesy the author.

Colors appear to change hue when placed in the proximity of other colors. The green vertical bars here are the same color, as can be seen by the lower bar, but they appear warmer when surrounded by yellow and colder when surrounded by blue.

Color Characteristics

All possible colors can be described by three attributes: hue, saturation, and brightness (HSB), also known (in a different order) as hue, luminance, and saturation (HLS). In Photoshop they are known as hue, saturation, and lightness (HSL). What most people mean when they say "color" is hue: the redness and blueness of a color, with no added black or white. The name comes from the Old English word *hiw*, meaning beauty.

The primary colors of pigments are red, yellow, and blue. The secondary colors are made from a mixture of any two primaries: red and yellow make orange; red and blue make purple; yellow and blue make green. The **tertiary colors** are made from a mixture of any two secondaries, or two complementary colors, such as red and green. Examples are olive green, maroon, and various browns. An **intermediate color** is any mixture of a primary with a secondary neighbor—yellow-green, for example.

These can be arranged into a 12-step color wheel, with yellow at the top because we perceive it to be lighter than the other colors (**7.10**). An equilateral triangle with vertices (sharp corners) at the primaries is called the **primary triad**. Similar triads can join up the secondaries and tertiaries.

Saturation, also known as intensity or chroma, is the strength or purity of a color. A saturated color is bright and intense, almost a pure hue; a desaturated color has no hue and is called achromatic—gray. Shocking pink and rose are two saturations of the hue red (**7.11**). Different saturations can be achieved by mixing a pure hue with a neutral gray or its complementary color. The complementary color of

7.10 Alan Pipes, Itten color wheel, 2003. Macromedia FreeHand drawing. Courtesy the author.

Itten's twelve-hue color wheel comprises the subtractive primaries—yellow, red, and blue—placed in an equilateral triangle with yellow at the top. Around this is a circle in which is inscribed a regular hexagon containing the secondaries—orange, green, and purple. Around this is another circle divided into twelve sectors. In the blanks are placed the six tertiary colors—yellow-orange, red-orange, and so on. The sequence of the colors is in the order of the spectrum.

7.11 Alan Pipes, Red, pink, rose, 2003. Macromedia FreeHand drawing. Courtesy the author.

Pink and rose are two different saturations of the hue red.

red, for example, is green—a mixture of the other two primaries, yellow and blue. A **tone** is a low-intensity color produced by mixing a hue with a shade of gray.

Brightness, which is also called luminance or **value** (see Chapter 6), is the relative lightness or darkness of a color. Zero brightness is black, 100 percent brightness is white, and intermediate values are light or dark colors. A **shade** is a dark color, produced by mixing a hue with black, and a **tint** is a light color, produced by mixing a hue with white (**7.12**).

It is difficult to change saturation without also changing brightness. Some hues, like yellow, are also naturally lighter than, say, violet. **High-key colors** are those that appear lighter than a mid-gray; **low-key colors** are darker than a mid-gray. Pure hues of red-orange and blue-green are roughly equivalent in brightness at 50 percent gray.

High-key colors at full saturation include orange, yellow-orange, yellow, yellow-green, and green; low-key colors include red, red-violet, violet, blue-violet, and blue. A low-key violet can of course be lightened by adding white, raising its value until it is equal in value to yellow-orange, for example, by checking its equivalence to a gray along the neutral scale. Similarly, a high-key color can be darkened to an equivalent low-key color by adding black. However it is obtained, a color-value pattern will give an underlying structure to a design.

7.12 Alan Pipes, Shades and tints, 2003. Macromedia FreeHand drawing. Courtesy the author.

A shade is a dark color, produced by mixing a pure hue with black; a tint is a light color, produced by mixing a hue with white.

Color Theory—Wheels, Triangles, and Trees

What do we mean by green? Is it sap green, viridian, or Pantone 354? How do we relate the cerulean blue, alizarin crimson, and Naples yellow we see in tubes on the shelves of an art store with the blue of the sky and the colors in a landscape? How can painters, interior designers, and textile artists be sure that they're talking about the same color?

Theoretically, because color has three attributes or dimensions, each individual color can be placed as a single point in an abstract, three-dimensional space called a **color space**, with similar colors close to each other. Such space can then be sliced into a series of two-dimensional color diagrams or maps, which would make up a color atlas. The simplest way of arranging colors is in a color wheel or triangle, the most familiar being the 12-step color wheel of Johannes Itten (1888–1967), a teacher at the Bauhaus in Germany (see **7.10**).

The best-known subtractive atlas (because it deals with pigments), the *Atlas of the Munsell Color System*, was developed by the American painter Albert Henry Munsell (1858–1918) and published in 1915, and it is related to the HSB system. The Munsell model is a tree, where the "trunk" has 10 brightness steps of gray, from black at the bottom to white at the top (**7.13**). Radiating out from the trunk are different intensities of color. If we take a cross-section at brightness 5, half-way up the trunk, we see 10 segments, with all the hues on the outer edge and colors becoming less saturated toward the center gray of the trunk (**7.14**).

The Munsell system was adopted by the US Bureau of Standards in 1942 for naming colors. Each color is given a notation—vermilion, for example, is 5R5/14, where 5R represents the hue red, the following 5 is the brightness (position vertically on the trunk) and 14 is the saturation. Pink, which is less saturated, is 5R5/4. The saturation scale is open ended, because it is based on the perceived brightness of the pure hues, so the tree has an irregular outer form (**7.15**).

A **partitive** color system is based on the perceptional relationship of colors. There are four (and not three) fundamental color hues, and the neurophysiological proof has been available since 1966. We perceive red, green, yellow, and blue

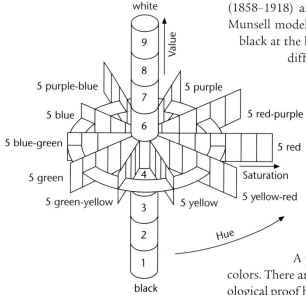

7.13 A three-dimensional diagram of a Munsell tree.

This diagram of the Munsell tree shows a slice at the mid-brightness level of 5. Because some hues are lighter than others, the branches are of unequal length.

Bauhaus: Germany, 1919–1933

This influential German school of art, design, and architecture was founded in 1919 when the architect Walter Gropius united two art schools in Weimar. Bauhaus is an inversion of "Hausbau"—house construction—and the Bauhaus style is characterized by severe geometric design, craftsmanship, and respect for materials. In 1925 the school moved to new buildings in Dessau and on to Berlin in 1932, where it was closed by the Nazis in 1933. Teachers included Paul Klee (1879–1940), Wassily Kandinsky (1866–1944), Johannes Itten (1888–1967), and Josef Albers (1888–1976). Many Bauhaus teachers later emigrated to America.

as pure colors containing no other hues, whereas orange, say, appears to us to contain yellow and red. Red and green, or yellow and blue are exact opposites—there is no such thing as yellowish-blue or greenish-red. The Swedish Natural Color System (NCS) is based on these observations. It has six "elementary" colors: white, black, yellow, red, blue, and green. Colors are defined by three values: specifying the amount of blackness, chromaticity, and a percentage value between two of the colors yellow, red, blue, or green.

In this notation, the yellow of the Swedish flag is NCS 0580-Y10R, where 0580 indicates 5 percent blackness and 80 percent chromaticity. The hue part of the notation, Y10R, means yellow with 10 percent redness. The blue of the flag is NCS 4055-R95B.

An additive atlas, such as the Standard Table of the CIE International Commission on Lighting (Commission Internationale de l'Éclairage), is based on the work of Isaac Newton on the additive mixing of colored light and is used in relation to the colors on the computer screen.

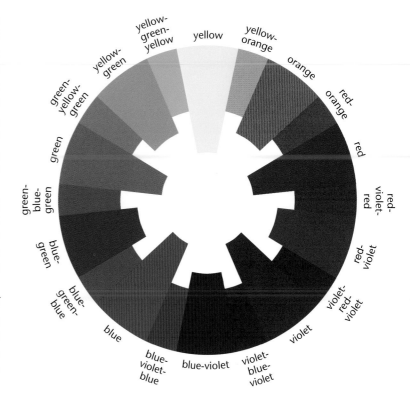

7.14 The Munsell wheel.

The hues are arranged perceptually, based on afterimages, so the complementaries are not opposite each other: red is opposite blue-green, instead of blue.

7.15 The Munsell tree.

The Munsell color space is a "tree" with an asymmetrical arrangement of branches, in which the "trunk" are brightnesses (values) from black at the bottom to white at the top; the hues are arranged in branches, with saturation changing from neutral at the trunk to pure hue at the extremities.

Color Through the Ages

The first attempts at developing color theory were made by Aristotle in ancient Greece. He theorized that seven colors arise from the struggle between the black of the night and the white of day: the white light of noon becomes tinged with yellow, changing to red. After sunset, this becomes a purple-violet, changing to a night sky of dark blue. Somewhere between, we have green.

More sophisticated color systems were developed in the 16th century. Leonardo da Vinci in about 1510 arranged the colors in a straight-line sequence, with the chromatic colors—yellow, green, blue, and red—between white and black. He was not happy about including green, however, because he knew he could make green by mixing yellow and blue. The system of Brussels-based Franciscus Aguilonius (1567–1617) used three basic colors, dispensing with difficult green from the main scheme, but placing it in the middle and beneath red in a bow-shaped diagram. Both colors thus stand opposite one another as complementaries.

The Finnish-born astronomer Sigfrid Forsius wrote in 1611 that: "One must begin with the five basic median colors, which are red, blue, green and yellow, with gray from white and black, and one must heed their grading, and whether they move nearer to the white because of their paleness or nearer to the black because of their darkness." Forsius introduced the first three-dimensional color space of four basic chromatic colors, applying to each color a grayscale running from bright to dark along the central axis of a sphere. The colors on the sphere's surface are arranged so that three opposing pairs are created: red and blue, yellow and green, white and black.

Isaac Newton developed a more logical color order based on scientific observation in 1666. Using a prism, Newton discovered that white light could be broken down into the colors of the rainbow, in a clear order: red, orange, yellow, green, cyan blue, ultramarine blue (or indigo), and violet-blue (**7.16**). Then he had the brilliant idea of joining the red end of the sequence to the violet to create a color wheel (**7.17**). Black was excluded, but the vacant center of the circle was assigned to white to symbolize that the sum of all the specified colors will result in white light. Note that the colors in Newton's wheel are not represented by equally sized segments, but by the proportions of space they occupy in the rainbow. Newton was not always rational: he chose seven colors to correspond with both the seven planets known at the time and the diatonic musical scale.

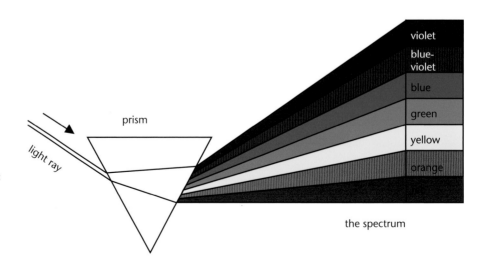

7.16 The visible spectrum.

Newton discovered that white light can be broken down into the colors of the rainbow by passing a beam through a prism. Pass these through another prism and they recombine to white light.

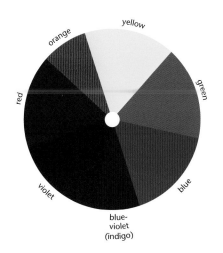

7.17 Newton's wheel.

Newton had the idea to join the ends of the spectrum in a loop to form a wheel. He divided the continuous spectrum into seven hues. The divisions are unequal and based on the proportion each wavelength occupies in the spectrum.

The English engraver Moses Harris wrote *The Natural System of Colors* in 1766 and produced the first equally spaced color wheel (**7.18**). The system has two circles, which demonstrate how "compound" colors can be created out of the primitives of red, yellow, and blue. At the center of his wheel, Harris showed the subtractive mixing of colors, with his most important observation that black will be formed by superimposing the three primary colors: red, yellow, and blue. Color theory was advancing alongside the discovery of new pigments, and Harris specified his primary colors according to the pigments available: red was cinnabar, which could be made from sulfur and mercury; yellow was King's yellow (an artificial orpiment); and ultramarine was used for blue.

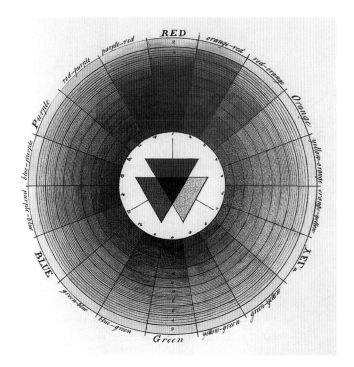

7.18 Moses Harris, Color wheel, from *The Natural System of Colors*, c. 1766. Royal Academy of Arts, London.

Harris's wheel has eighteen equally spaced sectors. At the center, he showed that black is formed by superimposing of the three primary colors. He specified his primaries according to the pigments available: red was cinnabar; yellow was King's yellow (an artificial orpiment); and ultramarine was used for blue.

The next major advance in color theory came in 1810, when Johann Wolfgang von Goethe's *Theory of Colors* appeared. His work was based on the psychological effects of color, and he started by creating a color wheel in which the three primary colors, red, blue, and yellow, alternate with the three secondaries, orange, violet, and green. Red is at the top of the circle, and green at the bottom. Later, he found his ideas were best expressed by an equilateral triangle (**7.19**).

In Goethe's original triangle, the three primaries—red, yellow, and blue—are arranged at the vertices of the triangle. The other subdivisions of the triangle are grouped into secondary and tertiary triangles, where the secondary triangle colors represent the mix of the two primary triangles to either side of it, and the tertiary triangle colors represent the mix of the primary triangle adjacent to it and the secondary triangle directly across from it. In 1810 the German painter Philipp Otto Runge (1777–1812) developed another three-dimensional color model in the form of a sphere, with colors arranged by hue, whiteness, and blackness (**7.20**). The twelve pure hues on the outside of the sphere lighten or darken as they reach the two poles.

The Scottish physicist James Clerk Maxwell developed a chart in 1872 from his studies of the electromagnetic theory of light. It was in the form of a triangle, similar to Goethe's. Newton had said that the seven basic colors created by a prism were elementary and unmixable, but Maxwell proved that only three colors—red, green, and blue—were necessary to create all the others. His work became the basis for color photography and color printing.

American art teacher Albert Henry Munsell used Runge's work as a starting point to develop his own three-dimensional color space, based on pigment, rather than

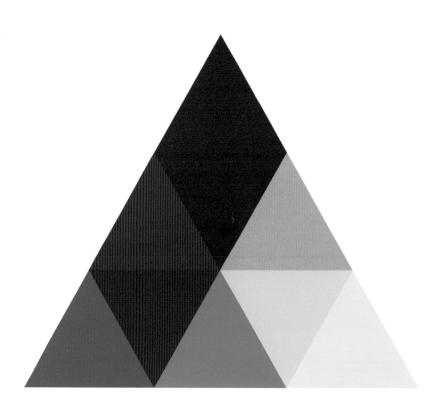

7.19 Goethe's triangle.

Goethe's color triangle has the primaries at the corners, with the secondaries along the triangle's sides and the tertiaries filling the interior spaces.

light. Munsell called red, yellow, green, blue, and purple the principal hues, and he placed them at equal intervals around a circle. He then inserted five intermediate hues—yellow-red, green-yellow, blue-green, purple-blue, and red-purple—making ten hues in all. The hue circle was arbitrarily divided into 100 steps, of equal visual change in hue, with the zero point at the beginning of the red sector. Munsell's complementaries were based on afterimages, so blue was placed opposite yellow-red, not yellow; and red was opposite blue-green (see **7.14**).

Munsell then placed the pure hues on different brightness levels. He had observed that pure hues—red, yellow, green, blue, violet—vary in their degree of brightness and should not therefore be on the same horizontal planes. In addition, colors such as red are more vivid than others, such as green, and should be further away from the axis. The resulting irregular and asymmetric color space is still used by artists and paint manufacturers (see **7.13**).

In 1931 a world standard for measuring color was established by the Commission Internationale de l'Eclairage (CIE) known as the CIE chromaticity chart (**7.21**), a 1976 version of which, the L*a*b model, is used to measure and quantify the colors produced by computer screens. L is for luminance; a and b are chromatic components—a for green to red, and b for blue to yellow. The resultant "uniform color-space" is based on the four psychological basic colors of red, green, blue, and yellow, which we know are transmitted directly to the brain. Programs such as Adobe Photoshop use the L*a*b model internally when converting from RGB to CMYK.

7.20 (left) Runge's color sphere.

Runge's color sphere has white at the "north pole" and black at the "south pole" with the pure hues arranged round the equator.

7.21 (right) The C.I.E. color diagram.

The 1931 CIE chromaticity "sail" has hues arranged around the outside edge with white near the middle, and defines the gamut of the visible spectrum. The gamuts of an RGB computer screen and CMYK printing can be mapped within this space.

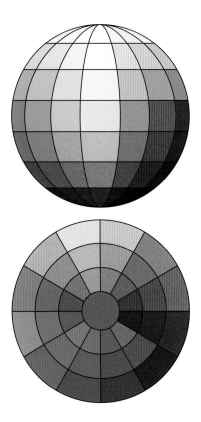

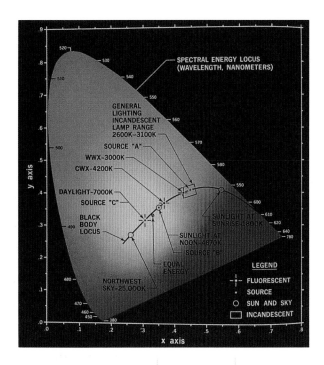

Color Printing, Computers, and the Web

Although this book is concerned mainly with the easel-based arts, you are, after all, looking at a printed book, and we cannot leave the subject of color models without discussing CMYK.

A single color used as a design element in a layout is called **flat color**, or match or spot color. The Pantone Matching System (PMS) is an industry-standard collection of colors that printers use—PMS 485, for example, is a red. Color guides, in the form of a fan chart or swatch book, show all the colors, along with the formulae for mixing the ink, and the effect of colors printed on both coated and uncoated paper (**7.22**).

Pantone colors are made from a mixture of two or more from a set of nine basic colors: yellow, warm red, rubine red, rhodamine red, purple, violet, reflex blue, process blue, and green, supplemented by transparent white and black.

If a job contains more than two colors (including black), it is neither economic nor practical to mix colored ink for every individual color to be found in a piece of artwork or color photograph. A more economical method uses the secondary colors of transmitted light—yellow (Y), magenta (M, process red), and cyan (C, process blue)—as the colors of inks used by printers to reproduce full-color work (**7.23**). In 1860 Clerk Maxwell demonstrated how colored filters could be used to record the blue-violet, green, and red constituents of any full-color subject.

The red filter allows through only blue and green components, creating cyan. The green filter allows through only red and blue, creating magenta, and the blue filter lets through only red and green, creating yellow. The negatives taken through these filters, known as color separations, are screened (turned into halftone dots) and the positives are used to make plates to be printed in sequence and in register

7.22 Pantone wheel.

The Pantone Matching System is used by printers to mix spot colors. These swatch books give formulas for matt coated and uncoated paper.

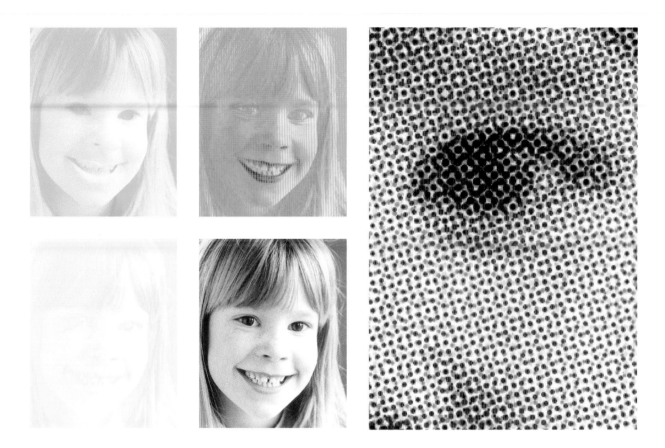

(correct alignment) in the process colors of yellow, magenta, and cyan. Today, color separations are made by computers driving laser imagesetters.

In theory, all three colors added together should produce black. In practice, printing ink, like school paint, never will produce a pure enough black, so a fourth color, black, is added to deepen the dark areas and increase contrast. In print jargon, black is referred to as key, so the system is known as CMYK.

Pantone's Hexachrome system, also referred to as HiFi color, uses six colors—brighter (fluorescent) versions of CMYK plus vivid orange and green. This expands the color gamut (the limited spectrum of colors that a particular device can reproduce). Green and magenta are prevented from appearing in the same area, as are orange and cyan. When printing, black goes down first, followed by green, cyan, magenta, yellow, and finally orange.

Computer screens use the additive color model, so website designers work in RGB—what they see on the screen will be the same as the finished product. There are slight differences, however, in the way Macs and PCs display colors, and how browsers, such as Netscape and Explorer, parse the color information. Most people are assumed to have at least a 256-color monitor, so we arrive at 216 "web-safe" colors, which can be displayed on any computer without dithering (optically mixing two or more colors). Web colors are described using three sets of hexadecimal numbers (numbers to base 16), one each for red, green, and blue. Thus white is FFFFFF (maximum color) and black is 000000 (absence of color).

7.23 The four-color printing process.

Four-color CMYK printing attempts to reproduce all colors by visually mixing cyan, magenta, yellow, and black (key) inks. The dots of each color are printed at different angles to produce the characteristic rosette seen in the enlargement.

Color Interactions

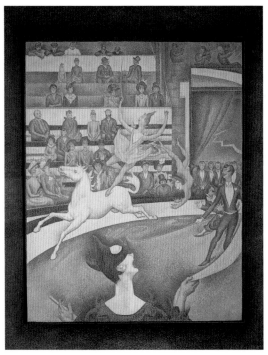

7.24 Georges Seurat, *Le Cirque*, 1891. Oil on canvas, 73 × 60″ (185.5 × 152.5 cm). Musée d'Orsay, Paris.

Seurat and the other Pointillists practiced Chevreul's theories and optically mixed paint on the canvas, using dabs of pure pigment to create secondaries and vibrant neutrals.

We are told as children that we can make any color by mixing the primaries in different proportions, but we know from experience that the results will be muddy and dull. It comes as a revelation to discover in later life that art stores stock a range of pigments that haven't been created by mixing colors. Color is a result of pigments absorbing some wavelengths of light. Adding more pigments to the mix will reduce the quality and quantity of the light re-transmitted. Artists can avoid this problem by a technique called optical or **visual mixing**. Instead of mixing colors on the palette, they are placed in a pure form in adjacent dabs on the canvas. Any color mixing then occurs in the eye and brain of the viewer.

Visual mixing also occurs in four-color printing (see **7.23**), where different sized dots of cyan, magenta, yellow, and black reproduce all the colors in an image, or on a computer screen, where luminous dots of red, green, and blue more successfully capture the colors of reality.

In art, this is called **divisionism**, and it can be executed using lines as well as dots and dabs, often on a complementary colored ground. Applying colored dots on a white ground is called **Pointillism** (**7.24**). When dots of hues close to each other on the color wheel are juxtaposed, new hues are formed; dabs of complements result in grays, albeit luminous grays. Visual mixing can be effective when the palette is restricted, as in mosaics and tapestries, for example.

Michel-Eugène Chevreul (**7.25**) was director of dyeing at the Gobelin tapestry workshop, and he received complaints about the "wrong" colors in tapestries of classical paintings, although the correctly colored thread had been used. From his investigations, he developed a theory of **simultaneous contrast**—that is, whenever two colors come into contact, their similarities will decrease and their dissimilarities will be enhanced. This phenomenon is most noticeable in complementaries, but it also occurs when the colors are related. Blue is at its most vibrant and will be seen to vibrate, when it is next to orange (**7.27**); as will green when it is next to red. Delacroix was one of the first artists to implement these ideas, extensively incorporating deliberate complementaries in his paintings.

Every hue has its afterimage—the complementary color you see on white paper after staring for a while at a patch of bright color—and this affects adjacent colors as well. **Successive contrast** is the afterimage reaction caused by our eyes skipping across a painting. Each new color we encounter is affected by the afterimage of the last color we saw. The brain always anticipates a complement, and if it isn't there will create it. Thus a white background around a patch of yellow will take on a bluish tinge. If the yellow is on a green background, the green will become a blue-green (see **7.9**). A hue surrounded by a gray will appear more intense. Delacroix embraced this effect saying: "Give me mud and I will make the skin of a Venus out of it, if you will allow me to surround it as I please." Successive contrast can be ameliorated by outlining an area of color in black, which will absorb the afterimage.

The rug designer Wilhelm von Bezold (1837–1907) discovered that changing a single color in a design could affect the overall tonality. If black, white, or a strong hue at full intensity is used throughout and the dominant one is changed, the Bezold effect seems to spread over the area, lightening or darkening the entire composition, and making light-valued areas seem larger than when they were rendered in a dark value (**7.26**).

7.25 Eugène Chevreul, Color Circle from *Des Couleurs et leurs Applications aux Arts Industrielles à l'aide des Cercles Chromatiques*, Paris, Baillère, 1864, pl. iv, fig. 5.

Chevreul's 72-part color circle depicts the three primaries, plus three secondary mixtures of orange, green, and violet, and six further mixtures. The resultant sectors were each subdivided into five zones separated into 20 brightness segments.

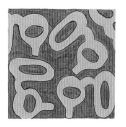

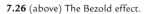

7.26 (above) The Bezold effect.

The Bezold effect: the yellow and orange are the same colors in each example, but seem to lighten or darken overall if white or black lines are added to the composition.

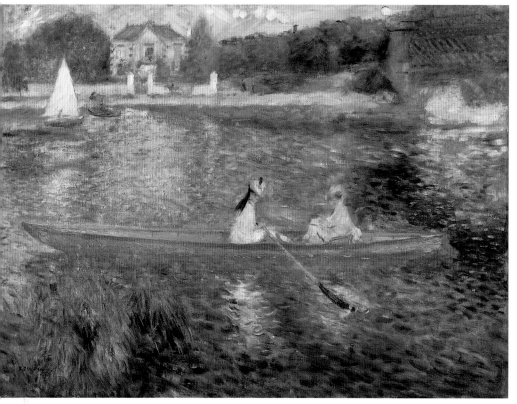

7.27 (left) Pierre-Auguste Renoir, *Boating on the Seine*, c. 1879–80. Oil on canvas, 28 × 36 ¼" (71 × 92 cm). National Gallery, London.

Complementary colors—the orange of the boat against the blue of the river—added vibrancy to Impressionist paintings, following Chevreul's observations of simultaneous contrast.

Color Schemes

Many of the color theorists mentioned earlier were not only interested in classifying color, but also investigated how colors work with each other. Color schemes may have connotations of interior design—matching the color of the walls with the woodwork and furnishings—but they also have a place in easel art. Even in classical landscapes, where grass is green and the sky blue, a more harmonious composition can be created if care is taken in the choice of colors and their placement in the design. Abstract artists have fewer constraints and can choose schemes purely on the basis of color theory.

Color schemes are like music, with colors like musical notes working with or against each other to form harmonies and chords—or jarring discords. Many of these schemes were devised by Bauhaus teacher Johannes Itten and his pupil Josef Albers (1888–1976) (**7.28**). We use Itten's 12-step color wheel for consistency.

An achromatic color scheme is created from black, white, and the grays between. There are no possible color contrasts. Black with white provides the strongest contrast available in art. A **chromatic gray** or neutral relief color scheme is formed from just dull colors, sometimes with a hint of brightness. Colors near the center of Munsell's color wheel are neutral, and this scheme will be harmonious because strong hue contrasts are not possible.

The **monochromatic** color scheme is the next simplest type of scheme, consisting of one hue and its various brightnesses, and sometimes variations in saturation (**7.29**). This scheme looks clean and elegant, producing a soothing effect, especially with cool blue or green hues. The **analogous** color scheme is based on a pie-shaped slice of three or more hues located next to each other on the color wheel, usually with one hue in common—yellow-orange, yellow, and yellow-green, for example (**7.30, 7.31**). They are at their most harmonious when the middle color is a primary.

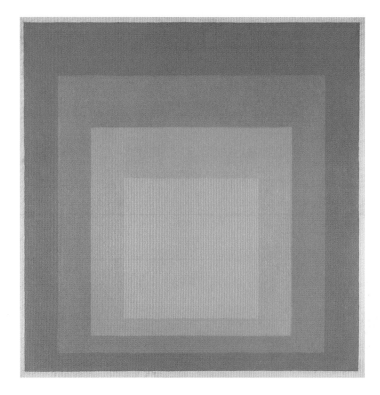

7.28 Joseph Albers, Study for *Homage to the Square: Departing in Yellow*, 1964. Oil on board, 30 × 30″ (76.2 × 76.2 cm). Tate, London.

Itten's pupil Albers examined the effect of placing analogous colors in proximity, and the way they interpenetrate each other along the edges where they meet.

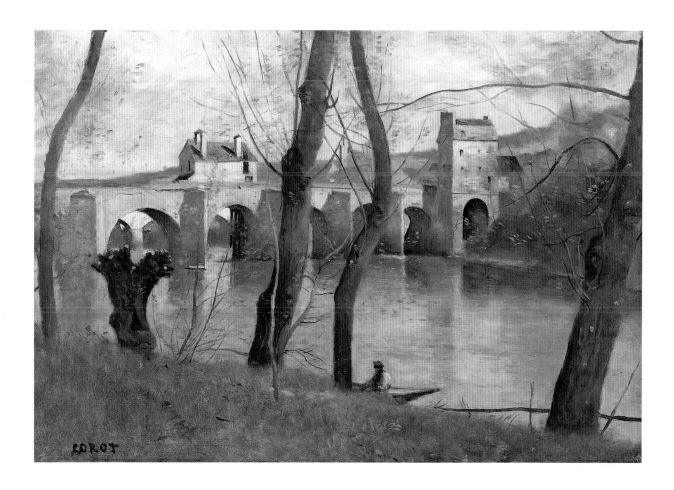

7.29 (above) Camille Corot, *Le Pont de Mantes*, nd. Oil on canvas, 15 × 21 ⅜″ (38 × 55 cm). Louvre.

Like Rubens (see **4.7**) and Constable (see **9.28**), Corot placed an accent of vibrant red in an otherwise predominantly green landscape to emphasize the diminutive figure.

7.30 (left) Alan Pipes, Analogous color schemes, 2003. Macromedia FreeHand drawing. Courtesy the author.

An analogous color scheme uses colors close or adjacent to one another on the Itten wheel.

7.31 (above) Kate Osborne, *Rosa Paulii*, 1994. Watercolor, 15 ¾ × 7 ⅞″ (40 × 20 cm). Courtesy the artist.

Osborne's analogous colors combine with the pure white of the paper to produce a calm, serene composition.

A complementary color scheme is built around two hues that are opposite one another on the color wheel (**7.32**). This scheme is intrinsically high-contrast and intense, to the point of creating vibrating colors (**7.33**). A **double complementary** scheme uses two sets of complementaries, and if they come from equidistant places on the wheel, this is termed a **quadrad**. This scheme is hard to harmonize, and if all four hues are used in equal amounts, the scheme may look unbalanced. A **split complementary** color scheme consists of any hue plus the two colors either side of its complementary. Contrast is less marked than with a pure complementary scheme, but is more intense than the double complementary and much more interesting.

7.32 Alan Pipes, Complementary and split complementary color schemes, 2003. Macromedia FreeHand drawing. Courtesy the author.

A complementary color scheme uses colors directly opposite one another on Itten's wheel; split complementaries (dotted line) use colors one sector along from the complementary.

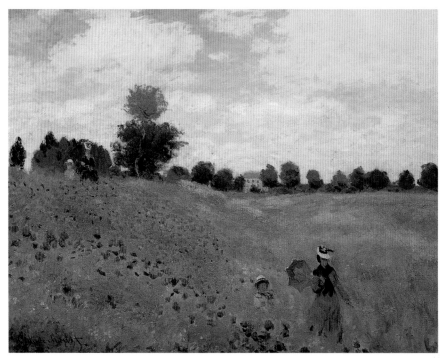

7.33 Claude Monet, *Poppies near Argenteuil*, 1873. Oil on canvas, 19 ⅝ × 25 ⅝" (50 × 65 cm). Musée d'Orsay, Paris.

The red of the poppies against the green of the vegetation are complementary colors, working together to make each other appear brighter.

7.34 Alan Pipes, Triadic and quadrad color schemes, 2003. Macromedia FreeHand drawing. Courtesy the author.

A triadic scheme (dotted line) uses three colors equally spaced on the Itten wheel, such as the three primaries; a quadrad uses four colors at the corners of a square placed on the Itten wheel.

A **triadic** color scheme is any set of three hues that are equidistant on the color wheel, forming the vertices of an equilateral triangle (**7.34**). A primary triad provides the liveliest of colors; a secondary triad is softer, mainly because, although the interval between the hues is the same, any two secondaries will be related, sharing a common primary—orange and green, for example, both contain yellow. A scheme based on the square is called a **tetrad**. The hues are equally spaced and will be a primary, its complement, plus a complementary pair of tertiaries.

The art of using one of these color schemes is to vary the proportions of the colors, rather than distributing them in equal measures. An artist can never be tied to a rigid set of colors, but taking a color scheme as a starting point and adapting it will result in a composition with a degree of "tonality"—a dominant hue or type of color scheme.

7.35 Mark Harrison, *Brighton Pavilion*, 2002. Acrylic on MDF, 27″ × 27″ (68.6 × 68.6 cm). Courtesy the artist.

Harrison has used a monochromatic blue color scheme for the majority of this composition, with touches of complementary orange to make the light from the windows glow.

Using Color

Armed with all these color theories and schemes and with a comprehensive selection of the colors available at the art store, how does the artist begin to use color? We have seen that colors are not constant—they are affected by the quality of light, the juxtaposition of other colors, and the mind of the artist. There are three main types of color in a painting: local, optical, and arbitrary. Objective or **local color** is the real-world color of an object under ordinary bright daylight, the color we know objects to be: the green of grass, the red of ripe tomatoes, and the orange of oranges (**7.36**).

Colors do change, however, under different lighting conditions and the time of day (**7.37**). Atmospheric effects give distant hills a bluish haze, and supermarkets put meat under red lighting to make it look fresh. Photographers need different types of film for daylight and indoor use; video cameras adjust the white balance of a scene to compensate for the yellow tinge of incandescent light or the blue tinge of fluorescent strip lights. The human eye adapts without our knowing it, so we have to look hard, or local color will over-ride what we see. This kind of observable color is called **optical color**.

7.36 William Holman Hunt, *The Hireling Shepherd*, 1851–2. Oil on canvas, 30 × 43″ (76.4 × 109.5 cm). Manchester City Art Galleries, Manchester.

Hunt was a Pre-Raphaelite and painted directly from nature in bright daylight, using local colors. The subject of a shepherd neglecting his sheep is from *King Lear*, but also has a Christian interpretation. Hunt also painted in moonlight (see **11.15**).

A third kind of color is **arbitrary color**, which is either the product of the artist's imagination or the result of an emotional response or visual defect. The bright, unnatural colors of van Gogh and Gauguin are termed **heightened colors**. The yellow skin of the Simpsons in the cartoon series is another example.

Warm and cool

Colors can be divided into **warm colors**, such as red and yellow, which are associated with fire and sunlight, and **cool colors**, such as blue and green, which we associate with ice, water, and crisp salads. On the Itten color wheel, the yellow to red-violet segment is deemed warm; the yellow-green to violet segment, cool. It is all relative, however, because green can seem warm next to blue but cool when it is placed next to orange.

Emphasis

Complementary colors offer artists the greatest contrast after black and white, with the added effect of vibrating edges (see **7.3**), and they are ideal for creating areas of emphasis. This is an effect well known to the Impressionists, who might place vivid red poppies among otherwise monotonous grassy green fields (see **7.33**). Patches of bright warm colors project themselves forward when they are surrounded by cooler or less saturated colors. Without color, we would emphasize an element by making it larger, a distinctive shape, or by isolating it from the rest of the composition. With color, however, the tiniest dab of red or orange among drab green or neutrals will shine out, demanding attention (**7.29**). Our eyes are drawn to bright colors, and when they are placed at the focal point of a picture, such an accent will draw our gaze into the story.

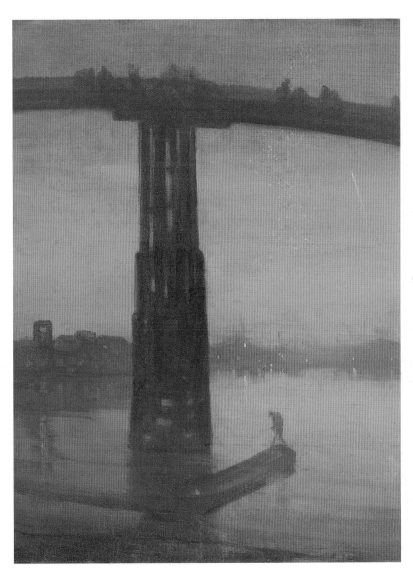

7.37 James McNeill Whistler, *Nocturne in Blue and Gold: Old Battersea Bridge*, c. 1872–5. Oil on canvas, 26 ⅞ × 20 ⅛″ (68.3 × 51.2 cm). Tate, London.

Subtitled *Old Battersea Bridge*, the subject of this Japanese-inspired "aesthetic" picture was less important than its harmonious arrangement of cool colors. The critic John Ruskin was unimpressed, accusing Whistler of "flinging a pot of paint in the public's face."

Visual balance

Because color is so powerful at accentuating design elements, it is also a useful tool in balancing a composition. A symmetrical composition is perfectly balanced around a central axis, the left-hand half being an approximate mirror-image of the right. We must be careful not to disrupt that balance by a too overpowering coloration on one side. In asymmetrical designs, we perform a balancing act with unequal elements. On a set of scales we can balance a small dense weight with a large bag of feathers, so a small patch of intense color can balance a larger neutral area. If an image appears to be well balanced, but when viewed in black and white looks off-balance, color has been holding it all together (**7.38**).

Space and depth

We have already seen the use of color in aerial perspective—the effect of distance scattering light toward the blue end of the spectrum (see **4.38**). Colors also have the property of moving forward or receding. Generally, warm colors will emerge and expand, whereas cool colors will contract and recede. A spot of red on a gray background will appear to hover in front of the picture plane, but a similar patch of blue will burrow into the background (**7.39**). Saturated and bright colors will move toward us when surrounded by desaturated colors. Objects colored by hues that are brighter at maximum saturation, such as yellow, will appear to spread and look larger than those that are intrinsically darker. Add all the other depth cues we have learned, and we will be able to create a convincing sense of space and depth. Similarly, artists can create more flattened confined spaces by giving a portrait, say, an orange or red background that almost pushes up against the back of the sitter.

7.38 (left) Joan Miró, *Personage Throwing a Stone at a Bird*, 1926. Oil on canvas, 29 × 36 ¼" (73.6 × 92 cm). Museum of Modern Art, New York.

The intense red of the bird's plumage against the scrubby green sky balances the larger white biomorphic shape of the personage, despite the figure with the giant foot swinging backwards in reaction to the movement of the stone.

7.39 (right) Bhupen Khakar, *You Can't Please All*, 1981. Oil on canvas, 69 ⅛ × 69 ⅛" (175.6 × 175.6 cm). Tate, London.

Aesop's fable of a father and son taking a donkey to market is reinterpreted in arbitrary color. First, the father rides; the son walks. Then they both ride, but when criticized for being cruel they decide to carry the donkey. They are burying the dead donkey when the father delivers the moral: "You can't please all."

Value

Value, as we have seen earlier, is one of the three attributes of color—it is called brightness in the HSB system—and in Chapter 6 we discussed value without color, restricting ourselves to black, white, and the grays between. During the Renaissance, there was much debate over which was more important, drawing or color—Michaelangelo even accused Titian of not being able to draw. Right up until the 19th century, some artists argued that color was merely an adjunct to a good drawing, like a watercolor wash placed over an engraving. Others insisted that color was fundamental to a design, as we know it is.

Paul Cézanne experimented in depicting the bulk and weight of forms, such as apples, not by the usual means of modeling in shades of value and coloring with local color, but by using warm colors where the forms should come forward and cool colors where they should recede (**7.41**). Gauguin strove to reverse this effect, using cool colors in the foreground and warm colors in the background, to produce an almost decorative space (**7.40**).

Nevertheless, drawings and paintings can be produced without color, and we can discuss line, shape, and texture with almost no reference to color. However, it would take a brave artist to attempt to create a painting using pure color, with no variation of value, compensating, of course, for the value component inherent in the hues. Although we could still "read" a Renaissance or Pre-Raphaelite painting in monochrome, so much of an Impressionist or Fauve painting would be lost that it would be almost pointless to attempt a reproduction. A color field painting reproduced in black and white would be laughable.

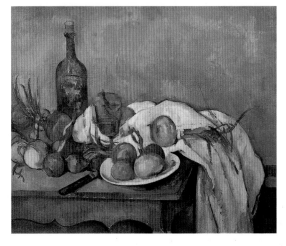

7.40 (top) Paul Gauguin, *The Vision after the Sermon (Jacob Wrestling with the Angel)*, 1888. Oil on canvas, 28 × 36" (73 × 92 cm). National Gallery of Scotland, Edinburgh.

Gauguin's use of red as the ground—a color known to emerge and expand, rather than recede—creates a more intimate space in which the action takes place.

7.41 (below) Paul Cézanne, *Still-Life with Onions*, c. 1895. Oil on canvas, 26 × 32 ¼" (66 × 82 cm). Musée d'Orsay, Paris.

Cézanne experimented in depicting the weight of forms by using warm colors where the forms would come forward and cool colors where they should recede, rather than modeling in shades of value and using local color.

Fauvism: France, 1905–1908

Fauvism was characterized by intensely vivid, non-naturalistic, and exuberant colors. The style was essentially Expressionist, and generally featured distorted landscapes. The Fauves first exhibited together in 1905 in Paris. A critic pointed to a Renaissance sculpture in the same gallery and exclaimed derisively "Donatello au milieu des fauves!" ("Donatello among the wild beasts!"). The name caught on, and was gleefully accepted by the artists themselves. The movement was subjected to mockery and abuse as it developed, but gained respect when art buyers such as Gertrude Stein took an interest. The leading Fauve artists were Henri Matisse (1869-1954), André Derain (1880-1954), and Raoul Dufy (1877-1953).

The Meaning of Color

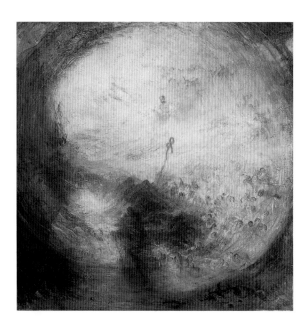

Colors of the spectrum may be just wavelengths of light, but the colors we see and use are subjective and come with cultural and psychological associations. In the West, the bride at a wedding wears white; in China, brides wear red. The bride in Jan van Eyck's painting *The Arnolfini Marriage* (1434) wears green—a symbol of her fertility (**7.42**).

Color has an effect on both minds and bodies. Children tend to be attracted more by color than by shape. We may become more form-dominant as we grow older, but creative people often remain color-dominant all of their lives.

Some colors seem to convey universal truths and have been codified by organizations such as the US Occupational Safety and Health Administration (OSHA). Yellow, for example, is a very visible color, which is why it is used on school buses. It is also used for marking, usually with yellow and black chevrons, physical hazards you might trip over. Red, for danger, is the color used for identifying fire protection equipment and emergency stop buttons.

The meanings of colors alter over time with fashion and social change. Green used to be unpopular for automobiles—it was regarded as unlucky because in the 19th century fashionable arsenic-based Paris Green caused several deaths and was renamed "Poison Green." Now green is back in fashion, with positive connotations of environmental awareness. The names of

7.42 Jan van Eyck, *The Arnolfini Marriage*, 1434. Oil on panel, 32 × 23″ (81.8 × 59.7 cm). National Gallery, London.

The wife is not pregnant but holding her dress in the contemporary fashion. The green of the dress is a symbol of fertility and the dog a symbol of fidelity. The mirror reflects two figures, one of which may be van Eyck.

7.43 (below, left) J.M.W. Turner, *Light and Colour—The Morning After the Deluge*, 1843. Oil on canvas, 31 × 31″ (78.7 × 78.7 cm). Tate, London.

In these companion pictures, Turner contrasts warm and cool colors, and their emotional associations. This one exploits the warm side of the spectrum, celebrating God's covenant with man after the flood.

7.44 (below, right) J.M.W. Turner, *Shade and Darkness—The Evening of the Deluge*, 1843. Oil on canvas, 31 × 31″ (78.7 × 78.7 cm). Tate, London.

Turner has chosen the biblical deluge as the vehicle for putting Goethe's ideas into practice. This adds an understanding of recent color theory to a preoccupation with elemental forces.

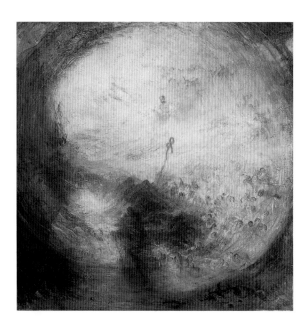

colors, too, can have an influence on the way they are perceived. In 1962, Binney & Smith renamed the Crayola color "flesh" to a less culturally charged "peach" and in 1999 Indian red was renamed "chestnut," even though the original name was not meant to represent the skin color of Native Americans but a pigment from India.

When he was developing his color theory, Goethe's original idea was "to marvel at color's occurrences and meanings, to admire and, if possible, to uncover color's secrets." His research marks the beginnings of color psychology (**7.43, 7.44**). He linked each color with certain emotions: blue with understanding, evoking a quiet mood (**7.45**), for example, and red with a festive mood, suggestive of imagination. He chose the primaries red, yellow, and blue for their emotional content, and he grouped the different subsections of his color triangle by elements of emotion—lucid, serious, mighty, serene, melancholic—as well as by mixing level.

The perception that red, orange, yellow, and brown hues are warm—inducing excitement, cheerfulness, stimulation, and aggression—while the blues, greens, and grays are cool—implying security, calm and peace, or sadness, depression, and melancholy—is perhaps too simplistic. It has been shown that in Japan blue and green hues are sometimes perceived to be "good" and the red-purple range as "bad." In the USA, the red-yellow-green range is sometimes considered "good," with oranges and red-purples "bad."

Architects and designers use color psychology to modify our behavior. Fast-food restaurants are painted orange or pink to induce excitement. They excite you to come in, eat quickly, then vacate the table for the next set of excited customers. Pink can be energizing or calming. Prisons are painted pink to cheer up those who work there and subdue the inmates. Blue is rarely used in restaurants, because it is a relaxing color, and the customers won't want to leave. Hospitals used to be painted pale green to soothe patients. "Green rooms" are where people who are waiting to appear on the stage or on TV can relax.

7.45 Pablo Picasso, *The Old Guitarist*, 1903. Oil on panel, 4′ ⅜″ × 2′ 8″ (1.23 × 0.83 m). Art Institute of Chicago. Helen Birch Bartlett Memorial Collection.

The tragic themes and sombre colors of Picasso's Blue Period began after a friend committed suicide. This bent and sightless man holds a large, sensual guitar, its brown body the painting's only shift in color.

Exercises

1 Found-object color wheel: Draw or copy an Itten color wheel (see **7.10**) and find some small brightly colored objects—mainly plastic—that correspond to the colors of the wheel. Make another wheel using your found objects, ordered by their position on the color wheel.

2 Brightness scale: Draw eleven equal squares in a line, abutting each other. Using two complementary colors, such as red and green, blue and orange, or yellow and purple, paint a square of pure color at each end of your scale (in squares 1 and 11). For square 6, add equal amounts of the two pure colors to create a neutral. In the remaining squares add small amounts of a complement to each pure color so that you have five graduated steps on either side of the middle color.

3 Afterimage: Divide a sheet of paper into two along the long side. In the left half paint a copy of a Mondrian painting, a flag, or any other image with blocks of strong bright colors—except paint only their complementary colors. For example, for a Mondrian painting render the white areas black, the red areas green, etc. When finished, stare at the center of the picture for several minutes then look at the white area to the right. You should see in the afterimage the picture as it really should be.

Part **2** | RULES

The principles of arranging and organizing the elements from Part 1 into an aesthetically pleasing composition have been developed over the centuries, either intuitively or according to mathematical and quasi-scientific methods. Here we present a guide to the principles of unity and harmony, balance, scale, emphasis, and rhythm.

There are no absolutes in art, neither a right nor a wrong way to assemble our elements into a perfect design. Artists delight in breaking the rules, pushing back the boundaries, and creating fresh ways of looking at the world around us.

But in order to break the rules, we must first appreciate what they are, why they exist, where they come from, and how they work.

Fra Andrea Pozzo, *The Glorification of St. Ignatius*, Church of Sant'Ignazio, Rome, 1691–4. Ceiling fresco.

Pozzo gives us a breathtaking perspective of vertiginous architecture. Personifications of the four continents tower above the heathens yet to be converted to Catholicism.

8 | Unity and Harmony

"All that is not useful in a picture is detrimental.
A work of art must be harmonious in its entirety; for
superfluous details would, in the mind of the beholder,
encroach upon the essential elements."

HENRI MATISSE

Richard Patterson, *Painted Minotaur*, 1996–7. Oil on canvas, 82 × 62 ¼" (208.3 × 158.2 cm). Tate, London.

Patterson takes photographs of toys smeared with paint, against various backgrounds. These photos are daubed with more pigment and then large-scale paintings are made of the resulting photographs, confusing the distinction between abstract and representational areas of paint.

Introduction

Throughout history artists have compared paintings with music. Isaac Newton chose seven colors for his spectrum to correspond with the notes of the diatonic scale. James Whistler (1834–1903) (see **7.37**) included in the titles of his paintings musical terms such as arrangement, nocturne, and harmony. The word "composition" can refer to a piece of music as well as to the way the elements of design are assembled into a unified whole. So, too, with the word "harmony," which can be a pleasing set of simultaneous sounds or a pictorial arrangement that is easy on the eye. Johannes Itten talked of color chords, and a composition, either deliberately or accidentally, can evoke pleasing chords or jarring (or stimulating) discords. A skilled artist or sculptor can lead the viewer's eyes on a journey around a composition. This can be a pleasurable or difficult experience, depending on the subject matter and the artist's intention (**8.1**).

8.1 Jeff Koons, *New Hoover Convertibles, Green, Blue; New Hoover Convertibles, Green, Blue; Double-Decker*, 1981–7. Vacuum cleaners, plexiglass, and fluorescent lights, 116 × 41 × 28″ (294.6 × 104.1 × 71.1 cm). Whitney Museum of American Art, New York.

The elements of this ready-made sculpture are linked by their potential usefulness around the home. But these vacuum cleaners have never been used; they are empty containers de-contextualized from their function and re-contextualized as art, a commentary on hollow desire.

8.2 Antony Gormley, *Field for the British Isles*, 1993. Terracotta (approx. 40,000 figures), sizes variable; each figure 3 ¼–10 ¼″ (8–26 cm). Courtesy Jay Jopling/White Cube, London. © The artist.

The work comprises 40,000 clay figures all positioned to face the same way like a huge crowd waiting in expectation, stretching out like a vast field. Each of the figures is slightly different, made in collaboration between Gormley and the local community. Each figure is a materialization of a moment of lived time.

In earlier chapters we learned about the elements of design—the building blocks, the kit of components—and now we assemble them into a finished work. The elements need to be chosen, controlled, and integrated to make a coherent whole. Unity is a juggling act, bringing all the elements together in the right proportions and using the rules of harmony, repetition, and variation to achieve a sense of completeness. This is no trivial task, and there is no simple recipe for success. Nor is there a "correct" solution every time. But if both the artist and viewer (and perhaps the critics, too) are happy with the outcome, that might be enough.

The simplest means of achieving unity is to bring together lots of similar objects, shapes, or forms. Such a collection of similar or related objects in a composition is called **thematic unity** (**8.2**). As in music, the human brain loves a degree of repetition, but not too much, or it may become monotonous. We must also introduce some variety, but again not too much, or we will end up with anarchy. We need repetition and variation in moderate amounts.

You might think that landscape painters simply reproduce what they see, but even the artist who is most "truthful to nature" will first choose a pleasing view, then simplify it, edit out or selectively move objects, alter colors, and introduce implied lines to arrive at something infinitely more interesting than a random snapshot. All the elements must work together—if they appear separate and incongruous, the composition will fall apart.

Once the painting is complete, people must see it as an entity first, before going on to examine the individual elements. The German word for an organized whole is **gestalt**. The human brain always tries to make sense of things, and if an obvious pattern cannot be found, it will either try to create one or reject the image. The artist, consciously or unconsciously, will offer up clues for the viewer, and the more puzzling and tantalizing they are, the more we enjoy the challenge. In Chapter 1, we found that we manufacture implied lines where they don't actually exist but where experience tells us they should. Our brains also like to create groups from objects that are close to each other and will group together objects of a similar shape or transform the areas of white space between elements into new shapes.

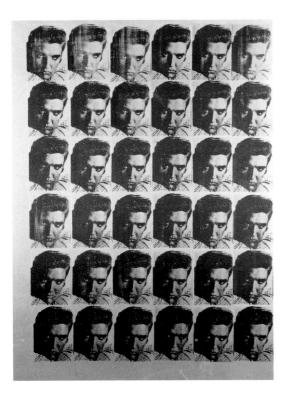

8.3 Andy Warhol, *Red Elvis*, 1962. Synthetic polymer paint and silkscreen ink on canvas, 5′ 9″ × 4′ 4″ (1.77 × 1.32 m). The Andy Warhol Foundation for the Visual Arts, Inc.

Warhol started using silkscreen to transfer a photograph onto canvas in 1962. The image is repeated on a grid pattern, sometimes overlapping slightly. He produced many portraits of celebrity icons, including Marilyn Monroe, Jackie Kennedy, Elizabeth Taylor—and Elvis Presley.

The most logical way to achieve unity is to place objects in **proximity**. Bringing elements close together, like the interlocking pieces of a jigsaw puzzle, and overlapping them will create an homogenous whole, at least in terms of shape and form. When we are reading we recognize words largely by the proximity of the letters. If the spacing between individual letters is increased we begin to lose the ability to see the "shape" of the words and legibility diminishes.

Repetition is another route to a unified image (**8.3**). Repeating elements produce patterns and, as we shall see in Chapter 12, introduce rhythm into a design. Repetition with variation is a powerful stimulus (**8.4**). Think of nursery rhymes and marching chants—repeated phrases with some progressive variations—then consider more complex forms, like campsite rounds and fugues, with counterpoint, and the pleasure they engender. So it is with paintings, sculpture, and architecture: we find delight from discovering harmonious relationships in forms of similar yet slightly varying shapes, marching across our field of view.

Unity by **continuation** is a rather more subtle concept. Our eyes like to follow real or implied lines around a composition, and if the artist has introduced, then hidden, such lines, the viewer's journey around the design will be more intriguing.

In many paintings, especially in graphic design, there will be an underlying **grid** of horizontal and vertical lines that acts as a guide for the positioning of largely rectilinear elements. A too rigid adherence to a grid can result in a boring, checkerboard layout, but a more inventive approach—aligning the top of one element with the bottom of another element some distance away or sharing common edges, for example—can be effective. A grid used in a book, magazine, or website ensures consistency and continuity throughout the publication, and if the grid is sufficiently flexible, there can be enough variety to keep the reader interested.

Curvilinear lines that extend from forms and snake around a composition can generate expectations as the viewer's gaze is led smoothly along these sinuous pathways. Collections of dissimilar shapes attached to these invisible lines can be fused into new, composite forms, integrating areas and forging hidden relationships.

8.4 Paolo da Venezia, *S. Chiara polyptych*, c. 1350. Oil on panel, 5′ 6″ × 9′ 5″ (1.7 × 2.9 m). Gallerie delle Accademia, Venice.

The lavish Gothic frame unites these panels which show stories from the life of Christ. At the center is the Coronation of the Virgin. This panel also illustrates the principle of hieratic scaling.

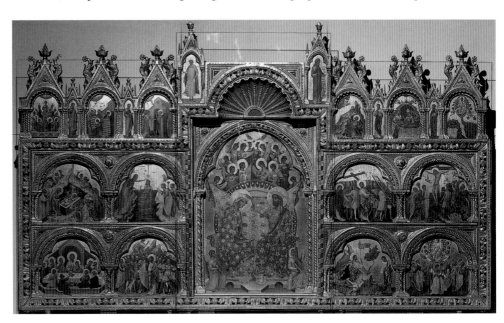

There is a downside, though. Repetition without variety can evoke negative feelings about a world of robotic meaningless jobs and institutionalized living. Too much variety threatens information overload and, ultimately chaos (**8.5**). Most artists aim to simplify reality into ordered, manageable experiences. Others strive to stimulate feelings of unease or alienation with apparently out-of-control assemblages that seem to be just nothing but thrown together, but may, in fact, be carefully considered compositions with an intellectual unity, designed to jolt us out of complacency (**8.6**). As artists experiment with almost every possible combination of control and chaos and their audience has learned to accept and assimilate their once-iconoclastic ideas, it will take more skill and imagination to produce worthwhile works that get us thinking.

8.5 Tomoko Takahashi, *Learning to Drive*, 2000. Mixed media installation. Turner Prize shortlist exhibition, Tate Turner, 2000. Courtesy Hales Gallery.

Takahashi collects found objects and arranges them in a gallery space—exploring the edge between order and chaos. She also lives in the installation she is creating. She explains. "Everything has its own life and I want to make things more themselves, to liberate them from rules."

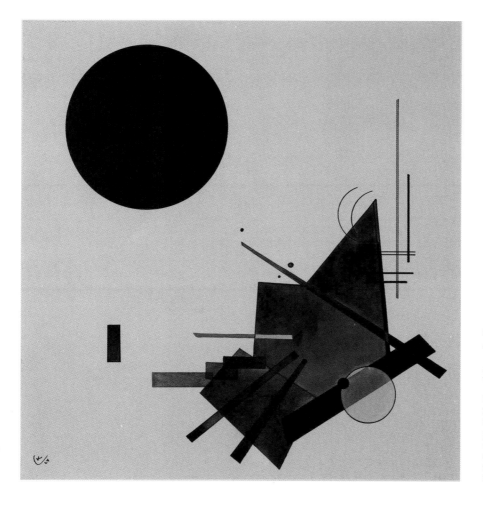

8.6 Wassily Kandinsky, *Black Relationship*, 1924. Watercolor, 14 × 14″ (35.5 × 35.5 cm). Museum of Modern Art, New York. Lillie P. Bliss Bequest.

Bauhaus artists were fascinated by the theories of gestalt. The shapes bottom right are united in their proximity. The circle, as a development of the point and an expression of a positive primary force, held a special importance for Kandinsky.

Thematic Unity

An arrangement of similar or related objects in a composition is called thematic unity (**8.7, 8.8**). If we see a stamp collection, we recognize all the elements as postage stamps, even though the individual stamps may differ in shape, size, and color. They will have different pictures on them, representing different visual textures, and will have different monetary values and be issued by different countries. A page from a stamp album may have several stamps connected by country or date, or, in a thematic collection, by subject—birds or works of art or famous people, for example. On the page, they will be aligned to a grid of horizontal and vertical lines, either in rows or more imaginatively arranged, but still probably positioned according to an underlying framework. Although you may want the pages of a stamp album to have an aesthetic appeal, the purpose behind the arrangement is to allow you to examine the stamps individually and in a logical order.

Some collectors arrange their stamps by country; others by theme. A theme, however, is also a melody that is repeated or on which variations are constructed. Every television series has a theme tune; at a fancy dress party, everyone dresses according to the theme. New media designer Hillman Curtis places theme above almost everything else in a design. In his book *MTIV* (which stands for "making the invisible visible") he wrote: "Themes have power. They can communicate so much more than literal messaging. As designers we have an opportunity to draw attention to theme through our designs ...

8.7 Lois Blackburn, *Sunglasses*, 1999. Batik and painting on silk, 19 ⅝ × 19 ⅝″ (50 × 50cm). Courtesy the artist.

Blackburn illustrates people's collections of objects, drawing them directly in hot wax on silk in a technique similar to batik. Here a collection of sunglasses are arranged in a simple grid.

8.8 Andrew Mockett, *Keil Kraft*, 2000. Woodcut, 18 ⅞ × 13 ⅞″ (48 × 35 cm). Courtesy the artist.

Mockett's repeating pattern of toy gliders with elements of type from the construction instructions can be built up module by module to a print of any size. Each module will be slightly different.

Without communicating a theme, our designs will simply be pretty pictures ... a bouquet of roses with no note attached."

The example Curtis gives is Jack Kerouac's 1957 novel *On the Road*, the theme of which is "reckless discovery." The book is effective, says Curtis, because the theme is never forgotten. You may not relate to the 1950s nor to its locations or plot, but you can relate to its theme. Curtis quotes film director Sidney Lumet from his book *Making Movies*, where he says style emerges from a constant reiteration of the theme, allowing the design to present itself. In the movie *High Fidelity* (directed by Stephen Frears), Curtis identified the theme as renewal, and the art director Nicholas Lundy reinforced this by ensuring that the color green appeared in small doses throughout the film, despite its setting in cold, gray Chicago. Green is the color of spring, and spring is a time for renewal. A book, movie, or painting may tell a story that bears little relation to the details of our lives, but we can all relate to their themes. The artist's job is to make the theme visible.

Simply scattering lots of similar objects around the picture plane does not automatically ensure thematic unity, even if they are somehow related. They must look as if they are meant to be there and are sharing space for a reason (**8.9**, **8.10**). There should be visual similarity between the elements—in shape, texture, and color—and in the important negative spaces between them. The key to thematic unity is repetition with variety, and the skill of the artist and designer is to create a unified composition from the component elements, with some purpose and never forgetting the theme.

8.9 Printed cotton with tractors, 1927. Textile. Russian State Museum, St. Petersburg.

Motifs repeating in a regular fashion soon become pattern, and pattern can also be on the edge of art, as in this Soviet-era textile celebrating progress by depicting the latest model of tractor.

8.10 Michael Craig-Martin, *Knowing*, 1996. Acrylic on canvas, 8 × 12' (2.4 × 3.6 m). Tate, London.

Craig-Martin paints representations of household items arranged in such a way that the scene seems to recede into the distance. This plays with our preconceptions of scale. The objects are unified by theme.

Gestalt and Visual Unity

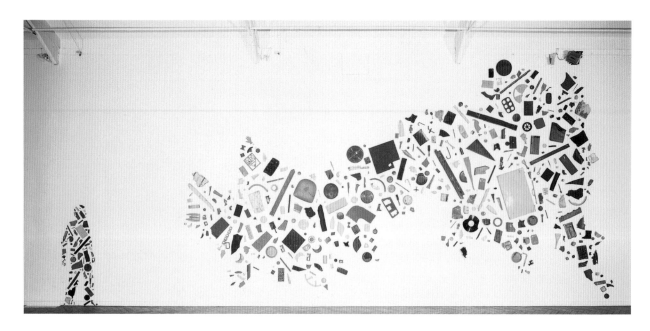

8.11 Tony Cragg, *Britain Seen from the North*, 1981. Plastic and mixed media, 14′ 5″ × 26′ ¼″ (4.4 × 8 m). Tate, London.

Cragg views his native Britain, on its side, through the eyes of an outsider. His work investigates the relationship of the part to the whole. It consists of found plastic objects, grouped by color to form a larger shape. The figure to the left is a self-portrait.

What makes a collage different from a scrapbook page? A collage may be made entirely from scraps, but we notice the whole composition before going on to examine its component pieces. All the elements may have some meaning, but the whole work will have a greater meaning than the sum of, or despite, the meanings of the parts (**8.11**).

The German term for this is gestalt. The Austrian philosopher Christian von Ehrenfels published *On Gestalt Qualities* in 1890 in which he pointed out that a melody played in different keys is still recognizable. If a melody and the notes of which it is formed are independent, a whole is not simply the sum of its parts, but a "whole effect," or gestalt. In 1910, Czech-born psychologist Max Wertheimer saw flashing lights at a railroad crossing that resembled the "moving" lights seen around circuses and theaters. He bought a toy zoetrope, in which a strip of still pictures, viewed through slits, appears to move, made his own strips of simple abstract lines, and began to investigate "apparent movement." He concluded that apparent movement is generated not by the individual elements but by their dynamic interrelation.

In 1923 Wertheimer published a pamphlet, "Theory of form," also called "the dot essay" because it was full of abstract patterns of dots and lines. He said that we have innate tendencies to constellate, or see as "belonging together," elements that look alike (similarity), are close together (proximity), or have structural economy (continuation) (**8.12**).

These tendencies are inborn, not learned—conjuring and camouflage, both of which subvert Wertheimer's laws—are effective across all cultures. But the interplay of such grouping tendencies is far from simple. As simultaneous contrast demonstrates, the appearance of parts (individual colors) is determined by wholes (their context); judgments about similarity or proximity are always comparative; and in compositions as intricate as paintings, parts may be purposely made to connect by one grouping tendency (similarity of color, for example), but to disconnect by others (distance or differences of shape, size, or direction).

One of the phenomena Wertheimer investigated was **closure**—the tendency to perceive incomplete forms as complete. Just as we join up the dots to see implied lines and constellations of stars, so we see shapes in incomplete patterns. Artists supply minimal information and a few clues; viewers provides closure, impose meaning, and recognize shapes that aren't really there. Gestalt theory explains how, when we squint, we see the value patterns (see Chapter 6) of light and dark shapes underlying a composition. Closure also acts on negative space, making the areas between elements into new shapes, and adding interest and meaning to a design. With carefully chosen spacing, any selection of seemingly unrelated objects can be organized into a harmonic unity, as they begin to relate and participate in implied groupings (**8.13**).

None of the gestalt psychologists was an artist, but their work had an effect on the Bauhaus artists Klee, Kandinsky (see **8.6**), and Albers and on designer László Moholy-Nagy (1895–1946). One of the reasons artists embraced gestalt theory is that it seemed to provide a scientific validation of age-old principles of composition. But because of its emphasis on flat, abstract patterns and structural economy, gestalt theory has become associated with Modernism.

The dynamic interplay of parts and wholes had, however, been anticipated as early as the 3rd century BC in China in the *Tao Te Ching*. The ideas of structural economy and closure are echoed in the Japanese emphasis on eliminating the insignificant, and in the ideas of implicitness and the active complicity of the viewer, because genuine beauty, said Okakura Kakuzo in *The Book of Tea*, "could be discovered only by one who mentally completed the incomplete."

8.12 (above) Alan Pipes, Gestalt, 2003. Macromedia FreeHand drawing. Courtesy the author.

The four main principles of gestalt are proximity, similarity, closure, and continuance. In the top diagram, we see two groups of elements sharing proximity. In the middle diagram we see a circle (closure) formed from elements of similar value. Bottom left, the gray cross highlights lines of continuance.

8.13 Louise Nevelson, *Black Wall*, 1959. Wood painted black, 24 units, 104 × 85 ¼ × 25 ½" (264 × 216.5 × 65 cm). Tate, London.

Nevelson collected wooden objects, assembled them, and painted them satin black. A crate she received one Christmas gave her the idea to place her assemblages into boxes. When she ran out of space, she stacked the boxes into a grid—creating her style of sculpture.

The Grid

A grid is a rectilinear arrangement of horizontal and vertical lines, often spaced at regular intervals, like graph paper. The simplest form of grid is the checkerboard—a regular array of squares (**8.14**). Many city plans are based on a grid—most of Manhattan and the 19th-century area of Barcelona, for example.

Grids provide continuity, either between a series of elements in a single composition, or in multiple designs, as in a series of related paintings or prints, or in the layout of books, magazines, and websites. The purpose of the grid is to unify a set of pictures or pages so that they look as if they belong to the same "family."

The De Stijl artists Mondrian and van Doesberg made extensive use of grids in their abstract paintings (**8.16**), and many contemporary artists relish the discipline that the grid can impose (**8.15**). But it is graphic designers who find the grid most useful or who reject it as a relic of uptight design. The grid came to prominence in the 1920s with Bauhaus-inspired periodicals by designers such as El Lissitzky (1890–1941) and reached the height of popularity with the post-war Swiss International Style.

The simplest type of grid is used for fiction books—a single column of text is surrounded by margins of white space. The column width is fixed horizontally, and the text is "wallpapered" page after page until the end of the chapter is reached. If there are illustrations, they can only be full column width, centered, or ranged (aligned) with the left or right edges of the text.

More complex grids are used for brochures, magazines, and newspapers—the more columns there are, the greater the opportunities for variety. Text can be the width of a single column or stretched across two or more columns. Pictures can be spread across any number of columns. There is even more flexibility vertically, with the designer aiming to hang or sit images on arbitrary horizontal lines.

8.14 (left) Tim Spelios, *Under the BQE*, 1998. Cut-and-pasted photographs on board, 80 × 60″ (203.2 × 152.4 cm). Edition of 3. Courtesy the artist.

Spelios takes scraps of paper, a styrofoam container, a gift bow, and other detritus—all found under the Brooklyn to Queens Expressway, the BQE in the title—and collages them into an aesthetically pleasing grid.

8.15 (right) Robert Rauschenberg, *Retroactive I*, 1964. Oil on canvas, 84 × 60″ (213.3 × 152.4 cm). Wadsworth Atheneum, Hartford, CT. Gift of Susan Morse Hilles.

Rauschenberg's grid is not so regular, but is still recognizable. He takes mass-media printed ephemera and silkscreens it onto canvas, in a similar way to Warhol (see **8.3**) to create memorials to more optimistic times.

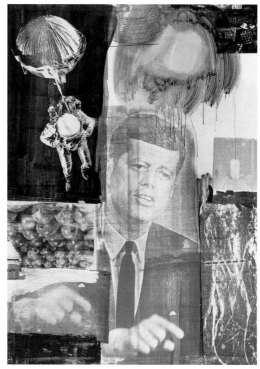

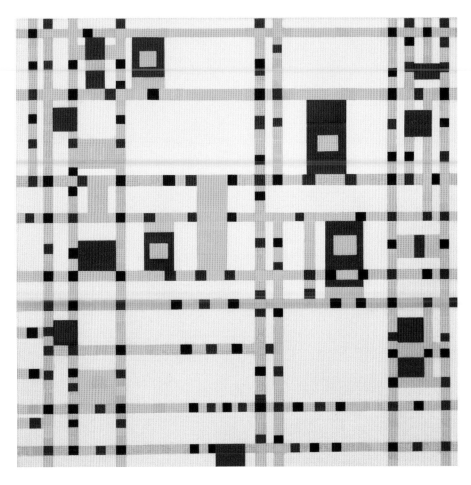

8.16 Piet Mondrian, *Broadway Boogie Woogie*, 1942–3. Oil on canvas, 50 × 50″ (127 × 127 cm). Museum of Modern Art, New York.

This picture is based on New York's grid pattern. It omits black and breaks Mondrian's once uniform bars of color into multicolored segments, bouncing against each other, creating a pulsing rhythm that jumps from intersection to intersection like the streets of his adopted city.

8.17 Website layout, Meta design screenshot. Courtesy the author.

Website designs are constrained by the code needed to create them, designers using hidden tables—a system of rows and columns—to align elements onto an underlying grid. This is no bad thing, as a clearly constructed site will be simple to navigate and assimilate, and have consistency over all the pages.

Before there were computers, designers would "cut and paste" typesetting and images onto boards, preprinted with grids in pale blue that wouldn't print, called mechanicals. Computer programs such as Quark XPress and Adobe InDesign demand grid information right from the start of a project; and although it is possible to over-ride or "break" the grid to create unexpected interest, it is always there if you need it. Graphic designers work with master pages, grids that set out where elements such as the text area, page numbers, and running headlines should be placed, thus achieving continuity thoughout a document. Designers of corporate identities supply style guides that specify how elements are to be positioned, complete with allowable white space, so as to ensure consistency across a wide range of different formats, sizes, and scales, from business cards to the sides of trucks.

Designers who created early websites had little control over layout. One method was to use invisible tables, and tables within tables, allowing them to position elements, such as blocks of text, images, and transparent spacers, into cells that could span multiple columns or rows (**8.17**). The only alternative was to use a program such as Photoshop to organize elements into large, user-unfriendly images of text and pictures. Web design programs GoLive and Dreamweaver still use tables to underpin their layout tools.

Achieving Unity

We generally prefer structure and simplicity to chaos, and one way of unifying a collection of shapes, particularly rectangular ones like the elements in an abstract painting or the images on a page layout, is to arrange them so that their edges line up. This **alignment** can be done overtly—a row of stamps in a checkerboard grid, for example—or more subtly, by **hanging** the top edges from a line, **sitting** the bottom edges on a line, aligning the top edge of one element with the bottom edge of another, by lining up their centerpoints or perceived centers of gravity, or aligning edges within an element with other edges elsewhere in a composition. Lines of edges thus form continuations that are relaxing on the eye and less work to "read."

Unity can also be achieved by using similarity and proximity, continuation and continuity. Similarity refers to the ways in which items look alike (**8.19**); proximity refers to the ways in which items are positioned relative to one another. The more

8.18 Edouard Manet, *Le Déjeuner sur l'herbe*, 1863. Oil on canvas, 6′ 9″ × 8′ 10″ (206 × 269 cm). Musée d'Orsay, Paris.

The characters are united by nearness and overlapping. Manet wanted to re-create classical compositions by Giorgione and Titian in modern dress (and undress).

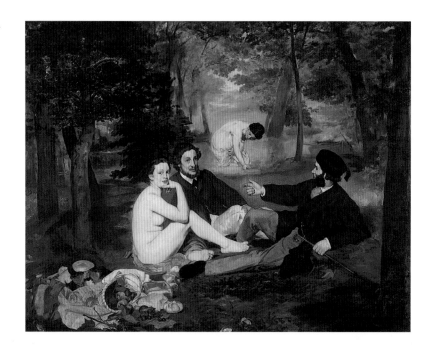

8.19 British School, *The Cholmondeley Ladies*, c. 1600–10. Oil on panel, 35 × 67″ (88.9 × 172.7 cm). Tate, London.

This quaint painting by an unknown artist was once in the collection of Thomas Cholmondeley (pronounced "Chumley"). They are said to be sisters, although the different colored eyes of the ladies and children show that they are not identical twins.

alike the objects are, the more likely they are to form groups, but if objects are distinctly dissimilar, they will resist grouping. Proximity will generally take precedence over similarity, but the greatest unity will be achieved when the two are used together. These tendencies can be used either to group or break groups apart, depending on the intention of the artist.

Objects can form a group if they are of a similar size, but only if the similarity between the sizes is more obvious than the similarity in their shapes, but because there is greater scope for size variation than shape differences, size is often the dominant factor (**8.18**).

The next type of similarity is that of **value** or **color**. Value is, of course, a component of color but whereas color makes items stand out and is hence a good grouping tool, a strong value pattern can be an even more powerful unifying factor. Similar shapes, and similarities in direction and texture can also form groupings.

The four main types of proximity are nearness, touching, overlapping, and combining. The closer items are to each other, the more likely they will be seen as a group. The distance between the objects is relative and subjective. **Nearness** grouping is particularly important in typography, because words are recognized as shapes, and when letters are too far apart they lose legibility. If there is too much space between words, especially when lines of type are too close, this may create unwanted vertical groupings.

Move objects closer together, and they will eventually touch each other (**8.21**). They may still be separate objects, but they will appear to be attached. The strongest proximity happens when elements overlap (**8.20**). If the two items are the same color or value, they form new, more complex shapes; if the items are different colors or values, the overlap produces the illusion of shallow space, warm shapes coming forward, and cooler ones receding.

Grouping objects together by using an external element can cause them to combine regardless of what other unifying strategies are being used. **Combining** can both group a collection of items and isolate them from the rest of the composition. Examples of the strategy include underlining or highlighting text, putting boxes around objects, or placing objects against a colored background.

8.20 (above) Edward Burne-Jones, *The Golden Stairs*, 1880. Oil on canvas, 9′ 1″ × 3′ 10″ (2.69 × 1.17 m). Tate, London.

Burne-Jones made his pictures enigmatic. Are the eighteen women all spirits in an enchanted dream or is the painting purely decorative? The underlying idea, popularized by the critic Walter Pater, is that "all the arts aspire to the condition of music."

8.21 William Roberts, *Trooping the Colour*, 1958–9. Oil on canvas, 72 × 107″ (182.9 × 274.3 cm). Tate, London.

This military parade takes place every June on the Queen's Official Birthday. She is seen on the only chestnut horse, with the Duke of Edinburgh to her left. Roberts has compressed a pageant of human and equestrian movement into this painting.

Artists have used grids to "square up" small sketches or cartoons (preparatory sketches) to large-scale canvases or frescos, or they have used geometric constructions, such as the golden section (see Chapter 10), as a starting point or underlying framework to help position elements within a design.

Shapes that share a common edge—either touching or abutting—are easy to unite and appear to inhabit the same spacial plane. When shapes with a common border also have a similar value or color, the dividing line between them starts to disappear and the two shapes merge into a new shape. Shapes that are some distance apart need some sort of invisible framework to unite them, and an underlying grid can be useful. The eye of the viewer is drawn along these edges, unifying the image.

Continuation is another device for directing the viewer's eyes around a composition. It is based on the idea that once you start looking along an edge, you will continue to look in that direction until you see something significant. This is a kind of closure, involving grouping disconnected shapes by movement and momentum. We use this in reading when we jump the gaps between words to make sense of sentences.

8.22 (above) Arthur Hughes, *April Love*, 1855–6. Oil on canvas, 35 × 19″ (88.9 × 49.5 cm). Tate, London.

Hughes based this painting on a Tennyson poem, "The Miller's Daughter," whose theme is the frailty of young love. The figure is off-center but is brought into balance by her eyes looking at the fallen rose petals, a symbol of love's transience.

8.23 Paul Cézanne, *Dr. Gachet's House at Auvers*, 1872–3. Oil on canvas, 18⅛ × 15″ (46 × 38 cm). Musée d'Orsay, Paris.

Cézanne uses the simple device of a country road in perspective, winding into the picture, to lead viewers toward a focal point in the composition—Dr Gachet's house.

Artists use various pointing devices to direct the gaze of the viewer and lasso shapes together. The first is eye direction (**8.22**). If a figure in a composition is looking in a particular direction, you will want to know what they are looking at. Next time you are outdoors, stop and look up to the sky—you will be surprised how many people will join you. Physical pathways, such as roads and rivers winding into the picture (**8.23**), and lines of perspective are other ways that artists have used to lead viewers toward a focal point in a composition. Other artists, particularly in the baroque period, used draperies to continue the lines from a figure's limbs, along the edges of the billowing cloth, to the edges of trees and rocks and back around other figures in the composition (**8.24**).

These extended serpentine edges can bring the entire composition into a harmonious whole. Projecting and continuing the edge of a shape and placing new shapes along the shared edge will create movement and rhythm, increasing the anticipation of the viewer that something fascinating will soon be found in an as yet undiscovered location. Interrupting the line with disguised or lost-and-found edges will add anticipation and intrigue to the experience.

Extended edges, like the grid, can be used to unify realistic images, decorative space, or abstract paintings, but try not to be too obvious. Vary and cover your tracks with counter-movements, accented regions, and false trails. The odd duff note in a rock song makes it human and easier to relate to. In the same way, temper too much harmony and repetition with variety, giving your designs edge and an individual touch. The challenge is to add excitement, contrast, change, and unpredictability to the bedrock of unity—and never forget the theme.

8.24 Peter Paul Rubens, *Samson and Delilah*, c. 1609. Oil on wood, 72 ⅞ × 80 ¾″ (185 × 205 cm). National Gallery, London.

Lines of continuance and extended edges lead us round and round this composition. Rubens shows a Philistine cutting the sleeping Samson's hair—the painting's focal point. Behind them is a statue of Venus and Cupid—a reference to the cause of his fate.

Exercises

1 Collections: Do you collect anything? Draw a few items from your collection (or that of a friend) on a plain background, paying attention to the white spaces between the objects. Try to avoid too rigid a grid. Look for a sense of unity and harmony.

2 Seeing things in a new light: Take some everyday objects that you may not normally associate with each other—from the kitchen and bathroom, for example—and arrange them against a background from a wholly different context. Try unusual angles and changes of scale.

3 Gestalt collage: Make a series of collages each consisting of a word and a picture. The picture may suggest the word, or vice versa. Make the word from large letters cut from magazines complete with an area of background, touching and overlapping the letters and their backgrounds. Use similarity to highlight certain words, for example, surrounding or overlapping a word such as "grass" in shades of green.

9 | Balance

"I find sometimes I may want to end up with subtlety, but I have to start out boldly ... All I can say is that you have to lean over a little to the left, and overdo it a bit, and then come back into balance, that ever-important balance."

ANDREW WYETH

Lubaina Himid, *Between the Two My Heart Is Balanced*, 1991. Acrylic on canvas, 60 × 47" (152.4 × 121.9 cm). Tate, London.

This picture belongs to a group entitled "Revenge," which aims to promote black women's voices as alternatives to those of white men. Here Himid parodies a painting by Victorian artist James Tissot, the original of which shows a Highland soldier seated in a boat between two women admirers.

Introduction

A design may have unity and be a coherent whole, but it may also need a degree of visual balance. We like balance. We try to balance our financial affairs and strike the right balance between work and play. We are also mostly symmetrical beings, at least on the outside, with two of everything—eyes, ears, arms, legs—except for those parts, like the nose and mouth, that are lined up along a central axis. But that symmetry is not quite a mirror image. Studies mirroring just the left or just the right side of faces show there are slight but distinct differences—the tiny flaws and subtle variations that make us look human.

Balance in a design aims to distribute the visual weight of elements so that they appear to be in equilibrium. In Chapter 8 we learned to balance repetition with variety. Now we will look at balancing the actual elements. A fulcrum, or point of balance, is the point on which a lever pivots. On an old-fashioned set of scales, if the weights placed in the pans on either side are of equal magnitude, the scale will be horizontal, tipping neither one way nor the other. If you have studied the math of levers, you will know that it is possible for a small weight that is placed a long way from the fulcrum to be in perfect balance with a heavier weight positioned nearer to the center point.

In art, a composition in which the main object is placed in the very center of the picture, with an equal distribution of elements at each side, is said to be **symmetrical** about the vertical axis, the line running from the center top to center bottom of the picture frame (**9.1**). Many early religious paintings are symmetrical, with all attention focused on a central figure, while subsidiary figures at the sides will generally emphasize this focal point by looking or gesturing toward the central axis. A symmetrical design is in equilibrium, like a balanced set of scales, but a perfectly symmetrical composition is generally static, and the only scope for movement is up or down the vertical axis (**9.2**).

Being off-balance makes us feel uneasy and apprehensive—like waiting to see if a tightrope walker will fall—but an off-balance composition can be more dynamic and visually interesting. A painting or sculpture with more appearing to be going on to one side of the composition than the other is said to be **asymmetrical** (**9.3, 9.4**).

9.1 Titian, *Sacred and Profane Love*, 1514–16. Oil on canvas, 46 ½ × 109 ⅞″ (118 × 279 cm). Galleria Borghese, Rome.

Titian painted this near-symmetrical painting to celebrate the marriage of the Venetian Nicolò Aurelio and Laura Bagarotto. The misleading title is a 17th-century interpretation giving a moralistic reading of the nude figure, which the artist intended to be an exaltation of both earthly and heavenly love.

An asymmetrical design need not be unbalanced, however. In a symmetrical painting or sculpture, the elements in equilibrium will generally be shapes and forms of a similar size, but other factors, such as value, color, and texture, will also come into play. A large, dull, amorphous shape, or an area of white space, can be balanced by a small but eye-catching patch of intense color, for example (see **7.38**). We anticipate balance, if we see something capable of motion is moving to its rightful space. Invisible lines, created by eye direction, can take up some of the weight of an otherwise unbalanced element (**9.5**), tying it into the design like the anchor chain of a boat. Even the way we read—left to right in Western cultures—has a bearing on how we see elements balancing.

9.2 (right) Antonio and Piero del Pollaiuolo, *The Martyrdom of Saint Sebastian*, c. 1475. Oil on wood, 114 ¾ × 79 ¾" (291.5 × 202.6 cm). National Gallery, London.

This symmetrical picture tells the story of Saint Sebastian who was shot with arrows on being discovered a Christian. The six archers have three basic poses, turned through space and seen from different angles.

9.3 Katsushika Hokusai, *Mount Fuji in Clear Weather*, 1830s. Colour print. British Museum, London.

The mass of the mountain is balanced by the texture of the white clouds. Japanese prints are rarely symmetrical.

In addition to horizontal balance, artists also consider vertical balance, which is not so straightforward. We are familiar with seeing an expanse of relatively featureless sky at the top of a landscape, and this affects the placement of objects, which tend to be grouped mainly toward the lower portion of a picture. This positioning also ties in with our appreciation of gravity: the higher we place objects, the more unstable a composition will feel—an inverted triangle standing on an apex seems more unsteady than a pyramid. But if instability and movement are necessary themes of a design, the more off-balance elements are, both vertically and horizontally, the better.

There are two other kinds of balance or non-balance. **Radial balance** has symmetry in circular or spherical space, with lines or shapes growing and radiating from a central point (**9.6**), like a mandala, daisy, or sunflower, or the rose-window of a cathedral, creating an immediate and obvious focal point. **Crystallographic balance** occurs when there is equal emphasis or an **allover pattern** with an absence of a focal point, where the eye is attracted everywhere and nowhere.

Psychological weight also plays a part in our "reading" of a composition. A circle positioned toward the top of a picture might represent the sun or the moon or a hot-air balloon, and we would be happy with its placement and may even perceive the sensation of its ascending. But we would expect a heavy object to fall, thus creating tension in the design. Non-objective elements have fewer symbolic properties than realistic objects, but they nevertheless have perceptual balancing connotations, depending on their shape, color, and texture.

Static symmetrical balance is also called **formal balance**, especially in architecture. Symmetry conveys a sense of stability, permanence, and dignity, as typified by Classical and Neo-classical designs. It could be argued that symmetrical buildings, like symmetrical product designs—an automobile, for example, is symmetrical in its plan view—are easier to make and build. Computer-aided design makes more complex asymmetrical forms possible, but whether they are as aesthetically acceptable to the public is another matter.

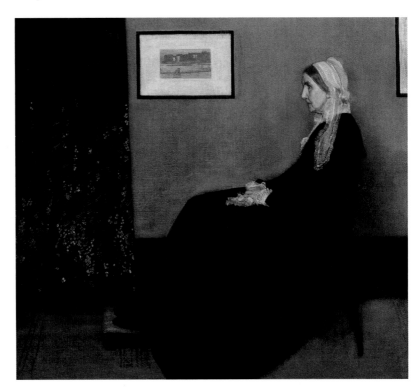

9.4 James Abbot McNeill Whistler, *Arrangement in Black and Gray (Portrait of the Artist's Mother)*, 1871. Oil on canvas, 4′ 9″ × 5′ 4″ (1.45 × 1.64 m). Musée d'Orsay, Paris.

This well-known painting is a perfect example of asymmetrical design.

Symmetrical balance appeals to our sense of order—our tendency to make things tidy by putting pencils and pens in straight rows or arranging similar sized pictures on either side of the fireplace. If we opt for asymmetrical or informal balance, we are being more subtle, taking time to position objects that are dissimilar in terms of their shape, size, and color so that an overall sense of equilibrium results. Compositions may seem more casual and unplanned, but they will require more thought and be richer than a simple, symmetrical, grid-like distribution. An asymmetric placement of elements may be purely intuitive, or it may be done according to the rules of proportion.

Many of us will have been taught at school the "rule of thirds"—to divide a composition horizontally and vertically into three and to position key elements at the points where the lines intersect. This is a useful rule and is based around a system of "ideal" proportion known as the golden section (see Chapter 10). For now, however, we will examine the ways in which elements can be balanced within a composition by their shape, size, and texture, by their position and direction, and by their value and color.

9.5 Edouard Manet, *Stéphane Mallarmé*, 1866. Oil on canvas, 10 ¼ × 14 ⅛" (27.5 × 36 cm). Musée d'Orsay, Paris.

Mallarmé was a Symbolist poet, writer, and critic—and close friend of Manet. Although seated to one side of the picture, his eye direction and the cigar as a focal point bring the composition into balance.

9.6 Soviet Russian cotton headscarf with sunburst motif, 1920–30. Textile.

Radial balance has symmetry in circular or spherical space, with lines or shapes growing and radiating from a central point, like this sunburst, creating an immediate and obvious focal point.

Formal and Informal Balance

9.7 Anthony Caro, *Emma Dipper*, 1977. Painted steel, 84 × 67 × 126" (213.4 × 170.2 × 320 cm). Tate, London.

Emma Lake in Canada was where Caro worked in 1977. Because of its relative inaccessibility, he used lightweight steel tubing and beams. The curved shapes on the left balance the rectilinear shapes on the right.

Formal balance is generally geometric and usually symmetrical, and it is characterized by the repetition of identical or similar elements on either side of a central axis. **Informal balance** is asymmetrical and more curvilinear, and it is often fluid and dynamic, creating a sense of curiosity and movement (**9.7**). Think of garden design. A formal garden is structured around geometric, often symmetrically positioned and planted beds, separated by clipped hedges and straight paths (**9.8**). An informal garden is characterized by sweeping curves and naturalistic areas of planting.

Formal balance is created when equal, or very similar, elements are placed on opposite sides of a central axis. It is the easiest kind of balance to recognize and to create. Many public buildings use formal balance to create a sense of permanence and dignity. Symmetrical balance is a special type of formal balance in which two halves of a composition are identical, a mirror image of one another. Because formal balance is so predictable, many artists use a more flexible form of **near symmetry**, also called approximate symmetrical balance, which is almost symmetrical, but not quite.

Formal balance is static and can be boring. Informal or asymmetrical balance is a way of organizing the elements of a design so that one side differs from the other but does not destroy the overall harmony. In informal balance the elements create equilibrium without being static. It is, therefore, dynamic and more exciting than formal balance, but it requires a little more imagination. Formal balance is consistent with more even divisions of the visual, whereas informal balance may use unequal proportions to achieve its effect.

The Renaissance architect Andrea Palladio (1508–80) was inspired by Classical architecture to create carefully proportioned buildings, such as the Villa Capra, also known as La Rotonda, which are symmetrical both in plane and elevation (**9.9**). These became models for stately homes and government buildings in Europe and North America, and US statesman Thomas Jefferson used Palladian ideals when he designed Monticello, his home in Virginia.

9.8 Garden of the Villa Gamberaia, Florence, 17th century and later.

A formal garden design is rigidly laid out in measured geometric flowerbeds, adhering to a strict plan; an informal garden is more laid back, with sweeping curves and naturalistic areas of planting.

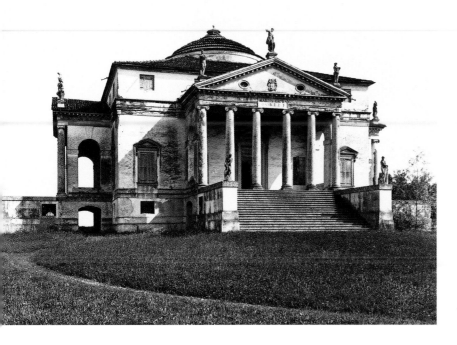

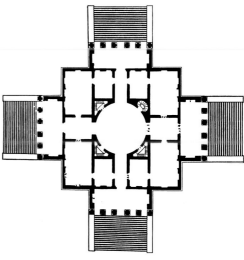

Greek architecture used the optical center, which is just above the mathematical center of a visual, as the exact center. An optical illusion causes the center of an object to appear slightly higher than its actual center, and the optical center of an image can be more pleasing to the eye than its mathematical center. This is the same principle that dictates that the bottom margin of a page or the width of a mat or mount in a picture frame is usually wider than the top and side margins.

In contrast, buildings such as the Imperial War Museum North in Manchester, England, designed by Daniel Libeskind (b. 1946), and the Guggenheim Museum in Bilbao, Spain, designed by Frank Owen Gehry (b. 1929), can be said to be informally balanced because their fragmented, deconstructed forms display no symmetry at all (**9.10**). They are, in effect, giant sculptures. Gehry has commented: "I don't know where you cross the line between architecture and sculpture. For me, it is the same."

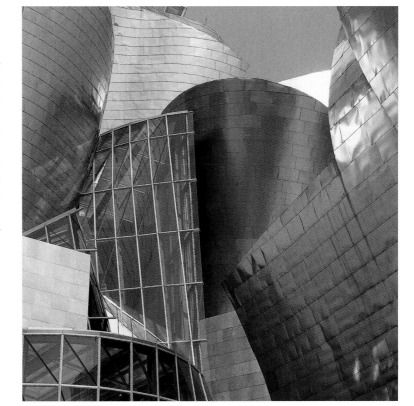

9.10 Frank Gehry, Guggenheim Museum (detail), Bilbao, Spain, 1997.

Gehry's deconstructed Guggenheim Museum in Bilbao, Spain, can be seen as giant sculpture.

Symmetrical and Asymmetrical Balance

True symmetry is a mirror image—one side of an object or design is a reflection of the other. Symmetry can occur in any orientation—horizontally, vertically, or about a diagonal—as long as the image is on either side of the axis.

Symmetry is very appealing. We are very nearly symmetrical beings, after all, and our axis of symmetry is about the vertical, which makes a good model for art and design. The strong emphasis on the center axis in symmetry provides a natural focal point, which can be easy to overemphasize. Top to bottom balance is also important, and images seem more stable if the lower section appears to be slightly heavier. A composition that is too top heavy can look precarious. Balance between the center and the edges of the image must also be considered.

Objects in the real world are rarely symmetrical. Leaves and flowers may look symmetrical, but close examination will reveal slight differences from one side to the other. Near symmetry or approximate symmetrical balance is more true to life—the two halves are similar but not identical. The slight variations will have little effect on the overall balance, but there will be more potential for variety (**9.11, 9.12**).

Inverted symmetry uses symmetry with one half inverted, like a playing card, which is an interesting variation but can make for awkward balance. **Biaxial symmetry** uses two axes of symmetry, vertical and horizontal, which guarantees top and bottom balance, as well as left and right balance. Top and bottom can be the same as the left and right, or they can be different. It is also possible to

9.11 Leonardo da Vinci, *The Last Supper*, c. 1495–8. Tempera wall mural, 15′ 2″ × 28′ 10″ (4.6 × 8.8 m). Sta. Maria delle Grazie, Milan.

Leonardo's famous fresco is near symmetrical, balanced around the figure of Christ in the center, with his disciples depicted in groups of three. It is painted parallel to the picture plane as if we were hovering at Christ's eye level, rather than standing on the refectory floor.

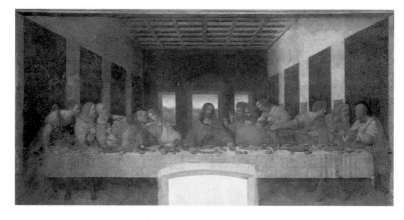

9.12 Leonardo da Vinci, *The Last Supper* with orthogonal lines.

By placing Christ in the center, as the focal point, with orthogonals leading toward him, Leonardo creates a stable triangle symbolizing Christ's calmness amongst the distraught group. It is the moment when Christ states that one of them will betray him.

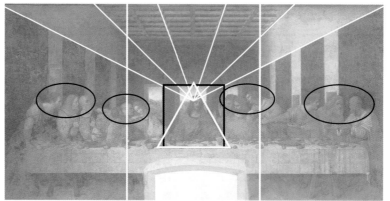

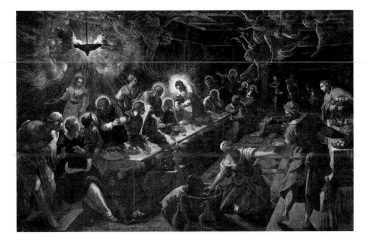

9.13 Tintoretto, *The Last Supper*, 1592–4. Oil on canvas, 12′ × 18′ 8″ (3.66 × 5.69 m). San Giorgio Maggiore, Venice.

Tintoretto takes the same scene as Leonardo but treats it asymmetrically. He chooses a different moment—the first communion. The two brightest areas, Jesus and the light fixture, fight for the viewer's attention and create a sense of uncertainty.

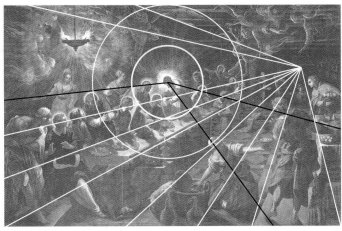

9.14 Tintoretto, *The Last Supper* with orthogonal lines.

Tintoretto places the table at an angle to the picture plane, and includes genre figures, such as the waitresses, to ground the viewer in reality. But he also has angels flying into the room, to give a balance between heaven and earth.

have more than two axes—snowflakes and kaleidoscopes, for example, have three axes of symmetry.

When there is too much symmetry, however, we enter the realm of pattern. All children fold paper and cut out shapes with scissors to produce lines of dancing dolls or circular doilies, and many will have used folded paper to "print" wet ink or paint, producing Rorschach-type ink-blot shapes. *Notan*, meaning dark–light, is a Japanese ideal of symmetry and an aesthetic version of these games. The principle of *notan* is the interaction between positive (light) and negative (dark) space, figure (or field) and ground. The cultures practicing *notan* seek a more balanced view of the world, just as the yin–yang symbol is an example of this desire for balance.

Informal or asymmetrical, on the other hand, is used to describe a composition that does not rely on symmetry (**9.13, 9.14**). There is no simple way to achieve balance by asymmetry, hence the term informal balance—it is for the artist to sense whether the composition is successfully balanced. If your eyes are continually drawn to the same off-center area, the balance is possibly suspect.

There are many ways of achieving balance with asymmetry, and these are examined in the following pages. A small, visually interesting object can balance a much larger, less interesting object or an area of negative space. Although there may be few rules or limits with asymmetrical balance, that does not mean that anything goes. The size, shape, color, and placement of the elements must be carefully and creatively adjusted before balance can be achieved. Dada and Punk artists composed images and designs deliberately lacking balance. They may have wanted to appear "anti-design," but planning a lack of balance to create a mood of chaos is still designing.

Balance by Shape and Texture

Although it is easier to balance elements by near symmetry (few if any paintings are exactly symmetrical), asymmetrical compositions form by far the larger group. In attempting to balance elements asymmetrically, we are using combinations of many attributes—shape, texture, color, value, position, and direction—to distribute visual interest around the canvas so that the overall effect is one of equilibrium.

In symmetrical arrangements, shapes are matched either side of a reflecting axis, and in the most extreme case they will be identical or, rather, mirror images of one another. The result is a static composition, and it will be necessary to introduce some variety. If there is a figure either side of the central character, for example, they may be in similar positions, but could be expressing different gestures or striking slightly different poses. If the colors of the costumes are varied, however, the artist must be careful not to throw the composition off balance by using one set of colors that is more eye-catching than the other.

In asymmetrical design the scheme is more forgiving, and we can place different objects to balance one another (**9.16**). Two elements, differing only in shape, could constitute a balanced composition if, for example, one was a large, simple shape and the other a smaller but more complex and busy shape (**9.15, 9.17**). In effect, we are equalizing the amount of information in each shape. A simple shape could be described using only a small amount of data compared with a more complex shape

9.15 J.M.W. Turner, *The Fighting "Temeraire" Tugged to her Last Berth to be Broken Up*, 1838. Oil on canvas, 35 × 48″ (90.8 × 121.9 cm). National Gallery, London.

The old ship pulled by a steam tug to the scrapyard is balanced by the dramatic sunset. There is also a balance between the thick paint of the sun's rays striking the clouds and the meticulously rendered ship's rigging.

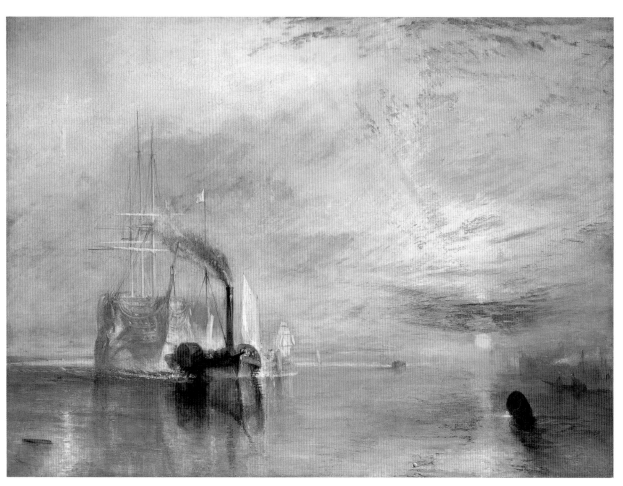

9.16 Jean-Baptiste Siméon Chardin, *Pipe and Jug*, n.d. Oil on canvas, 12 ¾ × 16 ½″ (32.5 × 42 cm). Louvre, Paris.

In this closed-form still life, the relatively large light-valued masses of the jug and similar items are balanced by the diagonal sweep of the pipe stem, leading our eyes to its smoking bowl.

in terms of dimensions, number of vertices, straight lines versus curves, angles of corners, and so on. It is as if our brains take longer to compute a complex shape, and this compensates for the data required to describe size.

As complexity increases, shapes turn into textures. There is more information in a highly textured shape than in a flat, smooth shape. Given two identical shapes and ignoring the effects of value and color, our eyes will be attracted to the one with obvious texture. As shapes break down into amorphous areas of pure texture, it should be possible to balance a small, distinct shape by a patch of texture or pattern.

In graphic design, blocks of text can be treated as areas of texture and can be used to balance photographs and illustrations on a page layout or website. Taken to a logical extreme, we can balance shapes with areas of nothingness, or white space, as long as it is obvious where the boundaries of the picture frame lie. This is a skill mastered by Chinese and Japanese artists—it is rare to see symmetry in Oriental art.

All shapes and forms have some sort of texture, whether they are smooth and shiny or rough and granular. Balance will best be achieved when both shape and texture are taken into account, with a small shape of interesting texture balancing a larger area of less visual interest, and a range of different shapes with differing textures will add variety to a composition. Achieving asymmetric balance is not easy: there is no center point and no dividing axis of reflection. We have to use our intuition and judgment to estimate the implied weights of shapes and textures, their tensions and forces, to create a balanced yet dynamic visual experience.

9.17 Henri Rousseau, *The Snake-Charmer*, 1907. Oil on canvas, 66 ½ × 74 ⅝″ (169 × 189.5 cm). Musée d'Orsay, Paris.

The snake-charmer stands off-center, in silhouette, balanced by the mass of trees and rushes. Rousseau never went abroad, making his studies of exotic flora and fauna at the botanical gardens in Paris.

Balance by Position and Eye Direction

9.18 (left) Paul Cézanne, *Madame Cézanne*, c. 1890–95. Oil on canvas, 51 ⅛ × 38″ (130.5 × 96.5 cm). Musée d'Orsay, Paris.

Madame Cézanne sits almost symmetrically in this composition, her slight movement off-center being balanced by her eye direction and the accent of the coffee cup.

9.19 (right) Jusepe de Ribera, *St. Jerome*, 1616–20. Oil on canvas, 70 ½ × 54 ¾″ (179 × 139 cm). Parish Museum, Collegiate Church, Osuna.

Ribera was a follower of Caravaggio, painting in the tenebrist style. Here St Jerome is depicted in an asymmetrical arrangement, the figure of the hermit balanced by a trumpet-blowing angel (see **9.27**).

The position of elements in a composition depends on the intention of the artist and on the subject matter. The simplest possible composition would be a single object placed in the center of the picture plane, surrounded by white space: simple and possibly symmetrical, depending on the object. A symmetrical object, such as a front-on figure, or a piece of fruit, a vase, or a bottle, placed thus would automatically create a symmetrical composition (**9.18**). An asymmetrical object will immediately cause problems. Western eyes tend to read from left to right, endowing the object with direction, and if the object is recognized as being capable of movement, we will anticipate it moving. A single fish placed centrally, for example, will throw the composition off-balance—the head is the focal point and would need space in front of it potentially to move into.

When there are several objects to place, there is more room to maneuver. Just as we achieve balance on scales by placing objects that are the same weight equal distances from an axis or fulcrum, we can create a symmetrical or near symmetrical design. An odd number of objects or a variety of different shapes will give an asymmetrical layout. As with items balanced on a fulcrum, a shape placed close to the central axis may appear heavier than one placed near the outer edge of a composition, and two or more small shapes can balance a single, larger one. We can also use gestalt theory to group certain objects, so that one group balances another,

or position larger objects or groups nearer the fulcrum and smaller groups or objects further away on the opposite side.

In figurative compositions other factors come into play. Figures in paintings have eyes and are generally looking at something. The implied lines that join the eyes to the object being looked at attract our attention—we are curious to know what the characters are looking at—and implied lines and extended edges link objects and help to unify a composition (**9.19**). They also have a "magnetic" effect on the weight and position of a figure or object. If someone is looking away from the center of the painting—out of the frame, for example—we feel their shape drifting toward the edge of the picture. If someone is looking into the picture, their shape will be pulled toward the center of the image (**9.20**). It is as if we anticipate them moving toward the object of their gaze.

Similarly, the orientation and shapes of objects can alter their perceived position and thus upset or reinforce the balance of the composition. Obvious examples are arrows, spears, and pointing fingers, but anything that our experience tells us could potentially move or is depicted in the act of moving—a fish, an automobile, an airplane or canoe—could appear to be changing its position, and its projected position is as important as its actual, frozen position on the canvas (**9.21**).

We are also manipulated by other directional lines in pictures, such as lines of perspective. Our gaze is directed by a long, straight road or a line of trees, diminishing toward their vanishing point, which may be to one side of the painting. To balance the composition we need something of visual interest on the other side of the image. If you examine paintings and sculptures you will begin to see that designs that at first glance appear unbalanced are using some or all of these techniques to convince us that all is in equilibrium.

9.20 Kitagawa Utamaro, *The Courtesan*, mid-1770s. Woodblock print, c. 10 × 15″ (25 × 38 cm). Private Collection, London.

Few Japanese prints are symmetrical. Here we are brought back into the picture by the eye direction of the courtesan.

9.21 George Caleb Bingham, *Fur Traders Descending the Missouri*, 1845. Oil on canvas, 29 × 36 ½″ (73.6 × 93 cm). Metropolitan Museum of Art. Morris K. Jesup Fund, 1933.

In this luminous early morning scene, we are assuming that the canoe is moving into the painting. At present the picture is off-balance, but we anticipate that it soon will be perfectly balanced. To place the canoe dead center would make the composition unstable.

Radial Balance

There are many other forms of symmetry. Physicists are fascinated by the symmetries in nature, the "handedness" of sub-atomic particles. There are symmetries in crystals (see pages 208–209), and in spirals and screws. The center of a sunflower, for example, is composed of numerous tiny seeds that not only radiate from the center of the flowerhead in a set of short spirals going clockwise, but also in another set of longer spirals going anticlockwise and related to the Fibonacci sequence of numbers. The same mechanism determines the patterns found on pine cones and pineapples.

Radial balance is a form of symmetry in which elements radiate from a center point, either in straight lines toward the edge of a circle, or spiraling outward like the seeds at the center of a sunflower. Radial patterns can also be centrifugal (radiating from inside to outside like a star-burst) (**9.22**), centripetal (radiating from outside to inside), or concentric (like a target).

Circles are simple, attractive shapes often seen in nature—the sun, moon, and flowers—but they are not so common in the easel and graphic arts, perhaps because circular picture frames and books are difficult to fabricate. Circles abound in the crafts, however, in thrown pots and jewelry, in domes and round windows, and sculpture (**9.23**). We see circular designs in cultures that are unbothered by the constraints of the picture frame, where compositions can be worked on the ground, in the round, from Buddhist mandalas to Navajo sand paintings (**9.24**).

In Tibetan Buddhism, a mandala is an imaginary place contemplated during meditation. A mandala, a Sanskrit word meaning circle, is often illustrated as a palace with four gates with the symbol of Buddha in the center, surrounded by eight deities—four male and four female—which, facing the corners of the earth, form a lotus flower. Mandalas are made from paper, textiles, or colored sand. In a sand painting, the construction process takes several days, and the mandala is destroyed shortly after its completion.

9.22 C.R.W. Nevinson, *Bursting Shell*, 1915. Oil on canvas, 29 × 22″ (76 × 56 cm). Tate, London.

Nevinson uses a swirling Vorticist spiral pierced by jagged triangles to recreate the disorientating sensory experience of a World War I explosion. The dark shapes could be shards of debris fracturing the bricks and timber of buildings.

9.23 Richard Long, *South Bank Circle*, 1991. Delabole slate, 6.2 × 6.2′ (1.9 × 1.9 m). Tate, London.

Long's work is based on the presence of humans in the landscape, contrasting geometric shapes with the irregularity of nature. *South Bank Circle* is made from roughly cut slate from Cornwall.

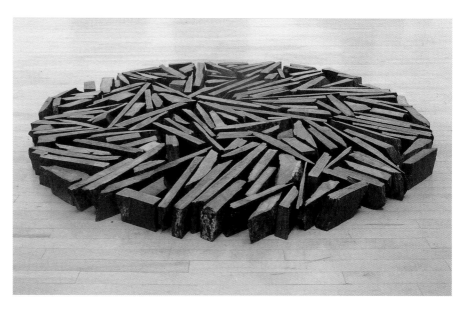

9.24 Monks and sand mandala, Sarnath, India, 1991.

Radial balance is a form of symmetry in which elements radiate from a center point, as in this mandala, an imaginary place contemplated by Tibetan Buddhists during meditation.

9.25 Chartres Cathedral, North transept interior with rose window and lancets, c. 1220.

The rose window—named after its resemblance to a rose and its petals—has mullions and traceries radiating from the center, filled with stained glass. By the middle of the 13th century, it attained the greatest possible size—the entire width of the nave.

The Navajo of New Mexico also produce sand paintings. They are called *iikaah*, meaning "place where the gods come and go," and they are used in ceremonies to restore balance or *hozho*. The sand painting is made on the ground and, like the mandala, is destroyed at the end of the ritual. Most are between 6 and 8 feet (1.8–2.4 meters) in diameter. The medicine man or singer directs, and helpers trickle sand or sometimes vegetable pigments of different colors through the fingers, starting in the center and working outward in a "sunwise" pattern, east, south, west, north, and back to east. The painting faces east and has a protective garland around three sides. In the late 1940s, Navajo artists began to create permanent sand paintings for sale and public display, but they changed the designs to protect their religious significance.

The rose window—named after its resemblance to a rose and its petals—is an architectural mandala, with mullions and traceries radiating from the center, and the gaps filled with stained glass (**9.25**). It is characteristic of medieval architecture, especially the French Gothic, and it attained the greatest possible size—the entire width of the nave—by the mid-13th century. The rose window in the Union Church of Pocantico Hills, New York, was the last completed work of Henri Matisse, who finished the design days before he died in 1954. Confined to a bed in his studio, he first mixed colors in gouache, then painted sheets of paper, which he cut out so that assistants could pin them on the wall opposite, a technique he succesfully used for much of his later work (see **3.14**).

Balance by Value and Color

9.26 Titian, *Pesaro Altarpiece*, 1519–26. Oil on canvas, 15′ 11″ × 8′ 10″ (4.85 × 2.69 m). S. Maria Gloriosa dei Frari, Venice.

Titian defied the tradition of centering the subject, by setting the Virgin and Child off axis. Jesus, the focal point, is balanced by a banner bearing the Borgia and Pesaro arms. Bottom right, members of the Pesaro family are introduced by Saint Francis (see **5.9**).

9.27 Jusepe de Ribera, *St. Jerome with the Angel of Judgment*, 1626. Oil on canvas, 103 ⅛ × 64 ½″ (262 × 164 cm). National Museum of Capodimonte, Naples.

Ribera painted over forty versions of St. Jerome. Here the vivid red of his robe balances the composition (see **9.19**).

We can achieve asymmetrical balance by attempting to equalize areas of visual interest. The visual weight of an element is determined by many factors—shape, size, position, texture—but one of the most powerful eye-catching devices is value. In Chapter 6 we looked at value patterns—the areas of light and dark we see when we squint our eyes and peer at a picture. The aim in balancing a value pattern is to position these areas so that the areas of light and dark, high contrast and low contrast, form a harmonious equilibrium.

Our eyes are naturally drawn to a patch of light value against a predominantly dark background or to a dark mass that is surrounded by lighter space. The higher the contrast between light and dark, the greater our curiosity, as we shall see in Chapter 11 on emphasis. As in the similar cases of shape and texture, a small, intense area that attracts the eye can balance a larger, more diffuse area of gray. This could be achieved by using one of the extremes of black or white or by using both together to create an area of high contrast. Generally, a dark shape will appear heavier than a light one the same size, and a smaller dark shape can balance a larger light one. A relatively small, contrasty area on one side of a picture can balance a larger area of various grays closely related in value.

As we saw in Chapter 7, value is a component of color. Everything that applies to value also applies to color, with the added influences of hue and saturation (**9.26**). Our eyes naturally gravitate toward bright colors, and some colors have a higher visibility than others—red and yellow, for example, which are used to identify hazards and safety equipment. This effect is accentuated if a vivid saturated color is surrounded by more neutral tones (**9.27**). We also have the contrast caused by complementary colors, so that a tiny fleck of red, say, can stand out and balance huge areas of green trees and foliage in a landscape. Paintings by English artist John Constable (1776–1837), for example, often use accents of red, which provide not only variety in a predominantly green landscape but also introduce balance by color (**9.28**).

Pure hues tend to eclipse all other colors, so they should be used sparingly, and using two or more pure colors in a composition could cause confusion. A pure hue combined with shades of the other colors will achieve greater contrast and harmony, giving the eye somewhere to rest. Color temperature can also have an effect: small amounts of warm color can offset larger areas of cooler colors.

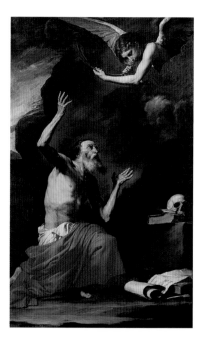

It is almost impossible to separate the influences of value and color. As Munsell discovered, different colors have different inherent values, yellow being naturally lighter than blue, for example. If a painting looks perfectly balanced in color, but off-balance when it is reproduced in black and white, we know that color has played its part (**9.29**). In the most successful compositions all the balancing strategies will work in concert. A painting in which the position, size, and direction of shapes suggest a dynamic, asymmetrical design can be "slowed down" by a careful distribution of colors. Conversely, an otherwise static symmetrical work can be activated and brought to life by added notes of color.

9.28 (above) John Constable, *The Haywain*, 1821. Oil on canvas, 51 × 73″ (130.2 × 185.4 cm). National Gallery, London.

The haywain, a type of horse-drawn cart, stands in the water in the foreground of this asymmetric scene. Across the meadow in the distance is a group of haymakers. Note the accents of red on the horse's bridle (see **4.7**).

9.29 (right) Franz Marc, *Fighting Forms*, 1914. Oil on canvas, 35 ⅞ × 51 ¾″ (91 × 131.5 cm). Staatsgalerie Moderner Kunst, Munich.

After painting symbolically colored animals (see **7.2**) Marc moved on to pure abstract shapes, as in this study of convulsive fury—the world on the edge of self-destruction—influenced by the Futurists.

Crystallographic Balance

All paintings and drawings will have some sort of focal point, even if it is the center of the canvas, the point furthest away from the edges and the frame. We have to start looking at the picture somewhere. Many of the compositions we have considered so far have a focal point away from the center, and are balanced by other shapes or areas of texture, value, or color elsewhere on the picture plane. There are some pictures, however, particularly non-objective ones, that do not seem to have an obvious beginning or end (**9.30**). The same degree of visual attraction is distributed uniformly across the surface of the painting or print, and our eyes wander aimlessly all over the place, intrigued by the apparent lack of emphasis.

This type of design is described as having **crystallographic balance**, which can be defined as a composition in which the visual elements are spread fairly evenly over the entire surface, either scattered informally or according to a grid (**9.31**). If they are not based on grid structures, crystallographic arrangements can appear chaotic and fractured, with a lively effect. The term refers to the endless symmetries inherent in crystalline structures. These arrays of atoms and molecules were first seen in x-ray diffraction patterns, and from these photographs, scientists were able to deduce and construct the latticed arrangements that make coal, for example, so different from diamonds, although both are made from a single element, carbon.

Of course, artists need not be restricted to using crystalline structures or patterns in their work and the term has come to mean any arrangement of elements that results in an **allover pattern**. We associate this type of pattern with printed or woven fabric designs, wallpapers, quilts, and mosaics, in which any focal point would detract from their intended utility and versatility, but there is also a style of painting and installation art, in which each element is given equal status and weight, most commonly arranged grid fashion, in rows and columns that occupy the whole of the picture plane or gallery wall. Here repetition, with or without added variation, is taken to its ultimate conclusion, and we are left to contemplate the subtle nuances created by the elements, forming directions, gestalt groupings, and symmetries before our eyes.

9.30 (left) Victor Vasarely, *Banya*, 1964, Gouache on wood, 23 × 23″ (59.7 × 59.7 cm). Tate, London.

This Op-art painting is symmetrical in many directions, making it an example of allover pattern and crystallographic balance.

9.31 (right) Jasper Johns, *Map*, 1961. Oil on canvas. 6′ 6″ × 10′ 3″ (198.2 × 307.7 cm). The Museum of Modern Art, New York. Gift of Mr. and Mrs. Robert C. Scull.

Although ostensibly a map of the United States, this checkerboard pattern displays crystallographic balance—a design in which the visual elements are spread fairly evenly over the entire composition.

9.32 Tom Friedman, *Untitled*, 1996. Cardboard box corners, 24 × 33 × 31″ (60.9 × 83.8 × 78.8 cm). Stephen Friedman Gallery, London.

For contemporary sculptors, free from the material and representational constraints of earlier sculptural forms, polyhedra, or forms approximating them, provide inspiration and a wealth of shapes, forms, and symmetries to draw upon.

Crystals are three-dimensional structures, and crystallographic balance can also be found in geometric sculptures, often based around the forms of balls, spheres, or polyhedral solids (**9.32**). Polyhedra fascinated Renaissance artists, including Uccello, Dürer, and Leonardo, and the 20th-century printmaker Escher. Although they are not artworks in their own right, they were used as intellectual exercises in perspective studies and as decorative elements in paintings, marquetry, mosaics, and trompe l'oeil intarsia (mosaics made of pieces of inlaid wood). For contemporary sculptors, free from the material and representational constraints of earlier sculptural forms—and, with computer visualization, also free from the constraints of gravity—polyhedra provide inspiration and a wealth of shapes, forms, and symmetries to draw upon to produce works of sublime crystallographic balance.

Exercises

1 Symmetry: Fold a square of black paper in half and cut out a shape. Unfold and glue it to a white sheet of paper. The shape should be symmetrical about the fold line, like a butterfly. Fold another square of black paper in half, in half again, and then across a diagonal. Cut out shapes and unfold the paper to find a shape with radial symmetry, like a doily. Or paint a shape in ink or paint and fold the paper to produce a Rorschach-type ink-blot shape.

2 Asymmetry: Make a collage from cut-out colored shapes: circles, triangles, and rectangles. Start with large shapes that break up the background. Then add smaller shapes, keeping the overall image balanced and interesting. Avoid putting anything in the center or in corners. Do not line up two or more objects on their center axes. Test the balance by looking at the collage from different directions and through a mirror. A well-balanced composition will be slightly bottom heavy. Do not glue the composition down until you are satisfied with it.

3 Expansion of the square: Use black paper, a craft knife or scissors, glue stick, and white paper. Cut out a square from the black paper. Cut shapes from the sides of the square, avoiding the corners and the center. Each time you cut out a shape, glue it down as the mirror image from where it was cut. No pieces can be discarded.

10 | Scale and Proportion

"Every now and then go away, have a little relaxation, for when you come back to your work your judgment will be surer. Go some distance away because then the work appears smaller and more of it can be taken in at a glance and a lack of harmony and proportion is more readily seen."

LEONARDO DA VINCI

Lee Miller, *Saul Steinberg and Long Man of Wilmington*, 1953. Photograph. © Lee Miller Archives.

American photographer Lee Miller took this photograph of the famous cartoonist near her Sussex farm. The Long Man is a prehistoric hill carving 230 feet high.

Introduction

It can be a surprise and delight to visit an art gallery or museum and discover for yourself the actual size of a favorite painting or sculpture (**10.1**). We are so used to seeing paintings reproduced in books, on postcards, and in calendars, all reduced (or sometimes enlarged) to a uniform format, that it can come as a shock to see the genuine artifact (**10.2**). Some are much smaller than you had envisaged (see **10.8**); others turn out to be gigantic.

Scale and **proportion** both relate to size. A scale model of a train or automobile is smaller than the real object it mimics but will be in proportion (to scale) to the actual object. Archeological finds are usually photographed with a ruler alongside so we know how big or small they really are. Objects sold by mail order sometimes have an "actual size" diagram alongside the photograph or artist's impression shown in the catalog so that we are not too disappointed when the items arrive and do not live up to our expectations. We talk of small-scale works and large-scale projects (**10.3**), which could range from something the size of a grain of rice to an entire city.

Small and large are relative terms, and the best yardstick we have for judging size is ourselves (**10.4**). Many units of measurement are based on parts of the human body. The cubit is traditionally the length of the arm from the elbow to the tip of the middle finger; an inch represents the width of a thumb; and the foot is the length of a long foot. We can estimate the size of a building in a painting if a person is depicted nearby, preferably with some overlapping to prevent any depth and space confusion (**10.5**).

Art began on a **human scale**. Some of the earliest rock paintings are of hands, either stamped or "airbrushed" onto cave walls. Depictions of hunters and animals are scaled down from life size, both for ease of drawing and viewing and so that distant views can be represented. When large areas of wall in villas and temples were decorated, paintings necessarily became bigger, with figures approaching or exceeding life size. Public sculptures from all ages need to look impressive, so are often scaled up to larger than life size (**10.6**).

10.1 Nagahama Sokei, *Netsuke, Depicting a Karako*, c. 1830. Ivory, 1 ⅝" (4.2 cm) high. Private Collection.

Netsuke are miniature sculptures, originally toggles worn by pocketless Japanese men to prevent objects slipping off their kimono sashes. These developed into an art form, as wealthier clients commissioned more elaborate designs.

10.2 Philip de Loutherbourg, *An Avalanche in the Alps*, 1803. Oil on canvas, 43 ¼ × 62" (109.9 × 160 cm). Tate, London.

Here de Loutherbourg supplies an element of narrative drama with tiny figures recoiling from their impending doom.

10.3 Robert Smithson, *Spiral Jetty*, 1970. Length 1,500' (457.2 m), width 15' (4.5 m). Great Salt Lake, Utah.

Smithson created large-scale earthworks "without cultural precedent". He bulldozed 6,650 tons of material to make this artificial whirlpool. It was seen by only a few people before it was destroyed by the natural fluctuations of the lake.

Over the centuries, artists have developed ways of initially working on a small scale and scaling up to larger, finished works. They might start with a fairly small "back-of-the-envelope" concept sketch and perhaps some thumbnail drawings to establish value patterns and experiment with compositional arrangements, then they produce a working drawing that can be "squared up" so that the design can be transferred to the wall or canvas. Sculptors work with small-scale maquettes (**10.7**), made of clay or wax, which can be scaled up either manually or by mechanical means to the size of the finished sculpture to be cast or carved.

Throughout this process of changing scale, the artist must make sure that the overall proportions are maintained—enlarging one dimension more than the others results in distortion.

10.4 Gustave Caillebotte, *The Painters*, 1877. Oil on canvas, 23 ⅝ × 28 ¾" (60 × 73 cm). Private Collection.

Even without the one-point perspective in the road (echoed in the painter's ladder) we know instinctively that the man with cropped legs in the foreground is nearer to us than the smaller figures in the distance.

Proportion is all about ratios: the ratio of the width of a painting compared with its height, or the ratio of head size to total height in the case of a sculptural figure. Maintaining proportion during the design process is a necessary mathematical chore when drawings and paintings are scaled up or down. But is there such a thing as an ideal proportion? The artists and architects of ancient Greece and Rome and of the Renaissance thought so. They were fascinated by geometry, squaring the circle (constructing geometrically a square equal in area to a given circle) and the supposedly magical qualities of numbers. The same artists who developed the rules of perspective were also on a quest to codify the most aesthetically pleasing proportions. We have already seen how the ancient Egyptians and Greeks attempted to find the ideal proportions for depicting the human body (see **2.32** and **2.33**). Renaissance artists built on these foundations to try to work out the most pleasing proportions for buildings, the shape of the picture frame, and where elements should be best placed in compositions. The **golden section** is the name given to their findings.

Other cultures have different ideas about ideal proportions. In parts of sub-Saharan Africa, for example, the length of the neck—as seen in the sculptures that inspired Picasso and Matisse in the early 20th century—is valued above other physical attributes. The Japanese have a system of proportion called **tatami**, named after the rice-straw floor mat. It is roughly based on human scale, being 6 feet long by 3 feet wide (about 2 × 1 meters), proportioned in the ratio 2:1. Rooms (*nihon-ma*) are built around a certain number of these mats, and the size of a room

10.5 Pieter Brueghel the Elder, *Tower of Babel*, 1563. Oil on panel, 44 ⅞ × 45 ¼″ (114 × 115 cm). Kunsthistorisches, Museum, Vienna.

The work in progress is so huge, the top of it is cloaked in cloud. King Nimrod and his workers bottom left, overlooking the building site, give us a human scale to the endeavor. The painting is an allegory of pride and vanity.

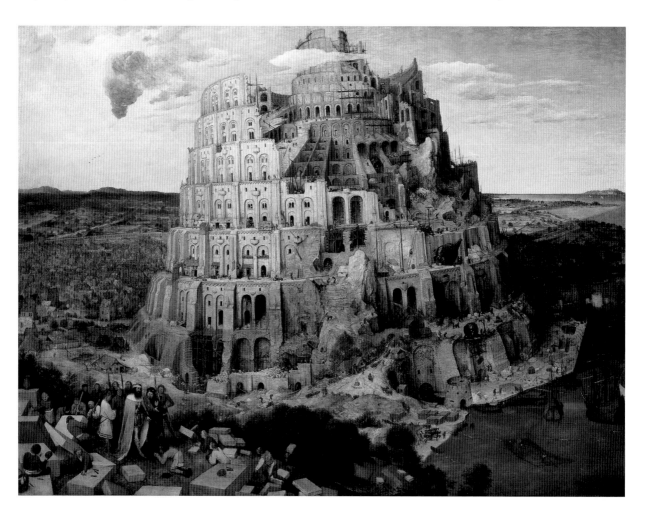

10.6 Fragments of the colossal statue of Constantine, from the Basilica of Constantine, Rome, 313 CE. Marble. Height of head 8′ 6″ (2.6 m). Palazzo dei Conservatori, Rome.

These fragments are from a colossal seated statue, about thirty feet high. The body would have been made of less valuable materials, while the head, hands, and feet were made of marble.

is defined by the number of mats it can accommodate. A four-and-a-half mat room, for example, is 9 feet by 9 feet (2.7 × 2.7 meters). A formal Japanese tea room is four-and-a-half mats. Doors, screens, and scrolls follow the same proportions.

As we will see in Chapter 11, scale has a huge impact on emphasis. Bigger is better, in most cases. Certainly, shapes and forms that are larger than other elements have a greater visual presence. Many artists have exploited unusual juxtapositions in scale and proportion to produce artworks that shock and surprise or simply grab our attention for a few moments in this media-rich environment. Others use intimate scale to nurture a one-to-one relationship between maker and viewer, producing a precious, almost spiritual experience. Whatever else anyone might say: size does matter.

10.7 Edward Steichen, *Henri Matisse*, from *Camera Work*, November 1913. Photogravure. Musée d'Orsay, Paris.

Sculptors such as Matisse produce small-scale maquettes in clay or other materials before embarking on the larger finished piece.

Human Scale

All culture begins and ends with human beings. Humans make art and other humans view it. By their very scale, some artifacts seem to defy this logic: the megaliths of Stonehenge, the pyramids of Egypt and Mexico, the Nazca lines in Peru, medieval cathedrals, modern skyscrapers and ocean liners, for example. Most art is more manageable, restricted perhaps by the interior spaces they occupy, but nevertheless at a scale we can relate to.

Humans like to impress, either by taking on enormous projects that overwhelm us with their sheer size and the amount of time and effort invested in them, or by making miniature masterpieces that amaze us by the amount of skill and dexterity required. Most often, the size and scale of an artwork are dictated by its intended location and use. Frescos on the walls and ceilings of churches and temples were intended to edify a mostly illiterate congregation with tales from the Bible or the life of Buddha, and they needed to be big and bright to make an impact in gloomy, candle-lit interiors. As building techniques improved, bigger windows could be filled with awe-inspiring stained glass, shining down heavenly light upon the people.

Miniature works of art can be equally impressive. Small-scale sculptures can be found on everyday objects such as coins, medals, and jewelry, as well as in elaborately carved netsuke, toggles worn by Japanese men to prevent pouches and purses from slipping off their kimono sashes (see **10.1**). These were originally utilitarian, but by the 19th century had developed into an art form, as wealthy clients commissioned increasingly elaborate designs.

A steady hand and excellent eyesight were required to produce the exquisite Elizabethan miniature portraits on vellum and ivory by artists such as Nicholas Hilliard (1547–1619), designed to be portable in the days before photography (**10.8**). These portraits, which often depicted lovers or mistresses, were intended for private viewing. The art of painting miniatures also flourished in periods of political stability in Persia and India during the 16th century when wealthy patrons paid for the many hours of labor and costly materials—paper, pure mineral pigments, and gold leaf—required to produce them. Miniatures were not always tiny. In the Middle Ages, monks decorated initial letters with a red lead pigment, *minium*, from which the word miniature derives (**10.9**). Illuminated manuscripts complemented frescos and altarpieces, but at a more human scale. In the Middle Ages books were copied by hand and were extremely expensive. Even after printing was introduced in the 15th century, they were rare enough to be embellished and illuminated by hand.

Miniatures are still painted today, but in more recent times paintings have ranged in size from intimate Dutch genre paintings of the 17th century, destined for the modest interiors of merchants, to

10.8 Nicholas Hilliard, *Young Man Against a Flame Background*, 1588. Watercolor on vellum, 3 × 2 ⅛″ (7.6 × 5.1 cm), actual size. Victoria & Albert Museum, London.

While to some artists, a miniature was merely a painting reduced to a small scale, Hilliard developed in his miniatures an intimacy and subtlety peculiar to that art. They often include enigmatic inscriptions and allegory.

10.9 Initial Q, from St. Gregory's *Moralia in Job* (detail), 1111. Parchment. Bibliothèque Municipale, Dijon.

The luxurious lifestyles of medieval monks were reformed by the Cistercian Order which required them to work, including illuminating manuscripts. Here two of the brethren in ragged habits are shown splitting a tree trunk, all within a letter Q.

the enormous Salon paintings of 19th-century France—Théodore Gericault's *The Raft of the "Medusa"* (1819), for example, measures 16 × 23 feet (5 × 7 meters). Only palaces and art galleries have walls large enough to hang them.

Much contemporary art is also destined to be housed in galleries rather than domestic settings and hence is made big. Sometimes it takes the form of a site-specific installation, drawn or painted directly onto the gallery walls and destroyed once the show is over. Computers make it possible to create art on the screen that can be scaled up to clothe entire buildings in giant, customized, inkjet prints, bigger than billboards. Christo and Jeanne-Claude have clothed entire buildings, such as the German Reichstag, in silvery fabric highlighting the features and proportions of the imposing structure (**10.10**). Sculptures, too, can be fabricated on a monumental scale, as our environment is enhanced and enriched by public art.

10.11 (below left) L.S. Lowry, *The Pond*, 1950. Oil on canvas, 45 × 60″ (114.3 × 152.4 cm). Tate, London.

This large-scale industrial landscape contains many typical Lowry elements; smoking chimneys, terraced houses, his so-called "matchstick" people who swarm like ants through the city's streets and open spaces—and, ironically, a predominance of white.

10.12 (above) Lee Miller, *Guy Peirera and Peter Fleming, Egypt*, c. 1937. Photograph. © Lee Miller Archives.

Miller plays with scale in this amusing photograph. We intuitively know that the man in the foreground cannot possibly be leaning on the more distant figure.

Humans are a frequent subject of paintings. Indeed, before the 19th century, it was rare to see a painting without a human being in it, whether as the subject of a portrait or as an incidental character adding scale cues to a painting of an impressive building or landscape (**10.11, 10.13**). In early works of art, the size of the central figure relative to any others was a sign of their importance. Religious figures, such as saints, or kings and emperors were painted at a larger scale than the lesser figures around them. This is called hieretic scaling (**10.14**).

This style, which seems strange to our modern eyes, was an instant clue to our ancestors as to who was in charge or should be revered. Today, we are more likely to accept relative size as a depth cue—if a figure is bigger than the others, it must be closer to the viewer (**10.12**).

In some cases relative size works in reverse. In Piero della Francesca's *Flagellation of Christ* (see **4.23**), the largest figures are the three contemporary characters talking among themselves to the right of the painting. We have no idea now who they are—they may be the patrons who commissioned the picture or celebrities of the day—but our attention—helped along by the perspective—is drawn to the diminutive figure of Christ in a distant part of the building to the left.

The idea of placing figures so close to the picture plane that they are cropped by the frame came into fashion with photography (see **4.18**). Cropping adds intimacy and spontaneity to an image, informed by the almost chance nature of the photograph. Before "snapshots" became popular after about 1860, compositions were relatively well ordered, with elements arranged carefully and accurately well within the edges of the picture frame. Edgar Degas was one of the artists who embraced the new way of seeing made possible by the camera. He was also heavily influenced by the Japanese *ukiyo-e* prints by Hiroshige and Hokusai, with their looming foreground figures framing the design and steep changes in scale. Cropping also suited Degas' subject matter—ballerinas waiting in the wings ready to go on stage and the like.

Degas was not the first artist to use heavily cropped figures and shapes. Some of Jan Vermeer's paintings include characters, facing away from the viewer and leaning back into the picture plane. We follow their gaze into the picture where the real (smaller) subject resides. Vermeer has often been accused of using optical devices, such as a camera lucida or camera obscura, to help him compose his pictures, so we shouldn't be surprised by the photographic-type scale distortion.

By the 1960s cutting off the tops of heads and other severe croppings by photographers such as Bill Brandt (1904–83) and David Bailey (b. 1938) was appreciated as being deliberate and not the result of incompetence! Photo-realists such as Chuck Close (b. 1940) were also homing in on the human face, not only enlarging it to gigantic proportions to show every hair, pore, and blemish but also closely cropping it to exclude every other element (**10.15**). The human was back center stage.

10.13 Jean Fouquet, *Building the Temple of Jerusalem*, from Josephus's *Antiquities and Wars of the Jews*, c. 1475. Illumination on vellum, 15 × 11" (39 × 29.2 cm). Bibliothèque Nationale, Paris.

Solomon's Temple, destroyed by the Romans, was a source of inspiration to medieval architects. In this illuminated manuscript it is shown in the style of a 15th-century French Gothic cathedral, complete with stonemasons at work.

10.14 Jacobello del Fiore, *Coronation of the Virgin*, 1438. Oil on wood, 9′ 3″ × 9′ 10″ (2.83 × 3.03 m). Galleria dell'Accademia, Venice.

An architectural form of hieratic scaling, this altarpiece was commissioned by the bishop of Ceneda, who kneels in the right foreground. The flowers at the bottom of the painting signify that this scene is located in the Garden of Eden.

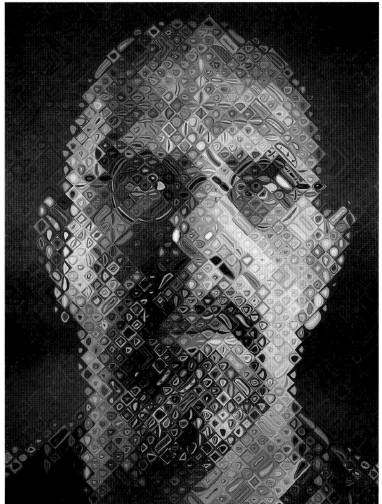

10.15 Chuck Close, *Self-Portrait*, 2000–01. Oil on canvas, 108 × 84″ (274.3 × 213.4 cm). Courtesy the artist. (See **1.10**)

In recent portraits, American artist Chuck Close has used optical mixing of colors in composite dabs, each "dab" comprising a complex pattern of shapes and colors.

Contrast and Confusion

Standing in front of a Chuck Close painting must be like being a mosquito ready to pounce. We see every microscopic detail of the skin, and it is unlikely we will ever be anywhere as close to a human face. If we get up close to a billboard figure, all we see are dots (**1.10**, **10.15**), which is what we see constitutes a late Close, where he plays with our perception. Magnifying tiny objects has fascinated humans since the invention of the microscope, when we were able to see snowflakes or a fly's eyes for the first time. Victorians were entertained by magic lantern shows of specimen slides blown up onto a screen. Today we are equally impressed by films in CinemaScope or Imax. We love movies shot from the viewpoint of insects, small toys, or incredible shrinking people, seeing commonplace objects become insurmountable obstacles to be conquered in a *Gulliver's Travels* world.

We also like paintings and sculptures to be big. Surrealist artist René Magritte (1898–1967) and Pop-artist Claes Oldenburg (b. 1929) satisfy our need to be enthralled by scale contrast and confusion by blowing up objects we think we know until they achieve unnatural proportions. They choose familiar objects—apples, combs, and wine glasses for Magritte (**10.18**), clothespins, trowels, and lipsticks for Oldenburg (**10.16**)—and place them in a context where they are out of proportion with their surroundings. This endows a normally utilitarian object with mystical properties and reminds us how sculptural are these objects we take so much for

10.16 Claes Oldenburg, *Lipsticks in Piccadilly Circus, London*, 1966. Mixed media on board, 10 × 8″ (25.4 × 20.3 cm). Tate, London.

In this postcard-based collage, Pop-artist Oldenburg imagines giant lipsticks in Piccadilly Circus replacing the statue of Eros.

granted—how beautiful a flower or a fruit is when seen close to, and how every manufactured article, whether precious or disposable, has been designed by someone. Product design is receiving a higher profile than ever before with "name" designers such as Ettore Sottsass (b. 1917) and Philippe Starck (b. 1949) making objects we never used to care much about into miniature sculptures.

Surrealism and Pop-art endeavor to confuse and perplex us. Surrealism employs the odd juxtapositions from our dreams to place ordinary objects into unusual surroundings, while Pop-art appropriates objects and images more associated with vulgar consumerist popular culture and gives them new life within the world of galleries and high art. With some artists the scale confusion is not obvious unless you see the works *in situ* or in a photograph showing spectators present. The figures of Australian sculptor Ron Mueck are either scaled up (see **3.25**) or, more often, scaled down from life size. We are quite used to sculptures being larger than life—our parks and public spaces are full of generals and politicians on plinths—but slightly reduced figures, especially if they have realistic hair and skin texture, can be eerie and unsettling, like waxworks of elves or fairies. A change of scale or proportion can enhance an artwork's enigmatic qualities (**10.17**).

10.17 Sam Taylor Wood, *XV Seconds* (Installation for the façade of Selfridges, London), 2000.

Taylor Wood's work for London department store Selfridges claimed to be "the world's largest photograph". In this 900-foot frieze, she updated the scenes from the Elgin Marbles, replacing the Greek gods with modern-day celebrities such as Elton John.

10.18 René Magritte, *The Listening Chamber*, 1958. Oil on canvas, 13 ⅜ × 18 ⅛" (34 × 46 cm). Private Collection.

The Surrealists confuse us by placing everyday objects into unlikely settings, or in this case, scaling up an apple to fill a whole room.

Ideal Proportion

Is there such a thing as ideal proportion? To the ancient Greeks and artists of the Renaissance, the search for perfect proportions was like a quest for the Holy Grail. Proportion is linked to ratio. When we scale up (enlarge) or scale down (reduce) an image, we change the dimensions, but preserve the ratio between the width and the height. The **golden ratio** or golden mean is a proportion with seemingly magical properties and, according to some, an in-built universal beauty. If a straight line is divided into two, and the ratio of the shorter portion to the longer is equal to the ratio of the longer to the whole length (the sum of the shorter and longer), then it is a golden ratio. Like π (pi), it cannot be expressed as a finite number, but approximates to 0.618. This number is also arrived at by dividing a high number in the Fibonacci sequence with the next number along.

A rectangle in which the ratio of the shorter side to the longer is this number is called the **golden section** (**10.19**). To construct a golden section using a ruler and compasses, draw a square, extend its base line, divide the bottom side in half and place the point of the compasses at this point. Place the pencil end of the compasses at top right corner and draw an arc to the baseline. The length from the left corner of the square to this point forms the longer side of the golden section. If you remove a square from a golden section, the remaining shape is also a golden section. The square that remains after subdivision is called a **gnomon**. Repeatedly subdividing a golden section into a reciprocal rectangle and a gnomon results in the whirling spiral found in nautilus shells.

The golden section was known to the ancient Greeks. In Chapter 2 we looked at the way in which Polycleitos used the height of the head as a measuring module to arrive at an ideal body. The architect Vitruvius thought that temples should be based on a perfectly proportioned body, where the height of a person equals the length of the outstretched arms, placed in a square, divided in half at the groin. Add a circle with its center at the navel and touching the feet and hands, and we have the canon used by Doryphoros among others and by Leonardo in his iconic "Vitruvian Man" (**10.23**). The ratio of head to navel and navel to feet constitutes another golden ratio. The same canon was used for sculpting facial proportions.

Luca Paccioli (*c*.1445–*c*.1514) wrote a book in 1509 called *Divina Proportione*, illustrated by his friend Leonardo, in which he made supernatural claims for this system of proportion (**10.22**). Many artists are taught the "rule of thirds." If we divide the picture plane into three, horizontally and vertically, the best positions for important elements are at the points where these lines intersect (**10.21**). As the golden ratio of 0.618 is approximately two-thirds (0.666), the "rule of thirds" is roughly based on the golden section.

10.19 Golden Section diagram.

A straight line divided into two, with the ratio of the shorter portion to the longer equal to the ratio of the longer to the whole length, is a golden ratio, numerically 0.618. A rectangle with this height-to-width ratio is a golden section. Removing a square creates another golden section.

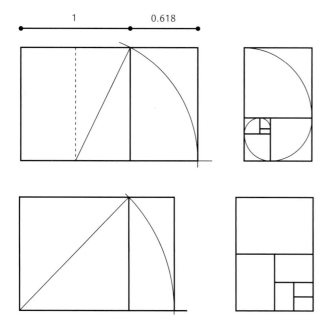

10.20 Ideal Proportions: root 2 diagrams.

A root 2 rectangle has a height-to-width ratio of 1:square root of 2, numerically 1:1.414. This ratio possesses the useful property that it can be endlessly subdivided into smaller root 2 rectangles and is the basis for DIN paper sizes.

10.21 Piero della Francesca, *Baptism of Christ*, c. 1445. Panel painting, 5′ 6″ × 3′ 9″ (1.68 × 1.16 cm). National Gallery, London.

Many elements are placed here according to the rule of thirds: the dove (Holy Spirit) is a third from the top; the tree and John the Baptist are on horizontal thirds.

10.22 (below left) Jacopo de' Barbari, *Fra Luca Paccioli and an Unknown Man*, 1495. Oil on wood, 39 × 47 ¼″ (99 × 120 cm). Museo di Capodimonte, Naples.

Paccioli, a Franciscan friar, coined the term "the divine proportion" for the golden section. He is shown illustrating a theorem from Euclid and examining a glass rhombicuboctahedron half-filled with water.

10.23 (below right) Leonardo da Vinci, *Vitruvian Man*, 1485–90. Pen and ink, 13 × 9″ (34.3 × 24.5 cm). Accademia, Venice.

Leonardo's iconic drawing relates the human body to the golden section: the figure is the height of the square, divided in half at the groin; the navel is the center of a circle touched by the hands and feet and divides the figure by the golden section.

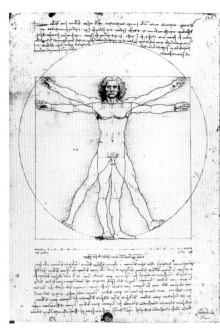

The canons of Polycleitos and Vitruvius and the idea of the golden section introduce another concept—that of the module. One of the first modules was a brick, an easy-to-handle building block of standardized shape and size. Most modern architecture relies on modular construction techniques based on standardized prefabricated parts. The Modernist architect Le Corbusier developed a system of measurement based on the Fibonacci sequence and the golden section called The Modulor.

Another popular system of proportion is called **root 2**, because if the shorter side of a rectangle is 1, the longer side is the square root of 2. It was first used by Italian architect Palladio. Numerically, the ratio is 1:1.414. This ratio possesses the useful property that it can be endlessly subdivided into smaller root 2 rectangles. To demonstrate root 2, first draw a square, extend the base line, place the compasses point at the bottom left corner and pencil end at top right, and draw an arc down to the base line. The length from the bottom left corner to this point forms the longer side of the rectangle (**10.24**).

The root 2 rectangle is the basis of the DIN system of paper measurement used throughout the world except the USA and Canada. An A0 sheet of paper is 1 square meter in area. Divide or fold it in two and the result is a sheet of A1, which has the same proportions but is half the area. Divide again and we have A2, and so on. This reduces waste, and because paper is bought in root 2 modules, the books, magazines, and posters made from it will also share these proportions.

A root 3 rectangle is constructed like the root 2, except the starting point is a root 2 rectangle rather than a square. A root 3 rectangle can be used to construct a regular hexagon, the shape of a honeycomb or snowflake. Similarly, root 4 and 5 rectangles are constructed using the previous root rectangle as starting points.

A root 5 rectangle is a square with a golden section attached at each end, which brings us full circle. This scheme is frequently seen in art and architecture—in Masaccio's *Tribute Money* (see **5.12**) and the façade of the Parthenon in Athens, for example (**10.25**). Systems of proportion based on whole numbers include the Japanese *tatami*, named after the modular floor mat used to measure and proportion rooms, screens, and scrolls. This is simply a double square, ratio 1:2, and can be oriented in one of two ways at right angles to each other, to produce various patterns.

The root rectangles are said to be dynamic, because they can be added together or subdivided in various combinations to create visually pleasing shapes and positions for placing elements in a composition—by drawing diagonals and drawing parallel or perpendicular lines where they intersect with other lines, for example. Whether these geometries and relationships exist because the ratios are naturally beautiful and an artist cannot help but place elements in their rightful positions, or whether they were placed deliberately, strictly applying a canon, and we respond because we are so accustomed to seeing the golden section everywhere, we will never know.

10.24 Ben Nicholson, *White Relief*, 1935. Relief, oil on wood, 40 × 65 ½″ (101.6 × 166.4 cm). Tate, London.

Nicholson's relief is proportioned to the golden section. Although seen as Modernist, cold, and mechanistic it was in fact carved from a mahogany table-top. Chisel marks are evident which, with the freehand circle on the left, show the hand of the artist.

10.25 Parthenon, Athens, 447–438 B.C.E.

The façade of the Parthenon fits into a golden section rectangle. A reciprocal rectangle forms the height of the architrave, frieze, and pediment. Gnomons define the heights of the columns and the pediment.

Exercises

1 Surreal photo-montage: Juxtapose an object that is relatively much too large—for example, a giant kitten—with an everyday scene. The resulting object should be large, clear, colorful, and full of contrast. The background should occupy most of the picture frame. Set the object into the background by letting some features of the background overlap it, otherwise it will look close but not large. Conversely, create a montage in which the subject is relatively much smaller than its surroundings.

2 Draw a square followed by a series of rectangles in different proportions: golden section, root 2, root 3, root 4, root 5, and *tatami*. Don't label them. Draw fancy picture frames around the rectangles with perhaps a simple motif inside to make them look like miniature paintings. Make a questionnaire and ask your friends or family to rate the shapes according to which they find the most aesthetically pleasing.

3 Visual analysis of design: Find some pictures of classic posters and product design, photographed side on—for example, a chair by Charles Eames and a VW Beetle. Photocopy them or use tracing paper to determine how many of their design features can be represented by circles, squares, golden sections, and golden ellipses (an ellipse that will fit comfortably into a golden rectangle).

11 | Contrast and Emphasis

"What I mean by 'abstract' is something which comes to life spontaneously through a gamut of contrasts, plastic at the same time as psychic, and pervades both the picture and the eye of the spectator with conceptions of new and unfamiliar elements."

MARC CHAGALL

Hieronymous Bosch, *Garden of Earthly Delights* (detail), c. 1505. Triptych, right panel (Hell), 86 ⅝ × 38 ¼" (220 × 97 cm). Prado, Madrid.

Bosch's most famous picture is a large-scale, three-part altarpiece, called a triptych; a fourth painting is on its outer doors. This right wing of the triptych represents the nightmarish torments of hell, a dark yet fiery place where we see in graphic detail what might happen to people who misuse musical and other instruments, as well as more conventional sinners. The face under the bagpipes is Bosch himself. (See **11.22**)

Introduction

In complex compositions, elements will be shouting or whispering for attention. Any artist who wants to engage the viewer will have to use an array of techniques to distinguish the relative importance of all the competing elements of an artwork. Most artists strive to make a particular point and want to communicate a theme, message, or story to the viewer. Here we take a look at how that can be achieved by creating a point of emphasis, **focal point**, or dominant element, which may be accompanied by subsidiary points of emphasis called **accents**. One main idea or feature is emphasized; the other elements are subordinate yet supportive (**11.1–11.6**).

You can, of course, be blatant, positioning your subject at center stage and surrounding it with flashing neon arrows—the equivalent of a television commercial from the Buy More Stuff School of Advertising. It is usually more effective, however, to be a "hidden persuader" and allow the viewer a little enjoyment in their quest for meaning. Your signposts should be subtle, but they do need to be there, and they do need to be understandable.

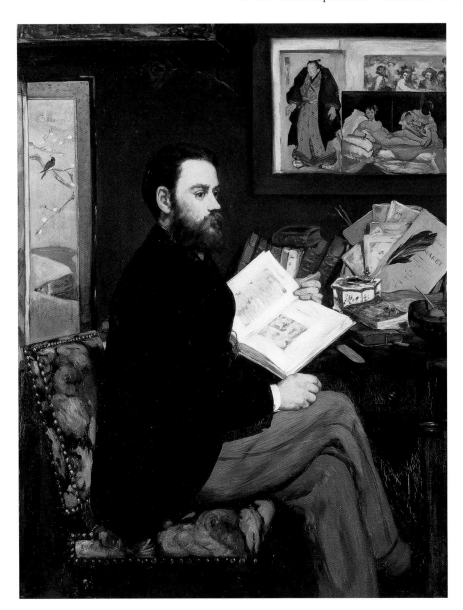

We have already seen how we can control the route the viewer's eyes take into and around a picture—using real and implied lines—and we have touched on the ways in which contrasts of value and color can be used to create emphasis. Now we wish to direct the viewer's eyes to the heart of the composition—its focal point—and then on to appreciate its context and the sub-plots. In music, we might work up to a crescendo that is complete with cymbal crashes; in text, we highlight important words and phrases in bold type; in the theater, we shine a spotlight on the star performer and turn down all the other lights. In photography, the focal point is the point at which an object must be placed to give a clearly defined image. The contrast is between what is in focus and what is blurred. In the easel arts and graphic design, we give an element dominance by making it a focal point.

11.1 Edouard Manet, Emile Zola, 1868. Oil on canvas, 57 ⅝ × 44 ⅞" (146.5 × 114 cm). Musée d'Orsay, Paris.

The white of the book creates an immediate focal point. Emile Zola, the French writer and critic, was a friend of Manet. Manet's nude Olympia is in the background along with Japanese prints.

To achieve this we have at our disposal placement, scale, line direction, and differences in value, texture, and color, plus other devices, such as isolation and separation. Artists who fail to establish a focal point are telling us that all the elements in their composition are of equal importance. This may, in fact, be the artist's intention: the deliberate absence of a focal point makes the composition as a whole a focal point. Alternatively, however, it could be through lack of care, because the artist has created too many equal points of emphasis that confuse the viewer. It is the contrast between the really important and less important parts of a picture that gives it coherence and a reason for being.

The challenges that artists face are, first, to impart every element with the appropriate degree of emphasis and, second, to place these elements in the design so that they do not disturb the unity, harmony, and rhythm of the image as a whole. It is a balancing act beyond the influence of the principles outlined in Chapter 9. All the rules we have learned so far must be put into practice: one significant area may be emphasized by a contrast in value, another by its busy texture or eye-catching shape, and yet another by its sheer size or mass.

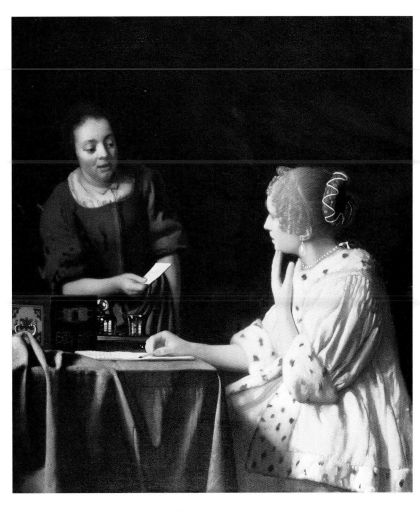

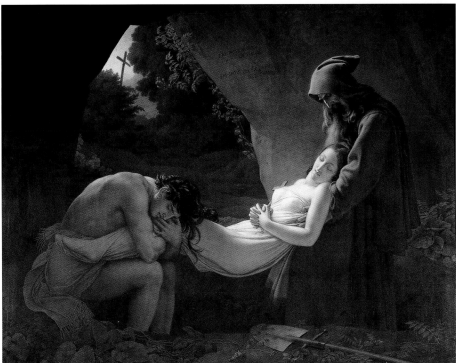

11.2 (above) Jan Vermeer, *Mistress and Maid*, c. 1667–8. Oil on canvas, 35 ½ × 31″ (90.2 × 78.7 cm). Frick Collection, New York.

Although the mistress dominates in her light-valued clothing, the viewer's eye is directed toward the mysterious letter. Note the highlights gleaming from the pearl jewelry, the sparkles from the glass and silver objects on the table, heightened by the dark background.

11.3 Anne-Louis Girodet-Trioson, *The Entombment of Atala*, 1808. Oil on canvas, 5′ 5″ × 6′ 11″ (1.67 × 2.1 m). Louvre, Paris.

Atala, a Christian girl who poisoned herself rather than succumb to carnal love, is being buried. Heavenly light pierces the cavernous gloom to highlight her chaste form.

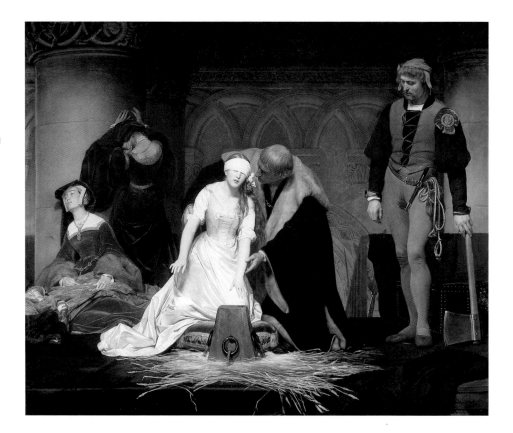

11.4 Paul Delaroche, *The Execution of Lady Jane Grey*, 1833. Oil on canvas, 8′ × 9′ 9″ (2.46 × 2.97 cm). National Gallery, London.

The focal point is a tragic woman in white. Lady Jane Grey ruled as Queen of England for nine days, but her supporters were defeated by the forces of the Catholic Mary I and she was beheaded.

In the past, images were few and far between. Unless you were wealthy, the only paintings you might ever see were in churches, where their aim was to edify and fill you with awe. Today we are bombarded by bright, colorful images—on billboards, in magazines, on television, and on the internet—and almost all of them use the language of art to persuade us to buy things or behave ourselves, or they enrich our visual environment, as pieces of public art. All these images vie for our attention, so not only must the image be eye-catching, standing out from all the others, but its message must be instantly clear and unambiguous.

There is less urgency in the calmer atmosphere of the art gallery, but even here images compete with each other, and the elements within each picture also demand our attention. Of course, the subject matter itself could be attention-grabbing, but our capacity to be shocked or affronted by an outrageous or previously taboo theme has been eroded, as we have become accustomed to the risqué nudes of Diego Velázquez (1599–1660) and Edouard Manet (see **8.18**), the "ready-mades" of Duchamp, the Expressionism of Francis Bacon (1909–92) and Jackson Pollock (see **11.23**), and, more recently, by works such as the unmade bed of Brit-pop maverick Tracey Emin (b. 1963) and the sliced-up cows of Damien Hirst.

How does an artist catch a viewer's gaze, draw them into a picture, and sustain their interest as they explore it further? The answer is by establishing a focal point. In realist works, this will almost certainly be the subject of the drawing or painting— the baby Jesus in a nativity scene, for example, or the fallen hero in a narrative picture. In an abstract or non-objective painting, on the other hand, a focal point adds interest, preventing our eyes from wandering aimlessly around the image. As we noted in Chapter 8, our brains crave repetition but with variation, and contrast supplies that stimulus. Although color-field paintings can evoke spiritual pleasure, even Barnett Newman felt compelled to add a contrasting stripe or "zip" to bring us back to earth.

As in music, where a single premature crescendo might leave us asking for more, artists like to add subsidiary focal points, termed accents, to counterbalance the main emphasis and provide variety. But we must be careful to establish the hierarchy of accents. When too many elements are emphasized, the composition as a whole will start to lose coherence and may tip over into visual anarchy. Sometimes, however, we need to be jolted from our complacency, and all rules, once understood and appreciated, are there to be broken, of course. A seemingly banal image or one that screams at the viewer like a fairground can be read as knowing irony—a commentary on our received views of what is harmonious and tasteful.

Graphic designers in particular are constantly re-inventing visual language so that it is noticed. As Postmodernism, with its playful references to the "tasteless" ornate past, took over from the austerity of Modernism, and Punk was a reaction to pompous stadium rock, fashions in art and design fluctuate according to the *Zeitgeist*. Art and design, however, rarely follow fashion; they precede it. Artists and designers are the pioneers, creating paths through unknown territories that the other media professionals will follow.

11.5 Victor Burgin, *The Office at Night*, 1985. Three panels, mixed media, 72 × 96″ (182.8 × 243.8 cm). John Weber Gallery, New York.

Conceptual artist Burgin contrasts a 1940s female office-worker from an Edward Hopper painting (and her photographic re-creation) with an area flat in color and pictograms examining her voyeuristic gaze and imagined reaction.

11.6 Arshile Gorky, *Abstraction*, 1936. Oil on canvas, laid down on masonite, 35 × 43 ⅛″ (89 × 109.5 cm). Private Collection.

Gorky's abstractions were influenced by Cézanne, Picasso, and Miró. Here the biomorphic shapes contrast with the other mainly rectilinear shapes in the background, with areas of white forming accents.

Contrast

When an examination question asks us to "compare and contrast" two events or works of literature, we are being asked to examine their similarities and their differences. In paintings and photography, the word contrast is used to denote a difference in value (**11.7**). A high-contrast photograph, for example, is black and white, with no grays and no detail in the highlights or shadows. If you look at a painting or photograph with your eyes screwed up, all you will see is the value pattern—vague areas of different values. If you notice a distinct patch of light against grays or black, or an area of black silhouetted against lighter tones or white, you are seeing contrast, and that area of the image is emphasized.

Photographers record all the visual information that enters their cameras and create contrast later, in the darkroom or on a computer. Artists, however, are able to create contrast as they work, making marks and selectively editing what they see, emphasizing some features in a portrait, say, and ignoring superfluous detail.

Artists are fascinated by the differences between exterior and interior light. In general, strong direct daylight is more contrasty than diffuse interior light, but a dull day softens the contrast outside, and harsh artificial light can produce strong shadows and highlights inside. Placing a subject by a window, say, and thereby

11.7 Thomas Gainsborough, *Mr & Mrs William Hallett*, 1785. Oil on canvas, 93 × 70 ½" (236.2 × 179.1 cm). National Gallery, London.

The light, feathery brushstrokes are typical of Gainsborough's late style. The sky, the dress, and dog contrast strongly with the sombre darkness of the man's clothing and the woods they are entering.

11.8 Johannes Vermeer, *The Astrologue*, nd. Oil on canvas, 20 × 17 ¾" (51 × 45 cm). Louvre, Paris.

The astronomer and his stellar globe are illuminated by light from the window. His eye direction directs us to the globe, which is also the area of lightest value. Many of Vermeer's paintings have a window on the left of the composition.

11.9 Anish Kapoor, *As if to Celebrate, I Discovered a Mountain Blooming with Red Flowers*, 1981. Drawing, wood, and mixed media, 37 ¾ × 30 × 63 ″ (96 × 76.2 × 160 cm). Tate, London.

Kapoor covers these forms with pure, intense, powdered pigment, some spilling onto the gallery floor. Although the yellow form is smallest, its isolation makes it a focal point.

11.10 Hans Hofmann, *Pompeii*, 1959. Oil on canvas, 7′ × 4′ 4″ (2.14 × 1.32 m). Tate, London.

Hofmann's late paintings are characterized by juxtaposed vivid colored rectangles. These create space because the human eye sees warm colors coming forward and cool ones receding. Hofmann termed this effect "push and pull."

including both interior and exterior light in a single image, emphasizes the value contrasts and makes for dramatic visual possibilities (**11.8**).

In a portrait or a simple still life, the subject of the picture is usually self-evident, and the focal point will be the sitter's face or the bowl of fruit. In a more elaborate composition, the focal point may not be immediately apparent or the artist may wish to draw the viewer's attention to another part of the image—to something in the sitter's hands, for example, or to some other object of symbolic significance (see **11.2**). A change in value is the artist's first choice to help establish a focal point—white hands against a darker cloth, bright white clothing shining through the gloom, a white dove against a dark sky, for instance.

Color contrast is one of the most powerful ways to create emphasis (**11.9**). Some colors—hot reds and oranges, for example—practically jump out of the picture (**11.10**), so a dab of red on a diminutive figure in an expansive landscape will attract the viewer's eyes. An element can be emphasized by its position, shape, size, or isolation, but a contrast in color and/or value will overpower all the other factors.

Isolation

The odd one out always demands our attention, and one of the easiest ways to create emphasis is to isolate an element from all the others, either by separating it physically or by making it symbolically different (**11.11**).

Emphasis by isolation is a special case of contrast by placement (see pages 236–237), and a powerful way to isolate an element is to have it stand in an empty space. A cut-out shape against pure white, without shadows, is an object removed from its context (**11.12**). There are no distractions, and we can only contemplate that object, whether it be a figure, a flower, or a piece of furniture. Stock images are often sold as photographs with a "clipping path." Extraneous background detail is cut away in Photoshop so that the image can be placed seamlessly on another stock background. Designers quickly grasped the visual possibilities of cut-outs and started to use them in their own right, and we have become accustomed to seeing objects this way, floating in nothingness. If a white background is judged to be too severe, the object can be placed against a black or neutral background or on a single, flat color, which may be cool if you wish the object to project, or warm if you would like to create a shallow, more intimate space.

Isolation and alienation may be the themes of the painting. We can feel lonely even in a crowd, and artists like to convey feelings of solitude, whether it is a human struggling against a harsh environment or someone being heroic against the odds (**11.13**). Such symbolic themes can be supported by careful placement, by scale, and by the choice of the color scheme.

When there are many elements to place, emphasis can be achieved by isolating the main element from the rest—positioning it to one side of the picture, and

11.11 Dorothea Lange, *White Angel Breadline, San Francisco*, 1933. Photograph. Oakland Museum of California, Oakland, CA. Dorothea Lange Collection.

This poignant study shows that we can be lonely even in a crowd. Artists and photographers were funded by various projects during the Depression to document the plight of farm workers and the urban poor.

11.12 Christina Ure, *Shuttlecock*, 2000. Oil on canvas, 18 ⅞ × 13 ¾″ (48 × 35 cm). Courtesy the artist.

By isolating this poppy as a cut-out against a pure white, featureless ground, Ure intensifies its already vivid color and focuses our attention on its form.

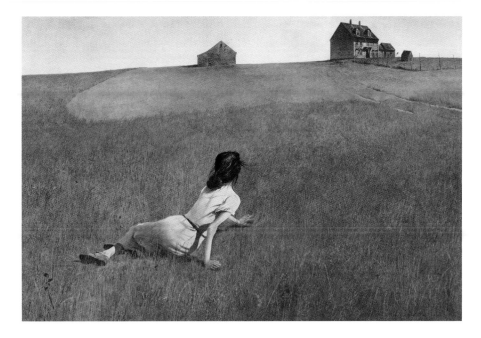

11.13 Andrew Wyeth, *Christina's World*, 1948. Tempera on gessoed panel, 32 × 47″ (81.2 × 119.3 cm). Museum of Modern Art, New York. Purchase.

Isolation is the theme of the painting. Wyeth and Christina Olson were neighbors in Maine. He admired this intelligent woman who was unable to walk due to a childhood illness but who "loved the feeling of being out in the field."

11.14 Joan Miro, *Painting*, 1933. Oil on canvas, 5′ 8″ × 6′ 5″ (174 × 196.2 cm). The Museum of Modern Art New York. Gift of the Advisory Committee (by exchange).

The red and white colored elements draw the eye into the composition—the red by its isolation and the whites by their contrast. These are balanced by the white outlined shape on the left.

the others to the opposite side, for example. It is important to retain balance in these circumstances, however. We require the focal point to be with the isolated element, and its visual weight should be sufficient to balance the other group (**11.14**). We can factor in the space around the isolated element, its value compared with the rest of the image, its relative color, and so on, perhaps adding unifying accents if necessary. Remember, too, the influence of eye direction. An isolated figure that is too close to the edge of the picture frame will draw the eye out of the picture. If the figure is looking back toward the center of the image or if a shape implies movement and direction away from the edge, the overall picture will be balanced and unified.

Your theme may need a dominant focal point, but resist the temptation to overdo it. If the viewer can discover the point of your painting without too much help, it will be a far more successful composition. The aim must always be to create an artwork that is unified, balanced, and harmonious and in which the focal point is an integral part of the design.

Placement

Isolating an element involves placing it apart from the other elements and thereby creating a focal point. Emphasis can also be achieved by placement, the most apparent example of which is to locate your subject in the very center of the picture plane (**11.16**). Unless there is a stronger emphasis elsewhere, our eyes naturally gravitate to the center of a painting or drawing, so placing the subject there, perhaps also isolated from the other elements, will catch the viewer's attention (**11.15**).

In medieval art, the subject was not only placed centrally, but was also usually larger than any subsidiary characters to reinforce its superiority. Our more sophisticated eyes do not require so many clues, but eye direction will help the viewer. Who is everyone looking at? Eye direction creates implied lines that are almost as strong as pointing fingers (**11.17**). There are other guiding lines too—both real and implied—that can lead our eyes to the focal point of a picture (**11.18**). Lines of perspective, for example, can draw our eyes into the painting to an element that is placed where it impedes our progress to the vanishing point. If all the implied lines lead in from the edges of the image to a central point, we call it a **radial design**. As with a target or the rose-window of a cathedral, our eyes, no matter where they may wander, are pulled back toward the center.

Our affinity with symmetry tends to make the dominant position in a composition the very center. The next best placement will be where our eyes seek out a golden section or mean. If we divide the picture plane into thirds, using horizontal and vertical lines, the points at which these lines intersect will be suitable locations for placing important elements (see pages 222–225).

11.15 William Holman Hunt, *The Light of the World*, 1851–3. Oil on canvas, 49 ⅜ × 23 ⅝" (125 × 60 cm). Keble College, Oxford.

Although we are naturally first attracted to the face of a figure, here the focal point is the lamp. Hunt painted this picture in the moonlight. He had the seven-sided lantern specially made.

11.16 Paul Cézanne, *The Card Players*, c. 1890–5. Oil on canvas, 18 ¾ × 22 ⅜" (47.5 × 57 cm). Musée d'Orsay, Paris.

In this symmetrical design, all real and implied lines—eye direction, arms, the pipe—lead to the center of the composition and the gap between the card players' hands, occupied by the bottle.

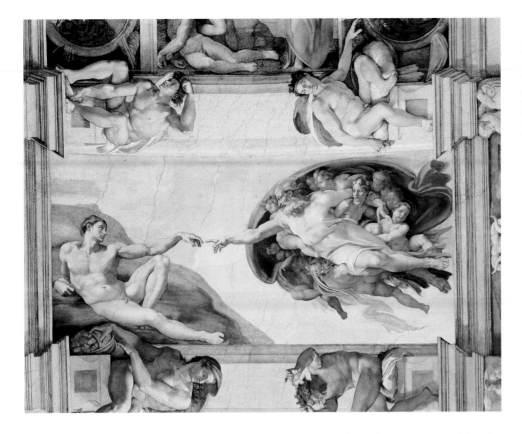

11.17 Michelangelo Buonarroti, *Creation of Adam*, 1510. Fresco. Sistine Chapel, Vatican, Rome.

By eye direction and pointing fingers we are drawn to the tiny gap between God and Adam. A scene from the Sistine Chapel ceiling, the touch of God's hand awakens the newly created Adam and thus begins the life of humankind.

Placement is, of course, generally determined by the subject matter and by the natural arrangement of the objects found in front of the artist or photographer. Although an artist is able to rearrange the positions of figures or items in a still life, the choice of viewpoint will be a determining factor. Unless the artist is being ironic by placing a figure or object provocatively full on, facing the real or proverbial camera, we like natural and realistic scenes. We also tend to prefer asymmetrical designs, with lively, interconnected shapes and spaces that allow us to explore and search out interesting juxtapositions to contrast and compare. A centralized emphasis can limit the potential for movement; a decentralized arrangement, on the other hand, which has changes in direction and multiple implied pathways, can produce a dynamic composition that holds our attention and prolongs our viewing pleasure.

There are a number of ways in which artists can adjust the placement and relative positions of elements to maintain unity and harmony, while at the same time introducing variety and emphasis. We can use our intellect, intuition, and humor to juggle these elements and principles, at the same time remembering why we are producing this particular painting or drawing. If the work is beautiful, or at least thought-provoking, speaks eloquently, and gives pleasure to the viewer, we may believe that all the elements and principles will have joined forces successfully.

11.18 Pietro Perugino, *Christ Giving the Keys to St. Peter*, 1482. Fresco, 11' 5 ½" × 18' 8 ½" (3.53 × 5.76 m). Sistine Chapel, Vatican, Rome.

Although the lines of perspective lead us to the door of the domed temple, the focal point is the silhouetted silver key seen hanging from St. Peter's hand, bottom center of the design.

Absence of Focal Point

If you cannot find an obvious center of attention in a painting or drawing, the picture as a whole becomes the focal point. Two kinds of image fall into this category: big, busy scenes with so much going on that no particular focal point dominates (**11.19, 11.20**), and non-objective paintings or sculptures, where the elements that make up the composition are so subservient to the whole that they melt into insignificance (**11.21**). Taken to the extreme, both types verge on becoming decorative space and pattern, but they are still identifiable as works of art.

Throughout art history, there have been examples of multiple focal points, from Chinese scrolls to quilts, mosaics, tapestries, and panoramas. Large paintings, like the nightmarish fantasies of Hieronymus Bosch (*c*.1450–1516) (**11.22** and page 226), contain so much action that we cannot pick out a dominant focal point. In the 20th century, the crowd scenes of L.S. Lowry (1887–1976) show tiny people going about their business in grim industrial landscapes (see **10.11**). Children are fascinated by Martin Hanford's *Where's Waldo?* (*Where's Wally?* in the UK) in which there *is* a focal point in the highly detailed pictures—Waldo himself—but the fun is in finding him. In sculpture, we have Antony Gormley (b. 1950) and his sculpture *Field*, a sea of 40,000 staring, biomorphic clay figures spilling out of architectural spaces (see **8.2**). In photography, we marvel at the monumental depictions of offices by Andreas Gursky (b. 1955) in which humans are reduced to the scale and status of ants.

Artists may also repeat a motif many times. Andy Warhol used a rectilinear grid for his screenprints of *Red Elvis* (see **8.3**), as did Damien Hirst in his painting of

an array of colored spots (see **3.29**). The pattern may not be so obvious, taking, perhaps, the form of a random scattering of shapes and textures that leaves no area of the canvas uncovered.

A completely empty canvas has no focal point, but the smallest mark will draw attention to itself. Kasimir Malevich's *White on White* does have a focal point, even if it is difficult to make out (see **0.8**). An entire canvas painted in a uniform ultramarine, as in a monochrome by French conceptual artist Yves Klein, makes the color—his own patented IKB (International Klein Blue)—the focal point. Blue symbolizes the infinity of space, free from form. "I espouse the cause of pure color," Klein said, "which has been invaded and occupied guilefully by the cowardly line and its manifestation, drawing in art."

Klein was an action painter, as was Jackson Pollock, who revolutionized painting in 1947 by directly pouring or dripping paint onto a canvas that was placed on the floor (**11.23**). Pollock allowed his unconscious mind to determine the outcome, and he used sticks over conventional brushes and painted "in the round" like Native American sand painters. Dripping paint vertically gave him more control over where the paint was applied than if he were standing at an easel, and it is striking how each of his compositions is so different from the others. When they are placed on a wall, the intricacy of the allover pattern on the canvas's surface creates a sense of intense energy that engulfs the viewer, whom Pollock asks to surrender intellectual control and empathize with the gestures and movements embodied in his works.

11.20 (above) Richard Dadd, *The Fairy Feller's Masterstroke,* 1855–64. Oil on canvas, 21 ¼ × 15 ½″ (54 × 39.4 cm). Tate, London.

Dadd painted this in Bethlem Hospital where he was sent after murdering his father. The meticulous detail, lack of focal point, shifting scale, and size of the painting all contribute to a sense of the fantastic seen later in Surrealism.

11.21 Gary Hume, *Water Painting,* 1999. Household paint on aluminum panel on paper, support 9 ½ × 12″ (24.2 × 30.3 cm). Tate, London.

Hume traces multiple overlapping outlines of nudes from photographs in magazines, creating decorative space in household gloss paint. Face, breast, arm and hand fragments do not seem to belong to any particular body, giving the painting an uncertainty conflicting with its glossy appearance.

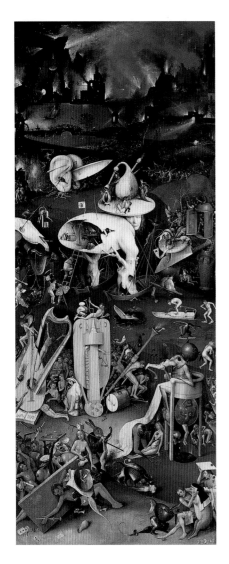

Jackson Pollock's action paintings were a record of an event—the process of painting—which was inspired by improvised jazz. He had also been inspired by the Impressionists, particularly the later works of Monet, in which the richness of the colored surface took over from the subject being represented. Mark Rothko (see **2.21**) was also influenced by Monet and modern music. His color-field paintings are soft clouds of color, often stacked one on top of the other. They fill the canvas almost to the edges and, like Pollock's paintings, are meant to be viewed close to, so that they fill the field of view and overwhelm the viewer. They directly affect the senses, and some people have said that they feel the same way in front of a Rothko as they do in a cathedral.

Like Pollock, Rothko had experimented with "automatic" drawing, a technique developed by the Surrealists to tap into the unconscious mind. He would produce loose doodles, then block in the background in thin, allover washes of color. By 1949, the color had taken over. He worked out his ideas directly on the canvas, his aim being to remove "all obstacles between the painter and the idea, and between the idea and the observer." Like Pollock's paintings, Rothko's works do not depict experience at second-hand but are an experience in themselves. "Free from the familiar," he said, "transcendental experiences become possible ... Pictures must be miraculous ... a revelation, an unexpected and unprecedented resolution of an eternally familiar need."

The action painters and the color-field artists paved the way for Minimal and conceptual art. Minimalists, such as Ad Reinhardt (1913–67), painted with colors that are so close in value that any shapes are almost invisible, and from 1955, Reinhardt worked almost exclusively in near-black.

In the 1960s, a branch of Minimalism called Op-art exploded into the art world. Its major artists were Bridget Riley and Victor Vasarely. Op is short for optical, and the images are optical illusions that evoke movement and three-dimensionality.

11.22 (above) Hieronymous Bosch, *Garden of Earthly Delights*, c. 1505. Triptych, right panel (Hell), 86 ⅝ × 38 ¼" (220 × 97 cm). Prado, Madrid. (See p. 226)

Bosch's complex allegories and nightmarish visions endeared him to the Surrealists. The *Garden of Earthly Delights* consists of four paintings on a series of folding panels.

11.23 (right) Jackson Pollock, *Number 23*, 1948. Enamel on gesso on paper, 22 ⅝ × 30 ⅞" (57.5 × 78.4 cm). Tate, London.

Pollock poured streams of black and white enamel paint onto the surface to produce an allover pattern. The liquid black bled into the white background to become gray, over which delicate white is rhythmically woven.

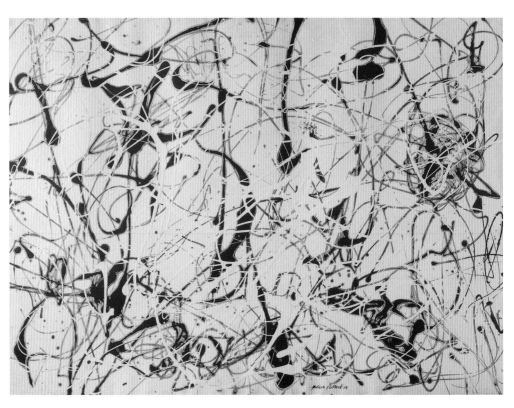

11.24 Paul Brown, *The Deluge, After Leonardo*, 1995. Iris print, 19 ⅝ × 19 ⅝" (50 × 50 cm). © Paul Brown, 1995.

Brown's computer-generated artworks take our eyes on a journey through an endless Op-art maze. On first glance an allover pattern of gray, closer inspection reveals a complex pit of writhing snakes. (See **5.3**)

These geometric arrays and patterns of wavy lines have a direct impact on our physiology of vision, producing fluctuating and tantalizing visual effects that leave us entranced (**11.24**). They move before our eyes. Action and Op-art paintings may lack a focal point, but they do have something we shall explore in the next chapter—rhythm.

Exercises

1 Value pattern: Starting with a Renaissance or Baroque painting such as **8.24** or **12.15**, use tracing paper to simplify the main shapes until you are left with just two or three biomorphic ones. Fill these in in black, against a white ground. Make another version, white on black.

2 Isolation: Chose a subject with an interesting silhouette—a flower, shell, or other natural object—and place it against a white ground. Draw an enlarged part of this object, emphasizing its sculptural form. The result should be semi-abstract, yet recognizable.

3 Absence of focal point: Find an image that has been created unconsciously, such as a doodle on a telephone pad. Enlarge it on a photocopier and if possible turn it into a mirror image. Then trace or copy it faithfully onto a large sheet of neutral paper using blue or brown paint. It might be best to do this with the image upside down, so as not to tempt you into cleaning it up. Finally, use white paint to block in the white areas, eroding into the "positive" areas. The aim is to avoid creating a focal point.

12 | Rhythm

"There are six essentials in painting: The first is spirit; the second, rhythm; the third, thought; the fourth, scenery; the fifth, the brush; and the last is the ink."

JING HAO

Bridget Riley, *Fall*, 1963. Emulsion on hardboard, 55 ½ × 55 ¼" (141 × 140.3 cm). Tate, London.

Riley's early monochromatic paintings reflect states of mind. A vertical curve of increasing frequency is repeated horizontally to create an Op-art field. The upper part is a gentle, relaxed swing, which increases and compresses toward the bottom of the painting.

Introduction

Rhythm in music is the pattern produced by a combination of emphasis and the duration of notes. In poetry it is the use of long and short syllables to create a pleasing sequence of sounds. We have the rhythm of the heartbeat, of Latin American dance, of the blacksmith's hammer. The rhythm section of a band—the drums and bass—holds everything together with a beat that forms a framework over which the other instruments can perform the melody. Rhythm can be a simple, steady metronome beat or something more eccentric, such as syncopated jazz, the sensual rolling of samba, the exuberance of African drumming, or the interlocking intricacies of Balinese gamelan.

In art and design, rhythm is created by the movement of the viewer's eyes across and around an image, taking in the repetition of elements that have been placed with some kind of structured variation (**12.1**). We are attracted to the flowing curves and sinuous shapes found in Art Nouveau and Op-art, but we can also find rhythm in more **staccato** changes of direction or in alternating changes in contrast from light to dark and back again (**12.2**), or in a succession of evolving shapes.

Just as handwriting can be slapdash and ugly, or beautiful and verging on the calligraphic, so paintings and sculptures exhibit varying amounts of rhythm. It almost always adds to the experience of viewing and is rarely inappropriate.

12.1 Sandro Botticelli, *Primavera*, c. 1482. Oil on panel, 6′ 8″ × 10′ 4″ (2.03 × 3.15 m). Galleria degli Uffizi, Florence.

At the center of Botticelli's "Allegory of Spring" is Venus with the blindfolded Cupid. To the left are the Three Graces. There is a slow rhythm in the equal distribution of the figures and in the way they move, emphasized by elegant arm gestures.

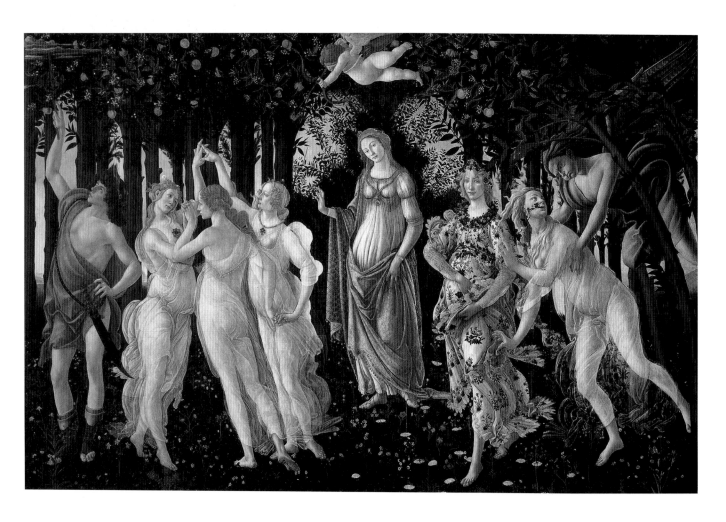

Introducing rhythm to an artwork adds a touch of finesse and can make an accomplished painting or sculpture into an exceptional one.

Music is the most abstract of all the art forms, and many artists have attempted to visualize the emotions that music can evoke: from the *Nocturnes* of Whistler, through the compositions of Malevich, to Walt Disney's animated film *Fantasia* and contemporary computer-based works. At the Bauhaus, students often started lessons with a session of eurythmic exercises to encourage them to appreciate geometric shapes physically. Freehand drawing of geometric and rhythmic patterns and eurythmics are still taught to children at Waldorf or Rudolf Steiner schools.

Paul Klee, in particular, was committed to teaching visual rhythm, and he developed studies that combine mechanical repetition with shifts of weight and character, which are either organic, like handwriting, or achieved through intentional change. He also translated the gestures that conductors make into movements of his pen, a three-four beat, for example, being transformed into the triangular sails of boats.

Art forms do exist in isolation, appealing to the different senses, but there is often some crossover—a piece of music can conjure up a pastoral scene or battlefield, and a painting or sculpture can have a lyrical quality, making us move in sympathy. There is even a condition called synesthesia, in which two sensations—usually color and sound—are triggered by the same stimulus. Synesthesics see sounds and hear colors—they could be listening to an opera, for example, but would see a painting, each musical instrument having its own color. The Mac MP3 program iTunes has a feature that turns the song being played into a Spirograph-type visual image that changes in real time to the music, making rhythm visible.

12.2 Giorgio de Chirico, *The Anxious Journey*, 1913. Oil on canvas, 29 × 42″ (78.4 × 106.7 cm). Museum of Modern Art, New York.

De Chirico's dreamlike labyrinth of dark, arched doorways creates an alternating rhythm in three dimensions. The effect is disorienting as perspective is subverted to undermine our stability in a solid, tangible world.

Rhythm in art relies on the reiteration of elements or motifs that have been systematically positioned around the picture plane and suitably accented (**12.3**). Repetitive divisions alone do not constitute a rhythm, however. It is necessary to set up a balance between a regular element and irregularities, between a major dominant element and the minor variants (**12.4**).

Rhythm depends on contrast, which may be between horizontal and vertical lines and diagonals, between geometric and biomorphic shapes, or between slow, smooth and fast, hectic transitions as the eye is directed around the picture. In short, it is achieved in the same ways we create emphasis, but with the extra dimension of progressive repetition.

We make music not only by moving up and down the scale to alter the pitch of the notes, but also by varying the duration of the notes and how loud or quiet they are. In art, we vary the sizes and shapes of elements, their value and color, their texture, and their relative positions.

We also consider the white spaces, which are the equivalent to pauses or intervals of silence, between the elements. If a drum produces a series of notes that are identical in pitch and volume, the pattern we hear is caused by the varying periods of silence between each beat. Similarly, we see rhythm in the relative spacing of elements within a painting, sculpture or building (**12.5, 12.6**). Repetition alone is not enough to create a visually engaging piece. There must also be variation, according to some scheme—an arithmetic or Fibonacci sequence, perhaps.

12.3 Mark Gertler, *Merry-Go-Round*, 1916. Oil on canvas, 74 ½ × 56″ (189.2 × 142.2 cm). Tate, London.

Gertler, a conscientious objector in World War I, transforms a fairground ride into a metaphor for the military machine. Contrasting the fun of the fair with the nightmare of war, he shows people rigid with fear trapped on an unstoppable carousel.

12.4 George Stubbs, *Reapers*, 1785. Oil on wood, 35 ⅛ × 53 ⅞″ (89.9 × 136.8 cm). Tate, London.

There is a gentle lyrical left-to-right rhythm in the poses and eye direction of the workers and the rise in the tree line. The idealized workers are spotlessly clean and the church in the distance and the farm manager on his horse suggest authority.

Mood is important, too. A military march or the incessant beat of House music may be appropriate in some circumstances, while swing or a bossa nova beat might be better in another context. A picture may be still and silent—a Rothko, for example—or could be a visual roller-coaster ride like a sax solo by Charlie Parker. A gentle rhythm of rolling hills, undulating fields, and flowing streams suggests peaceful calm; a jerky, jagged rhythm creates excitement and action.

When we look at a painting our eyes are being taken on a mystery tour along roads created by the artist. There are speed limits and stop lights; there are rest areas along the way, where we can pause for refreshment and take in the surroundings. The real and implied lines, lost and found edges, created by the shape and direction of elements, gestalt groupings, and motifs linked by association, sometimes allow us to cruise along comfortably, but then we are forced to leap over precipitous gaps. The pace of our journey is controlled by the painting's rhythm.

Movement and rhythm go hand in hand. With the exception of kinetic sculpture and the time-based arts, we are attempting to create the illusion of movement on a two-dimensional surface or the three-dimensional static form of a sculpture. Rhythm in art is movement with an added groove—a musical dimension—and we see it in the flowing lines of drapery on the Classical figure as well as in the curves and twists of one of Pollock's action paintings.

12.5 Claude Monet, *Poplars on the Epte*, 1891. Oil on canvas, 36 × 29″ (92.4 × 73.7 cm). Tate, London.

Monet learned that a row of poplar trees near his home were to be felled and paid for them to be left standing long enough to paint them, at different times of day and in different weather conditions. The stripes of trees and sky create an alternating rhythm.

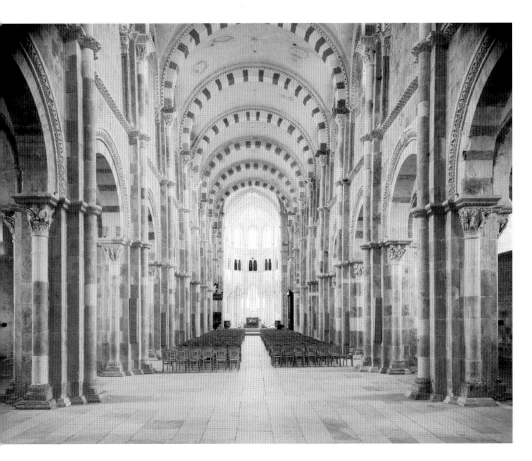

12.6 Sainte Madeleine, nave and choir, Vézelay, 1120–32.

Vézelay is a Romanesque pilgrimage church. Its interior has alternating rhythms not only in the contrast between the bright clerestory windows and the supporting piers for the cross vaults, but also in the Moorish-inspired alternating dark and light "striped" stonework.

Rhythm and Motion

12.7 Giacomo Balla, *Swifts: Paths of Movement + Dynamic Sequences*, 1913. Oil on canvas, 38 × 47″ (96.8 × 120 cm). Museum of Modern Art, New York. Purchase.

Balla expresses the dynamism of birds in flight by leading the eye across the surface in a delicate series of sweeping waves.

At the beginning of the 20th century, there was excitement about the progress in science and technology. Trains and automobiles were getting faster, photography had been invented, electricity was being generated, and flight was possible. Italian Futurist artists worked at fever pitch to keep up with the latest developments (**12.7**). They were inspired by the painting techniques of divisionism, in which "divided strokes" of pure colors were applied in long, meandering lines, dematerializing shapes into kinetic and luminous vibrations that suggested their inner rhythms. They were also influenced by the time-based photographs of Marey (see **5.18**) and Muybridge (see **5.17**), and the studies of sound waves by Ernst Mach, who gave his name to the speed of sound. Their pictorial dynamism went beyond the mere depiction of motion, for they also painted sound waves in space, and the repetitive shapes and positions of their figures express movement and rhythm. The Futurists inspired the English Vorticists (**12.8**) and the artists, designers, and architects of Art Deco, who loved to visualize speed and motion in their flowing and streamlined forms.

If lines—real and implied—map our route around a composition, rhythm regulates the tempo—where we can move quickly, where we linger, and where we skip to the next area of interest (**12.10**). We can use musical terms to describe the experience: *adagio* for a leisurely, graceful motion, *legato* for a smooth, evenly paced wander, *allegro* for a lively cheerful jaunt, and *staccato* for a jerky, disconnected journey.

Although rhythmic patterning will bind elements into a higher order of relatedness, mere repetition can quickly become predictable and monotonous. Our attention will stray and the image will be perceived as boring or even become invisible. To stimulate our attention, the artist must introduce higher levels of organization. Returning to our musical analogy, we can consider the canon or round, in which a simple melody is sung by different voices starting at different times. In songs like "Frère Jacques" and "London's Burning" someone starts off and the next voice joins in a few beats later. A single theme accompanies itself—it need only be staggered and overlapped to result in a rich, complicated pattern that retains a strong rhythm.

Klee used a similar technique to repeat, overlap, reverse, and invert motifs to create complex patterns (**12.9**). He was a

12.8 David Bomberg, *The Mud Bath*, 1914. Oil on canvas, 60 × 88 ¼″ (152.4 × 224.2 cm). Tate, London.

Bomberg reduces the human figure to a series of dynamic geometric shapes. The scene probably derives from steam baths in east London frequented by the Jewish population, a place for physical and spiritual cleansing.

trained musician and transposed his knowledge into a graphical notation of divisions, repetitions, weights, and accents.

Op-art painters, such as Bridget Riley, use a more methodical approach, designing repetitions that act directly on the eye and brain (see p. 242). Riley was inspired by Klee, who showed her what abstraction really meant. Klee said that abstraction was the beginning, not the end of a process, and he used elements that are essentially abstract compared with the pictorial experience that can be built using them. He observed that a triangle encompasses more than the geometric definition of three points not on a straight line connected; it is also the tension between a line and a point, a base and a directional thrust—it has energy and a potential for movement. "Form as movement, as action, is a good thing," he said. "Form as rest, as end, is bad."

12.9 (right) Paul Klee, *Pastoral*, 1927. Tempera on canvas on wood, 27 × 20″ (69.3 × 52.4 cm). Museum of Modern Art, New York. Abby Aldrich Rockefeller Fund.

Klee was a trained musician and transposed his knowledge into a graphical notation of divisions, repetitions, and accents.

12.10 (below) Lisa Milroy, *Shoes*, 1985. Oil on canvas, 5′ 6″ × 7′ 3″ (1.7 × 2.2 m). Tate, London.

Milroy presents objects alienated from any context, set against a neutral ground. We are invited to appreciate their abstract qualities and rhythmic arrangement. These shoes suggest musical notation.

Alternating and Progressive Rhythm

Alternating rhythm is the contrast between day and night, winter and summer. It is the simplest type to achieve in art and can be created by simply repeating two or more elements on a regular, interchanging basis—triangle, circle, triangle, circle, and so on. Because it is so simple and tends to monotony, it must be introduced subtly, as in the shadows cast by a row of poplar trees, for example (see **12.5**). It has particular application in architecture, such as the alternating columns and spaces in a classical building, or the alternating round and triangular pediments above windows in baroque and Regency architecture (**12.11**).

Baroque is the art of the 17th century. The word baroque derives from a Spanish word meaning an irregular, oddly shaped pearl. The key characteristic of baroque architecture is movement, seen in undulating, curved walls or the use of fountains. Architects wanted their buildings to be extravagant and theatrical, giving the impression of activity. They used curvilinear shapes and made dramatic contrasts of light and shadow, juxtaposing projections and overhangs with deep recesses, adding carved, small-scale elements to join surfaces at different levels so that the façade is uninterrupted.

Curvy buildings with rhythm are not common, perhaps because rectilinear buildings are easier to fabricate, but we see further examples in the Art Nouveau style, in the architecture of Gaudí (**12.12**), in Expressionist buildings, such as Erich Mendelsohn's Einstein Tower, Potsdam, in the buildings in Art Deco style (**12.13**), and now that we have computers to help us, in the modern buildings of Frank Gehry (see **9.10**).

Alternating rhythm is also important in Islamic art, particularly in wall patterns and friezes, where motifs and colors are inverted and reflected, and positive and negative shapes are balanced to create intriguing combinations of figures and grounds. Using reflecting and shining glazes, repeating designs, and contrasting textures, Islamic decoration becomes intricate and sumptuous. Water features, such as courtyard pools, are used to reflect the architecture and multiply the decorative themes, generating layers of pattern. Calligraphic inscriptions are used to frame main elements of buildings, such as portals and cornices, or on pierced details that provide patterns of light filtering through windows (**12.14**). The arabesque is a scrollwork motif, which splits regularly, producing secondary stems that split again or reintegrate with the main motif. This limitless, rhythmical alternation of movement, conveyed by the reciprocal repetition of curved lines, produces a design that is balanced and free from tension.

Progressive rhythm is created by regular changes in a repeated element, such as a series of circles that progressively increase or decrease in size. They are often found in nature—in diminishing echoes and the growth patterns of plants and shells, for example—but alternating rhythms can become monotonous. We need some periodicity—alternating activity and rest—to make sense of a relentless continuous

12.11 Oratory of St. Philip Neri, Rome (left), by Francesco Borromini, façade 1637–40; adjacent church of S. Maria in Vallicella, Rome (right), façade by Fausto Rughesi, 1605.

Baroque architects used movement, in undulating curved walls and dramatic contrasts of light and shadow, because they wanted their buildings to be extravagant and theatrical, giving the impression of activity.

12.12 Antonio Gaudí, Casa Milá, Barcelona, 1905–11.

Situated on a corner, this apartment block was dubbed La Pedrera (the quarry) because of its cliff-like walls. It seems sculptural, with contrasts between the wavy curves of the balconies, cave-like voids, and the pale limestone with the dark ironwork. The rooftop contains strange robotic chimneys.

stream of information, otherwise we would become overwhelmed and lose interest. To hold the attention of our viewers, we can make the rhythms modulate—that is, undergo progressive change or development. These higher order patterns can be created by varying any of the elements—position, size, shape, color, or texture—and in a variety of modes: regular or irregular, formal or informal, romantic or classical, free or constrained. Architecture has been described as "music in space," and we can imagine a building, street, or city as a continuous pattern. In the built environment, our motion through space releases the inherent rhythms around us.

12.13 (far left) William van Alen, Chrysler Building (detail), New York, 1928–30.

This Art Deco building not only scrapes the sky but pierces it. The stainless steel pinnacle, with seven fan-like diminishing arcs overlapping like fish scales, and triangular windows, is a prime example of progressive rhythm.

12.14 Mihrab, attrib. Isfahan, Iran, 1354. Mosaic, monochrome-glazed tiles on composite body in plaster, 135 ⁷⁄₁₆ × 113 ¹¹⁄₁₆″ (343.1 × 288.7 cm). Metropolitan Museum of Art, New York. Harris Brisbane Dick Fund, 1939.

Alternating rhythm is important in Islamic art, particularly in wall patterns and friezes. Calligraphy is used to frame main elements of a building such as niches, portals, and cornices, or on pierced details providing a pattern of light filtering through windows.

Rhythmic Sensation

Many artists have attempted to merge the sensations of music with the visual arts. We can see movement and rhythm in the baroque paintings of Rubens (**12.15**), the exuberant brushwork of van Gogh, the frantic activity of the Futurists, and the physicality of Pollock, or we can note the lack of motion in the calm *Nocturnes* of Whistler or the serene color-field paintings of Rothko. Other artists have taken a more intellectual approach to the link between music and painting.

Kasimir Malevich, a pioneer of abstract art, vowed to "free art from the burden of the object." He started the Suprematist movement—so-called to assert human ascendancy over nature—and painted such radical pictures as a black square on a white ground as early as 1913. He later introduced other geometric shapes and color into his compositions. Suprematism was defined as "the primacy of pure sensation in the visual arts." Paintings had to be truly visual. Malevich's compositions had no meaning beyond the perceptual relationships between colored shapes, and a sensation of rhythm is inherent in the way the shapes are arranged (**12.16**).

Piet Mondrian's approach to abstraction developed from a van Gogh style of Expressionism to black horizontal and vertical lines enclosing rectangles of white or a primary color (see **0.6**). His earlier images derived from trees or the rhythm of the sea (**12.17**), but as time went by, he progressively extracted the structure and rhythm from objects to arrive at what he called "the emotion of beauty." His middle period paintings are full of rhythm, with lines criss-crossing in an allover pattern. The lines gradually became smaller and the shapes took over, until they were bisected by the edge, suggesting something bigger—the continuous rhythm of life.

Wassily Kandinsky (1866–1944) taught at the Bauhaus, where he used musical parallels in his work. He was fascinated by music's emotional power. The move from figurative to free abstract work followed the developments in free-form music, by Schoenberg for example. Kandinsky's richly structured, polyphonic motifs create spatial and compositional ambiguities, visual beauty, emotional impact, and

12.15 Peter Paul Rubens, *Marie de Medici, Queen of France, Landing in Marseilles, 3 November 1600*, 1622–25. Oil on canvas, 12′ 8″ × 9′ 6″ (3.9 × 2.9 m). Louvre, Paris.

Rubens painted a series of paintings for the widow of Henry IV. It was not easy: the queen was far from being a beauty and her life had few interesting events. Here he spices up the scene with some of his characteristic "Rubenesque" nudes.

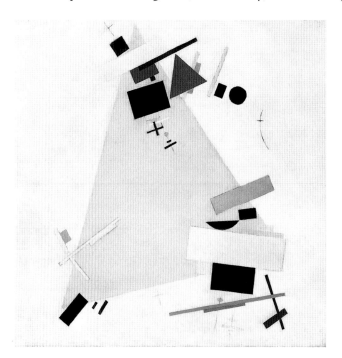

12.16 Kasimir Malevich, *Dynamic Suprematism*, c. 1916. Oil on canvas, 31 × 31″ (80.2 × 80.2 cm). Tate, London.

Malevich developed Dynamic Suprematism, in which forms appear to be in flux, clustering together or drifting apart. He wanted to "free art from the dead weight of the real world."

intellectual stimulation (**12.18**). He divided composition into two groups: a simple form he called melodic—resembling the works of Cézanne, in which a clear rhythm in the arrangement of trees invites the eye to travel from one shape to the next—and a more complex form, consisting of several rhythms, subordinated to an obvious or concealed principle, which he called symphonic.

Kandinsky believed that music remained the more advanced art, but his fellow teacher at the Bauhaus, Klee, disagreed, saying: "Polyphonic painting is superior to music in that, here, the time element becomes a spacial element. The notion of simultaneity stands out even more richly." Klee brings us full circle. A point is punctuation, in the visual rather than the grammatical sense. A moving point becomes a line, and if a line moves, it can be seen as a melody. There may be two or more voices, or counterpoint. By varying their character and pace, we can give an image content beyond the mere depiction of interwined shapes. The drawing begins to sing; the painting is making music.

12.17 (above) Piet Mondrian, *Composition 10 in Black and White*, 1915. Oil on canvas, 33 ½ × 42 ½" (85 × 108 cm). Kröller-Müller Museum, Otterloo.

At first glance, this may appear to be totally abstract. It represents a pier stretching into an ocean of short horizontal and vertical lines. These lines reflect the rhythmic ebb and flow of the sea, and, with the areas of white paint, the reflected starlight overhead.

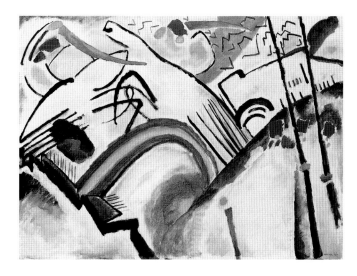

12.18 Wassily Kandinsky, *Cossacks*, 1910–11. Oil on canvas, 37 ¼ × 51 ¼" (94.6 × 130.2 cm). Tate, London.

Kandinsky believed that abstract paintings could convey spiritual and emotional feelings comparable to the effects of music. This was painted during a transitional period, when he retained some representational elements, such as the Russian cavalrymen in the right foreground.

Exercises

1 The sound of music: Draw four large squares, labeling them "classical," "jazz," "hip hop," and "Broadway" (Broadway show tunes). Using pencil or pen, interpret each style of music in turn using different qualities of line and line direction to emphasize their differences. Make use of legato, staccato, and alternating and progressive rhythm patterns. Try doing this in color.

2 Make a psychedelic poster of your dream gig: Draw the names of your favorite bands in bubble writing along curvy, flowing lines, then expand each letter to fill any remaining white space around it. Color the letter shapes in bright colors with the ground in a complementary color.

3 Making melodies: Using elements such as straight vertical lines or semicircular arcs, design some simple motifs. Combine, repeat, invert, or reverse them, in order to form a linear "melody." Trace this four times freehand, end to end, onto a long strip of paper. Prepare three more identical strips to complete the four "voices" of your canon. Place the second strip above or below the first, displaced to the right, and the third strip the same interval along again. Develop linear continuances from the lines of one voice to the next so as to create unexpected shapes. When you find a pleasing combination, trace a section containing all four voices onto a new sheet of paper.

Glossary

Abstract Describing an object or representation that has been simplified or distorted down to its basic essentials, with superfluous detail removed to communicate a fundamental aspect of a form or concept.

Abstract texture Simplified natural textures stylized almost into **pattern**. There is no attempt to fool the viewer: these textures are shorthand, used for their decorative effect.

Academic High Art that conforms to rule-bound traditions and conventions, as taught and practiced in art academies.

Accent A subsidiary **focal point** or any stress or emphasis given to an element by, for example, a brighter color, darker tone, or greater size, to counterbalance the main emphasis and provide variety.

Achromatic The absence of hue and saturation. Black, white, and the grays in between.

Achromatic grays Made from mixing just black and white together with no other color.

Actual shape Clearly defined or positive areas (as opposed to **implied shape**).

Actual texture *see* **Impasto, Tactile texture, Visual texture**

Additive color Color created by superimposing light. Adding together (or superimposing) the three primaries—red, blue, and green—will produce white. The secondaries are cyan, yellow, and magenta. (*See also* **Transmitted color**)

Aerial perspective The illusion of deep space. Distant objects such as mountain ranges, seen through the haze of atmosphere, appear to have less detail and contrast than nearer objects, lighter values, and a shift in color toward the blue end of the spectrum—also called atmospheric perspective.

Aesthetics The theory of what is considered artistic or beautiful. Traditionally a branch of philosophy, now a concern with the artistic qualities of form, as opposed to mere description of what we see.

Afterimage The complementary color seen after staring at an area of intense color for a certain amount of time and then quickly glancing away toward a white surface.

Alignment Unifying a collection of shapes by arranging them so that their edges, or perceived "centers of gravity," line up.

Allover pattern The repetition of motifs into an organization covering the entire surface, with no obvious focal point. Emphasis is distributed uniformly throughout the two-dimensional surface with no obvious focal point. Also called **Crystallographic balance.**

Alternating rhythm A rhythm created by repeating two or more elements or motifs on a regular, interchanging, and anticipated basis.

Amorphous shape A formless and indistinct shape without obvious edges, like, for example, a cloud.

Amplified perspective A dramatic effect created when a distorted object projects toward the viewer, as in a fish-eye lens photograph.

Analogous colors Colors that are closely related in hue, usually near or adjacent to each other on the color wheel.

Analogous color scheme Color scheme based on a pie-shaped slice of three or more hues located next to each other on the color wheel, usually with one hue in common: yellow-orange, yellow, and yellow-green, for example.

Anticipated motion The perception of impending movement on a static two-dimensional surface caused by the viewer's past experience with a similar pose or posture.

Approximate symmetry *see* **Near symmetry**

Arbitrary color Unnatural colors that are the product of the artist's imagination, or the result of an emotional response or visual defect.

Assemblage A three-dimensional form of collage with bulky 3D found objects added to the painted surface.

Asymmetrical balance Balance achieved using dissimilar objects but with equal visual weight or emphasis.

Asymmetry Meaning without symmetry, an artwork without any visible or implied axis, displaying an uneven but balanced distribution of elements. A painting or sculpture with more seemingly going on to one side of the composition than the other.

Axis An imaginary line around which a form or composition is balanced.

Axonometric projection A non-perspective representation of a 3D object that contains a true plan, made up of verticals and lines at 45 degrees to the horizontal. Circles on plan remain true circles; but circles in elevation become ellipses.

Background In a landscape, the space we see in the distance—the sky, mountains, or distant hills. In a still life or an interior portrait, it is the area behind the subject.

Balance A sense of equilibrium achieved through there being equal amounts of implied weight or emphasis in the elements of a composition, when distributed either side of an axis.

Bezold effect If black, white, or a strong hue at full intensity are used throughout a design and the dominant one is changed, the entire composition seems to lighten or darken.

Biaxial symmetry Two axes of symmetry—vertical and horizontal. This guarantees top and bottom balance, as well as left and right. Top and bottom can be the same as the left and right, or they can be different.

Biomorphic shapes Blobby shapes, reminiscent of single-cell creatures such as amebas, derived from organic or natural forms.

Bird's-eye view A view from high on the picture plane looking down. We may still see the horizon, but the ground is now some distance below our feet and some objects may be nearer.

Blueprint *see* **Orthographic projection**

Bridge passage Where two adjacent parallel planes are graduated in opposite directions, from dark to light and light to dark, there will be an area where differences of value dissolve.

Brightness The relative lightness or darkness of a color. Zero brightness is black and 100 percent is white; intermediate values are light or dark colors, also called luminance or value.

Cabalistic reduction Reducing the visual representation of a double-figured number to a single number by adding them together; for example, 53 is reduced to 8 (5+3). Used with the **Fibonacci series** in Islamic art.

Cabinet projection A non-perspective oblique representation of a 3D object. The oblique angle is usually 45 degrees. The oblique lines emerging from the elevation are half the true length.

Calligraphy Elegant, decorative writing; rhythmical, flowing lines suggestive of writing with an aesthetic value that transcends literal content.

Camera lucida A reflecting prism that enables artists to draw outlines in correct perspective. The term means "light room" in Latin.

Camera obscura A darkened room in which an image of the outside can be projected through a convex lens and reflected down onto a viewing surface. The term means "dark room" in Latin.

Canon A system of mathematical proportions using the height of the head (in Greek art) or fist (in Egyptian art) as a measuring module to arrive at an ideal representation of the body.

Cast shadow The dark area projected from an illuminated form onto other objects or the background.

Cavalier projection A non-perspective oblique representation of a 3D object. The oblique angle is usually 45 degrees. The oblique lines emerging from the elevation are the true length. (*See also* **Cabinet projection**)

Chiaroscuro The distribution of light and dark in a picture. From the Italian *chiaro* for clear or light, and *oscuro* for obscure or dark. It has come to refer to the dramatic theatrical compositions of Caravaggio and Rembrandt.

Chinese perspective Chinese artists developed a form of oblique projection for their scrolls, called *dengjiao toushi*, which means "equal-angle see-through."

Chroma *see* **Saturation**

Chromatic Pertaining to the presence of color.

Chromatic gray Dull "almost neutral" colors, sometimes with a hint of brightness.

Chromatic value The perceived value of a given hue. Some colors are naturally lighter or darker than others.

Chronophotographs Multiple exposures on glass plates or strips of film, a technique invented by Étienne-Jules Marey.

Classical Greek and Roman ideals of beauty and purity of form, style, or technique.

Closed composition Composition in which the elements are contained by the edges of the canvas or the boundaries of the picture frame. (*See also* **Open composition**)

Closure A concept borrowed from Gestalt psychology which takes advantage of the observer's desire to perceive incomplete forms as complete. The artist provides minimum visual clues, and the observer brings them to final recognition.

CMYK In graphic design, a color system in which successive printings of cyan, magenta, yellow, and black (black is referred to as "key") visually mix to produce a wide gamut of colors; also called four-color printing or full-color printing.

Collage Artwork created by assembling and pasting various materials onto a two-dimensional surface, often combining them with painted or drawn passages; from the French verb *coller*, to glue or stick.

Collograph A type of relief printing in which a collage of shapes cut from card, folded paper, corrugated cardboard, hardboard (masonite), even chicken wire or bubble wrap is inked and pressed against paper.

Color The perceptual response to the wavelengths of visible light named red, green, blue, and so on; having the attributes of hue, saturation, and brightness.

Color constancy Psychological compensation for changes in light conditions when identifying a color. A viewer always interprets grass to be green. (*See also* **Constancy effect**)

Color discord A perception of dissonance in a color scheme.

Color harmony A color relationship based on groupings within the color wheel. (*See also* **Analogous colors**, **Complementary colors**)

Color space Because color has three attributes or dimensions, each individual color can be placed as a single point in an abstract three-dimensional space, with similar colors placed close to each other.

Color symbolism Using color to signify and simulate human character traits or concepts.

Color temperature A physical attribute equivalent to the temperature you would have to heat a "black body" and measured on the Kelvin (K) scale. Not to be confused with the subjective warm and cool colors.

Color tetrad Four colors, equally spaced on the color wheel, containing a primary and its complement and a complementary pair of intermediates. Any organization of color on the wheel forming a rectangle that could include a double split-complement. (*See also* **Complementary colors**, **Split complementary color scheme**)

Color triad Three colors spaced an equal distance apart on the color wheel forming an equilateral triangle. Itten's 12-color wheel is made up of a primary triad, a secondary triad, and two intermediate triads.

Color wheel An arrangement of colors based on the sequence of hues in the visible spectrum, arranged as the spokes of a wheel. The most common is Itten's 12-step wheel.

Combining In **gestalt** theory, the four main types of proximity are nearness, touching, overlapping, and combining. Combining can both group a collection of items and also isolate them from the rest of the composition.

Complementary colors Two colors directly opposite each other on the color wheel. A primary color is complementary to a secondary color, which is a mixture of the two remaining primaries. Complementary colors accentuate each other in juxtaposition and neutralize each other in mixture.

Complementary color scheme Built around two hues that are opposite one another on the color wheel. This scheme is intrinsically high-contrast and intense, to the point of creating vibrating colors.

Composition An arrangement and/or structure of all the elements on a two-dimensional surface, according to the principles of organization, to achieve a unified whole; also called **design**.

Concept An idea or generalization. A scheme that brings diverse elements into a basic relationship.

Constancy effect The proximity of other colors affects our perception of colors; because we *know* grass to be green, we see it as green even when it really appears blue-gray, as at twilight. (*See* **Color constancy**)

Content The essential meaning, significance, or aesthetic value of an artwork. The sensory, subjective, psychological, or emotional responses we feel, as opposed to our appreciation of its descriptive aspects alone.

Continuation A real or implied line or edge that continues from one form to another, allowing the viewer's eye to move smoothly through a composition.

Continuity The visual relationship between two or more individual designs, or between the pages in a publication or website. The designer's task is to unify a set of pictures or pages so that they look as though they belong to the same "family."

Contour The lines within an outline that give an object its volume, such as the hoops around a barrel. Sometimes used synonymously with **outline**.

Contrast The value relationship between adjacent areas of light and dark. The highest contrast of all is black and white.

Cool colors Colors have subjective temperatures: blue and green we associate with ice, water, or, say, crisp salads. On the Itten color wheel, they are the yellow-green to violet segment. (*See also* **Warm colors**)

Core shadow The dark part of an object, away from and not directly illuminated by the light source. It is attached to the object, or encompasses a space.

Cross-hatching Superimposing hatched lines at right angles to the initial hatched lines, to build up value and to suggest form and volume.

Crystallographic balance Balance with equal emphasis or an **allover** pattern with an absence of focal point, where the eye is attracted everywhere and nowhere over an entire two-dimensional surface; also called **Allover pattern**.

Curvilinear shapes Shapes based on the sinuous organic shapes found in nature.

Decorative space Ornamental areas, emphasizing the two-dimensional nature of an artwork or any of its elements.

Deep space Majestic, awe-inspiring landscapes of distant mountains or rolling hills, also called infinite space.

Design The planned arrangement of visual elements on which artists base their work. In easel-based art, design is synonymous with the term **composition**.

Diagonal vanishing point (dvp) In Jay Doblin's perspective method, the point at which diagonals across a checker-board grid meet the horizon.

Dimetric projection A special case of a **trimetric projection** in which the scales of two of the axes are the same. These projections use "idealized" angles of 7 degrees and 42 degrees to the horizontal for the x and y axes.

Distortion A departure from the accepted perception of a form or object, often manipulating conventional proportions.

Divisionism A technique for visually mixing colors on the canvas using short lines of pure pigment as well as dots and dabs, often on a complementary colored ground. (*See also* **Pointillism**)

Dominance Where certain elements assume more importance than others in the same composition or design: some features are emphasized, others are subordinated.

Double complementary color scheme Two sets of complementaries. If they come from equidistant places on the color wheel, this is termed a **quadrad**.

Drawing An artwork in which line is the predominant element. A preparatory sketch for a painting.

Dynamic range The range of pigments from the lightest to the darkest, usually within the range from white to black.

Earthworks Artworks created by altering a large area of land, using natural and organic materials; usually large-scale projects that take advantage of the local topography.

Economy Distilling the image to its essentials.

Elements Line, shape, value, texture, and color: the basic ingredients the artist uses in combination to produce an artwork.

Emotional color A subjective approach to color usage intended to elicit an emotional response in the viewer.

Environmental art Assemblages and installations made from found natural materials, such as leaves, twigs, thorns, and berries chosen for their range of colors and textures. Often sited in remote locations and unlikely to be seen by anyone else, but recorded in photographs or films. Also called site or earth art.

Equilibrium Visual balance between opposing compositional elements placed about an axis.

Equivocal space An ambiguous space where it is difficult to distinguish figure from ground, or positive from negative shapes, and our perception alternates from one to the other. Many optical illusions make use of this phenomenon.

Explicit line A line or edge within which forms are clearly delineated: it may not always be a black line, but it has clear and distinct edges that stand out from the background.

Expression Conveying a thought, emotion, or meaning in an artwork, sometimes synonymous with **content**.

Façade The face, elevation, or frontal aspect of a form, especially a building.

Fibonacci series A sequence of numbers starting with one number (usually 1) added to the previous number to produce the next in the series: 0+1=1, 1+1=2, 2+1=3, 3+2=5, and so on. Used with **cabalistic reduction** in Islamic art. (*See also* **Golden section**)

Field A synonym for **figure**, taking in the possibility of color fields—colored shapes against a ground of contrasting value or color, as in the work of abstract expressionists.

Figure The recognizable object we are depicting: a human figure (hence the name), vase, or flower, for example. Traditionally, the figure is described as a positive shape, the ground as a negative shape. (*See also* **Field** and **Ground**)

Flat color An even area of color with no shading or variation in value. In graphic design, also known as match or spot color. The **Pantone Matching System (PMS)** is an industry-standard collection of flat colors used by printers.

Focal point A compositional device emphasizing a certain area or object to draw the viewer's attention. In photography, the focal point is the point at which an object must be placed to give a clearly defined image. (*See also* **Accents**)

Forced perspective In a stage set, the illusion of distance created by using properties that are physically smaller than their real equivalents, so that they give the impression of being located some distance away.

Foreground The space that the subject of an artwork, or the space before the subject, inhabits.

Foreshortening The perspective effect means that something seen lying away from us appears to be shorter than if it were viewed full on: a circle, for example, is foreshortened to an ellipse.

Form The apparent solidity or three-dimensionality of a drawn or painted object. The composition and structure of the work as a whole.

Formal Describing a composition that is traditional and rule-based.

Formal balance Static symmetrical balance, especially in architecture, characterized by the repetition of identical or similar elements on either side of a central axis.

Fractional representation A device used by various cultures (notably the Egyptians) in which several spatial aspects of the same subject are combined in the same image, such as the front view of an eye on a side view of the head.

Frame *see* **Picture frame**

Fresco A mural painting technique in which water-based pigments are applied to wet plaster, binding with it and becoming an integral part of the wall.

Frottage Creating texture by rubbing crayon or pastels on paper placed on a rough surface; from the French *frotter*, to rub.

Genre Subject matter concerned with everyday domestic life.

Geometric shapes Simple mechanical shapes defined by mathematical formulas, which can be produced using the implements found in geometry sets: triangles, rectangles, and circles.

Gestalt German word for "form," used to mean that the whole is greater than the sum of its parts. Theory developed by Czech-born psychologist Max Wertheimer. The four main gestalt properties are **proximity**, **similarity**, **continuation**, and **closure**.

Gesture drawing A free line within and around a form showing the dynamics of a scene or pose, the action of drawing, and the movement of the eye, rather than a tight arrangement of shapes.

Golden ratio A mathematical ratio discovered by the ancient Greeks derived when a line is divided into two sections such that the smaller part is to the larger as the larger is to the whole. The ratio is 0.618:1 or 1:1.618, or roughly 8:13. It can also be found in natural forms; also called the golden mean.

Golden section A rectangle in which the ratio of the shorter side to the longer is the **golden ratio**. It is a system of proportion related to the geometry of squares and circles, and also to the **Fibonacci series** of numbers.

Graduated tint A continuous change in value with no observable banding.

Graphic art Two-dimensional artworks based on line and tone rather than color, such as drawings and prints. The crafts and techniques of printing.

Grid A network of horizontal and vertical intersecting lines that provides a framework to guide designers as to where they should place elements.

Grisaille A monochromatic version of *chiaroscuro* in shades of gray or a neutral color which imitates the appearance of low-relief sculptures.

Ground The unoccupied or relatively unimportant space in the picture, as in background. Traditionally, the figure is a positive shape; the ground a negative shape. Also a name for the substrate onto which we paint. (*See also* **Figure**)

Ground plane The ground we stand on, rather than the (back)ground or canvas of the painting—or a more abstracted plane.

Guide lines *See* **Orthogonals**

Hanging Aligning elements on a grid so that their top edges line up. (*See also* **Sitting**)

Harmony Combining elements to create a pleasing and consistent composition.

Hatching Drawing several thin (usually parallel) lines close together to create an area of value. (*See also* **Cross-hatching**)

Heightened colors The bright unnatural colors of, for example, van Gogh and Gauguin.

Hexachrome A Pantone system, also referred to as HiFi color, using six colors: brighter (fluorescent) versions of CMYK plus vivid orange and green. (*See also* **Pantone Matching System [PMS]**)

Hieratic scaling In early art and some non-Western cultures, size used to denote status or importance, making the subject of the painting—a saint or king—larger relative to the minor characters.

High-key color A color that has a value of middle gray or lighter.

High-key value A value that has a level of middle gray or lighter, tints between the mid-tones and white.

Highlight The part of an object that, from the viewer's position, receives the greatest amount of direct light. The highest value of a modeled form, or a bright distinct dot or area on the surface of a shiny form that accentuates its glossiness.

HLS The three attributes of color: hue, luminance, and saturation. (*See also* **HSB**)

Horizon The farthest point we can see, the boundary between the sky and the ground. The line on the picture plane on which is located the **vanishing point**.

HSB The preferred terms for the three attributes of color: **hue**, **saturation**, and **brightness**.

HSL In Photoshop, the three attributes of color are known as hue, saturation, and lightness. (*See also* **HSB**)

Hue The common name of a color and its position in the spectrum determined by the wavelength of the ray of light: for example, red, blue, yellow, and green.

Human scale Art on a scale that we can relate to. The size of an object relative to the proportions of the human body.

Hyper-real *See* **Photo-realism**.

Idealism The world depicted as an artist thinks it should be, rather than as in **naturalism**, in which it is depicted as it is, warts and all. All flaws and deviations from an the norm are corrected.

Iikaah Sand paintings by the Navajo people of New Mexico. "Iikaah" means the "place where the gods come and go."

Illusion texture *See* **Visual texture**.

Imbalance Where opposing or interacting elements in a composition are out of equilibrium.

Impasto A painting technique in which paint is applied thickly to create a rough three-dimensional surface.

Implied line An imaginary line created by arranging points or short lines in such a manner that our brains join them, for example, a dotted or dashed line. With lines that appear to stop, start, and disappear, the missing portions are implied to continue and are completed in the mind of the viewer.

Implied shape A shape suggested by a grouping of elements, creating the visual appearance of a shape that does not physically exist. (*See also* **Gestalt**)

Infinite space *See* **Deep space**

Informal balance Asymmetrical fluid and dynamic composition, creating a sense of movement and generating curiosity.

Installation A large assemblage, usually one that you can walk into or through, created to heighten the viewer's awareness of the environmental space it occupies. (*See also* **Site-specific installation**)

Intensity *See* **Saturation**

Intermediate color A color produced by a mixture of a primary color and a secondary color— yellow-green, for example.

Interpenetration Where planes, objects, or shapes seem to slice through each other, locking them together within a specific location in space.

Intuitive space The illusion of space that the artist creates by overlapping, transparency, interpenetration, and other spatial properties of elements. Where the conventions of perspective are manipulated for pictorial effect, with little attempt to mimic reality.

Invented texture An artificial texture from the imagination of the artist, generally a decorative pattern. (*See* **Abstract texture**)

Inverted symmetry Symmetry with one half inverted, like a playing card or crossword puzzle; an interesting variation, but an awkward balance.

Isolation Creating emphasis by separating one element from all the others, either physically or symbolically.

Isometric projection A non-perspective representation of a 3D object in which elevations are constructed at 30 degrees and the "plan" is distorted. Isometry means "equal measures," because the same scale is used for height, width, and depth. Circles appear as ellipses in both plan and elevational views. (*See also* **Axonometric projection**)

Kinetic art From the Greek word *kinesis,* meaning motion, art that involves an element of random or mechanical movement. (*See also* **Mobile**)

Kinetic empathy Where the viewer consciously or unconsciously recreates or anticipates a sense of impending movement from a pose observed in an artwork.

Legato A connecting and flowing rhythm.

Line The path a point makes as it moves across a surface. In mathematics, a line joins two or more points. It has length and direction, but no width. In art, lines have breadth, but this is not their most important parameter. In graphic design, line art means black or another single color, with no other values or colors.

Line quality A characteristic of line determined by its weight, direction, uniformity, or other feature.

Linear perspective A formal method for drawing the way distant objects appear to be smaller than similar objects nearer to us by making parallel lines converge at a **vanishing point** or points on the horizon. (*See also* **Aerial perspective**)

Local color Color as perceived in the real world under ordinary daylight, the color we know objects to be—such as the green of grass; also called objective color.

Local value The relative light and dark of a surface, seen in the real world, independent of any effect created by the degree of light falling on it. A smooth rounded object will disperse the light gradually and subtly, whereas light shining on an object with angular surfaces will result in distinct areas of contrasting light and shade.

Logotype A symbol, often incorporating some lettering, used to identify an organization, corporation, or product. Usually shortened to logo.

Lost-and-found edges Where edges are sometimes hard and sharp against a background, and sometimes are soft and blurred, receding into the background. Now you see them, now you don't.

Low-key color Any color that has a value level of middle gray or darker. (*See also* **High-key color**)

Low-key value The darker tints from middle gray to black. (*See also* **High-key value**)

Luminance *See* **Brightness**

Mandala In Tibetan Buddhism, a circular radial design contemplated during meditation; the term is Sanskrit for "circle."

Maquette Preliminary small-scale sculpture or model, which can be scaled up either manually or using mechanical means to the scale of the finished sculpture to be cast or carved.

Mass The apparent solidity of a form. The illusion of bulk and weight achieved by shading and lighting, or by overlapping and merging forms. In sculpture and architecture, mass is the actual or apparent material substance and density of a form. Mass can be thought of as positive space, volume as negative space.

Match color *See* **Pantone Matching System (PMS)**

Medium The tools, materials, or type of paint used to create an artwork, such as pencil, collage, or watercolor.

Merz Kurt Schwitters' name for **collage**, taken from a scrap that once read *Kommerz und Privatbank*. A combination, for artistic purposes, of all conceivable materials, having equal importance to paint.

Metric projections Non-perspective representations of a 3D object: see **Axonometric projection**, **Dimetric projection**, **Isometric projection**, and **Trimetric projection**.

Mezzotint A printmaking process in which the plate is first pitted all over with tiny indentations which, if printed, would give a uniform dark area. The artist then scrapes and burnishes these away to create areas of white.

Mid-ground In a landscape, the space between the foreground and background: trees, bushes, and buildings, for example, also called middle ground.

Mid-tones The tints at the center of a chromatic scale, midway between black and white.

Mixed media An artwork that has been created using more than one medium.

Mobile A three-dimensional kinetic (moving) sculpture, usually activated by wind.

Modeling A sculptural technique of shaping a pliable material. Computer modeling builds a virtual 3D model of an object.

Module A specific defined measured area or standard unit.

Monochromatic Colors of one hue; the complete range of value from white to black.

Monochromatic color scheme Consists of one hue and its various brightnesses, sometimes with variations in saturation.

Montage Collaging parts of photographs into new compositions that are recognizable, yet with their original meanings changed or subverted; also called photomontage.

Motif A recurring thematic element or repeated feature in design. It can be an object, a symbol, a shape, or a color that is repeated so often in the total composition that it becomes a significant or dominant feature.

Motion blur Blurring in the direction of motion, as in slow-speed photography.

Movement Eye travel directed by visual pathways in a work of art. A group of artists practicing a particular style during a particular period in history.

Multiple image A means of suggesting movement, in which a single figure or object is seen in many different positions superimposed in a single image.

Multiple perspective Where paintings and drawings allowing us to see planes we couldn't possibly see in reality, unless we could get inside the picture and walk around.

Multipoint perspective A way of depicting space in which each plane or group of parallel planes has its own set of vanishing points and horizons.

Munsell system A system for naming colors developed by Albert Henry Munsell, related to the **HSB** system. The system is like a tree, in which the "trunk'" has ten brightness steps of gray from black at the bottom to white at the top. Radiating out from the trunk are different saturations of color; hues are around the outer edge.

Naturalism The skillful representation of a scene as seen in nature with the illusion of volume and three-dimensional space. The opposite of **Idealism**.

Near symmetry The use of similar imagery on either side of a central axis. The elements on one side may resemble those on the other in shape or form, but are varied to provide visual interest; also called approximate symmetry.

Nearness In **gestalt** theory, the four main types of proximity are nearness, touching, overlapping, and combining. The closer items are to each other, the more likely it is that they will be seen as a group. The distance between the objects is relative and subjective.

Negative space The unoccupied or empty area left after positive elements have been created by the artist.

Neutral color Color that has been reduced in saturation by being mixed with gray or a complementary color. The sensation of hue is lost or dulled.

Non-objective shapes Entirely imaginary shapes with no reference to, or representation of, the natural world. The artwork is the reality. Also called **subjective** or non-representational shapes.

Non-representational See **Non-objective shapes**

Notan Japanese ideal of symmetry, meaning dark–light. The interaction between positive (light) and negative (dark) space, figure (or field) and ground.

Objective Having real, tangible existence outside of the artist's mind, not influenced by personal feelings or opinions. (*See also* **Subjective**)

Objective color *See* **Local color**.

Objective shapes Shapes meant to look like objects found in the real world or nature, also called naturalistic, representational, or realistic shapes.

Oblique projection A non-perspective representation of a 3D object, in which the front and back sides of the object are parallel to the horizontal base, and the other planes are drawn as parallels coming off the front plane at a 45-degree angle. (*See also* **Cabinet projection** and **Cavalier projection**)

One-point perspective A system of spatial illusion based on the convergence of parallel lines at a single vanishing point, usually on the horizon; only appropriate to interiors or vistas.

Opaque A surface impenetrable by light.

Open composition Placing elements in a composition so that they are cut off by the frame implying that the picture is a partial view of a larger scene. (*See also* **Closed composition**)

Open-value composition Composition in which values cross over shape boundaries into adjoining areas.

Optical color Color that has changed under different lighting conditions according to the time of day. (*See* **Local color**)

Orthogonals Imaginary receding parallel lines at right angles to the field of vision which join horizontal lines of, say, a building, to the vanishing point; also called sight lines or guide lines.

Orthographic projection Two-dimensional views of an object, showing a plan, elevations (side views), and (cut away) sections, used by architects, engineers, and product designers; known as the "blueprint."

Outline A real or imaginary line that describes a shape and its edges or boundaries.

Overexposed When photographers adjust their cameras to capture a dark object against a light background, then the light areas will be bleached out and lacking in detail. (*See also* **Underexposed**)

Overlapping In **gestalt** theory, the four main types of proximity are nearness, touching, overlapping, and combining: if two items are the same color or value they form new, more complex shapes. If the items are different colors or values, the overlap produces the illusion of shallow space, with warm shapes coming forward, cooler ones receding. A depth cue, in which some shapes are in front of and partially hide or obscure others.

Pantone Matching System (PMS) An industry-standard collection of flat colors used by printers; also called match or spot color.

Papier collé Collage in which the attached scraps are paper-based, for example, newspaper cuttings or tickets.

Partitive color system Based on the perceptional relationship of colors in which there are four (not three) fundamental color hues: red, green, yellow, and blue. The Swedish Natural Color System (NCS) is based on these observations.

Patina A natural coating, usually greenish, that results from the oxidation of bronze or other metallic materials.

Pattern Repetition of an element or motif in a regular and anticipated sequence, with some symmetry. Texture involves our sense of touch, but a pattern appeals only to the eye; a texture may be a pattern, but not all patterns have texture.

Perspective A system used to create the illusion of three-dimensionality on a two-dimensional surface. (*See also* **Aerial perspective** and **Linear perspective**)

Photomontage See **Montage**

Photo-realism A painting intended to look as real as, or more real than, a photograph; also called hyper-realism.

Pictogram An image in which a highly stylized shape represents a person or object, for example, in map symbols, warning signs, and Egyptian hieroglyphs.

Picture frame The outermost limits or boundary of the picture plane. This can be a physical wooden frame, the edge of the sheet of paper or canvas, or an arbitrary boundary.

Picture plane A transparent plane of reference used to establish the illusion of forms existing in three-dimensional space, usually coinciding with the surface of the paper or canvas.

Pigment A mineral, dye, or synthetic chemical with permanent color properties. Pigments are added to a liquid medium to produce paint or ink. A lake is a pigment made from a liquid dye combined with an inert white chemical.

Pigment color The materials in pigments and dyes absorb different wavelengths of light, and reflect or retransmit others. They are inherently subtractive: a mixture of all pigment primaries—red, yellow, and blue—will in theory produce black.

Plane The position and orientation of a shape in space. When the plane of a shape coincides with the surface of the paper or canvas, we call this the **picture plane**.

Plastic space Real three-dimensional space or the illusion of space. Artwork such as sculptures, jewelry, and ceramics—anything made using molding or modeling—are termed the plastic arts.

Point In mathematics, a point has no dimensions, just a position in space. In art and design, we have the dot, dab, or blob. Like the breadth of a line, the size of a point is not usually its most important attribute.

Pointillism A system of visual color mixing based on the juxtaposition of small dabs of pure color on a white ground. (*See also* **Divisionism**)

Positive space Where the creation of elements, or their combination, produces a figure or field against a ground. (*See also* **Negative space**)

Primary colors The brain accepts four colors—red, yellow, green, and blue—as primaries, and this fact is reflected in the composition of modern color wheels. The basic hues in any color system may in theory be used to mix all other colors. In light, the three primaries are red, green, and blue; in pigments, the three primary colors are red, yellow, and blue.

Primary triad On a 12-step color wheel, an equilateral triangle with vertices (sharp corners) at the primaries. Similar triads join up the secondaries and tertiaries.

Progressive rhythm Repetition of shape that changes in a regular pattern. Progressive rhythm is created by regular changes in a repeated element, such as a series of circles that progressively increase or decrease in size.

Projections Non-perspective methods for creating the illusion of three-dimensional forms. (*See also* **Axonometric projection, Dimetric projection, Isometric projection, Trimetric projection, Oblique projection**)

Proportion Size measured against other elements or against a canon or standard. The comparative relationship of parts to a whole. When changing scale, the artist must ensure that overall proportions are maintained: enlarging one dimension without the others results in distortion. Proportion is concerned with ratios: the ratio of the width of a painting compared with its height, or the ratio of head size to total height in the case of a sculptural figure. (*See also* **Scale**)

Proximity In **gestalt** theory, the four main types of proximity are nearness, touching, overlapping, and combining. Proximity refers to the degree of closeness in the placement of elements. It will generally take precedence over similarity, but the greatest unity will be achieved when the two are used together.

Psychic line A mental connection between two points or elements. An imaginary ray of light joining, for example, a person's eyes to the object they are looking at, or the line that extends into space from the tip of a pointing arrow directing the viewer's eye to follow it.

Quadrad A **double complementary color scheme** using two sets of complementaries from equidistant places on the color wheel.

Radial balance A composition in which all elements are balanced around and radiate from a central point. Symmetry in circular or spherical space, with lines or shapes growing and radiating from a central point, like a mandala, a daisy, or a sunflower, or the rose window of a cathedral.

Radial design Where lines of perspective, for example, draw our eyes to a focal point in a painting.

Radiosity Computer graphics technique for lighting a scene globally by calculating the light-energy equilibrium of all the surfaces in an environment, independent of the viewer's position.

Ray tracing Computer graphics technique for lighting a scene developed by Turner Whitted. Every time a ray encounters a surface, it divides into three parts: into diffusely reflected light; into specularly reflected light; and into transmitted or refracted light. Rays are traced back from the viewer, bounced around the scene, and arrive eventually back at the light source.

Realism Faithfully reproducing the appearance of a scene or object with a fidelity to visual perception. (*See also* **Idealism**)

Rectilinear shapes A subset of geometric shapes, produced using straight lines, usually parallel to the horizontal and vertical.

Reflection A type of symmetry. When we look at an object's reflection in the mirror, does it change? A circle does not, but your signature and your hand do.

Relief sculpture A type of sculpture using shallow depth, meant to be viewed frontally. Ranges from a limited projection, known as low relief, to more exaggerated development, known as high relief.

Repeated figure Where a recognizable figure appears more than once within the same composition in different positions and situations so as to relate a narrative to the viewer.

Repetition The use of the same motif, shape, or color several times in the same composition, producing patterns and introducing rhythm into a design.

Repoussoir In aerial perspective, a prominent dark or contrasting form in the foreground, such as a tree or a lonely figure silhouetted against the landscape.

Representational Where the artwork reminds the viewer of real-life scenes or objects. (*See also* **Naturalism** and **Realism**)

RGB The **primary colors** of light are red, green, and blue. **Transmitted color** is light direct from an energy source, shining through colored filters in a theater or displayed on a computer screen via a cathode-ray tube.

Rhythm A continuance, flow, or sense of movement achieved by repeating and varying motifs and using measured accents.

Root 2 A system of proportion based on a rectangle with a shorter side of 1 and longer side of the square root of 2, numerically 1:1.414. This ratio possesses the useful property that it can be endlessly subdivided into smaller root 2 rectangles.

Root 5 A rectangle comprising a square with a Golden Section attached at each end.

Rose window A circular cathedral window, named after its resemblance to a rose and its petals, with mullions and traceries radiating from the center, filled with stained glass. It is characteristic of medieval architecture, especially the French Gothic.

Rotation A type of symmetry. When you rotate an object, does it change? Take two copies of the object and rotate one of them to see whether (or when) it is identical to the other one.

Saturation The strength or purity of a color, also known as intensity or chroma. A saturated color is bright and intense, a pure hue, whereas a desaturated color has no hue and is called **achromatic**—neutral gray, black, or white.

Scale Size relative to actual size, as in a scale model; size relative to human dimensions, as in small-scale or large-scale; to make larger or smaller. (*See also* **Proportion**)

Secondary color A color produced by a mixture of two primary colors. In pigment colors, secondaries are orange, green, and purple.

Sfumato Leonardo da Vinci's shading technique, from the Italian for "smoke". A transition of value from light to dark so gradual that the eye cannot detect any distinct tones or boundaries between values.

Shade A hue mixed with black.

Shadow The darker value on the surface of an object that is away from the source of light or obscured by another object. (*See also* **Cast shadow** and **Core shadow**)

Shallow space The illusion of limited depth: the imagery is only a slight distance back from the picture plane.

Shape An enclosed area identifiably distinct from its background and other shapes. It can be bounded by an actual outline or by a difference in texture, color, or value surrounding a visually perceived edge. A shape has width and height, but no perceived depth. It is two-dimensional, but can exist on a plane other than the picture plane.

Sight lines *See* **Orthogonals**

Silhouette A shape, usually solid black, with little or no detail inside its outline.

Silverpoint A precursor to the pencil: a pen-like instrument with a silver tip or a silver wire gripped within a clutch holder. Produces fine lines that are permanent and cannot be erased.

Similarity In **gestalt** theory, the ways in which items look alike. The more alike the objects are, the more likely they are to form groups.

Simulated texture A convincing copy or rendition of an object's texture.

Simultaneity Separate views, representing different points in time and space, brought together and sometimes superimposed to create one integrated image.

Simultaneous contrast When two different colors are juxtaposed in close contact, their similarities decrease and their dissimilarities are enhanced.

Site-specific installation An installation created specifically for a particular location, making use of the local environment or architectural space.

Sitting Aligning elements on a grid such that their bottom edges line up. (*See also* **Hanging**)

Size The physical or relative dimensions of an object. In **gestalt** theory, objects can form groups if they are of a similar size, but only if the similarity between the sizes is more obvious than the similarity in their shapes.

Space The three-dimensional void that elements occupy; the empty area between elements.

Spectrum The bands of identifiable hues that result when a beam of white light is divided into its component wavelengths by a glass prism.

Specular reflection A type of reflection that distinguishes shiny glossy surfaces or objects from dull matt ones.

Splines Long plywood strips or pieces of thick piano wire held in a position of tension by lead weights, or "ducks," once used to draw freeform curves. Also a term for Bézier curve tools in drawing programs such as Adobe Illustrator or Macromedia Freehand.

Split complementary color scheme Any hue plus the two colors either side of its complementary. Contrast is less marked than with a pure complementary scheme, but more intense than the double complementary.

Spot color *See* **Pantone Matching System (PMS)**

Staccato Abrupt, sometimes violent, changes in visual rhythm.

Stippling A method for producing areas of value by clustering small dots or points.

Stochastic screening In the graphic arts or printing, producing areas of continuous tones of gray by randomly scattering equal-sized dots—as opposed to halftone screening, which uses a regular array of different-sized dots.

Style The characteristic use of materials and treatment of forms during different periods of history and art movements. Also the way particular artists use media to give their works individuality.

Subject The content of an artwork. The main figures or objects represented, or the theme. In non-representational art, the visual marks, signs, or inspiration used by the artist, rather than anything experienced in the natural environment.

Subjective Derived from the mind of the artist, reflecting personal taste, viewpoint, bias, or emotion. Subjective art tends to be idiosyncratic, inventive, or creative. (*See also* **Objective**)

Subtractive color *See* **Pigment color**

Successive contrast The afterimage reaction caused by each new color we encounter being affected by the afterimage of the last color we saw. The brain anticipates a complement, and, if it isn't there, will create it.

Symbolic shapes Invented shapes communicating ideas or meaning beyond their literal form. Meanings are assigned and agreed upon by the community, for example, in musical notation, signage, and technical diagrams.

Symmetry The mirror-like duplication of a scene or group of elements on either side of a (usually imaginary) central axis. As well as **reflection**, other common symmetry operations include **rotation** and **translation**.

Tactile texture Actual physical texture that can be felt or touched, a surface characteristic of the material or a result of how the paint or sculptural material has been manipulated by the artist. (*See also* **Impasto** and **Visual texture**)

Tatami A Japanese system of proportion named after a rice-straw floor mat. It is roughly based on human scale, being 6 feet long by 3 feet wide, proportioned in the ratio 2:1.

Technique The manner and degree of skill with which artists use their tools and materials to achieve an effect.

Tenebrism A technique of painting, from the Italian word *tenebroso* meaning "obscure," used by Caravaggio and his followers, and characterized by a little bright light and lots of almost black shade. (*See also* **Chiaroscuro**)

Tension The manifested energies and forces of elements as they appear to pull or push in a composition, affecting balance.

Tertiary color Color resulting from mixing a primary and an adjacent secondary color, two complementary colors or two secondary colors in differing amounts. Examples are olive green, maroon, and various browns.

Tessellation Covering a plane with an interlocking pattern, leaving no region uncovered. From the Latin *tessera*, meaning a small square piece of stone or tile used for mosaics.

Tesserae Small cubes of colored marble or glass used to make mosaics, from the Latin *tessera* meaning "square tablet."

Tetrad color scheme A scheme based on a square: the hues are equally spaced and will comprise a primary, its complement, plus a complementary pair of tertiaries.

Texture The surface character of a material which can be experienced through touch (**tactile texture**) or the illusion of touch (**visual texture**).

Thematic unity Achieving unity by assembling a collection of similar or related objects, shapes, or forms.

Three-dimensionality The illusion of possessing the dimension of depth, as well as height and width.

Three-point perspective Linear perspective in which vertical lines converge toward a third vanishing point directly above or below the object. (*See also* **Two-point perspective**)

Tiling Making a pattern by placing simple geometric shapes next to each other.

Tint A hue mixed with white.

Tonality A single color or hue that dominates the composition despite the presence of other colors.

Tone A low-saturation color produced by mixing a hue with a shade of gray or its complement.

Touching In **gestalt** theory, the four main types of proximity are nearness, touching, overlapping, and combining. Touching objects may still be separate objects, but they will appear to be attached.

Translation A type of symmetry. Starting with two copies of the object that are superimposed (one on top of the other), you can glide or slide one of them (without rotating or reflecting) and have it land in a new place where the lines of the objects still match.

Translucency A visual quality in which objects, forms, or planes transmit and diffuse light, but with a degree of opacity that does not allow clear visibility through the object.

Transmitted color Light direct from an energy source, or shining through colored filters in a theater or displayed on a computer screen via a cathode-ray tube. The primary colors of light are red, green, and blue (**RGB**). Light color is inherently **additive color**.

Transparency A visual quality in which an object or distant view can be seen clearly through a nearer object. Two forms overlap, but both are seen in their entirety.

Triadic color scheme Three equally spaced colors on the color wheel, forming the vertices of an equilateral triangle. A primary triad provides the liveliest set of colors; a secondary triad is softer, because any two secondaries will be related, sharing a common primary: orange and green, for example, both contain yellow.

Trimetric projection A non-perspective representation of a 3D object needing scales or templates for each axis: **dimetric projection** is a special case in which the scales of two of the axes are the same. They use "idealized" angles of 7 degrees and 42 degrees to the horizontal for the x and y axes.

Trompe l'oeil Where the artist fools you into thinking that all or part of a painting is the real thing, from the French for "deceives the eye." Objects are often in sharp focus and depicted in meticulous detail.

Two-dimensionality Possessing the dimensions of height and width, a flat surface or plane.

Two-point perspective Linear perspective with two vanishing points, placed on the horizon at the left and right of the object, as far apart as possible, usually off the picture plane or canvas. Vertical lines remain parallel. (*See also* **Three-point perspective**)

Ukiyo-e Japanese woodcuts—characterized by simplicity of line, absence of shadows and clutter, and the use of white space—which influenced 19th-century European painters. The term means "paintings of the floating world."

Underexposed If a photographer decides to capture the light areas of a scene, then the dark areas will be uniformly black and lacking in detail in the shadows. (*See also* **Overexposed**)

Unity Harmony in a composition, the result of an appropriate arrangement of elements to achieve a sense of everything belonging together as a whole.

Value A measure of the relative lightness or darkness of a color, also known as brightness.

Value contrast The relationship between adjacent areas of light and dark colors. The highest contrast of all is black and white.

Value emphasis Where a value contrast is used to create a focal point within a composition.

Value pattern The shapes that an arrangement of various light and dark value areas in a composition make, independent of any colors used.

Vanishing point In linear perspective, the point at which converging parallel lines appear to meet on the line of the horizon. There may be one or more vanishing points.

Variation In unifying a composition, variety is used to prevent too much repetition from becoming monotonous.

Vernacular A prevailing or common style relating to a specific locality, group of people, or time period.

Vertical location A depth cue in which the higher a figure or object is on the picture plane, the farther back we assume it to be.

Vertical vanishing point In three-point perspective, the vanishing point at which vertical lines will appear to converge, somewhere along the line of the viewer's location point.

Vibrating colors Colors that create a flickering effect where they abut. This effect depends on a similar value relationship and strong hue contrast.

Viewer's location point In one-point perspective, a vertical axis through the vanishing point. One-point perspective assumes that the viewer is at a fixed point looking with one eye through the picture plane to the 3D world beyond.

Visual mixing Instead of mixing colors on the palette, dabs of pure hues are juxtaposed on the canvas. Any color mixing occurs in the eye and brain of the viewer. (*See also* **Divisionism** and **Pointillism**)

Visual texture The illusion of texture created by the skill of the artist, also called illusion texture. (*See also* **Tactile texture**)

Void A volume of negative space. A spatial area within an object which penetrates and passes through it.

Volume The illusion of enclosed space surrounded by or implied by a shape or form, and the space immediately adjacent to and around a painted form. In sculpture and architecture, the space occupied by the form and/or the immediate surrounding space. Mass can be thought of as positive space, volume as negative space.

Warm colors Colors have subjective temperatures: red and yellow we associate with fire and sunlight. On the Itten **color wheel**, the yellow to red-violet segment. (*See also* **Cool colors**)

Wireframe A mesh of points and planes in space, as found in computer graphics, which can accurately describe solid forms. Produced using a 3D modeling program or by laser-scanning a 3D object or body.

Worm's-eye view A view from low on the picture plane looking upward; the effects of three-point perspective will be exaggerated.

Bibliography

Art History and Appreciation

Berger, John, *Ways of Seeing*, Viking Press, New York, 1995.

Despite being first published in the 1970s, this inexpensive, pocket-sized collection of art appreciation essays is still held in high esteem and deemed relevant to today's art and design fields.

Fineberg, Jonathan, *Art Since 1940: Strategies of Being*, 2e, Laurence King Publishing, London, and Prentice Hall, Upper Saddle River, NJ, 2000.

A well-illustrated personal account of art from the last half of the 20th century. Fineberg describes movements and schools, linking them firmly to specific artists—a series of astute biographical profiles linked by illuminating discussions on how art has challenged the modern world.

Fisher, Mary Pat, and Paul J. Zelanski, *The Art of Seeing*, 5e, Prentice Hall, Upper Saddle River, NJ, 2001.

An exploration of traditional and contemporary art from the artists' points of view. Also includes maps with timelines showing where major trends in Western art were developed and giving a global historical context for the evolution of Western art.

Gombrich, Ernst Hans, *The Story of Art*, 16e, Phaidon Press, London, 1995.

The classic, chronological narrative study of art history, first published in 1950. Gombrich writes conversationally, yet his immense erudition shines through to make this beginner's book both accessible and informative.

Honour, Hugh, and John Fleming, *The Visual Arts: A History*, 6e, Prentice Hall, Upper Saddle River, NJ, 2002.

An authoritative account of art history from the latest discoveries in prehistoric art to the most recent developments in contemporary art, placing art and artists in their cultural, political, and religious context. Covers the arts of Europe and the Americas, Asia, Africa, and Oceania.

Preble, Duane, et al, *Artforms: An Introduction to the Visual Arts*, 7e, Prentice Hall, Upper Saddle River, NJ, 2003.

A comprehensive introduction to the visual arts with companion website and interactive CD-ROM containing interviews with artists.

Scharf, Aaron, *Art and Photography*, Penguin, London and New York, 1995.

A fascinating exploration of the history of photography and the significant influence that its pioneers had on the development of 19th- and 20th-century painting.

Drawing

Edwards, Betty, *The New Drawing on the Right Side of the Brain*, J. P. Tarcher, Los Angeles, CA, 1999.

The classic "drawing for the apprehensive" guide, exploring the "other" side of your brain. The left side is where words and numbers originate. The right side of the brain has been neglected in the educational system. Edwards recognizes that art unlocks creative thinking, insight, and "visual literacy."

Smagula, Howard J., *Creative Drawing*, 2e, Laurence King Publishing, London, and McGraw-Hill, New York, 2002.

A lively, comprehensive introduction to the history and practice of drawing, handsomely illustrated throughout. Includes sections on individual artists and many projects for students.

Smith, Ray, *The Artist's Handbook*, Alfred A. Knopf, New York, 1987.

An encyclopedic, definitive, yet practical guide to all the tools, techniques, and materials used for painting, drawing, printmaking, and related visual arts. Contains step-by-step guides and art historical asides.

Color

Albers, Josef, *Interaction of Color*, Yale University Press, CT, 1987.

This slim masterwork by Itten's pupil, and later a teacher himself at Yale, has few of the color plates from the original silkscreened, limited-edition volume. He advocates learning through experience, so be prepared to create your own color plates.

Ball, Philip, *Bright Earth: Art and the Invention of Color*, Farrar, Straus, & Giroux, New York, 2002.

Ball recounts the intriguing scientific and artistic quests to enlarge the palette of new colors that were permanent but not toxic, from the experiments of ancient alchemists to the discoveries of 20th-century chemists.

Bomford, David, and Ashok Roy, *Color*, Yale University Press, CT, 2000.

A pocket-sized handbook, produced by the National Gallery, London, this explains all aspects of color using examples from the gallery's own collection.

Feisner, Edith Anderson, *Color Studies: How to Use Color in Art and Design*, Fairchild Publications, New York, and Laurence King Publishing, London, 2001.

This is a thorough and well-illustrated grounding in color theory with expert advice on putting the principles into practice.

Finlay, Victoria, *Color: A Natural History of the Palette*, Ballantine Books, New York, 2003.

Part history, travelogue, art, and anthropology, Finlay travels the world in search of stories behind the colors that we take for granted. There are few pictures but the style is breezy and full of fascinating anecdotes.

Gage, John, *Color and Culture: Practice and Meaning from Antiquity to Abstraction*, Bullfinch Press, New York, 1993.

An in-depth investigation of the perception and symbolism of color in the West. Gage explores color as a language of emotions, psychological meaning, and religious significance.

Itten, Johannes, *The Elements of Color*, John Wiley & Sons, New York, 1970.

A condensed and affordable version of Itten's major work, *The Art of Color*, this book covers the color theories of the famous Bauhaus teacher, including the twelve-part color wheel, color contrasts, and color mixing.

Zelanski, Paul, and Mary Pat Fisher, *Color*, 4e, Prentice Hall, Upper Saddle River, NJ, 2002.

A well-illustrated, informative, but non-dogmatic introduction to color theory and

practice aimed at students of both the fine and applied arts. Zelanski is a former student of Albers.

Design Principles

Albarn, Keith, et al, *The Language of Pattern: An Enquiry Inspired by Islamic Decoration*, Thames and Hudson, London, 1976.

This book contains everything you ever wanted to know about how to make patterns using the Fibonacci series and cabalistic reduction.

Bothwell, Dorr, et al, *Notan: The Dark-Light Principle of Design*, Dover Publications, New York, 1991.

Notan is a guiding principle in Eastern art and design, focusing on the interaction between positive and negative space. A practical introduction for artists, architects, and potters, and graphic designers, textile designers, and interior designers.

Bowers, John, *Introduction to Two-Dimensional Design: Understanding Form and Function*, John Wiley & Sons, New York, 1999.

A foundation course in two-dimensional design principles with examples from fine art, graphic design, architecture, web design, and interactive media.

Curtis, Hillman, *MTIV: Process, Inspiration, and Practice for the New Media Designer*, New Riders Publishing, New York, 2002.

Aimed at new media designers, but also of interest to traditional artists and designers, Curtis explains how to "make the invisible visible" with lots of practical tips on how to find inspiration and create great graphic design.

Elam, Kimberly, *Geometry of Design: Studies in Proportion and Composition*, Princeton Architectural Press, NJ, 2001.

An introduction to systems of proportion developed in classical antiquity and still in use today: the golden section and the root 2 system. Aided by vellum overlays, Elam analyses examples from the Parthenon to the reworked Volkswagen Beetle.

Fletcher, Alan, *The Art of Looking Sideways*, Phaidon Press, London and New York, 2001.

An extraordinary and beautifully designed "guide to visual awareness," an indescribable compilation of anecdotes, quotes, images, and bizarre facts from a founding partner of Pentagram. An inspiring book to be dipped into, frequently.

Itten, Johannes, *Design and Form: The Basic Course at the Bauhaus and Late*r, John Wiley & Sons, New York, 1975.

First published in 1963 when Itten was alive, subsequent editions were updated by his widow Anneliese. Contains the basic Bauhaus course, together with refinements made later at other art schools.

Lauer, David A., and Stephen Pentak, *Design Basics*, 5e, Wadsworth Publishing, Belmont, CA, 2000.

An introduction to two-dimensional design with design concepts presented in two-page spreads with visual examples from art history, nature, and popular culture, emphasizing the universal application of design principles.

Ocvirk, Otto G., et al, *Art Fundamentals*, 9e, McGraw-Hill, New York, 2001.

A popular and well-illustrated introduction to both design elements and principles with a concise art history. The latest edition includes a CD-ROM and an online learning center with practical exercises, self-guided tutorials, and interactive examples.

Sausmarez, Maurice de, *Basic Design: The Dynamics of Visual Form*, 2e rev, Sterling Press, London, 2002.

A revised edition of this primer, first published in 1964, aimed at students working alone with the minimum of resources. The topics are general enough to apply both to two- and three-dimensional design: primary elements, spatial forces, and visual kinetics.

Wilde, Judith and Richard, *Visual Literacy: A Conceptual Approach to Graphic Problem Solving*, Watson-Guptill Publications, New York, 2000.

An engaging hands-on course in creative thinking comprising assignments followed by students' design solutions. Each visual problem shows the assignment sheet given to the students and includes an analysis of the problem's underlying intent.

Wong, Wucius, *Principles of Two-Dimensional Design*, John Wiley & Sons, New York, 1997.

A course on design fundamentals for art students and lay people dealing with visual logic, forms, and structures, with exercises. Color and three-dimensional design are not covered.

Graphic Design

Arntson, Amy E., *Graphic Design Basics*, 4e, Wadsworth Publishing, Belmont, CA, 2002.

An introductory review of basic graphic design principles covering foreground/background, form, structure, juxtaposition of elements on a page, gestalt theory, and typography. There is also some history, color theory, and computer-related issues.

Peterson, Bryan, *Using Design Basics to Get Creative Results*, North Light Books, New York, 1996.

The first half discusses the fundamental elements of line, type, shape, and texture, and the principles of balance, contrast, unity, color, and value. The second half features working designers putting these lessons into practice.

Holtzschue, Linda, and Edward Noriega, *Design Fundamentals for the Digital Age*, John Wiley & Sons, New York, 1997.

Aimed at students of graphic design, this text teaches traditional design fundamentals in the context of computer-assisted design, covering form, space, and color.

Swann, Alan, *Graphic Design School*, 2e, John Wiley & Sons, New York, 1999.

This book covers the techniques and tools of basic graphic design: the language of design, principles, and techniques, and aspects of commercial practice. It concisely stresses the importance of craftsmanship for a solid design foundation.

White, Alex W., *The Elements of Graphic Design: Space, Unity, Page Architecture, and Type*, Allworth Press, New York, 2002.

This explores the role of white space as a connection between page elements through examples from art, design, and architecture.

Web Resources

The Internet is a great place for finding out about specific artists or looking at particular paintings and designs. But just as books go out of print, so websites sometimes change addresses or disappear. Below is a selection of interesting sites, which is by no means comprehensive.

Artists and Movements

A to Z of Surrealism:
www.bbc.co.uk/radio3/speech/surrealazidx.shtml
Lots of information on the Surrealists from this BBC Radio 3 website.

Artcyclopedia:
http://artcyclopedia.com
Brief biographies of artists with links to museum sites.

Art archive:
www.artarchive.com
Mark Harden's website has 2000 scans from 200 artists, organized alphabetically or by movement.

Art history resources:
http://witcombe.sbc.edu/ARTHLinks.html
Professor Chris Witcombe's list of art history links.

Art movements directory:
www.artmovements.co.uk/home.htm
Concise reference guide to the major art movements and periods.

Artnet:
www.artnet.com
From *Artnet* magazine, mainly contemporary artists, with auction prices.

Art-online:
www.Art-Online.com
Fine art directory links website with sections on art history and artists.

Web gallery of art:
http://gallery.euroweb.hu/welcome.html
European paintings and sculptures, 1150–1800.

Web museum:
www.ibiblio.org/wm
Artist biographies, art movements, and a glossary.

Galleries

Most galleries have their own websites: some show only highlights of their collections; others are more comprehensive, including databases of artists and paintings, with biographies and descriptions.

24-Hour Museum:
www.24hourmuseum.org.uk/
Gateway to 2,500 UK galleries and heritage attractions.

Guggenheim museums:
www.guggenheim.org/
Gateway to New York, Bilbao, Venice, Berlin, and Las Vegas art galleries.

Museum of Modern Art, New York:
www.moma.org/index.html
Features highlights from their collection.

The Art Institute of Chicago:
www.artic.edu/aic/
Features highlights from their collection.

National Gallery, London:
www.nationalgallery.org.uk/default.htm
Includes database of their collection.

Tate Galleries, UK:
www.tate.org.uk/home/default.htm
Includes database of the collections from Tate Britain, Tate Modern, Tate Liverpool, and Tate St Ives.

Louvre, Paris:
www.louvre.fr/louvrea.htm
Includes database of their collection.

Musée d'Orsay, Paris:
www.musee-orsay.fr
Features highlights from their collection.

Color

Pigments through the ages:
webexhibits.org/pigments/index.html
Informative website, arranged by hue, telling us where the colors came from.

Causes of color:
webexhibits.org/causesofcolor/index.html
This website explains why things are colored.

Color matters:
www.colormatters.com/entercolormatters.html
Everything you need to know about color.

Crayola crayon colors:
www.factmonster.com/ipka/A0872797.html
Fascinating facts about crayon colors.

Munsell color system:
www.gretagmacbeth.com
This covers everything about the Munsell Color System.

Virtual color museum:
www.colorsystem.com
This covers color theory through the ages in great detail.

Optical Illusions

Optical Duchamp:
www.xs4all.nl/~abandon/optical.htm
Surrealist Duchamp's optical experiments.

Optical toys:
courses.ncssm.edu/gallery/collections/toys/opticaltoys.htm
Laura Hayes and John Howard Wileman's exhibit of pre-20th century optical toys and illusionary devices.

Lightness perception and lightness illusions:
www.bcs.mit.edu/gaz/
Interactive optical illusions based on the work of Edward H. Adelson at MIT.

Miscellaneous Topics

Fibonacci numbers and the golden section:
www.goldenmeangauge.co.uk/fibonacci.htm
www.mcs.surrey.ac.uk/Personal/R.Knott/Fibonacci/fib.html
Find out more about Fibonacci in nature and art at these two sites.

Leonardo da Vinci:
www.bbc.co.uk/science/leonardo/
A BBC website devoted to Leonardo.

Mandalas:
www.graphics.cornell.edu/online/mandala
This covers Buddhist mandalas.

Navajo sand painting:
www.americana.net/sandptest.html
Find out more about the evolution of the modern Navajo sand painting.

Polyhedra and art:
www.georgehart.com/virtual-polyhedra/art.html
Sculptor George Hart's informative survey of polyhedra in art.

Quilts:
ttsw.com/MainQuiltingPage.html
Everything you wanted to know about quilting.

Radiosity:
freespace.virgin.net/hugo.elias/radiosity/radiosity.htm
Hugo Elias's tutorial on lighting computer models.

The rose window:
kalispell.bigsky.net/proctor/Main%20Rose%20Window.html
A history and survey of the rose window in architecture.

Picture Credits

Collections are given in the captions alongside the illustrations. Sources for illustrations not supplied by museums or collections, additional information, and copyright credits are given below. Numbers are figure numbers unless otherwise indicated. Laurence King Publishing has endeavored to contact all copyright holders. Corrections or omissions will be noted for any future edition.

Frontispiece © Tate, London 2003/ © ADAGP, Paris, and DACS, London 2003; © Copyright, The British Museum; **0.2** © CAMERAPHOTO Arte, Venice; **0.3** © Fotografica Foglia, Naples or © Vincenzo Pirozzi, Rome; **0.4** UCLA Fowler Museum of Cultural History/photo Don Cole; **0.5** © Photo Josse, Paris; **0.6** © Tate, London 2003/© 2003 Mondrian/Holtzman Trust c/o hcr@hcrinternational.com; **p. 12** © 2003, Digital image, The Museum of Modern Art, New York/Scala, Florence © DACS 2003; **0.7** Bridgeman Art Library, London; **0.8** © 2003, Digital image, The Museum of Modern Art, New York/Scala, Florence; **p. 16** Bridgeman Art Library, London. © Succession H. Matisse/DACS 2003; **1.2** © Themerson Archive, London D48.3; **1.4** © Tony Morrison, South American Pictures, Woodbridge, UK; **1.5** The Museum of Modern Art, New York. Purchase. © The Saul Steinberg Foundation/Artist Rights Society, NY, and DACS, London; **1.8** © Photo Josse, Paris; **1.10** Photography by Ellen Page Wilson, reproduced courtesy of the artist and Pace Wildenstein, New York, © Chuck Close; **1.15** © Tate, London 2003; **1.17** Albright-Knox Art Gallery, Buffalo, New York, Charles Clifton Fund, 1982; **1.18** Whitney Museum of American Art, New York. Purchase, with funds from the Friends of the Whitney Museum of American Art. © ARS, NY, and DACS, London 2003; **1.19** © The National Gallery, London; **1.20** © 2003, Digital image, The Museum of Modern Art, New York 524.1941/Scala, Florence; **1.26** © Graham Rounthwaite (Angus Hyland, *Pen and Mouse: Commercial Art and Digital Illustration*, Laurence King Publishing (London), 2001]; **1.27** © Tate, London 2003/© Patrick Caulfield 2003. All Rights Reserved, DACS; **1.28** © Julian Opie, courtesy the Lisson Gallery, London, and EMI; **1.30** Alinari, Florence; **1.34** The Museum of Modern Art, New York. Gift of Aldrich Rockefeller; **1.38** Witt Library, Courtauld Institute of Art, London; **1.39** Courtesy Stockton-on-Tees Borough Council; **p. 40** Bauhaus-Archiv Berlin.

© DACS 2003; **2.1** © Tate, London 2003/ © ADAGP, Paris, and DACS, London 2003; **2.4** © Bowness, Hepworth Estate/Tate, London 2003, courtesy Yorkshire Sculpture Park; **2.5** The 1993 Artangel/Beck's Commission, Grove Road, East London. Courtesy Artangel, London; **2.6** © Paul M.R. Maeyaert; **2.7** © Tate, London 2003; **2.12** © 2003, Digital image, The Museum of Modern Art, New York/Scala, Florence; **2.14** © courtesy of the artist's estate/Bridgeman Art Library, London; **2.15** Bridgeman Art Library, London; **2.16** © Tate, London 2003/© Estate of Edward Wadsworth 2003. All Rights Reserved, DACS; **2.17** © Tate, London 2003/© Salvador Dalí, Gala-Salvador Dalí Foundation, DACS, London 2003; **2.20** © 2003, Digital image, The Museum of Modern Art, New York/Scala, Florence © Sucession Picasso/DACS 2003; **2.21** Photo by Michael Cavanagh & Kevin Montague; **2.23** © 2003, Digital image, The Museum of Modern Art, New York/Scala, Florence, © Kate Rothko Prizel and Christopher Rothko/DACS 2003; **2.25** © 2003 The Nelson Gallery Foundation. All Reproduction Rights Reserved; **2.27** © 2003, Art Resource/Scala, Florence. © 2003 Cordon Art B.V. Baarn, Holland. All rights reserved; **2.29** © Fotografica Foglia, Naples; **2.31** © Paul M.R. Maeyaert; **2.34** © FLC/ADAGP, Paris, and DACS, London 2003; **2.35** Photo A.C.Cooper, London; **p. 60** © The National Gallery, London; **3.1** © Inigo Bujedo Aguirre, London; **3.2** © Sue Bolsom; **3.3** © Photo Josse, Paris; **3.4** © Tate, London 2003/ © Chris Ofili; **3.5** © Photo Josse, Paris; **3.7** & **3.8** © Tate, London 2003/© Frank Auerbach; **3.9** © Paul M.R. Maeyaert; **3.10** © 2003, Digital image, The Museum of Modern Art, New York/Scala, Florence, © DACS 2003; **3.11** © Tate, London 2003/ © Sucession Picasso/DACS 2003; **3.12** © 2003, Photo The Newark Art Museum/Art Resource/Scala, Florence; **3.13** © Paul Maeyaert; **3.14** © Tate, London 2003/© Succession H. Matisse/DACS 2003; **3.15** © Tate, London 2003/© DACS 2003; **3.16** © DACS 2003; **3.18** Smith College Museum of Art, Northampton, MA. Purchased, Drayton Hillyer Fund, 1940; **3.19** © Tate, London 2003; **3.20** © The Estate of Roy Lichtenstein/DACS 2003; **3.21** Courtesy of the San Antonio Museum of Art, San Antonio, TX. Purchased with funds provided by the Lillie and Roy Cullen Endowment Fund; **3.22** © Vincenzo Pirozzi, Rome; **3.23** Courtesy the artist and The Marlborough Gallery, Madrid; **3.25** © Tate,

London 2003/© Ron Mueck; **3.26** Courtesy the artist and Barbara Gladstone Gallery, New York, photo Bill Orcutt © DACS 2003; **3.27** UCLA Fowler Museum of Cultural History; photo Don Cole; **3.29** © Damien Hirst/Science Ltd; **p. 78** Courtesy eBoy; **4.1** Bridgeman Art Library, London; **4.3** © The National Gallery, London; **4.5** © Photo Josse, Paris; **4.7** & **4.9** © The National Gallery, London; **4.10** © Studio Fotografico Quattrone, Florence; **4.12** & **4.13** © Vincenzo Pirozzi, Rome; **4.14** © Fotografica Foglia, Naples; **4.15** © 2003, Photo Art Resource/Scala, Florence; **4.19** © Studio Fotografico Quattrone, Florence; **4.20** © The National Gallery, London; **4.21** © Studio Fotografico Quattrone, Florence; **4.23** Scala, Florence; **4.24** Harry Ransom Humanities Research Center. The University of Texas at Austin; **4.27** © photo du Musée des Beaux-Arts de la Ville de Reims; **4.30** © Tate, London 2003/© Ed Ruscha; **4.31** Courtesy Otto Naumann Ltd, New York; **4.34** © The National Gallery, London; **4.35** The Museum of Modern Art, New York/Scala, Florence, © DACS 2003; **4.36** © DACS 2003; **4.37** © 1990, Photo Scala, Florence, courtesy of the Ministero Beni e Att. Culturali; **4.40** Courtesy eBoy; **4.41** © David Hockney; **4.45** The Pennsylvania Academy of the Fine Arts, Academy Purchase with Funds from the National Endowment for the Arts (Contemporary Arts Purchase) & Benice McIlhenny Wintersteen, The Women's Committee of the PAFA, Marion B. Stroud, Mrs H. Gates Lloyd & Theodore T. Newbold; **4.47** © 2003, Digital image, The Museum of Modern Art, New York/Scala, Florence; **4.48** © Tate, London 2003/© Howard Hodgkin; **4.49** Courtesy Phyllis Kind Gallery, New York & Chicago; **4.51** © 2003, Art Resource/Scala, Florence, © 2003 Cordon Art B.V. Baarn, Holland. All rights reserved; **p. 110** © Tate, London 2003/© Cornelia Parker; **5.1** Digital Image © 2003 The Museum of Modern Art, New York. 590.1939.a-d SCALA 0120864, © ARS, NY, and DACS, London 2003; **5.2** Bridgeman Art Library, London; **5.4** © Henri Cartier-Bresson/Magnum Photos; **5.5** © Stephen Dalton/NHPA Limited; **5.7** Bridgeman Art Library, London; **5.8** Craig & Marie Mauzy, Athens mauzy@otenet.gr; **5.9** © CAMERAPHOTO Arte, Venice; **5.10** © Photo Josse, Paris; **5.12** © Studio Fotografico Quattrone, Florence; **5.13** Krazy & Ignatz © 2002 Fantagraphics Books. All rights reserved; **5.15** © Succession Marcel Duchamp/ADAGP, Paris, and DACS, London 2003; **5.16** © DACS 2003; **5.19** The Museum

Index